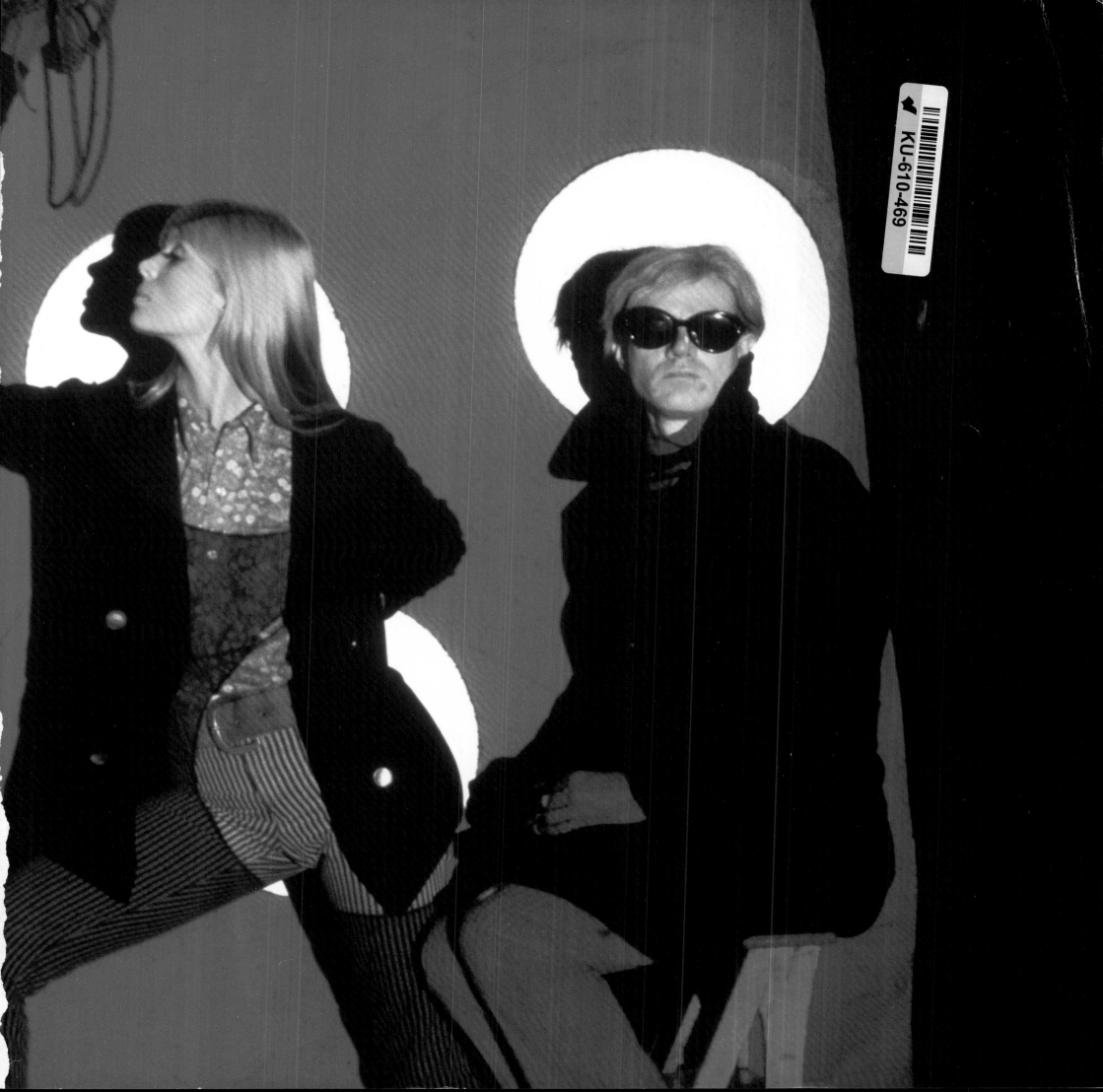

EDITED BY STÉPHANE AQUIN

MUSIC
AND
DANCE
IN
ANDY
WARHOL'S
WORK

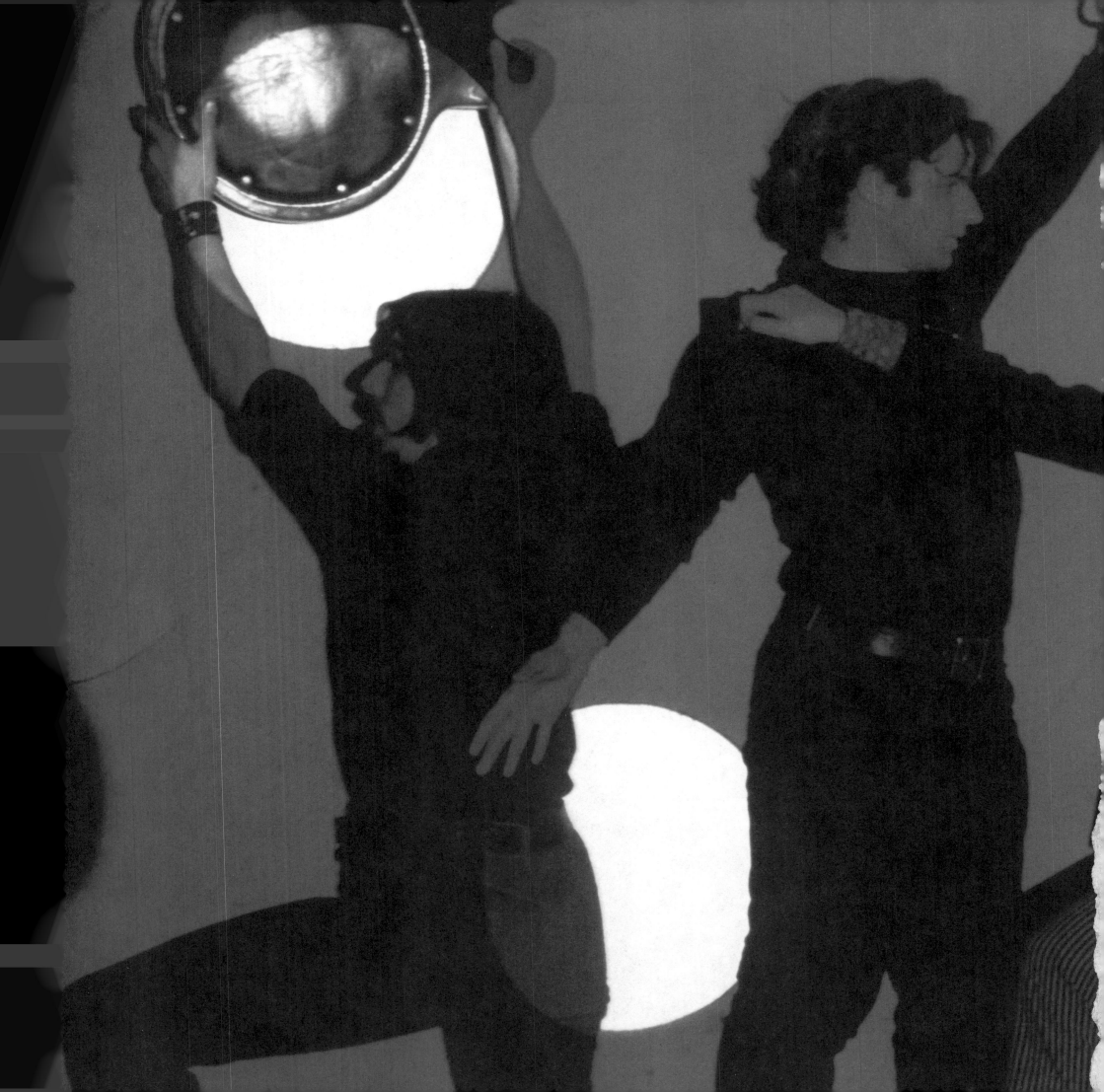

WARHOL
LIVE

THE MONTREAL
MUSEUM
OF FINE ARTS

THE MONTREAL MUSEUM
OF FINE ARTS

Bernard Lamarre
President

Nathalie Bondil
Director

Paul Lavallée
Director of Administration

Danielle Champagne
Director of Communications
Director of the Montreal Museum
of Fine Arts Foundation

—

THE ANDY WARHOL
MUSEUM

David M. Hillenbrand
President of Carnegie Museums
of Pittsburgh

Randall S. Dearth
President of the Board

Tom Sokolowski
Director

Colleen Russell-Criste
Deputy Director

Jesse Kowalski
Director of Exhibitions

The international exhibition program of the Montreal Museum of Fine Arts receives financial support from the Exhibition Fund of the Montreal Museum of Fine Arts Foundation and the Paul G. Desmarais Fund.

The Museum would like to thank the Volunteer Association of the Montreal Museum of Fine Arts as well as its Friends and the many corporations, foundations and individuals for their contributions.

—

The Andy Warhol Museum is one of the four Carnegie Museums of Pittsburgh and was created as a collaborative project of Carnegie Institute, Dia Center for the Arts and The Andy Warhol Foundation for the Visual Arts, Inc.

The Andy Warhol Museum receives state arts funding support through a grant from the Pennsylvania Council on the Arts, a state agency funded by the Commonwealth of Pennsylvania; the National Endowment for the Arts, a federal agency, and The Heinz Endowments. Further support is provided by the Allegheny Regional Asset District.

The Montreal Museum of Fine Arts also wishes to thank the Canada Council for the Arts and the Conseil des arts de Montréal, in addition to the Department of Canadian Heritage for its assistance through the Canada Travelling Exhibitions Indemnification Program. The Museum also acknowledges Quebec's Ministère de la Culture, des Communications et de la Condition féminine du Québec for its ongoing support.

—

Located in Pittsburgh, Pennsylvania, the place of Andy Warhol's birth, The Warhol is one of the most comprehensive single-artist museums in the world. The Andy Warhol Museum is one of the four Carnegie Museums of Pittsburgh. Additional information about The Warhol is available at www.warhol.org.

THIS CATALOGUE IS PUBLISHED
IN CONJUNCTION WITH THE EXHIBI-
TION *WARHOL LIVE*, AN EXHIBITION
ORGANIZED BY THE MONTREAL
MUSEUM OF FINE ARTS IN
PARTNERSHIP WITH THE ANDY
WARHOL MUSEUM, PITTSBURGH.

THE VOLUNTEER ASSOCIATION
OF THE MONTREAL MUSEUM OF
FINE ARTS HAS HELPED FINANCE
THIS WORK.

THE MONTREAL MUSEUM OF FINE
ARTS IS DEEPLY GRATEFUL TO
MEYER SOUND FOR GENEROUSLY
CONTRIBUTING TO THE EXHIBITION'S
SOUND ENVIRONMENT.

EXHIBITION

Stéphane Aquin
Curator
of Contemporary Art
The Montreal
Museum of Fine Arts

Emma Lavigne
Curator,
creation contemporaine
et prospective
Musée national
d'art moderne / CCI
Centre Pompidou, Paris

Matt Wrbican
Archivist
The Andy Warhol Museum,
Pittsburgh

FILM, VIDEO AND TELEVISION

Greg Pierce
Associate Curator
of Film and Video
The Andy Warhol Museum,
Pittsburgh

SOUND

Emma Lavigne
Conception

Thierry Planelle
Artistic direction

Philippe Wojtowicz
Sound and
system engineering

EXHIBITION VENUES

**The Montreal Museum
of Fine Arts**
Jean-Noël Desmarais Pavilion
September 25, 2008–
January 18, 2009
Design
Guillaume de Fontenay
with the assistance of
Irena Lesiv

**Fine Arts Museums of
San Francisco, de Young**
February 14,
2009–May 17, 2009

**The Andy Warhol Museum,
Pittsburgh**
June 10, 2009–
September 15, 2009

THE POP ARTIST WHO WANTED TO BE A POP STAR, BUT NOT ONLY THAT

—

Nathalie Bondil
Director
The Montreal
Museum of Fine Arts

"To tell the truth, I don't really like music—I like the people who make it," Warhol remarked in his magazine *Interview* one year before his death. Although it may seem to be one of his paradoxes, it is rather an admission he made to himself.

Warhol Live: To look at Warhol's work through the prism of music, sounds and silence is to take another listen to better hear what he was all about, in short, to recount the trajectory of a Pop artist who wanted to be a pop star. But not only that. "I'll be your mirror, I'll be your mirror, I'll be your mirror . . ." was to keep playing on the final track of the Velvet Underground album, Lou Reed recalls. Warhol composed his image and chose his double. He was the youngster transfixed by Shirley Temple on the big screen. He was the star-struck artist swooning over Mick Jagger the stage man. The aura of narcissism, from the diva to the rising rock stars who give it their all on stage, like the oh-so-punk Callas (as he saw her), the theatricality of the stage and costume designs, the body happening, all fascinated Warhol, who fabricated a character, a persona of himself, like Karl Lagerfeld today. As Roy Lichtenstein put it, he was his art; his studio was his art.

Behind the persona, seen again and again *ad nauseam*, the essays in this volume paint a picture of Warhol from within, approaching an almost complete physical check-up: "his ear was his eye"; he "saw music." His optic nerve resonated in unison with his eardrums. He had an "affair" (a sexualized description of his relationship) with his tape recorder—a prosthesis, like in a Cronenberg movie. For the man who wants to be a machine, the voice is penetrable. His artist's studio was a recording studio, a psychiatrist's office, the listening eye. The Factory—where "whatever was around then blended in with the arias"—and then Studio 54 were his auricular extensions, the acoustic pavilions of rock, pop and disco. In the enclosed spaces of nightclubs and his world—"I really like being a vacuum"—were read and recorded every sound and visual track to later be dissected as creative and narrative processes: Cage's seriality, the Exploding Plastic Inevitable's operatic total work of art, he himself as an icon of glam rock. Warhol was not a musician, any more than he was a singer, but he was a music lover, now under academic consideration. He was a groupie who, as a child, wanted to walk in the shoes of the music hall star—"I always wanted to be a tap dancer"—and who, after temporarily taking a stab at being the producer of a band, ended up with the status of rock . . . star. On the other hand, he was a conductor all his life, beginning with that of other people, and sound—music, noise, speech, silence—constantly fed his fine-tuned ear (there is nothing better than a machine) an organic flow of material into everything he produced.

Warhol Live is not an inventory of his jukebox, or a background soundtrack for his life, or a catalogue of images rudimentarily connected to the world of music. Nor is it simply bowing to fashion, now that rock and roll has achieved certain status, Warhol's value has gone so high, and there are more exhibitions in which disciplines collude and collide. The Montreal Museum of Fine Arts has come to be known for its all-encompassing and cosmopolitan nature due to its long-standing exploration of approaches across disciplines. However, the interdisciplinary study of visual art, music and sound is new territory, which will only be further charted in the near future with our new foundation, *Arte Musica*.

On behalf of the Museum and on my own behalf, my thanks first of all to Tom Sokolowski, director of the Andy Warhol Museum, our partner, for his support, advice and enlightened generosity. Our warm thanks also to the Warhol Museum's deputy director, Colleen Russell Criste, director of exhibitions Jesse Kowalski, registrar Heather Kowalski, interim associate registrar, Amber Morgan, and to its entire dedicated staff, who handled and supervised with special care the loan of a great many objects. Greg Burchard, the Warhol Museum's rights and reproductions / photography services manager, put enormous effort into gathering photo material with exemplary kindness and reliability, qualities shared by Geralyn Huxley, curator of film and video. To Greg Pierce, assistant curator of film and video, we owe the exhibition's film and video program.

I extend my deepest thanks to John Buchanan, director of the Fine Arts Museums of San Francisco, for agreeing to participate in this project with such enthusiasm and trust. Sincere thanks for their support to Lynn Orr, senior curator of European art, Krista Brugnara, director of exhibitions, and Allison Satre, exhibitions coordinator, who will coordinate the project's installation in the new de Young Museum with the help of Timothy Anglin-Burgard, curator of American art.

We are also very grateful to Joel Wachs, president, and Michael Hermann, director of licensing, at the Andy Warhol Foundation for the Visual Arts Inc. for their unwavering and generous support.

At the Montreal Museum of Fine Arts, my greatest thanks and much more go to its entire staff, without exception. For coordinating the project as a whole, my thanks to Pascal Normandin, head of exhibitions management, and his team. Along with the first complete, critical catalogue of the record covers created by Warhol, compiled by Paul Maréchal and published simultaneously, the present publication will contribute far from anecdotal analysis of the work, creative process and personality of one of the most important artists of the twentieth century. My sincere thanks to Sébastien Hart, associate publisher working alongside Stéphane Aquin, to the members of our publishing department, to all those involved in the publishing and production of these two books, and finally to the authors: Roger Copeland, John Hunisak, Branden W. Joseph, Melissa Ragona and especially Glenn O'Brien, who graciously granted reproduction rights for the covers of issues of the magazine *Interview*. The layout created by Orangetango is divine, as were their speed and professionalism. In Montreal, the exhibition was designed by Guillaume de Fontenay with the help of Irena Lesiv and the assistance of Sandra Gagné and Richard Gagnier and their staff at the Museum, while Philippe Legris designed the layout. All of them brought an energetic drive to the task. For the original sound program and environment a team of experts—Emma Lavigne, Thierry Planelle and Philippe Wojtowicz—orchestrated for us a soundtrack in synch with the objects on display that constitutes an exhibition in itself.

Last but not least, the exhibition organizers. Matt Wrbican, archivist at the Andy Warhol Museum, drew on his knowledge and his inexhaustible archives on Warhol to come up with a number of hitherto unseen documents. His participation was crucial, and our Museum will always be his. And Emma Lavigne, my friend from my youth, my friend forever, formerly the curator of the Musée de la Musique in Paris, where she had already mounted innovative exhibitions on the visual arts and music in the twentieth century. Stéphane Aquin, my colleague, my Montreal friend, my friend plain and simple, demonstrated on many occasions his fine taste and his profound knowledge. My thanks to everyone. Encore!

WARHOL LIVE

—
Nathalie Bondil
Director
The Montreal Museum
of Fine Arts

—
Thomas Sokolowski
Director
The Andy Warhol
Museum

—
John Buchanan, Jr.
Director
Fine Arts Museums
of San Francisco

The Montreal Museum of Fine Arts has initiated and organized a major exhibition in partnership with the Andy Warhol Museum that examines Warhol's work as seen through the lens of music. *Warhol Live,* for the first time in the artist's historiography, proposes a comprehensive period-by-period reading of the role of music in Warhol's work, and of his multiple roles within the world of music. The exhibition will travel to the de Young Museum in San Francisco and to the Andy Warhol Museum in Pittsburgh.

Music is manifest in Warhol's oeuvre, from the drawing of an orchestra he made in 1948 for the cover of *Cano,* the Carnegie Institute of Technology student magazine, to his high-society portraits of stars such as Mick Jagger, Liza Minnelli, Michael Jackson or Grace Jones. A little-known fact is that he illustrated nearly fifty album covers for diverse recordings, from the time he arrived in New York in 1949 until the year of his death in 1987. The sequence of these covers reads like a history of postwar American musical taste, encompassing classical, jazz, rock, pop, soul, and disco, which have helped define the history of record cover design.

The role of music in Warhol's work, however, goes beyond mere iconography and illustration. He orchestrated the All Tomorrow's Parties at the Factory, providing ideal yet fleeting events to showcase Edie Sedgwick, his muse and first alter ego. He also acted as producer for the Velvet Underground, for which he conceived the total artwork that is the Exploding Plastic Inevitable, and lent his Silver Clouds to Merce Cunningham's choreography *Rainforest,* and made Studio 54 an extension of his own studio. He used music in his films, filmed concerts, made video clips and interviewed musicians, for *Interview* and for *Andy Warhol's TV.*

Many of the defining aesthetic traits of Andy Warhol's seminal work in painting and in film, which include his use of serial composition, his reliance on chance and his attention to the world around him, show strong affinities with the music of his contemporaries, namely John Cage and La Monte Young. Through music, and through the company of musicians, Warhol achieved the transformation of his image, from passive listener to the music of Hollywood movies, to producer, to celebrity nightclubber, to rock star himself, speechless mirror to Mick Jagger or Debbie Harry, who served as Warhol's last alter ego.

The exhibition *Warhol Live* brings together around this central theme both the major iconic paintings (portraits of *Elvis* and *Marilyn,* serial arrangements of *Coca-Cola Bottles,* films such as *Sleep* and *Empire,* and more) and the lesser-known ephemeral work (album covers, illustrations, photographs, Polaroids, among other items) that Warhol created in tune with music. The show will reveal the creative energy and connections between the arts underlying Warhol's work. *Warhol Live* will also recreate some of the high points of this relationship between art and music, such as the world of the Silver Factory; the multimedia spectacle Exploding Plastic Inevitable, set to music by the Velvet Underground; the Silver Clouds; and the musical ambience of Studio 54.

Remarkably, this is the first thorough exploration of this crucial aspect of Andy Warhol's work. The exhibition is accompanied by a fully illustrated catalogue of the exhibition, published by the Montreal Museum of Fine Arts, with essays by prominent scholars, as well as the first catalogue raisonné of the record covers designed by Andy Warhol from 1949 to 1987. As such, the exhibition and catalogue will constitute a major contribution to the understanding of this great artist's work and of his time.

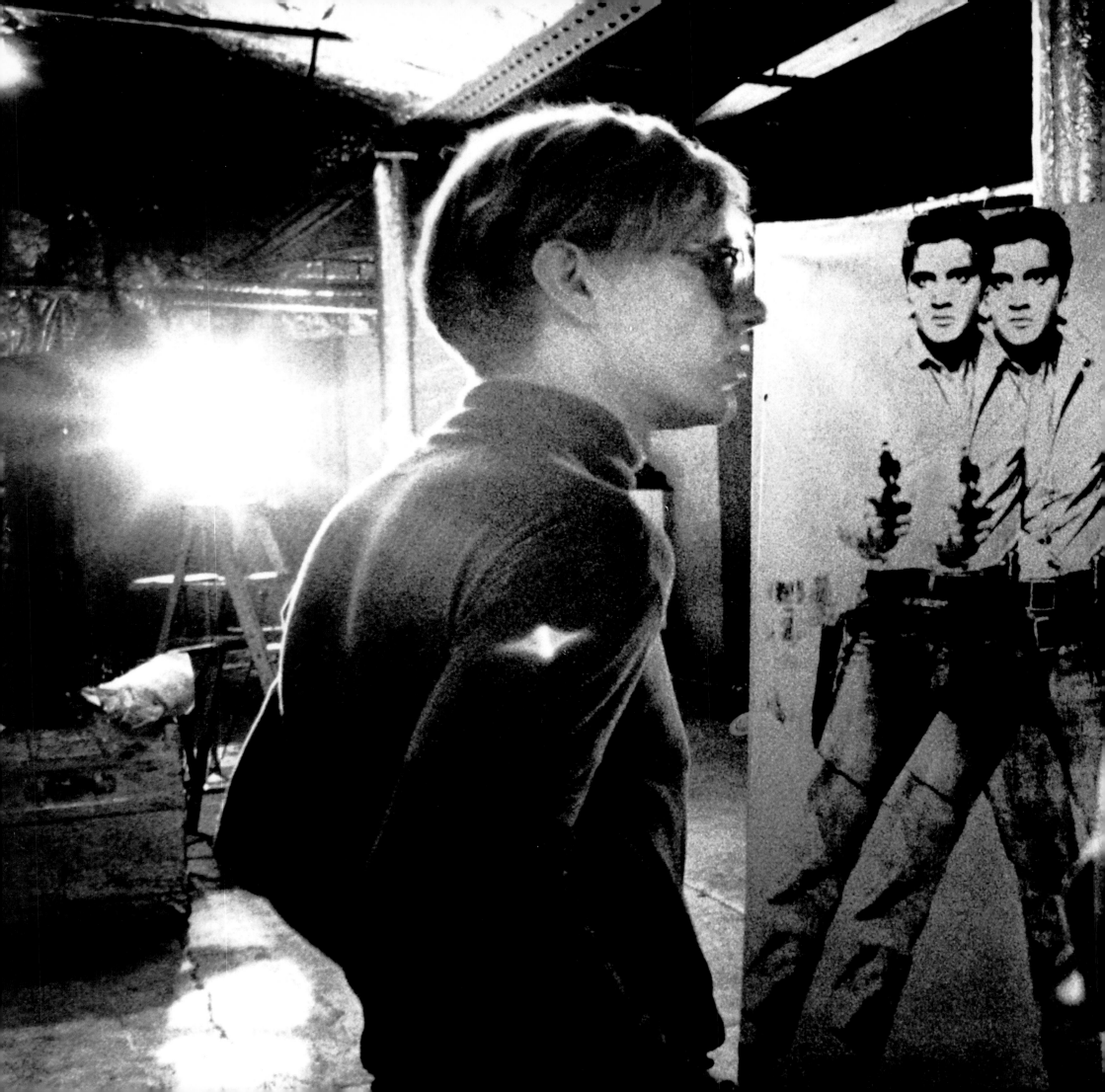

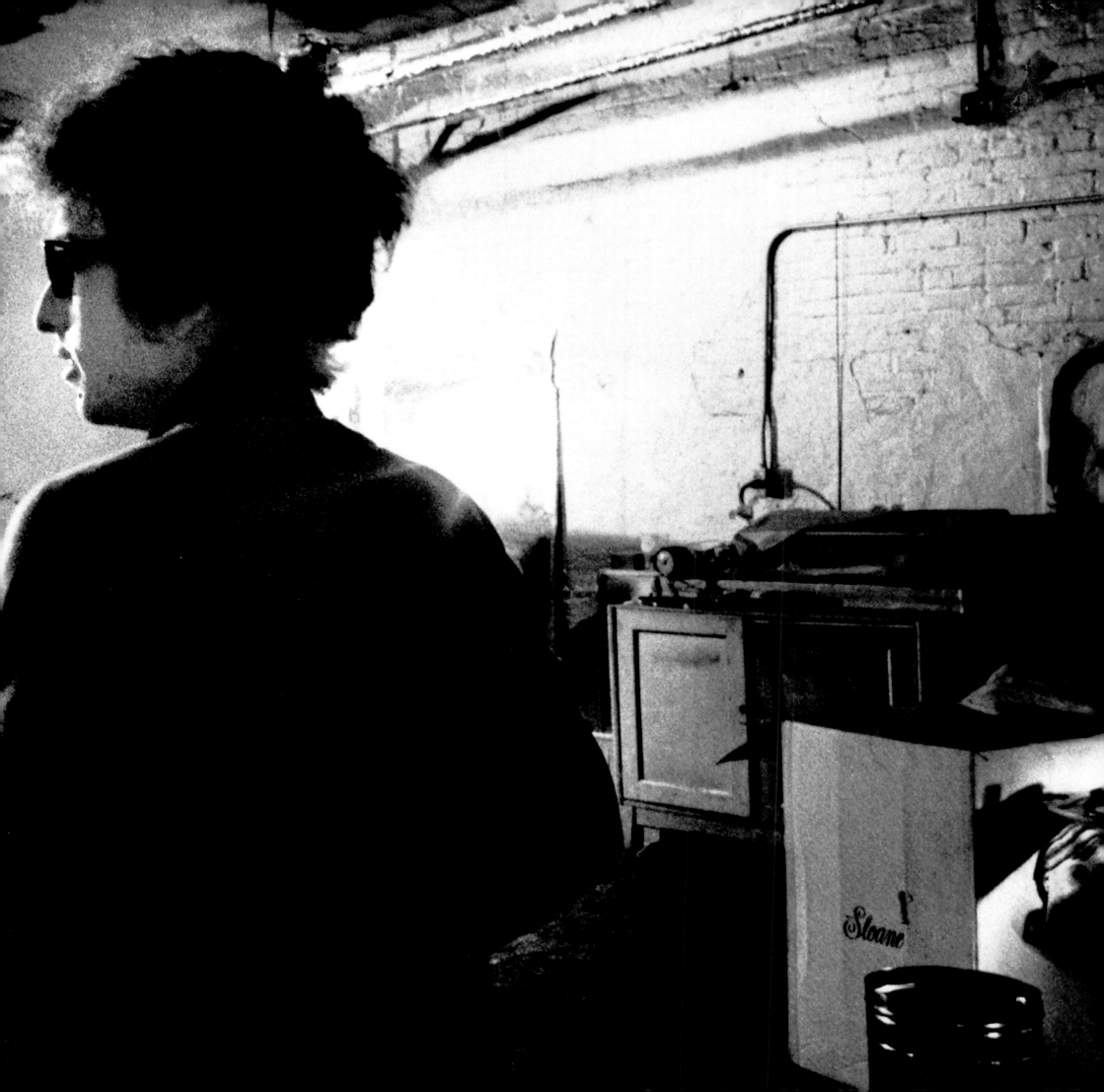

ACKNOWLEDGEMENTS

The curators of the exhibition would like to thank the following people for their kind co-operation.

L. Lynne Addison
Marianne Aebersold
Pierre-Henri Aho
Darsie Alexander
Giselle Arteaga-Johnson
Daina Augaitis
Nicolas Baby
Anita Balogh
Rachel Baron-Horn
Kathleen Bartels
Neal Benezra
José R. Berardo
Dr. Evelyn Bertram Neunzig
Jean Bickley
F. Ann Birks
Bruno Bischofberger
Renate Blaffert
Lara Blanchy
Irving Blum
Eugen Blume
Vincent Bonin
Udo Brandhorst
Peter M. Brant
Karin Breuer
Kerry Brougher

Krista Brugnara
Cheryl Brutvan
Greg Burchard
Bernhard Mendes Bürgi
S. Victor Burgos
Lorna Campbell
Rose Candelaria
Alexandre Carel
Therese Chen
Jean-François Chougnet
Karen Christenson
Roger Copeland
Jean-Pierre Criqui
Colleen Russell Criste
Chantal Crousel
Felicia Cukier
James Cuno
Danielle Currie
David D'Arcy
Claudia Defendi
François Dell'Aniello
Dr. Stephan Diederich
Lynn Dierks
Donna di Salvo
Alisa Dix
Anthony d'Offay
Amy P. Dowe
Wolfgang Drechsler
Marc S. Dreier
Douglas Dreishpoon

Paul F. Driscoll
James Elliott
Lisa Escovedo
Éliane Excoffier
Nuno Ferreira de Carvalho
Elizabeth Finkelstein
Nat Finkelstein
Jennie Fisher
Shirley Fiterman
Laura Fleischmann
Suzanne Folds McCullagh
Marie-Hélène Fox
Emmanuel (Jun) Francisco Jr.
Vincent Fremont
Sara Friedlander
Josef Froehlich
Robert Futernick
Jean Gagnon
Mimi Gardner Gates
Tina Garfinkel
Patricia Garland
Martin Gladu
Ann B. Gonzalez
David Gordon
Delphine Gorges
Michael Govan
Louis Grachos
Sue Grinols
Jennifer Gross
Chris Hand
Stephanie Hansen
Keith Hartley
Jon Hendricks
Jim Henke
Michael Hermann
Dr. Hans-Michael Herzog
Evelyn Hofer
Antonio Homem
Abigail Hoover
Mary Hottelet
Anna Hudson
John Hunisak
Annette Hurtig
Stewart Hurwood
Anette Hüsh
Geralyn Huxley
Alex Israël
Lauren Ito
Branden W. Joseph
The Honourable Serge Joyal
Ana Isabel Keilson
Joe Ketner
Udo Kittelmann
Julie Klüver
Prof. Kasper König
Markus Kormann
Heather Kowalski
Jesse Kowalski
Howard Kramer
Mario Kramer
Courtney Kremers
Jonathan Laib
Diane Lamarre

Jessica Lantos
Frank Lautenberg
Marcie Lawrence
Emmy Lee
Heidi K. Lee
Margareta Leuthardt
Jasmine Levett
Stephen Lockwood
Thierry Loriot
Glen D. Lowry
Emilie Luse
Emily Macel
Christopher Makos
Gerard Malanga
Philippe Manzone
Paul Maréchal
Irene Martin
Julie Martin
Jessica Mastro
Gloria McDarrah
Liza Minnelli
Bob Monk
David Moos
Amber E. Morgan
Martha Morrison
Patty Mucha
David Mugrabi
José Mugrabi
Christian Müller
Mariko Munro
Kathleen Mylen-Coulombe
Esty Neuman
Claudine Nicol
Tim Niedert
Alex Nyerges
Glenn O'Brien
Jane O'Meara
Lynn Orr
Derek Palladino
Marie Papazoglou
Kelly Parady
Alexia Parousis
Kim Pashko
Jean-Marc Patras
Andreas Pauly
Istek Peker
Frazer Pennebaker
Howell W. Perkins
Emily Poole
Berit Potter
Robert Powell
Kimiko Powers
Xan Price
Melissa Ragona
Yvonne Rainer
John Ravenal
Lou Reed
Jay Reeg
Dennis Reid
Maria Reilly
Patrick Renassia
Jean-Michel Reusert
Jock Reynolds

Mischa Richter
Lauren Rigby
Jennifer Riley
Malcolm Rogers
Thaddaeus Ropac
Cora Rosevear
Anastasia Rygle
Nicholas Sands
Allison Satre
Beth Savage
Mark Scala
Steve Schapiro
Erin M. A. Schleigh
Burghard Schlicht
Peter-Klauss Schuster
Stephen Shore
Allison A. Smith
Amy Snyder
Marie-Justine Snyder
Isabel Soares Alves
Mary Solt
Walter Soppelsa
Daniel Soutif
Emily Spiegel
Barbi Spieler
Jeff Stalnaker
Laura Steele
Richard Stoner
Amy E. Sullivan
Mary Sullivan
Kim Svendsen
Niklas Svennung
Andrea Szekeres
Krisztina Szipócs
Barbara Tannenbaum
Matthew Teitelbaum
Annabelle Ténèze
Ian M. Thom
Carol Togneri
Simone Tops
Keri A. Towler
Lauren Tucker
Arnold Tunstall
Steina Vasulka
David Vaughan
Olga Viso
Xaver Von Mentzingen
Joel Wachs
Anna Mae Wallowitch
Mark Webber
Adam D. Weinberg
Christopher Whent
Jenny Wilson
Wes Wilson
Peter Wise
Joseph Wolin
Queenie Wong
Henry Wrenn-Meleck
Nancy Wulbrecht
La Monte Young
Jason Ysenburg
Marian Zazeela
Tanya Zhillinsky

We would also like to express our deepest gratitude to the following companies,

Beggars Group
Concord Music Group, Inc.
Elvis Presley Enterprises, Inc.
EMI Group Limited
ESP Agency, Ltd.
 (New York and London)
Folkways Records
 (Center for Folklife and
 Cultural Heritage,
 Smithsonian Institution)
Jamie Record Co.,
 Philadelphia PA,
 special thanks to
 Frank Lipsius
Karmic Release, Ltd.
Marathon Music
Promotone B. V.
Sony BMG
 Music Entertainment
Universal Music Group
Warner Music Group

in addition to:

Bibliothèque nationale
 de France
Dance Magazine
Opera News
Interview Magazine

LENDERS TO THE EXHIBITION

We gratefully acknowledge the generosity of the institutions and individuals whose loans have made this exhibition possible.

CANADA Montreal PAUL MARÉCHAL Toronto ART GALLERY OF ONTARIO Vancouver VANCOUVER ART GALLERY **FRANCE** Paris GALERIE CHANTAL CROUSEL, GALERIE THADDAEUS ROPAC **GERMANY** Cologne MUSEUM LUDWIG Leinfelden-Echterdingen SAMMLUNG FROEHLICH **POR-TUGAL** Lisbon MUSEU BERARDO **SWITZERLAND** Zurich DAROS COLLECTION **UNITED STATES** Akron AKRON ART MUSEUM Boston MUSEUM OF FINE ARTS Chicago STEVE SCHAPIRO Cleveland ROCK AND ROLL HALL OF FAME AND MUSEUM Milwaukee MILWAUKEE ART MUSEUM New York NAT FINKAELSTEIN, STEWART HURWOOD, MARTHA MORRISON, MUGRABI COLLECTION, PENNEBAKER HEGEDUS FILMS, INC., STEPHEN SHORE, SONNABEND GALLERY, 303 GALLERY, WHITNEY MUSEUM OF AMER-ICAN ART Pasadena NORTON SIMON MUSEUM OF ART Pittsburgh THE ANDY WARHOL MUSEUM Richmond VIRGINIA MUSEUM OF FINE ARTS San Francisco FINE ARTS MUSEUMS OF SAN FRANCISCO, SAN FRANCISCO MUSEUM OF MODERN ART Washington, DC HIRSHHORN MUSEUM AND SCULPTURE GARDEN—SMITHSONIAN INSTITUTION

CATALOGUE

**THE MONTREAL MUSEUM
OF FINE ARTS**

Associate publisher
Sébastien Hart

Revision and editing
Clara Gabriel

Proofreading
Jane Jackel

Copyright
Linda-Anne D'Anjou

Research and documentation
Manon Pagé

Technical support
Sylvie Ouellet
Micheline Poulin

Graphic design
orangetango

Pre-press and printing
Transcontinental Litho Acme

PRESTEL PUBLISHING LTD.

Coordination
Anja Paquin

Revision
Jill Corner
Jane Michael

Translation
Timothy Barnard
Robert McInnes

Warhol Live
© The Montreal Museum
of Fine Arts / Prestel
Publishing Ltd. 2008
ISBN The Montreal
Museum of Fine Arts:
978-2-89192-326-2
ISBN Prestel Publishing Ltd.:
978-3-7913-4088-3

Also published in French
under the title *Warhol Live.
La musique et la danse dans
l'œuvre d'Andy Warhol*
© The Montreal Museum
of Fine Arts / Prestel
Publishing Ltd. 2008
ISBN The Montreal
Museum of Fine Arts:
978-2-89192-325-5
ISBN Prestel Publishing Ltd.:
978-3-7913-4089-0

**THE MONTREAL MUSEUM
OF FINE ARTS**
P.O. Box 3000
Station H
Montreal, Quebec
Canada
H3G 2T9
www.mbam.qc.ca

PRESTEL VERLAG
Königinstrasse 9
80539 Munich
Tel. +49 (0)89 24 29 08-300
Fax +49 (0)89 24 29 08-335
www.prestel.de

PRESTEL PUBLISHING LTD.
4 Bloomsbury Place
London WC1A 2QA
Tel. +44 (0)20 7323-5004
Fax +44 (0)20 7636-8004

PRESTEL PUBLISHING
900 Broadway, Suite 603
New York, NY 10003
Tel. +1 (212) 995-2720
Fax +1 (212) 995-2733
www.prestel.com

Library of Congress Control
Number is available;
British Library Cataloguing-in-
Publication Data: a catalogue
record for this book is avail-
able from the British Library;
Deutsche Nationalbibliothek
holds a record of this
publication in the Deutsche
Nationalbibliografie; detailed
bibliographical data can be
found under: http://dnb.ddb.de

Prestel books are available
worldwide. Please contact
your nearest bookseller or
one of the above addresses
for information concerning
your local distributor.

Legal deposit:
3rd quarter 2008
Bibliothèque et Archives
nationales du Québec
National Library of Canada

Printed in Canada

THE MONTREAL
MUSEUM
OF FINE ARTS

PRESTEL

AUTHORS

STÉPHANE AQUIN
Curator
of Contemporary Art
The Montreal Museum
of Fine Arts

—

ROGER COPELAND
Professor
Theater and Dance Program
Oberlin College, Ohio

—

JOHN HUNISAK
Professor
Department of History of Art
and Architecture
Middlebury College, Vermont

—

BRANDEN W. JOSEPH
Associate Professor
Department of Art History
and Archaeology
Columbia University, New York

—

EMMA LAVIGNE
Curator, création
contemporaine et prospective
Musée national d'art
moderne / CCI
Centre Pompidou, Paris

GREG PIERCE
Associate Curator
of Film and Video
The Andy Warhol Museum,
Pittsburgh

MELISSA RAGONA
Assistant Professor of Art
Carnegie Mellon University,
Pittsburgh

MATT WRBICAN
Archivist
The Andy Warhol Museum,
Pittsburgh

3 PRODUCER 4 FAME

In the Works sections of this catalogue, numbers in bold refer to works in the exhibition, and numbers in italics refer to illustrations used as figures.

ANDY WARHOL, MUSICIAN
Stéphane Aquin

SUSAN TOLD ME THE REASON SHE TAKES ME OUT SO MUCH IS BECAUSE I'M EASY TO PLEASE. SHE SAID, "NO MATTER WHAT KIND OF MUSIC I TAKE YOU TO SEE, IT'S YOUR FAVOURITE KIND OF MUSIC. YOU LIKE EVERYTHING, ANDY. YOU WOULD MAKE A *GREAT* PUBLICIST." — ANDY WARHOL, *EXPOSURES*, 1979

Beneath a well-tended mask of the perpetual adolescent, credulous and delighted, and far from this image of the "easy-to-please" fan, Andy Warhol (1928–1987) was a seasoned music lover and keen connoisseur of the music, or rather the different kinds of music, of his day. Susan Blond's above-mentioned comment, as described by Warhol in *Exposures*, reveals not so much a lack of critical discernment as the exceptional eclecticism of his taste, a hyperbolic love of music, evidence of which abounds in his archives (fig. 1). A record collection containing the work of Judy Garland, Elvis Presley and Eartha Kitt, plus opera tickets, Rolling Stones concert tickets and books by John Cage all point to a musical culture that embraced Wagnerian opera and the Hollywood musical, pop music hits and the avant-garde. Even during the turbulent years of the Silver Factory (1964–68), surrounded by a crowd doped up on amphetamines and rock and roll, Warhol maintained his annual subscription to New York's Metropolitan Opera. His ability to embrace every form of music, an unusual trait at a time when musical taste still conformed to an elitist hierarchy, was equalled perhaps only by his ambition as an artist to adopt every art form.

Andy Warhol touched every artistic discipline, or almost: graphic design, illustration, drawing, painting, printmaking, sculpture, film, photography, stage design, installation and performance. He wrote a variety of texts: a novel, a philosophical summary, a journal and more. He recorded thousands of hours of all kinds of conversations. He started a magazine and produced television shows. He even made music videos. But he never composed or recorded music; this art, like dance, is absent from the catalogue of Warhol's work. And yet music and dance are everywhere in his work, as well as his life, proof positive of his clear fascination for these worlds. Perhaps the best-known example of Warhol's interest in music was his collaboration with the New York rock group the Velvet Underground, for which he was producer between 1966 and 1967. And yet depictions of the world of music are a dominant feature of his art, from drawings of musicians and bands in the late 1940s to portraits of pop stars such as Debbie Harry and Grace Jones in the 1980s, thinly veiled foreshadowings of his electrified self-portraits at the end of his life. While he created a number of portraits of Mick Jagger,

he also painted Merce Cunningham, Martha Graham, Rudolf Nureyev, and a number of other dancers. A little-known aspect of his work is the more than fifty record cover illustrations he made for everything, including Tchaikovsky, Diana Ross and the Rolling Stones, who asked him to design the now-legendary covers for albums such as *Sticky Fingers* and *Love You Live* (fig. 2).

Nevertheless, the presence of music in Andy Warhol's work has, until now, been examined only in a fragmentary manner, and the presence of dance hidden from view. Matt Wrbican has organized two exhibitions at the Andy Warhol Museum in Pittsburgh on his relations with the Velvet Underground and the Rolling Stones respectively, which unfortunately were not accompanied by publications.[1] More recently, the Albertina in Vienna devoted an exhibition to Warhol's drawings and collages of pop stars. Apart from the impressive artistic and graphic inventiveness of this series from the late 1970s, most of the preparatory sketches for the better-known works (screen prints, record covers, painted portraits) and the diversity of their subjects, from Charles Aznavour to the Beatles, without forgetting Mick Jagger of course, already afforded a glimpse of Warhol's broad interest in music. In the Albertina's exhibition catalogue, Rainer Crone and Alexandra von Stosch make an initial foray into what lay beneath Warhol's star worship and the artistic issues it raised.[2] Branden Joseph, one of the few other scholars to examine the role of music in Warhol's work, has taken up the subject of the Exploding Plastic Inevitable, the multimedia spectacle Warhol organized with the Velvet Underground, and especially the structural similarities between the serial nature of a film like *Sleep* and the compositional experiments of contemporary avant-garde music.[3] Reflecting on the allegorical aspects of Warhol's life and work, Thomas Crow looked closely at the problematic relationship between Warhol and Bob Dylan in addition to their common view on art.[4] Apart from these recent contributions, the relationship between Warhol's work and music and dance has not been the subject of any comprehensive analysis or vision that does justice to its multidisciplinary aspect. In fact, this state of affairs highlights another oversight in the historiography of Warhol's work. Although readings according to theme (portraits, disasters and so on) and medium (cinema,

FIG. 1 – "The flip side of Andy Warhol," advertisement in *Rolling Stone* magazine, September 7, 1973

screen prints, Polaroids, among others) are frequent, those that approach the structural logic and plural practices of this artist's work are rarer. Just recently, at the Stedelijk in Amsterdam, the exhibition *Other Voices, Other Rooms* had the merit of presenting various facets of Warhol the "video artist" in the form of his film and television work.[5] But one exhibition above all others stands out in this respect and is a model for cross-disciplinary readings of the artist: *The Warhol Look*, put together by Mark Francis and Margery King and based on a simple yet brilliant premise, which was to examine the entirety of Warhol's work from the perspective of his fascination with the overlapping worlds of glamour, style and fashion.[6]

The exhibition *Warhol Live*, reflected in this publication, is the result of an intuition: that music, far from being a marginal aspect of Andy Warhol's sensibility, was a fundamental part of it. To confirm this hypothesis, it was necessary first of all to carry out a systematic rereading of the already familiar elements of his artistic output: painting, screen prints, photography, film, television, illustration and writing. Thanks to our special access to the rich archival resources of the Andy Warhol Museum, nearly intact sources of information were explored: Warhol's personal record collection, sound recordings and day-to-day archives. A large body of documentation, scattered about his Time Capsules—the boxes in which, after 1974, he preserved helter-skelter correspondence, newspapers, books, sketches, press clippings, agendas, invitations, invoices, receipts for flight tickets, photographs, concert tickets and many other items—served as the basis of this new reading, providing not only anecdotes about Warhol's life but also the materials and sources of his artistic endeavours. Finally, this exhibition has provided an opportunity to publish a catalogue raisonné of the record covers Warhol designed, the fruit of ten years of research conducted by Paul Maréchal.[7] This little-known facet of Warhol's output, which spanned his entire career from 1949 to 1987, is a constant exercise in conveying music visually. More than an iconographic motif, or one more pretext among many to create commissioned artworks, what is revealed by this research is that music was one of the fundamental aesthetic elements of Warhol's work. It was the work's emotional substratum, inspiring him philosophically and providing him with his ideal form of expression.

The following pages, the first attempt at an exhaustive exploration of Warhol and music, attempt to encompass this phenomenon in its totality, including the artist's musical culture, the influence of music on the forms of his art, and his own musical experiences. For Warhol was a musician! If only briefly. Branden Joseph's original research reveals a very little-known aspect of Warhol's life, his participation in a rock group called the Druds. In 1963, Warhol and a few other New York artists—Lucas Samaras, Larry Poons, Walter De Maria, Patty Oldenburg (the wife of Claes Oldenburg, now known as Patty Mucha), Jasper Johns, who wrote the songs' lyrics, and La Monte Young, the pioneer of the Fluxus movement who soon left the group, complaining that they were not real musicians—rehearsed on many occasions in the Oldenburgs' apartment. Patty Mucha recalls that the band was Warhol's idea. Billy Klüver, the engineer to whom Warhol later entrusted the production of *Silver Clouds* (1966), recorded one of the group's rehearsals. With titles like "The Coca-Cola Song," "Movie Stars" and "Hollywood," the band's repertoire was a clear reference to Warhol's favourite themes, while the music itself, accentuated by the musicians' outlandish performances, with Warhol on back-up vocals, parodied the pop tunes of the day. Perhaps the first "art band" in history, according to Joseph, the Druds made manifest through music Warhol's project of bringing together in a self-reflexive manner the heretofore far-removed worlds of fine art and popular culture.

Andy Warhol's musical initiation took place in 1930s Pittsburgh, in the midst of the Great Depression. Born into a humble family of Ruthenian immigrants, the young Andrew Warhola discovered music at the St. John Chrysostom Church, with its many icons and captivating Byzantine Rite Catholicism, and at the movies, which he attended faithfully. This was the first golden age of the musical, the heyday of Shirley Temple and Judy Garland—the heroine of *The Wizard of Oz* (fig. 3), which met with unprecedented success when it was released in 1939—whom the young Andrew adored: "I always wanted to be a tap dancer, just like Betty Ford and Barbara Walters. When I was a kid not growing up in Pittsburgh, I saved my pennies, wolfed down my salt and pepper soup, and ran downtown to see every Judy Garland movie. That's why it's so great to be good friends with her daughters, Liza Minnelli and Lorna Luft," he once remarked.[8] Warhol,

2

3

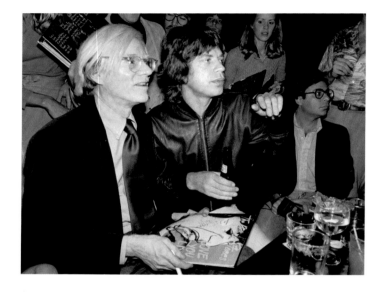

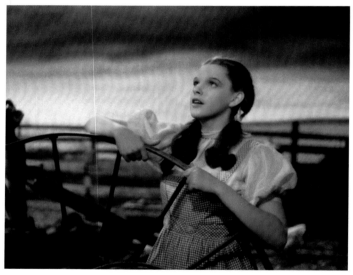

FIG. 2 – Andy Warhol and Mick Jagger, New York, 1977. Photo Bob Gruen FIG. 3 – Judy Garland as Dorothy Gale in *The Wizard of Oz* (1939)

we believe, owes his emotional sense, love of splendour and taste for harmony to the combined effect of his exposure to these two different but equally powerful cultural forms of musical exaltation of the image. In many ways, music is the hidden underpinning of his work. His visual art conveys the feelings that first came to him through music. His paintings are completely alive with an extreme lyricism that propels things seen and depicted into an uncanny dimension of beauty. This quality is nowhere as evident as it is in his early portraits of Hollywood stars, to whom he transferred his star worship and adoration. Marilyn Monroe and Judy Garland, but also Jackie Kennedy as the Mater Dolorosa, were religious figures, icons, as has been suggested many times with reason. They found their full evocative power only when accompanied by music and song, a special kind of prayer.

At the Carnegie Institute of Technology in Pittsburgh, Warhol studied in that cultural temple, the very eclectic College of Fine Arts building designed by Henry Hornbostel, where at the time architecture, drama and music were taught alongside painting and design. Philip Pearlstein, the classmate with whom Warhol shared an apartment in New York in 1949, relates moreover that one of the exercises they performed in school was drawing music.[9] In addition to finding in this academic setting and experience the ferment of his multidisciplinary approach to art, Warhol acquired there his appreciation of dance and classical music, going so far as to take a modern dance class in 1948. This sensibility is apparent in many of his early drawings and paintings, and extends to his work as a sought-after graphic designer in New York, where he created illustrations for publications such as *Dance Magazine* and *Opera News*. It was a sensibility that would never leave him. Dance is the subject of his very first Pop art works, the Dance Diagram paintings, whose motifs were taken from a dance manual. He showed these works in the *New Realists* exhibition at the Sidney Janis Gallery in 1962, where he invited visitors, using diagrams drawn on the ground, to "dance" their own painting.[10]

Even as he became a media star of the new Pop art phenomenon, Warhol began to frequent the small and closely connected worlds of contemporary music and dance. In late 1962, he began a series of paintings on the choreographer and dancer Merce Cunningham, who was also the companion and collaborator of the most influential musician and music theorist of the day, John Cage. At the time, Warhol attended the Judson Memorial Church, where he saw the dance troupe of choreographer Yvonne Rainer, herself a former student of Cunningham's. He was at the premiere of her piece *Sleep* in April 1963, in which a self-absorbed sleeper lies stretched out on the ground, looking off into space. He claims he attended in September the full-length performance of Erik Satie's *Vexations* at the Pocket Theater, a work composed of a single phrase repeated 840 times and played consecutively by ten pianists conducted by John Cage, who, along with John Cale, was also one of the pianists. Cale, another major avant-garde music figure of the day and founder with La Monte Young of the group the Dream Syndicate, saw in rock and roll a new field for experimentation; later, he became a member of the Velvet Underground. As for La Monte Young, who had left the Druds earlier that same year, in 1964 Warhol commissioned him to compose music to accompany excerpts from his films *Eat*, *Sleep*, *Kiss* and *Haircut*, presented on four Fairchild projectors at the New York Film Festival in Lincoln Center's Philharmonic Hall. In 1968, Jasper Johns, artistic director of the Merce Cunningham Dance Company, asked Warhol if he could use his Silver Clouds in the choreography *Rainforest*. That same year, Johns asked Marcel Duchamp for permission, which he granted, to reuse some of his works for another choreography, *Walkaround Time*.

"John Cage uses graffiti noise in his pieces and Merce Cunningham uses everyday noise in his dance," Warhol explained to Ultra Violet, but to the question "And why do you put words in paintings? Is it to create visual noise?"[11] there was no response. The subject of so much conjecture, Warhol's famous silence may also be the expression of a posture inherited from Cage, the creator of *4'33"* (1952), a composition of "four and a half minutes of silence" in the course of which the pianist remains motionless while listening to the ambient murmur. On a record published in 1966 by the *East Village Other* newspaper, Warhol wrote a completely Cage-like track entitled *Silence (copyright 1932)*, paradoxically his only musical composition ever published. Also on this record was a piece entitled *Gossip*, by his assistant, Gerard Malanga, and Ingrid Superstar, and *Noise*, the Velvet Underground's very first recording. Unnoticed until now, this little piece encapsulates an essential aspect of Warhol's art: the reflective and reflexive nature of its silence, which amplifies the world's noise, the clamour of consumer society and the disasters depicted in the media. If contemporary music and dance inspired Warhol's philosophy of art, they also provided him with models for generating form. Despite his silence and his extreme receptiveness to the tiniest details of his immediate reality, it is to them that Warhol may also owe some of the dominant features of his art. Although they were only rarely the subject of commentary and questions, to which Warhol never provided a conclusive reply, the structural similarities between his Pop works and innovations in contemporary music, in particular the concepts of repetition, seriality and sustained frequencies, were already quite plain to see to his contemporaries. "When I first saw Andy's Coke bottles, Brillo pads and repetitive images," John Cale recalls, "for a long time I was very suspicious because I had it confused in my mind with sustained tones, which was exactly what we'd done in La Monte's music."[12] With its serial structure, the film *Sleep* (1963), composed of repeated shots of the poet John Giorno sleeping, thus flows directly from the art of John Cage, but also, as Roger Copeland suggests in his essay, through its title and the objectification of its subject, from Yvonne Rainer's dance piece performed earlier in the year.

In January 1964, Warhol opened a new studio on the fourth floor of an industrial building at 231 East Forty-seventh Street. The Silver Factory, so-called because of its silver decor by Billy Name, a photographer and opera enthusiast, became party central for a motley crowd of artists and Superstars. In this catalogue's essay on this legendary living and working space, Emma Lavigne shows how Warhol explored there an experiential understanding of art. It embodied the Fluxus movement's holistic desire to conflate art and life, to which La Monte Young and Cage subscribed. The Silver Factory was a place where everything visible, but also everything audible and tangible that took place there, was capable of becoming art—*was* art. From his vantage point as conductor and observer, Warhol set out to record this non-stop happening. He produced a prodigious number of films during this period, numbering in the hundreds, including nearly five hundred Screen Tests, portraits on film of the Factory's regulars and visitors. Beginning in 1965, the year in which he purchased his first portable tape recorder, he also recorded thousands of hours of conversations and ambient noises of all kinds. Until now relegated to the status of sound archive, these recordings were, as Melissa Ragona demonstrates, a long-term musical composition and another Cage-like inspiration.

The Silver Factory was also where Warhol set about to mix the worlds of classical culture, the avant-garde and popular culture, reputed to be foreign to one another but which to him were familiar. In keeping with Warhol's hybrid musical culture—studied in depth and in detail by John Hunisak and Matt Wrbican in this catalogue—the Factory's loudspeakers played everything from opera to rock. In addition, after their famous encounter in December 1965, Warhol invited the Velvet Underground there to rehearse their cutting-edge music, which was essentially punk before the term existed. To this group, born of an encounter between the Brooklyn-born rocker Lou Reed and the Welsh musician John Cale, who studied at Goldsmiths College in London and created experimental music with an Eastern flavour, Warhol added a singer, Nico, a German fashion model with a voice from beyond the grave. Everything was thus in place for Warhol's studio to become a place of Dionysian confluence for various art forms—film, painting, dance, music—and the laboratory for his total artwork the Exploding Plastic Inevitable (fig. 4). In this multimedia spectacle, designed to accompany the Velvet Underground's performances, Warhol revived and gave concrete form to the concept of the total artwork, Wagner's nineteenth-century theory of the *Gesamtkunstwerk*, a formal utopia in which every art comes together.

Skilfully turning his role as the group's "producer" to his advantage, Warhol set out to fuse every artistic dimension around the Velvet Underground's music. From the balconies of the halls where the group performed, Warhol projected films, slides and stroboscopic lights on the band's musicians and dancers as well as the crowd in the audience, which had become artistic material and part of an all-encompassing and moving work. "Then they flash lights on you and everything and turn you into wallpaper," a Velvet Underground concert poster announced (ill. p. 152). The Exploding Plastic Inevitable, a synesthetic experiment whose music is an invisible and moving totality in which other art forms blended together, coalesced the many forces at work at the Factory. It was an expression of Warhol's constant search for an ecstatic fusion of art and life.

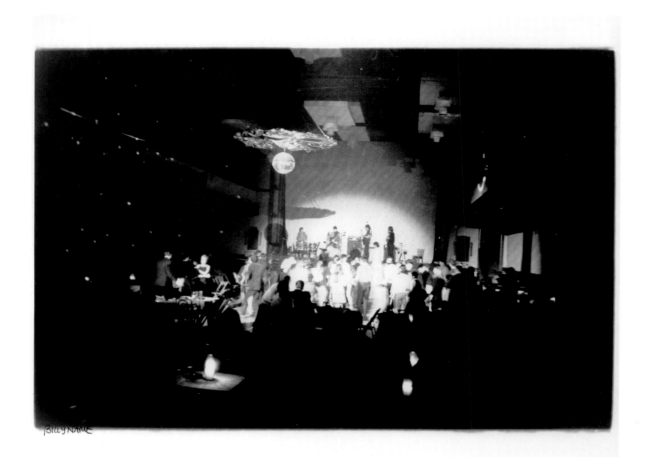

4

5

FIG. 4 – Exploding Plastic Inevitable presented by the Velvet Underground at the Trauma, Philadelphia, 1967. Photo Billy Name (cat. 434) FIG. 5 – Studio 54, New York, early 1980s (cat. 199)

Ten years after the end of the Factory, at the legendary nightclub Studio 54, which opened in 1977 and where he was one of the best-known regulars, Warhol rediscovered—this time as an actor and not an orchestrator—this fusion in an excess of every art form: not only music, dance and light shows (fig. 5), but also fashion, glamour and fame. Studio 54 brought together on its dance floor everything that shone: musicians, millionaires, actors, models, fashion designers. At the heart of this stunning and fantastic gallery of portraits with names such as Truman Capote, Bianca Jagger, Grace Jones and Liza Minnelli, Warhol functioned as a mirror for their conceits and as their tragic conscience. His final self-portraits, dating from 1986, traced over top of those of Debbie Harry and Grace Jones, depict him as a simultaneously electrified and Medusa-like rock star.

Rightly seen as one of the central elements of Warhol's work, fame is intimately tied to music, one of its foremost vehicles. While the 1960s saw the advent of a new kind of cultural hero, the pop star, in later years this figure would transcend the traditional limits of his or her talent, the pop song, to embody through fantasy an ideal life, style and attitude: an ideal look. In so doing, music became image. "Image is so important to rock stars," Warhol wrote. "Mick Jagger is the rock star with the longest running image. He's the one all the young white kids copy. That's why every detail of his appearance is really important."[13] Warhol's idol worship, already at work in his early adoration of Hollywood stars, found in the lead singer of the Rolling Stones a model, friend and muse. Was he not a "Pop" artist too? Their first meeting, in 1964, at the home of Baby Jane Holzer, a model and close friend of the Factory, was the beginning of a friendship that took various forms over the years, including invitations to Stones' concerts, group rehearsals at Warhol's property in Montauk on Long Island, and private parties. Mick Jagger asked Warhol on several occasions to design the Rolling Stones record covers, including *Sticky Fingers* (1972) and *Love You Live* (1977). Warhol's various portraits of Jagger are awash in his desire for his youthful idol: his gaze lingers on fragments of Jagger's body, his hips, arms and torso, as if he were under the spell of a kind of love-smitten or fetishist metonymy. Warhol responds to his subject's sexual ambivalence with an unequivocal affirmation of his own identity. A true muse, Jagger inspired him to innovate, especially in the collage-like play of masking and revealing faces in the screen-print portrait album of 1975.

"I think you'd have to say about Andy's taste in music—he liked it when he saw it," Glenn O'Brien, *Interview*'s music columnist after 1977, explains later in this catalogue. "His ear was his eye. I think Andy saw music," he concludes. Mick Jagger was the star most featured on the magazine's cover, beginning with its second issue, five times in total. *Inter/VIEW*, founded by Warhol in 1969 as a film magazine, became in 1972 *Andy Warhol's Interview*, when it began to cover the worlds of art and high society under the all-inclusive banner of fame, whose strong allure it exalted. Music played an important role in the magazine, both on its cover, which paraded most of the day's pop stars, and in its underlying leaning, which was to tap into the pulse of urban life, its "beat," in the words of the title of O'Brien's influential music column. Life is rhythm, sounds, bursts of noise, echoes, distant rumblings. Far from being overshadowed by the dazzling logic of fame, music dictated its movement and became what bound it together. Warhol's foray into television in 1982 with the series *Andy Warhol's TV* was the fulfilment of the nature of *Interview*. The magazine-format program examined a variety of subjects in the form of video-clips, short reportages with a rapid and syncopated rhythm and music soundtrack. Warhol himself tried his hand at the music video, and his clips of the Cars, Curiosity Killed the Cat and Miguel Bosé, among others, mark the beginnings of the genre.

Warhol's presence on the disco scene at Studio 54 and his foray into television and the variety clip, while they may seem to be in contradiction aesthetically with his former role as the Velvet Underground's producer, are in fact an extension of his underlying project. Driven by a hyperbolic eclecticism in which the traditionally most antagonistic forms of culture were brought together, Warhol was carried by the goal of embracing reality in its entirety and a desire to fuse all of art's resources, like those of life itself, in a single experience. Following the thread of music and dance throughout the numerous metamorphoses of his work confirms its profound coherence and reveals little-known aspects of it. Seen in the light of their influence, works with seemingly little in common, including early pieces such as the Disaster paintings, the film *Empire*, the

rows of Coca-Cola bottles and the Screen Tests, share a common but essential key element. In the early 1960s, a major turning point in art history, Warhol seems to have played a crucial role in fusing the various aesthetic movements of the day. Beyond the iconographic reading of his work, reduced to its Pop nature, his ability to reconcile the diverse worlds of Fluxus, new music, performance art and even Conceptual art makes him much more of a central than an oppositional figure in this narrative.

Twenty years after his death, the controversies he attracted in his lifetime—which saw him accused of commercialism, superficiality and political naïveté, among other things—have largely faded, giving way to a critical (and commercial) consensus that Warhol was the greatest artist of the latter half of the twentieth century, one who summed up his era and pointed the way of the future to art, like Picasso in the first half of the century. Warhol's work has never been as extolled as it is today and it continues to reveal a depth and complexity that is apparently only now beginning to truly be understood. A musical reading of Warhol confirms the frequent portrait of an artist with a sponge-like sensibility, open to everything without discrimination, who occupied a unique cultural position and had a novel disposition to embracing and being inspired by the most varied art forms. He was the first to employ the freedom to define himself as an artist through his attitudes and gestures as much as through his work, taking on new roles such as a behind-the-scenes driving force, producer and impresario, and moving between disciplines with a dazzling and never before seen ease. He thus appears as a stunning precursor of art forms—installation, sound art, multimedia—which are now familiar aspects of today's artistic scene, and as a model of the artist tuned into his time.

1 *All Tomorrow's Parties: Remembering The Velvet Underground*, May 17–September 1, 1996; and *Starf★cker: Andy Warhol and The Rolling Stones*, August 12, 2005–January 17, 2006. Also at the Andy Warhol Museum, Pittsburgh, was *Watching from the Wings: Warhol and Dance*, February 27–May 3, 1999, curated by John W. Smith.
2 Klaus Albrecht Schröder, ed., *Andy Warhol. Popstars: Zeichnungen und Collagen / Popstars: Drawings and Collages* (Vienna: Albertina, 2006).
3 Branden W. Joseph, "The Play of Repetition: Andy Warhol's Sleep," *Grey Room*, no. 19 (Spring 2005), 22–53; and "'My Mind Split Open': Andy Warhol's Exploding Plastic Inevitable," *Grey Room*, no. 8 (Summer 2002), 80–107.
4 Thomas Crow, "Lives of Allegory in the Pop 1960s: Andy Warhol and Bob Dylan," in Charles G. Salas, *The Life and the Work: Art and Biography* (Los Angeles: Getty Research Institute, 2007), 108–109.

5 Eva Meyer-Hermann, ed., *Andy Warhol. Other Voices, Other Rooms: A Guide to 706 Items in 2 Hours 56 Minutes*, exhib. cat. (Rotterdam: NAi Publishers, 2008).
6 Mark Francis and Margery King, eds., *The Warhol Look*, exhib. cat. (Boston; London: Bulfinch Press, 1997).
7 Paul Maréchal, *Andy Warhol: The Record Covers 1949–1987, Catalogue Raisonné* (Montreal: The Montreal Museum of Fine Arts, 2008).
8 *Andy Warhol's Exposures* (New York: Andy Warhol Books / Grosset & Dunlap, 1979), 201.
9 Interview with Matt Wrbican.
10 *The New Realists*, October 31–December 1, 1962, Sidney Janis Gallery, New York.
11 Ultra Violet, *Famous for 15 Minutes: My Years with Andy Warhol* (New York: Avon Books, 1988), 98–99.
12 Stephen Shore and Lynne Tillman, *The Velvet Years: Warhol's Factory 1965–67* (New York: Thunder's Mouth Press, 1995), 64.
13 Warhol 1979, 196.

"SOMETHING IS ALWAYS HAPPENING"
SET TO MUSIC
Emma Lavigne

Many visitors to the Factory—the "Open House" Lou Reed and John Cale sang about in their *Songs for Drella* album—including the collector Emily Tremaine, noted that "Andy usually was playing two stereos simultaneously, one belting out Bach, the other blasting Rock and Roll."[1] On other occasions, Maria Callas records were played at top volume between two rehearsals of the Velvet Underground (fig. 1). What could be seen as a kind of iconoclastic musical short circuit in fact set the tone for a body of work that, with its echoes of music and theatre arts, reconciled the poles of musicals and opera, tap dancing and contemporary dance, rock and disco. Warhol had a great admiration for personalities as different as Callas, Elvis Presley, Miles Davis and John Cage. The 1960s transformed him into an insatiable listener. "I have Social Disease. I have to go out every night"[2] was how he justified his frenzied nocturnal outings. This unflagging curiosity led to his discovery of the underground music scene at the San Remo and Max's Kansas City, the Fluxus happenings in the lofts of New York, the Judson Dance Group's shows, and the All Tomorrow's Parties, all of which set the rhythm for the artistic community of the Lower East Side. His judgment of musical matters was so astute that it permitted him to assimilate, in artistic form, a wide range of avatars—including record covers, portraits, theatre and film productions, interviews and performances—in his search for a total work of art with suggestions of certain precepts of the Bauhaus or Black Mountain College just beneath the surface. Warhol laconically acknowledged, "I think John Cage has been very influential,"[3] when making a connection between his work and that of the composer who pioneered introducing life into art and who affirmed that "the world, the real is not an object. It is a process."[4]

"I REALLY LIKE BEING A VACUUM"

The permanence of themes dealing with music in Warhol's work is remarkable, ranging as it does from the *Elvis* multiples, which were exhibited in Irving Blum's gallery in Los Angeles in September 1963, to the portraits of the icons of popular music, which Warhol created throughout his career. In addition to these portraits, which through the print-screen process led to a "dematerialization of the art object" already initiated in cinema and photography and to the exposure of the music industry's star-making machine, producing commodities and idols alike, Warhol's work is analogous to the compositional procedures of music. The two are based on attention to environmental sounds and an exceptional capacity to hear. Nietzsche postulated that "there are far more languages than we imagine; and man betrays himself more often than he would like. Everything speaks! But few know how to listen . . . Isn't it a pity that the vacuum has no ears?"[5] The Silver Factory was not only a mirror reflecting the Superstars in Warhol's universe, it was also an anechoic chamber, a sound trap, a "vacuum" turned into an auditory pavilion in which sounds reverberate off its walls before being absorbed and transformed in an amplified process of creation. Warhol frequently confided, "I think we're a vacuum here at the Factory: it's great. I like being a vacuum; it leaves me alone to work."[6] Jonas Mekas described how "Andy and the Factory were, in a sense, like a huge psychiatrist's couch,"[7] and how he was basically a listener, an unruffled observer taking in everything that went on around him without ever judging, a "garbage can" that anything could be thrown into because he accepted everything. Mekas added that Warhol was also like an extremely fine-meshed sieve, which allowed him to filter out the images and subjects he wanted. They did not pass through but remained caught in the sieve of his spirit, of his eyes, and were transformed into his art.

On account of his legendary reticence and horror of being touched, Warhol found the tape recorder and telephone useful shields: "You should have contact with your closest friends through the most intimate and exclusive of all media—the telephone."[8] However, they were also prostheses with which Warhol became one (fig. 2), his instruments for disclosing intimacy to the extent that he described his tape recorder as his wife and said he was having an affair with his telephone. Pascal Quignard observed that "listening is like being touched from a distance. . . . One is not impervious to sound . . . A sound touches the body *immediately* as if the body was more than naked—without skin—before the sound."[9] These devices, borrowed from the harbingers of concrete music and sound poetry, became the tools of an intentionally Pop aesthetic that implemented audio archiving and recycling: the transforming of the heard into an entirely separate creative process, mutating the ready-made sounds generated inside the microcosm of the Factory into works of art. In 1968, Warhol published his book *a: A Novel*, a response to James Joyce's *Ulysses*, which replaced authorial narration with a transcription of an almost-24-hour-long recording made by Ondine (one of the Factory's Superstars).

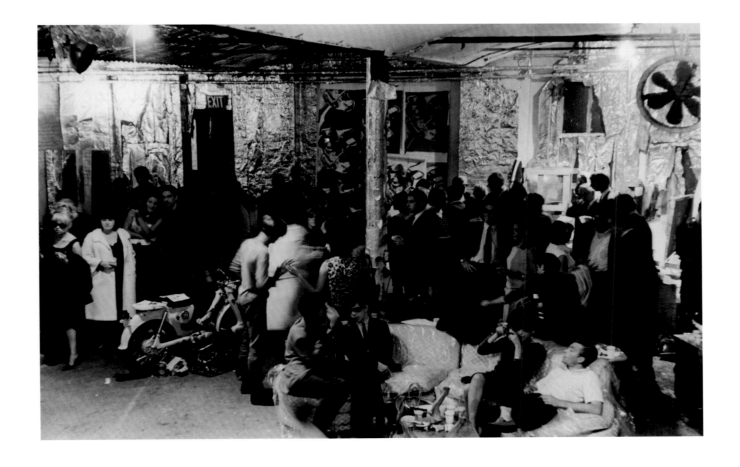

FIG. 1 – Party at the Factory, 231 East Forty-seventh Street, with its aluminum-foil covered walls, September 1965. Andy Warhol at the rear, near the centre, wearing sunglasses. Photo Fred W. McDarrah

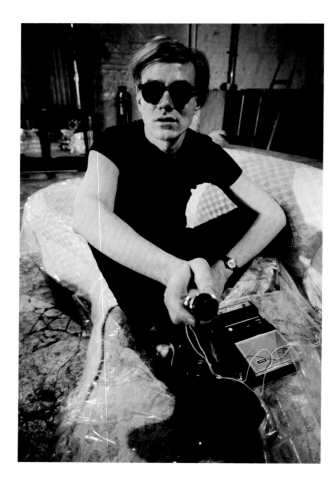

2

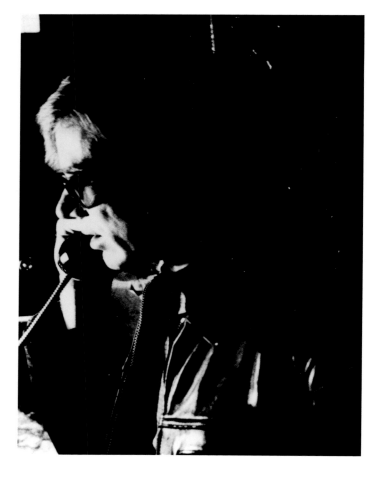

3

FIG. 2 – Andy Warhol at the Factory, 1965–67. Photo Stephen Shore FIG. 3 – Andy Warhol on the telephone at the Factory, 1966

In 1973, the film *Phoney,* which made the telephone one of the main protagonists, was inspired by Marshall McLuhan, who, in *The Medium is the Message*, considered the telephone, along with television, to be an extension of a person's nervous system. In 1978, when Debbie Harry sang "Hangin' on the Telephone" in the episode *Andy Warhol on the Phone* in *Factory Diary* (fig. 3), an essentialist self-portrait of the artist on the telephone was made after James Joyce's character Leopold Bloom, whom Jacques Derrida described in "Ulysses Gramophone" as "his being is a being-at-the telephone. He is hooked up to a multiplicity of voices and answering machines. His being-there is a being-at-the-telephone, a being for the telephone."[10] These works bear a certain relationship to the cut-ups of Byron Gysin and William Burroughs, and to the *Project of Music for Magnetic Tape*, initiated by John Cage, Morton Feldman, Christian Wolff and Earle Brown, who created music for tape. They also resemble Pop manifestations of the rhapsodic telephone monologue in Jean Cocteau's *La Voix Humaine*, orchestrated by Francis Poulenc, in 1958, or the harsh expressionist recitative in Schoenberg's *Erwartung*. The semantic possibilities of recording, which were already present in Warhol's work, have been revisited today by numerous artists, from Janet Cardiff to Bruce Nauman, who attempt to eradicate the omnipresence of the image dominating contemporary thought in order to explore the depths of listening and renew, even rather explicitly, the profound and subconscious mechanisms of every person, who "depends on stories," as proposed by Georges Bataille, because they "discover the manifold truth of life. Only such stories . . . confront a person with his fate."[11]

"I PLAY A RECORD FOR A LONG TIME UNTIL I LEARN TO UNDERSTAND IT"

Warhol was perfectly aware of the problems in creating contemporary music, and the approach of John Cage, in particular, enriched and defined his relationship with the "world of sound." In *Popism*, he describes in detail the instrumentation of Cage's score "for viola, gong, radio, and the door-slams, windshield-wipes, and engine-turnovers of three cars"[12]—which accompanied a dance performed by Merce Cunningham's company. Describing the composition of a concrete score based on the sounds of the Factory, he said, "I'd sit there and listen to every sound: the freight elevator moving in the shaft, the sound of the grate opening and closing when people got in and went out, the steady traffic all the way downstairs on 47th Street, the projector running, a camera shutter clicking, a magazine page turning, somebody lighting a match, the colored sheets of gelatin and sheets of silver paper moving when the fan hit them, the high school typists hitting a key every couple of seconds, the scissors shearing as Paul cut out EPI clippings and pasted them into scrapbooks, the water running over the prints in Billy's darkroom, the timer going off, the dryer operating, someone trying to make the toilet work, men having sex in the back room, girls closing compacts and makeup cases. The mixture of the mechanical sounds and the people sounds made everything seem unreal and if you heard a projector going while you were watching somebody, you felt that they must be a part of the movie, too."[13] Like Cage, whose aspirations embraced extremes ranging from the search for silence to the celebration of noise, Warhol created what was in essence an "open work," a response to the contemporary world; from the Screen Tests, the visual equivalents of *4'33"*, where the soundtrack rewrites itself by incorporating ambient noise, to the violent detonations and explosive sound effects of the series *Car Crashes* and *Disasters*.

Of their first meeting in 1961, Ivan Karp, Leo Castelli's assistant and one of the first supporters of Warhol's work, remembers noting, with perplexity, that "Warhol played one rock-and-roll record over and over again—"I Saw Linda Yesterday" by Dickey Lee. When I finally asked if he ever made alternate music selections, he replied, 'Well, I play a record for a long time until I learn to understand it.' I have speculated as to the influence of this type of repetitive behaviour on Warhol's art-making process, but I never got any concrete answers because he did not intellectualize the process of his art making on any level."[14] Warhol explained it to some extent: "I started repeating the same image because I liked the way the repetition changed the same image. Also, I felt at the time, as I do now, that people can look at and absorb more than one image at a time."[15] The principle of repetition became a concrete leitmotif in his screen prints and films from the mid-1960s, when the American repetitive composers—La Monte Young, Philip Glass, Tony Conrad, Steve Reich, most of whom lived in New York— were creating their major works. Warhol offered a physical equivalent of the repetitive structures that had changed the language of music, from Erik Satie's *Vexations*, where

a series of 180 notes is played 140 times, to the 53 melodic formulas and rhythms in Terry Riley's *In C*. Warhol also maintained that he had attended the entire eighteen-hour-and-forty-five-minute performance of *Vexations*, performed by ten pianists, including John Cage, David Tudor and John Cale, at the Pocket Theater between September 9 and 10, 1963. Warhol apparently loved the performance.[16] That same year his film *Sleep* employed subtle modulations, using loops and repeated images following the same principles as those used in repetitive music, to capture the poet John Giorno sleeping. As Lou Reed recalls, some years later Warhol suggested that the musicians of Velvet Underground rearrange the structure of a song, which Reed thought was a great idea. The last grooves of the "I'll be Your Mirror" recording could be tampered with so that the disc would never stop and would eternally repeat the refrain of "I'll be your mirror."[17] John Cage concluded, "Andy has fought by repetition to show us that there is no repetition really, that everything we look at is worthy of our attention. That's been a major direction for the twentieth century, it seems to me."[18]

With *Empire* (1964), Warhol demolished traditional screenwriting and its narrative codes to explore another relationship to time by filming the Empire State Building from a fixed position in eight hours of real time. A similar approach was taken by a good many composers, like La Monte Young, who in his *Drift Study* (1966) created a unique sound made by stable electronic frequencies. Young was a member of Fluxus and initiator of the Dream Syndicate and Theatre of Eternal Music; it was from him that Warhol commissioned the minimalist music—a version of *Composition 1960/9*— to accompany the three-minute extracts from his four films *Sleep*, *Kiss*, *Haircut* and *Eat*, which were shown continuously using 8mm projectors in the Second Annual New York Film Festival at Lincoln Center's Philharmonic Hall in September 1964. As Branden W. Joseph pointed out, Warhol adopted Young's minimalist strategy: "By transferring a single, three-minute segment from each of his films onto the repeating loop cartridges, Warhol further reduced their already minimal variation and eliminated any appreciable development while extending their duration indefinitely by means of continuous repetition. As reported in a press release: 'The quartet of Warhol films, according to the artist's definition, are 'endless.'"[19] Young, who had followed Warhol's activities closely and owned several of his works, asserted that the artist understood his work very well and was convinced that his experiments in expanded temporal structures had had a certain influence on Warhol's exceedingly long works, such as the films *Sleep* and *Empire*.[20] Jonas Mekas also remembers how attentively Warhol listened to one of Young's concerts they attended together in the winter of 1962–63, in which he played one of his very, very long compositions, variations on one note lasting four or six hours. Warhol, who was already producing series of images, repetitions of the same subject, sat through the performance without moving. Mekas points out how by expanding time, Jackson Mac Low had already written his note/synopsis on the idea of filming a tree for twenty-four hours. *Empire* was in the air, and Warhol was not an amateur artist. He was absolutely up to date on what was happening in the artistic universe, and it could be maintained that *Empire* represents his participation in the exchange of views with other avant-garde artists of his era. Mekas pointed out that this was a dialogue with the minimalists, the conceptualists, artists working in real time and, simultaneously, an aesthetic celebration of reality. As such, it would never become dated and would always remain alive and unique.[21] It is significant that, in return, Warhol's films had a decisive influence on Cage, who said he loved Warhol's films and thought about making films himself but had never carried it out because Warhol had already done almost the same thing,[22] and that the dozen experimental films, including *Fly* and *Erection* (1971), which John Lennon created, alone or with the assistance of Yoko Ono, were directly influenced by *Sleep* and *Empire*.

"SONGS LIKE 'SUGAR SHACK' OR 'BLUE VELVET' OR 'LOUIE, LOUIE' —WHATEVER WAS AROUND THEN—BLENDED IN WITH THE ARIAS"[23]

Patrick de Haas noted that although he devoted his best efforts to the production of his films, Warhol did not expect his audience to pay them strict attention, even if "the 'repetitive' musicians (Glass, Reich, Riley, among others) demand via repetition the listener's careful attention, repetition in Warhol does not seem to be motivated by the exaltation of these small differences which occur in a state of overall indifference. . . . The detachment exhibited by Warhol towards his object (the film) suggests that for him it was more a question of *furniture films*, intended by Erik Satie when he

spoke of making 'furniture music.'"[24] In March 1920, Satie addressed the audience at the Barbazange Gallery with "we ask that you pay no attention to what you hear and that you react as if you heard nothing." In *Living Room*, John Cage recommended bringing about "a music which is like furniture, a music, that is, which will be part of the noises of the environment, will take them into consideration."[25] Warhol's emphasis on distancing offered another way of perceiving art. The focused attention span with a beginning and an end was replaced by a disconnected sensory perambulation through an aestheticized space; the Factory became both the setting and the subject of the show (whether theatrical, musical, or artistic) orchestrated by Warhol and, at the same time, his most accomplished masterpiece. Roy Lichtenstein noted that Warhol did exactly what he did not do—he was his art; his studio was his art. Music, by virtue of its element of chance and its stylistic telescoping, was deliberately incorporated into this total work of Pop art, and it was right in the midst of the racket, the background that invades the space, that its undisputed deejay, Warhol, "levelled" everyone in attendance "and made them stars. He made them famous by ruthlessly insisting that they perform themselves out loud and in public on tape or on film," as Dave Hickey wrote (fig. 4). The history of music is rich in such stylistic collages, from Cage's *Imaginary Landscapes I* and *IV* for two variable-speed tape recorders with twelve radios and twenty-four musicians respectively, to Bernd Alois Zimmermann's *Requiem for a Young Poet,* written between 1967 and 1969, which creates a dialogue between Beethoven's *Ninth Symphony*, the Beatles' *Hey Jude*, and a segment of a Stalin radio broadcast. Warhol could be called the orchestra conductor of the acoustic environment of the Factory in all its dimensions, whether improvised, arbitrary, or unfinished.

A studio like a Fourierist phalanstery, a hybrid, scaled-down workshop, the Factory was the archetype for the multimedia shows Warhol produced for the Velvet Underground beginning in 1965: *Andy Warhol Up-Tight* at Jonas Mekas's art cinema, and then Exploding Plastic Inevitable presented at the Dom (Polsky Dom Narodny) in New York and later in several other American cities. They were, as Jonas Mekas recalls, "the most energy-charged performances I have ever seen anywhere. The film-maker here became a conductor, having at his fingertips not only all the different creative components— like sound controls, a rock band, slide projectors, movie projectors, lighting—but also all the extreme personalities of each of the operators of each piece of the equipment. He was structuring with temperaments, egos and personalities! Warhol maneuvered it all into sound, image and light symphonies of tremendous emotional and mental pitch . . . which reached to the very heart of the New Generation. And he, the conductor, always stood there, in the balcony, next to projectors, somewhere in the shadow, totally unnoticeable, but following every second and every detail of it, structure-wise, that is"[26] (fig. 5). These performances of "expanded cinema," as Jonas Mekas put it, were, according to Kenneth Goldsmith, a mix of performance art and the nightclub. They renewed the aesthetic of the total work of art, combining live music with screenings of films by Warhol and Paul Morrissey with superimposed slides by Barbara Rubin, Nat Finkelstein and Billy Name, lighting by Danny Williams, and Gerard Malanga's whip-dance numbers. Lou Reed said they were then like an artwork in progress.

4, 6

5

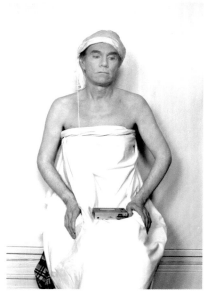
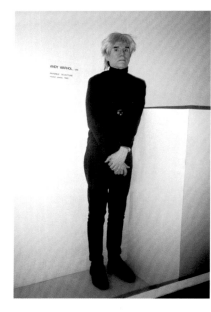
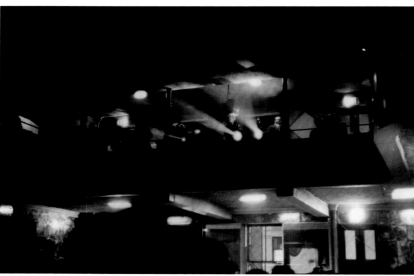

FIG. 4 – Andy Warhol posing in a sheet and turban, 1981. Photo Christopher Makos FIG. 5 – Andy Warhol up high at the centre in the projection booth during an Exploding Plastic Inevitable show by the Velvet Underground at the Dom, 23 St. Mark's Place, April 1966. Photo Fred W. McDarrah FIG. 6 – Andy Warhol as the *Invisible Sculpture* at Area, New York, 1985. Photo Patrick McMullan

"I WOKE UP, SUDDENLY I JUST WOKE UP TO THE HAPPENING"[27]

Although the Factory has often been looked at from the point of view of its analogies with Hollywood,[28] when from 1962 to 1968 Warhol was caught up in film and no longer painted—"I don't paint any more, I gave it up about a year ago and just do movies now"[29]—it was the ongoing dialogue between dance, music, painting and theatre at the Judson Church, driven by Reverend Moody and the composer Al Carmines, that provided the model Warhol brought to the Factory. Warhol confirmed that "two major feeders of personalities and ideas into the early Factory were the San Remo/Judson Church crowd"[30] and recalled that he had gone to his first "Judson Church 'happening' because of Rauschenberg—he was arranging the lighting there and I wanted to see it. I called up David Bourdon and told him to come with me to this beautiful concert by Yvonne Rainer called *Terrain*." He also remarked that "almost every group event in the sixties eventually got called a 'happening'—to the point where the Supremes even did a song by that name."[31] Allan Kaprow's definition of a happening as a spontaneous, theatrical event devoid of any plot can be applied to Warhol's life, which merged with his work and can be seen as an endless happening. He turned his first retrospective, held at the Institute of Contemporary Art in Philadelphia in 1965, into a happening by recreating the musical ambience of the Factory. Warhol remembered with pleasure that "it was fabulous: an art opening with no art! . . . The music was going full blast and all the kids were doing the jerk to songs like 'Dancin' and Prancin'' and 'It's All Over Now' and 'You Really Turn Me On.' . . . I wondered what it was that had made all those people scream. I'd seen kids scream over Elvis and the Beatles and the Stones—rock idols and movie stars—but it was incredible to think of it happening at an *art* opening. Even a Pop Art opening. But then, we weren't just *at* the art exhibit—we *were* the art exhibit, we were the art incarnate."[32] Due to the hysterical uproar of the crowd on opening night, it became necessary to remove the paintings. The art disappeared, the music was eclipsed by screaming, and the exhibition turned into a ritual. According to the philosopher and art critic Arthur Danto, it was not, strictly speaking, an exhibition without art because it had become art itself through its own image, and in the definitive catalogue of his works, Warhol's own life would have to be listed as a work in and of itself.[33]

Warhol, who declared: "I never wanted to be a painter; I wanted to be a tap-dancer"[34] and who made nightclubs, particularly Studio 54, extensions of his studio, was surprised in a conversation with Benjamin H. D. Buchloh on May 28, 1985: "Disco art? You haven't done disco art yet? Really good art—you should see it. It's going to be over soon. A lot of work by about thirty artists; it's really interesting."[35] It was at this exhibition, held in the Area nightclub in Tribeca, that he showed his *Invisible Sculpture* (fig. 6), a performance for which he stood motionless on a pedestal, next to an accompanying label displaying the title of the work, for an hour every night for a whole month. It revives Yves Klein's idea that "a painter must paint only one masterpiece: himself, constantly, and thus become a kind of nuclear reactor, a kind of constant generator of beams that permeate the atmosphere and, in their wake, leave an impression of their entire pictorial presence in that space." It is also part of the movement towards "attitudes that become form" that can be found on the contemporary art scene from the late 1960s to Felix Gonzales-Torres's *Go-Go Dancer* (1991). Before displaying the most radical version of this work at Area, Warhol had developed a more sophisticated version with various alarm systems and light beams triggered by sensors, creating an interactive sound installation activated by the bodies of the viewers as they moved about. In a brilliant metonymic shift, Warhol made the viewer the conductor of the latent sound effects, the improviser of a luminous choreography in the process of being invented.

Merce Cunningham said that he saw no contradiction between art and entertainment, that dance is entertainment and that art does not contradict entertainment. He also asserted that he had never had the least intention of changing the world, but quite the contrary, sought to see it as it is and to do what is possible with such a world. These views of Merce Cunningham sum up this account of the soundtrack that is there in Warhol's work for those with ears to hear it.

1 Emily Tremaine in *The Tremaine Collection: 20th Century Masters: The Spirit of Modernism* (Hartford, Connecticut: Wadsworth Atheneum, 1984), 29.
2 In *Andy Warhol's Exposures* (New York: Andy Warhol Books / Grosset & Dunlap, 1979), 19.
3 In G. R. Swenson, "What Is Pop Art? Answers from 8 Painters, Part I" (*Artnews*, November 1963), repr. in *I'll Be Your Mirror: The Selected Andy Warhol Interviews. 1962–1987*, Kenneth Goldsmith, ed. (New York: Carroll & Graf Publishers, 2004), 20.
4 John Cage, *For the Birds: John Cage in Conversation with Daniel Charles* (Boston; London: Marion Boyars, 1981), 80.
5 Friedrich Nietzsche, *Kritische Gesamtausgabe*, vol. VII/I, Giorgio Colli, Mazzino Montinari, eds. (Berlin; New York: Walter de Gruyter, 1977), 270.
6 Gretchen Berg, "Andy Warhol: My True Story" (*The East Village Other*, November 1966), repr. in *I'll Be Your Mirror*, 91.
7 Jonas Mekas in Stephen Shore and Lynne Tillman, *The Velvet Years: Warhol's Factory 1965–67* (New York: Thunder's Mouth Press, 1995), 155. More of Mekas's stories regarding Warhol and the Factory were published in "Quelques notes sur Andy Warhol" in *Jonas Mekas. Anecdotes*, presented by Jérôme Sans (Paris: Scali, 2007), 261 and 263.
8 Andy Warhol, *The Philosophy of Andy Warhol (From A to B and Back Again)* (New York: Harcourt Brace, 1975), 147.
9 Pascal Quignard, *La haine de la musique* (Paris: Gallimard, 1997), 108 and 110.
10 Jacques Derrida, "Ulysses Gramophone," in *Acts of Literature* (New York: Routledge, 1992), 273.
11 Georges Bataille, *Blue of Noon* (London; New York: Marion Boyars, 1986), 153.
12 Andy Warhol and Pat Hackett, *Popism: The Warhol Sixties* (New York: Harvest Books, 1980), 274.
13 Ibid., 216.
14 Ivan Karp, "Andy Starts to Paint," in *Andy Warhol: "Giant" Size* (London; New York: Phaidon, 2006), 86.
15 Gerard Malanga, "A Conversation with Andy Warhol" (*The Print Collector's Newsletter*, January–February 1971), repr. in *I'll Be Your Mirror*, 193.
16 Tim Mitchell, *Sedition and Alchemy: A Biography of John Cale* (London: Peter Owen Publishers, 2003), 34.

17 Lou Reed cited by Michel Nuridsany, *Warhol* (Paris: Flammarion, 2001), 326.
18 John Cage, quoted in *Andy Warhol: A Retrospective*, exhib. cat. (New York: The Museum of Modern Art, 1989), 13.
19 Branden W. Joseph, "'My Mind Split Open': Andy Warhol's Exploding Plastic Inevitable" (*Grey Room*, Summer 2002), repr. in *Summer of Love: Psychedelic Art, Social Crisis and Counterculture in the 1960s*, Christoph Grunenberg and Jonathan Harris, eds. (Liverpool: Liverpool University Press, 2005), 244.
20 La Monte Young in Bernard Blistène and Jean-Michel Bouhours, eds., *Andy Warhol. Cinéma* (Paris: Éditions du Centre Pompidou and Éditions Carré, 1990), 55, in response to the question: "Don't you think that your thoughts on time and eternity expressed in your music had a determining influence on the films created starting the following year; *Sleep* and *Empire*, for example?"
21 "Quelques notes sur le film *Empire* et sur Andy Warhol," in *Jonas Mekas. Anecdotes*, 208–209.
22 Richard Kostelanetz, *Conversations avec John Cage* (Paris: Éditions des Syrtes, Flammarion, 2000), 255.
23 Warhol and Hackett, 82.
24 Patrick de Haas, *Andy Warhol. Le cinéma comme « Braille Mental » / The Cinema as "Mental Braille"* (Paris: Éditions Paris Expérimental, 2005), 53.
25 John Cage, "James Joyce, Marcel Duchamp, Erik Satie: An Alphabet," in *X: Writings '79–'82* (Middletown, Connecticut: Wesleyan University Press, 1983), 88.
26 Jonas Mekas, "Notes after Reseeing the Movies of Andy Warhol," in John Coplans, ed., *Andy Warhol* (Greenwich, Connecticut: New York Graphic Society, 1970), 141.
27 Diana Ross and the Supremes, "The Happening," 1967.
28 De Haas, 53 (modified translation).
29 In "Andy Warhol: My True Story," 88.
30 Warhol and Hackett, 69.
31 Ibid., 65–66.
32 Ibid., 166–168.
33 Quoted in Nuridsany 2001, 357.
34 In "Andy Warhol: My True Story," 89.
35 In Benjamin H. D. Buchloh, "An Interview with Andy Warhol" (*October Files 2: Andy Warhol* [Cambridge, Massachusetts: MIT Press, 2001]), repr. in *I'll Be Your Mirror*, 329.

SEEING WITHOUT PARTICIPATING:
ANDY WARHOL'S UNSHAKABLE DETERMINATION NOT TO BE MOVED
Roger Copeland

IT IS A STARE OF DISTANCE, INDIFFERENCE,
OF MECHANICALLY COMPLETE ATTENTION AND
ABSOLUTE CONTACTLESSNESS.
—STEPHEN KOCH ON ANDY WARHOL'S FILMS
IN *STARGAZER*, 1973

. . . NO TO INVOLVEMENT OF PERFORMER AND
SPECTATOR . . . NO TO SEDUCTION OF SPECTATOR
BY THE WILES OF THE PERFORMER . . .
NO TO MOVING OR BEING MOVED.
—YVONNE RAINER, "PARTS OF SOME SEXTETS," 1965

Writing about the grand opening of the Andy Warhol Museum in Pittsburgh for the *New York Times* in 1994, Roberta Smith complained that "one canvas, *Dance Diagram*, [was] displayed horizontally on the floor as if to teach viewers the tango."[1] Ms. Smith, it seems safe to assume, chose not to *play footsie* with Warhol's Tango; but she did inadvertently put her foot in her mouth.

Indeed, her critical misstep was not to realize that when Warhol's *Dance Diagrams* were first exhibited in New York (as part of Sidney Janis's epochal *New Realists* show in 1962, and subsequently in his first solo show a week later at the Stable Gallery), not only were they displayed in precisely that manner—horizontal to the floor, on a step-up platform under glass—but they were accompanied by a printed placard inviting viewers to remove their shoes and put their best foot forward: that is, literally to follow the numbered footprints in Warhol's teach-yourself-how-to-tango (or fox-trot) diagrammatic dance lesson.

Warhol's strategy was to create an either/or dichotomy that pits the eye against the rest of the body, forcing the gallery-goer to choose between looking at the image or physically interacting with it. To *see* the painting in its entirety required spectators to distance themselves from it and to de-emphasize radically their degree of physical participation. In other words, the spectator was required to remain . . . a spectator.

Even as early as 1962, Warhol's meticulously cultivated aura of dandified cool, what Baudelaire once referred to as the dandy's "unshakable determination not to be moved,"[2] makes it easy to imagine him suppressing a sly, condescending smile when—from behind his dark sunglasses—he watched naïve, unsuspecting and all-too-eager *participants* try and get into the spirit of the painting by dancing with it.

Flash-forward to April of 1966. Andy Warhol is unveiling his Exploding Plastic Inevitable in the heart of the East Village on St. Mark's Place in Lower Manhattan. Nico and the Velvet Underground are performing on stage with an indifference towards their audience that borders on contempt. (They often turn their backs towards their listeners; and if anyone in the audience is presumptuous enough to actually try and *dance* to their music, Lou Reed, John Cale and company deviously change the tempo.) But their icy aloofness is countered by the hot mix of media—films beamed on the walls, slide projections that appear to melt into one another when cross-fading, rotating mirror balls, periodic eruptions of brilliant strobe flashes—all serving to saturate the space in dense layers of swirling imagery and pulsating light. In fact, the *son et lumière* that constituted an essential component of Warhol's Exploding Plastic Inevitable was consciously envisioned as a simulation of a psychedelic drug experience, the externalization of an interior voyage.

Whenever the Velvets were on break, a much more aggressively exhibitionistic performer, Warhol's studio assistant, Gerard Malanga, would hurl himself into a number of different dance routines. His sadomasochistic *whip* dance had the effect of startling the otherwise zoned-out audience into periodic moments of shared attention. At other times, Malanga would spin in circles like some sort of psychedelic dervish, entangling himself in labyrinthine spiderwebs of glow-in-the-dark wrapping tape. And on still other occasions, he would dance with a handheld strobe light pointed directly at his face; its fast-flicker intensity had the effect of momentarily transforming him into a spectral hallucination, a sort of Loie Fuller for the 1960s.

Three interrelated elements lent both an optical and a symbolic order to this potentially chaotic mix of media. First, there was the periodic pulse of a powerful overhead strobe light, illuminating both the audience and the performers, and thereby freezing—however briefly—this otherwise amorphous blur of motion into a series of still (or *captured*) images. And, among the vast range of visual patterns and effects, one image often dominated the others by virtue of the frequency with which it appeared and the length of time it remained visible: the projected image of a gigantic, unblinking eye (fig. 1),

an emblem, no doubt, of Warhol himself, the éminence grise who presided over this sensory onslaught from the detached, omniscient vantage point of the balcony. There he stood, night after night, the unmoved mover, the eye of this multimedia storm.

But—as even Warhol seemed to suggest with his *Dance Diagrams* four years earlier—dance is routinely regarded as the most *participatory* of the arts. Almost all of us have danced at one time or another, if only socially, and perhaps that is why we continue to think of dancing as something to *do* rather than something to look at. In fact, Havelock Ellis in *The Dance of Life*, his rhapsodic ode to the underlying rhythms of nature, argues that "even if we are not ourselves dancers, but merely the spectators of dance, we are still, according to that Lippsian doctrine of Einfühlung or 'empathy' feeling ourselves in the dancer who is manifesting and expressing latent impulses of our own being."[3]

What then could be more antithetical to the spirit of dance than Andy Warhol's legendary mode of *dis*engagement, his desire to remain uninvolved, unmoved, *untouched*, both emotionally and kinetically?

But the fact of the matter is that Andy Warhol managed to exert a considerable influence on experimental dance during the 1960s—an influence especially visible in the work of the so-called postmodern choreographers who created their most innovative dances under the auspices of the Judson Dance Theater. Conversely, Warhol himself was undoubtedly influenced (in ways that have yet to be widely acknowledged) by some of the work he is known to have seen at Judson, particularly the early dances of Yvonne Rainer.

Michael Kirby, in his unjustly neglected 1968 essay "Objective Dance," one of the earliest attempts to theorize about the connections between the Judson Dance Theater and concurrent developments in the visual arts, writes, "In the new dance, the subjective empathetic relationship which exists in all traditional performance dance [by which he means ballet and modern] is replaced by an objective relationship in which the observer sees but does not 'participate' in the work."[4] "Sees but does not 'participate.'" Was there ever a more aptly phrased description of Andy Warhol's mode of being (and seeing) in the world?

Kirby is referring to that moment in the early 1960s when Yvonne Rainer and other members of the Judson Dance Theater were beginning to test their radical premise that *any* movement—no matter how pedestrian, no matter how kinesthetically unaffecting, no matter how *undancerly* (in conventional terms)—could be defined as *dance* by virtue of the way it was recontextualized in the presence of observers.

Unlike the pioneers of modern dance, who were determined to invent unique ways of moving that would reflect their own inner—that is *subjective*—musculatures (Martha Graham spoke of her desire to "make visible the interior landscape"), many Judson choreographers simply transplanted impersonal, pedestrian—in other words *objective* —movements into an *art context* (where, like Duchamp's ready-mades, they were involuntarily stripped of their worldly function and "aestheticized"). Yvonne Rainer, in fact, coined the term "found movement" as the direct choreographic equivalent for Duchamp's ready-mades and found objects. The very titles of many of Rainer's early dances (*We Shall Run*, *Ordinary Dance*, *Person Dance*) give the game away.

Warhol too was quick to distinguish the cool *objectivity* of his own art from the hot, tortured, internally driven subjectivity of the Abstract Expressionists. "Pop comes from the outside,"[5] he liked to say.

But the relationship between Warhol and Judson was more than a matter of shared sensibility. In fact, a well-travelled, two-way street connected Judson to Warhol's famous "Factory." One of the founding members of the Judson Dance Theater, Fred Herko, also performed in some of Warhol's earliest and most distinctive films (including *Haircut* and

Kiss, both produced in 1963). That same year, Herko was also the featured performer in Warhol's *Dance Movie* (also known as *Rollerskate*), a short film that must surely have been inspired by one of Herko's Judson dances, *Binghamton Birdie*, staged three months earlier. (*Birdie* included a sequence in which Herko, adorned in a yellow and blue jersey with the words "Judson" emblazoned across the front, glided breezily about the space on one roller skate.)

Herko also lived for a while with Billy Linich, who subsequently renamed himself "Billy Name" (in the self-inventing manner of Warhol's Superstars). Linich designed the lighting for a number of early Judson productions, and it was he who had the *bright* idea of coating the surfaces of Warhol's studio with silver paint and reflective tinfoil, thereby transforming it into the "Silver Factory" (fig. 2). And Herko was typical of the amphetamine junkies who infused the Silver Factory with its distinctive drug-driven pulse. Warhol claimed to love the way "Freddie . . . would just dance and dance until he dropped. The amphetamine people believed in throwing themselves into every extreme—sing until you choke, dance until you drop, brush your hair till you sprain your arm . . . it was the perfect time to think silver . . . silver was narcissism—mirrors were backed with silver.[6]

And Warhol's studied passivity allowed him to serve as the human mirror for whom hopped-up exhibitionists like Herko could pull out all of the stops.

In July of 1961, as part of a dance performance organized by James Waring at the Living Theatre, Fred Herko performed one of his own high-energy (and no doubt, high-camp) dances, *Possibilities for a Pleasant Outing*, alongside an early minimalist solo by Yvonne Rainer titled *The Bells*. It is difficult to imagine two conceptions of dance more antithetical to one another than Herko's and Rainer's. If Herko was the sort of person who was always *on*, always performing, always in search of—perhaps in need of—an audience, then Rainer was the exact opposite. Indeed, she would soon write, "If my rage at the . . . narcissism and disguised sexual exhibitionism of most dancing can be considered puritan moralizing, it is also true that I love the body—its actual weight, mass, and unenhanced physicality."[7]

In other words, Rainer wanted to treat the body like an *object* in a gallery, something incapable of playing *roles* or of pandering to the gaze of an appreciative perceiver (the very opposite, in other words, of the sort of Warhol *Superstar* that Herko aspired to become). In fact, if Herko can be said to have approached dance principally from the vantage point of the (exhibitionistic) performer, then it is fair to say that Rainer sought to reconceive of dance from the vantage point of the *perceiver*—the sort of perceiver more likely to be encountered in a museum or gallery than at a traditional dance performance.

Rainer again: "I remember thinking that dance was at a disadvantage in relation to sculpture in that the spectator could spend as much time as he required to examine a sculpture, walk around it, and so forth—but a dance movement—because it happened in time—vanished as soon as it was executed. So in a solo called *The Bells* I repeated the same seven movements for eight minutes . . . in a sense allowing the spectator to 'walk around it.'"[8]

"Repetition," Rainer went on to write in her 1966 essay "The Mind is a Muscle: A Quasi Survey of Some 'Minimalist' Tendencies . . .," "can serve to enforce the discreteness of a movement, objectify it, make it more objectlike."[9]

Relentless repetition as a strategy for making human activity more "objectlike." It is easy to see why Warhol, the master of serial repetition, would take an interest in Rainer's work. And Rainer was quick to return the compliment. In the same essay just cited, she proposed a number of analogies between her own dances and the work of visual artists such as Warhol, Judd and Morris. Her "Quasi-Survey" begins with an illustrative chart juxtaposing "Objects" (left-hand column) with "Dances" (right-hand column), establishing a set of "family resemblances" between them. For a painter like Warhol, the "role of artist's hand" would be replaced by "factory fabrication" (for example, photo screen-print techniques). For Rainer, the corresponding strategy was to substitute idiosyncratic choreographic "phrasing" for "'found' movement."[10]

Rainer's performance style was almost the exact antithesis of Herko's, but considered in tandem, they tell us something important about Warhol's *taste* in dance during the 1960s. In fact, between them, Herko and Rainer managed to embody what might be called the two poles of Warhol's sensibility more generally: his attraction, on the one hand, to the most extreme forms of human exhibitionism (the wannabe superstars who *enacted* themselves in the presence of his passive gaze) and, on the other hand, his ongoing fascination with the most minimal experiences imaginable (for instance, Robert Indiana eating a mushroom in the film *Eat*; Billy Linich getting his hair trimmed in the three versions of *Haircut*). These are experiences that possess little or no *intrinsic* interest for the viewer. Like Yvonne Rainer's found movements, they acquire aesthetic and philosophical significance by virtue of the *way* they are looked at, which is to say, by virtue of the self-reflexive manner in which the *act of looking itself* becomes a metaphor for the relationship between *subject* and *object*. And Warhol's editing strategy periodically reminds us that what we are looking at is being perceived through the *medium of film*: each of the one-hundred-foot reels was spliced together end-to-end, producing a brilliantly bright white *flare-up* effect every time the clear white leader with its perforated sprocket holes ran through the projector.

These exercises in minimalism—culminating in Warhol's eight-hour fixed (camera) *stare* at the Empire State Building (in *Empire*)—also suggest another important connection between Warhol and postmodern dance: the implication that absolute *stillness* is an illusion. (John Cage had already argued that "there is no such thing as silence."[11]) But it was Warhol—with his *seemingly* static films—who demonstrated that "there is no such thing as absolute stillness," even if the *movement* that eventually proves his point can only be perceived over excruciatingly long periods of time (for example, the setting of the sun in *Empire*).

In April of 1963, Andy Warhol attended two events that must surely have influenced his steadily growing interest in the relationship between stillness and motion, a dynamic that would soon become a central dialectic in almost all of his work. The first was a commemoration to mark the fiftieth anniversary of the landmark 1913 Armory Show, at which Marcel Duchamp had first unveiled his fusion of Cubist stillness and Futurist motion, *Nude Descending A Staircase No. 2*. Duchamp's notorious painting employed a number of photographic techniques that had already begun to figure in Warhol's art as well (for example, the nude appears to be descending the stairs in a painterly version of the stop-motion photography pioneered by Étienne-Jules Marey). Indeed, Duchamp's fascination with the photographic *freezing* of motion firmly situates his painting in the long tradition that begins with Marey and Eadweard Muybridge, and extends through the work of Harold Eugene "Doc" Edgerton, who experimented with multi-flash strobe-light photography in the 1930s.

Warhol would subsequently contribute to this tradition in a variety of ways (the role that strobe lighting played in *freezing* the swirl of psychedelic motion at his Exploding Plastic Inevitable has already been discussed). But there is a more fundamental connection between stroboscopic *flash* photography and the countless images that Warhol produced of celebrities. His famous photo-silkscreen images of Marilyn, Liz, Jackie and other figures suggest the simultaneous *freezing* (and flattening) that occurs when an object is momentarily illuminated by a bright flash of light. (Tellingly, Warhol's portfolio of fourteen colour screen prints documenting the four days between the assassination of John F. Kennedy and his funeral is titled "Flash . . . November 22, 1963.") But—as with almost all of Warhol's work—the impulse to *freeze* motion in a *flash* is offset by the relentless, time-bound rhythm of mechanical reproduction, the way in which these media-generated images are infinitely replicated.

Later that same month, Warhol attended another event that addressed these concerns in a rather different way: Yvonne Rainer's *Terrain*, performed at the Judson Memorial Church. *Terrain* was a further exploration of the way in which human movement could be made more objectlike, thereby transforming the spectator's experience of watching a dance into something more closely resembling the museum-goer's mode of apprehending static, inanimate objects. In particular, *Terrain* contained two solos that must surely have intrigued Warhol; and, when examined in the light of his subsequent development, may even have deeply influenced him.

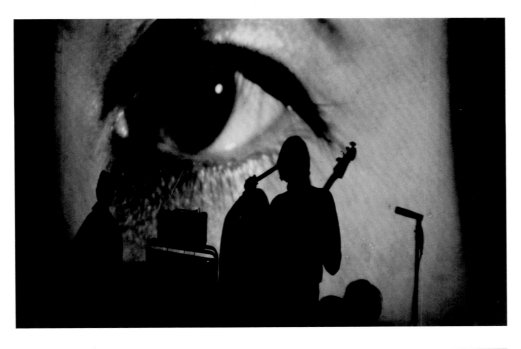

1

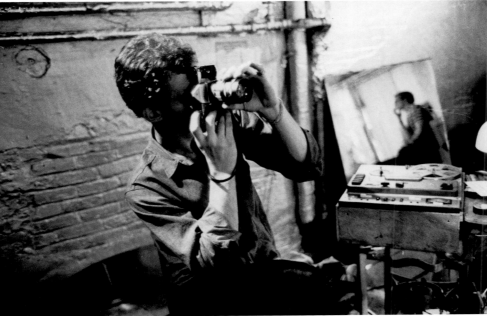

2

FIG. 1 – A Velvet Underground show at the Dom, with John Cale's silhouette standing out against a projection of an eye, April 1966. Photo Fred W. McDarrah FIG. 2 – Billy Name photographing Andy Warhol at the Silver Factory, 1965. Photo Stephen Shore

The solos were titled "Sleep" and "Death," two, states that have been connected with one another historically in a variety of metaphorical ways (for example, nightly sleep as a memento mori; *dreamless sleep* as a metaphor for eternity). Rainer's book *Work: 1961–73* includes a photograph of the two solos being performed simultaneously by Trisha Brown and Albert Reid (fig. 3). Brown, upstage, lies prone on the floor, clutching what appears to be a pillow. Reid, in quasi-arabesque, displays an oddly contorted expression on his face, apparently an allusion to the *faces* that Jean-Paul Belmondo makes in his famous "Death Run" at the end of Godard's *Breathless*.

Both sleep and death were soon to become recurring motifs in Warhol's work as well (for example, the "Death and Disaster" series of photo-silkscreened images was already underway, and paintings of skulls and shadows would loom large later in his career). Furthermore, "Sleep" would soon provide both the title and the subject for one of Warhol's most ambitious films. In addition, his famous floating sculptures, the Silver Clouds—which would eventually become the decor for Merce Cunningham's legendary dance *Rainforest* in 1968 (fig. 4)—are of course, really silver *pillows*, suggesting that sleep, in one form or another, had become a continuing fascination of Warhol's.

Returning to Rainer's treatment of these themes in *Terrain*: sleep and death are both states in which the body becomes literally objectlike, unaware of its surroundings, unable to acknowledge the perceiver's gaze—no matter how glaring, intrusive or voyeuristic. Of course, in Rainer's dance, the state of sleep is merely simulated (Trisha Brown clutches her pillow) and death is merely alluded to in the form of an ironic visual quotation from *Breathless*. But there are other activities incorporated into *Terrain*—referred to by Rainer as "tasks"—that more closely approximate the objectlike nature of both the sleeper and the corpse. Rainer's rehearsal notes contain the following jottings about the "tasks" she assigned the soloist in "Sleep": "Stretching arms between two objects that were too far apart to touch."[12] In other words, the performer is asked to do something that is technically impossible, an activity that will *absorb* all of the performer's effort and attention. Other notes refer to the way the performer's own gaze creates a sense of self-absorption: "focusing all of the attention on the objects . . . never taking notice of anything else going on around one."[13]

In Rainer's recently published autobiography, *Feelings Are Facts,* there is an especially revealing photograph of Albert Reid performing the "Sleep" solo. He is posed in a low crouch, staring obsessively into a bag filled with objects. Upstage of him, Yvonne Rainer, Judith Dunn, Trisha Brown and Steve Paxton are standing behind a police sawhorse barrier. Rainer contrasts "the cool detachment" of the dancers watching from behind the barricade with the self-obsession of the soloist. The *watchers* are also distinguished from the *sleeper* by virtue of their relationship to the floor and to gravity. The *sleeper* is never permitted to stand upright—in part because upright posture constitutes the clearest physical evidence of being *awake*. Rainer is particularly insistent on this point: "The performer never stood erect in this solo,"[14] she writes.

The physical barricade between sleeper and watcher thus becomes a metaphor for the ideal relationship between *subject* and *object* in much of the work of *both* Rainer and Warhol. Indeed, in Warhol's first film, *Sleep*, made just a few months after he saw *Terrain*, Rainer's (still illusionary) premise is carried to its literal and logical conclusion. Here, the body that the camera gazes upon really *is* asleep, truly oblivious to the camera and (by extension) to the viewer's gaze; almost as oblivious as the inanimate *star* of Warhol's last and most minimalist silent film, *Empire*.

Our *access* to Warhol's sleeper (John Giorno, fig. 5) stops at the visual edge of his semi-naked body. Whatever dream-life he may be experiencing will never be made known. Indeed, even his breathing is not heard because this six-hour-long film is silent. As a subject watching an object, the viewer's experience becomes purely optical. The spectator views him *objectively*, entirely from the *outside*.

FIG. 3 – Yvonne Rainer's *Terrain*: the solos *Sleep* and *Death* performed simultaneously by Trisha Brown (in the background) and Albert Reid (in the foreground), 1963. Photo Al Giese FIG. 4 – Merce Cunningham's *Rainforest*, with Andy Warhol's Silver Clouds, 1968 (cat. 169) FIG. 5 – Andy Warhol's *Sleep* (1963): close-up of John Giorno's face (cat. 170)

Given Yvonne Rainer's radical redefinition of dance as movement with the sole function of being *seen* (a purely optical experience *untouched* by kinetic empathy), then Warhol's *Sleep* must surely qualify as one of the most original *dance films* ever made. And *Sleep* exists in a fascinating dialectical relationship to a dancer like Fred Herko who seemed *never* to sleep, who often exhibited the frenetic hyperactivity of the speed freak. In fact, Warhol, who spent much of the 1960s surrounded by people whose central nervous systems were perpetually sped up (by a steady diet of *uppers*), once expressed his fear that sleep would soon become obsolete.

The relationship between the spectator and the spectacle in *Sleep* is further complicated by the fact that Warhol shot the film at twenty-four frames per second, but insisted that it be projected at *silent* speed (sixteen frames per second). The result is an almost imperceptible tinge of dream-like slow motion, a subliminal sense of floating, countered by the unyielding fixity of the camera and the gravity of its gaze.

The accumulating tension in *Sleep* finds its metaphorical antidote—its *release*, if you will, in the Silver Clouds, Warhol's most successful foray into the realm of kinetic sculpture. These helium-filled silver (Mylar) balloons, which floated languorously about the Factory, can be thought of as a cross between the soft sculpture of Claes Oldenburg and the mobiles of Alexander Calder. And what connects them most intimately to Warhol's recurring concerns is the simple fact that the so-called "Silver Clouds" are really silver *pillows*: shiny, reflective emblems of sleep and of dreaming, an image of consciousness finally floating free of the body entirely. And it was the Silver Clouds that led to Warhol's first full-fledged entry into the world of concert dance: his *collaboration* with Merce Cunningham on *Rainforest* in 1968. Cunningham saw the Clouds at Leo Castelli's gallery in 1966, and he had Jasper Johns, then the chief designer of settings and costumes for his company, ask Warhol for permission to use them as the decor for *Rainforest* two years later.

Perhaps it was inevitable that Warhol and Cunningham would eventually work together, if only because they shared such peculiar ideas about what it means for two artists to *work together*. Cunningham (along with his partner John Cage) had already pioneered a model of artistic collaboration that proved temperamentally perfect for Warhol: what might be called *collaboration at a distance*. In the Cunningham/Cage aesthetic, movement, sound and decor are all conceived and executed independently of one another; and all remain *autonomous* in performance, never melding into an organic whole.

But there is an even more fundamental similarity between Warhol and Cunningham: both cultivated an aesthetic of *impersonality*. Under the influence of Cage, Cunningham began in the early 1950s to use *chance methods* as a strategy for liberating himself from his own ingrained, hardwired habits of movement. Thus Cunningham was the first modern dance choreographer to break with the Gospel of Graham, which—as already explained—had emphasized moving in a manner unique to the choreographer's own body. And in so doing, he set the stage for the Judson generation of postmodern choreographers like Rainer who would go on to explore what Michael Kirby has called "objective dance."

Andy Warhol once famously declared, "I think everybody should be a machine."[15] Clearly, the machine he most wanted to emulate was the lens—the unblinking eye—of the 16mm Bolex movie camera with which he filmed John Giorno in *Sleep*. And the movie camera—which remains kinetically indifferent to anything and everything it records—is the utmost manifestation of what it means to *see, without participating*. It is also the ultimate embodiment of Baudelaire's "unshakable determination not to be moved."

So it is understandable why many people are inclined to dismiss Warhol as *inhuman*. Certainly he never presented himself to the world as a *sympathetic*—let alone empathetic—figure. Still, the word "unshakable" assumes a certain poignancy when considered in the light of his childhood. At the age of eight, the young Andy suffered through a debilitating—and no doubt, humiliating—bout of St. Vitus' dance, a neurological disorder that leads to an involuntary shaking of the feet and hands. It also left him painfully hypersensitive to touch for the rest of his life.

Traumatic to be sure: yet also ironic, because Warhol—whose earliest Hollywood idol was the tap-dancing child-star Shirley Temple—once confessed to Gretchen Berg, "I never wanted to be a painter. I wanted to be a tap dancer."[16]

But the involuntary tics of St. Vitus' dance had little in common with the effortless self-confidence that Shirley Temple exuded in, say, her tap duet on the staircase with Bill Bojangles Robinson in *The Little Colonel*. In fact, to the homely, pathologically shy, "little, queer, mommy's boy" (as Simon Watney described the young Andy), St. Vitus' dance must have felt more like an invitation to public bullying of the sort associated with another Hollywood product, the grade B Westerns in which sadistic gunslingers fire bullets at the feet of hapless townspeople, barking orders at them to . . . "Dance!" Maybe this helps to explain Warhol's life-long aversion to what John Martin called "the inherent *contagion* [author's emphasis] of bodily movement."

Perhaps it was then and there, at the tender age of eight, that Warhol decided to transform himself into a still point, an all-seeing, God-like audience for whom the *rest* of the world dances. As T. S. Eliot wrote in "Four Quartets," "Except for the point, the still point, There would be no dance, and there is only the dance."[17]

1 Roberta Smith, "The New Warhol Museum: A Shrine for an Iconoclast," *The New York Times* (May 26, 1994).
2 Charles Baudelaire, *The Painter of Modern Life* (London; New York: Phaidon, 1963), 29.
3 Havelock Ellis, "The Dance of Life," in Roger Copeland and Marshall Cohen, eds., *What Is Dance?* (New York: Oxford University Press, 1983), 494.
4 Michael Kirby, "Objective Dance," in *The Art of Time* (New York: E. P. Dutton and Co., 1969), 110.
5 Andy Warhol, quoted by Eric Shanes in *Warhol* (New York: Portland House, 1991), 17.
6 Andy Warhol and Pat Hackett, *Popism: The Warhol Sixties* (New York; London: Harcourt Books, 1980), 61.
7 Yvonne Rainer, *Work 1961–73* (Halifax, Nova Scotia: The Press of the Nova Scotia College of Art and Design, 1974), 71.
8 Yvonne Rainer, quoted by Barbara Rose, "ABC Art," in Gregory Battcock, ed., *Minimal Art: A Critical Anthology* (New York: E. P. Dutton & Co., 1968), 290.
9 Rainer 1974, 68.
10 Ibid., 63.
11 John Cage, *Silence* (Middletown, Connecticut: Wesleyan University Press, 1961), 3.
12 Rainer 1974, 21.
13 Ibid.
14 Ibid.
15 Andy Warhol, quoted by Gene Swenson in "What Is Pop Art? Interview With Andy Warhol," *Art News*, vol. 62, no. 7 (November 1963), 24.
16 Andy Warhol, quoted by Patrick Smith in *Andy Warhol's Art and Films* (Ann Arbor, Michigan: UMI Research Press, 1986), 132–133.
17 T. S. Eliot, *The Four Quartets* (New York: Harcourt, Brace, 1943), 66.

1

TUN

ING
IN

ANDY WARHOL'S JUKEBOX From 1949 to 1987—the time between his arrival in New York until his death—Andy Warhol did illustrations for some fifty record covers.[1] Although straightforward commercial works, they still bear Warhol's artistic signature. They parallel the evolution of his art and style, beginning with his Cocteau-like affectation of the blotted line technique so characteristic of his 1950s creations (Ravel, 1955; Tchaikovsky, 1955), to the close-up portraits after Polaroids from his society years (Diana Ross, 1982; Billy Squier, 1982; Aretha Franklin, 1986). And there is Pop too, as seen in the use of full-page commercial lettering (Giant Size $1.57 Each, 1963) and the serialized photobooth pictures (John Wallowitch, 1964). His record designs are also expressions of his art philosophy: the record, by being a multiple circulating freely in the market, is a vehicle through which art becomes accessible to diverse audiences. Warhol made truly historic contributions to record-cover design, that special niche of commercial art. He worked for the biggest labels of the time, including Columbia, RCA, Blue Note, Prestige, Verve and EMI, and for the greatest artists, such as Count Basie, Moondog, the Rolling Stones, Aretha Franklin, to name only a few. He was an innovator. His banana sticker and accompanying instruction to "Peel slowly and see" made the very Duchamp-like cover of the first Velvet Underground recording (1967) the world's first "interactive" jacket. Another novelty was the absence of the band's name, although Andy Warhol's signature is clearly visible in the lower right corner. The Rolling Stones' *Sticky Fingers* (1971), in which the zipper teasingly invites a conceptual undressing, is one of the most popular album covers ever produced, and it earned Warhol the Art Directors Club Certificate of Merit. It is tempting to see this series of commissions as a fast-forward survey of the evolution of the musical tastes cultivated by the various incarnations of American society's artistic elite, with whom Warhol identified by turns over the years—from the classical music the sophisticated youth who frequented Serendipity listened to in the early 1950s, to the more urbane and intellectual world of jazz at the end of the decade, followed by the experimental rock of the Factory days, then towards the world of rock stars and glam rock in the 1970s. And then came pop, soul and the disco sounds of the wild Studio 54 years. Warhol's record illustrations provide a changing portrait of the sensibilities of an artist preoccupied with being tuned in to the dominant frequencies of his time. Warhol the record illustrator, who was tapped into changing fashions, differs from Warhol the music lover. The accounts of those who knew him and his personal archives both reveal a more nuanced musical profile. He went to the opera throughout his life, but he apparently never liked jazz. He was a great fan of musicals and cabaret singers like Mabel Mercer and Eartha Kitt. He was crazy about pop hits. Clearly, his affinity with music stemmed from affectivity in addition to his stylistic concerns and aesthetic considerations. **S.A.**

1. There may be more, but this aspect of his body of work has been little studied. Paul Maréchal's work, published jointly with this catalogue, is the most comprehensive reference on the subject. See: *Andy Warhol: The Record Covers 1949–1987. Catalogue Raisonné.*

Opposite: Diana Ross, interior of the *Silk Electric* record cover, 1982 (cat. 44)

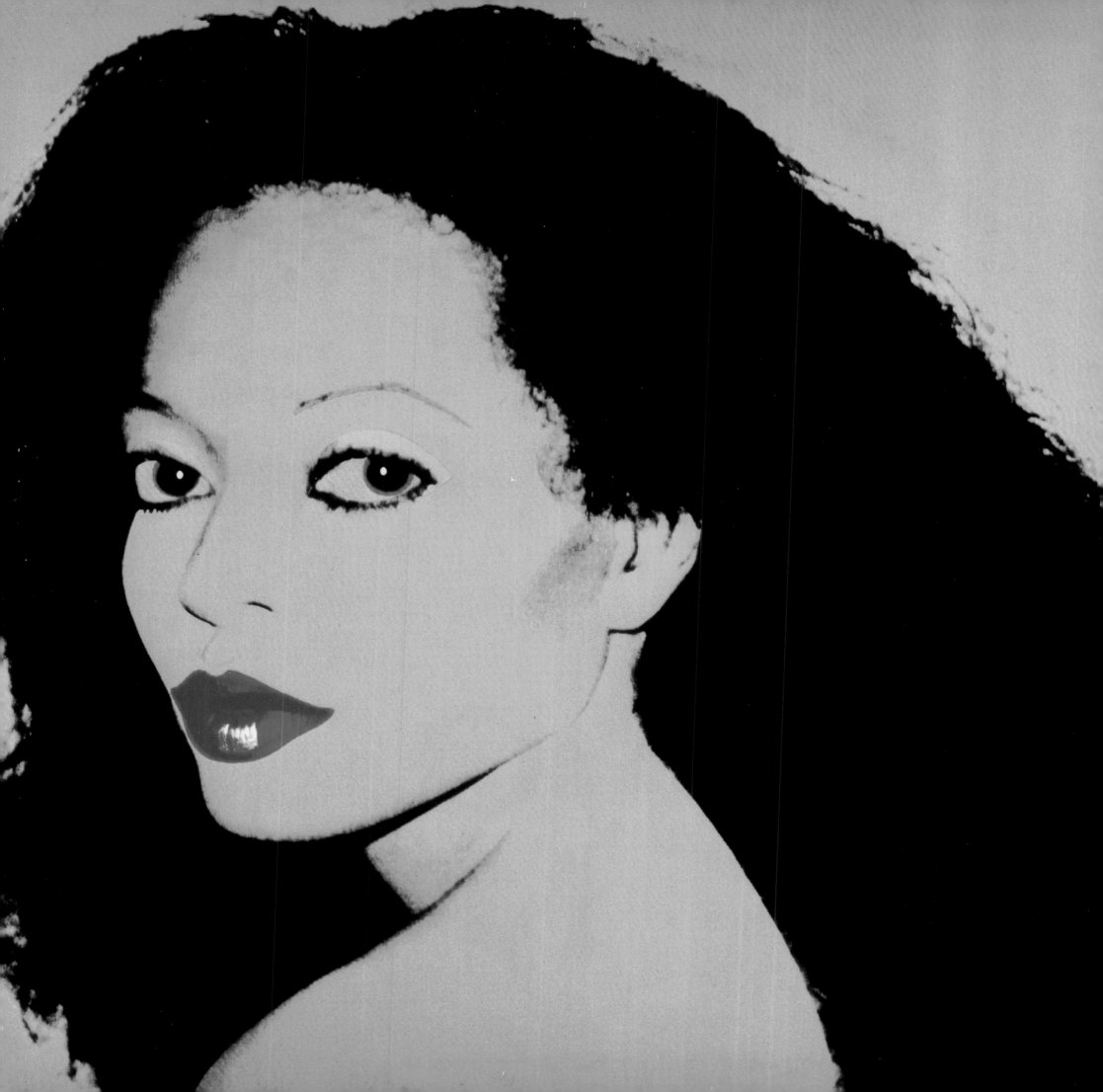

1, 2, 3

4, 6, 7

9, 8, 10

Pages 42 to 47: Record covers illustrated by Andy Warhol between 1949 and 1987

11, 20, 16

19, 17, 18

15, *1*, 14

21, 23, 24

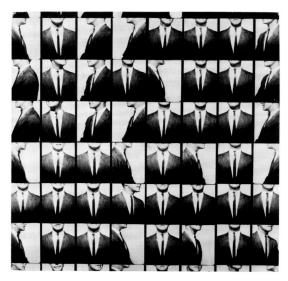
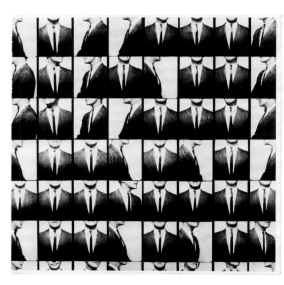

26, 29, 30

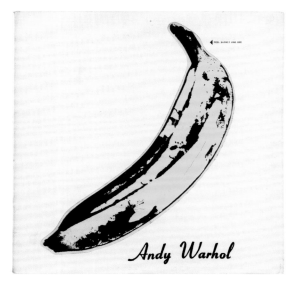
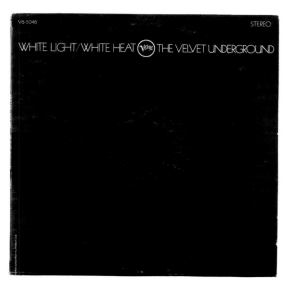

22, 32, 33

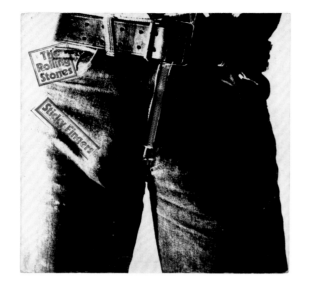

34, **35**, *3*

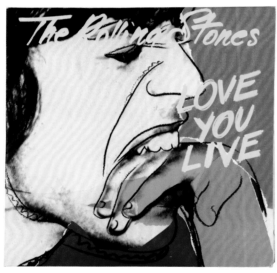

38, **37**, **39**

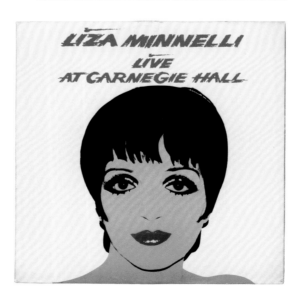

40, **42**, **41**

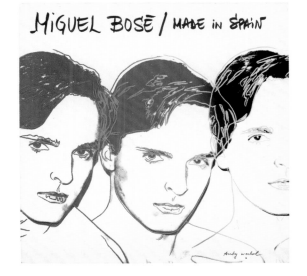

44, 45, 46

48, 43, 49

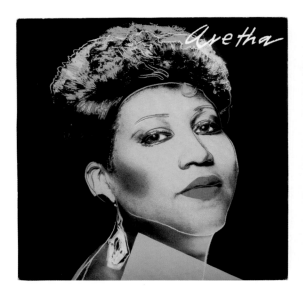

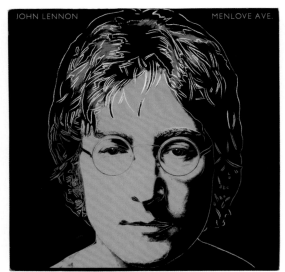

50, 56, 58

HOLLYWOOD ROMANCE Warhol had been enthralled by the world of Hollywood since his childhood. He collected photographs of actors and actresses, asked for autographs, and devoured magazines. He devotedly idolized the "stars" of the day, whom he gazed at admiringly on the big screen of the Leona Theater in Homestead, the working-class district of Pittsburgh where he grew up. The Time Capsules (the cardboard boxes now housed at the Andy Warhol Museum in Pittsburgh, in which he stored indiscriminately what he collected) are packed with proof of his deep, lifelong love of cinema, which he always maintained and which imbued his work. With movies comes music. This invisible yet essential element to the magic of filmmaking punctuates the performance of actors, heightens their emotions, and projects their image into an almost supernatural dimension. Warhol discovered film when it was making the most of the expressive and formal power of music by capitalizing on the resources of the recently invented synchronized soundtrack. Musicals became the genre par excellence of the era, and the child prodigies performing in them, including Shirley Temple, Alice Faye, Mickey Rooney and Judy Garland, simply dazzled. Of the first celebrity, Warhol preserved throughout his life one of his most cherished treasures: a photograph autographed "To Andrew Worhola [*sic*], From Shirley Temple." The beautiful Judy Garland also made an impression on Warhol; she personified deeper aspirations, as expressed in her historic role in *The Wizard of Oz* (1939), in which she sang "Somewhere over the Rainbow." These were aspirations with which Warhol, the frail and pale son of a working-class family of Ruthenian immigrants, could identify in his dream of a better life. Warhol became acquainted with Judy Garland in the 1960s—she was at a Factory party in 1965—and attended her funeral in 1969. Ten years after her death, he painted two portraits of her at different ages from headshots. It was at a time when he kept company with Garland's daughter, Liza Minelli, a singer and musical-comedy actress herself. Warhol also did a portrait of her, which was used on the cover of one of her albums, and even published a scrapbook-like collage of publicity photos of the mother and daughter together. He returned one last time to *The Wizard of Oz* in his "Myths" series in 1981, and asked Margaret Hamilton, the Wicked Witch of the West, to replay her role for his depiction of *The Witch.* Music, in this case of a religious nature, also serves as an appropriate backdrop when considering Warhol's gold tondo portrait of Marilyn Monroe, who was a singer too when she fancied. Historians have often pointed out the formal similarities between the portraits of Marilyn, particularly those on a gold background, and the icons that the young Warhol contemplated in the Catholic Byzantine Church of St. John Chrysostom, where he went every Sunday with his mother and where, along with movies, he was given his first taste of music. Marilyn inspired star worship, and Elvis, irony. In 1963, Elvis Presley was no longer the singing rebel of rock's beginnings, but had become the star of second-rate musicals and an object of mockery for many. Warhol depicted him standing and had the idea of an accompanying soundtrack of gunshots. By unveiling his portraits of the star at the Ferus Gallery in Los Angeles—painted after a publicity photo for the film *Flaming Star* (1960)—the New York avant-garde artist was making an ironic statement on the world of Hollywood. It was this same world that Warhol wanted to win over when he released his silent film *Sleep* (1963) in the same year. **S.A.**

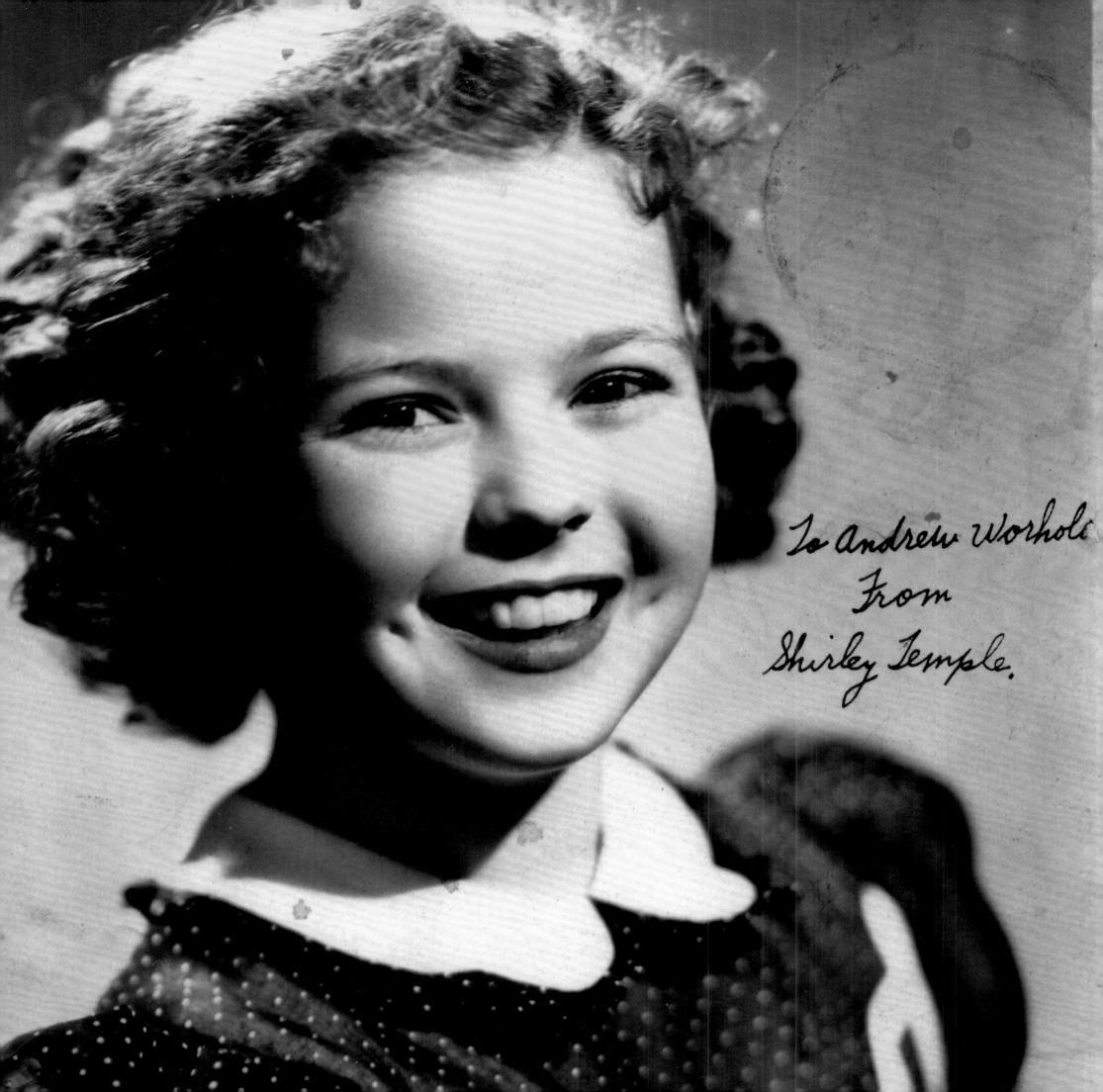

To Andrew Worhola From Shirley Temple.

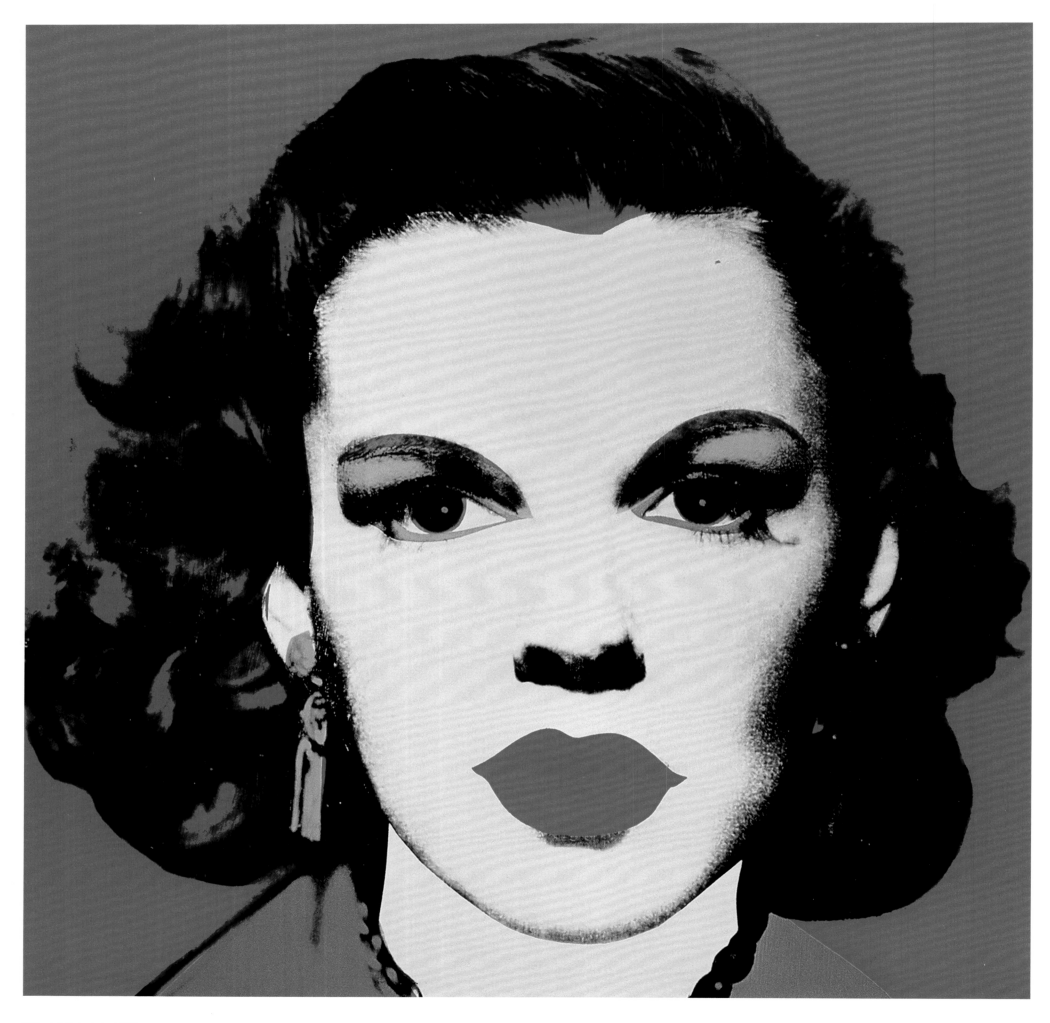

116 – *Judy Garland*, about 1979

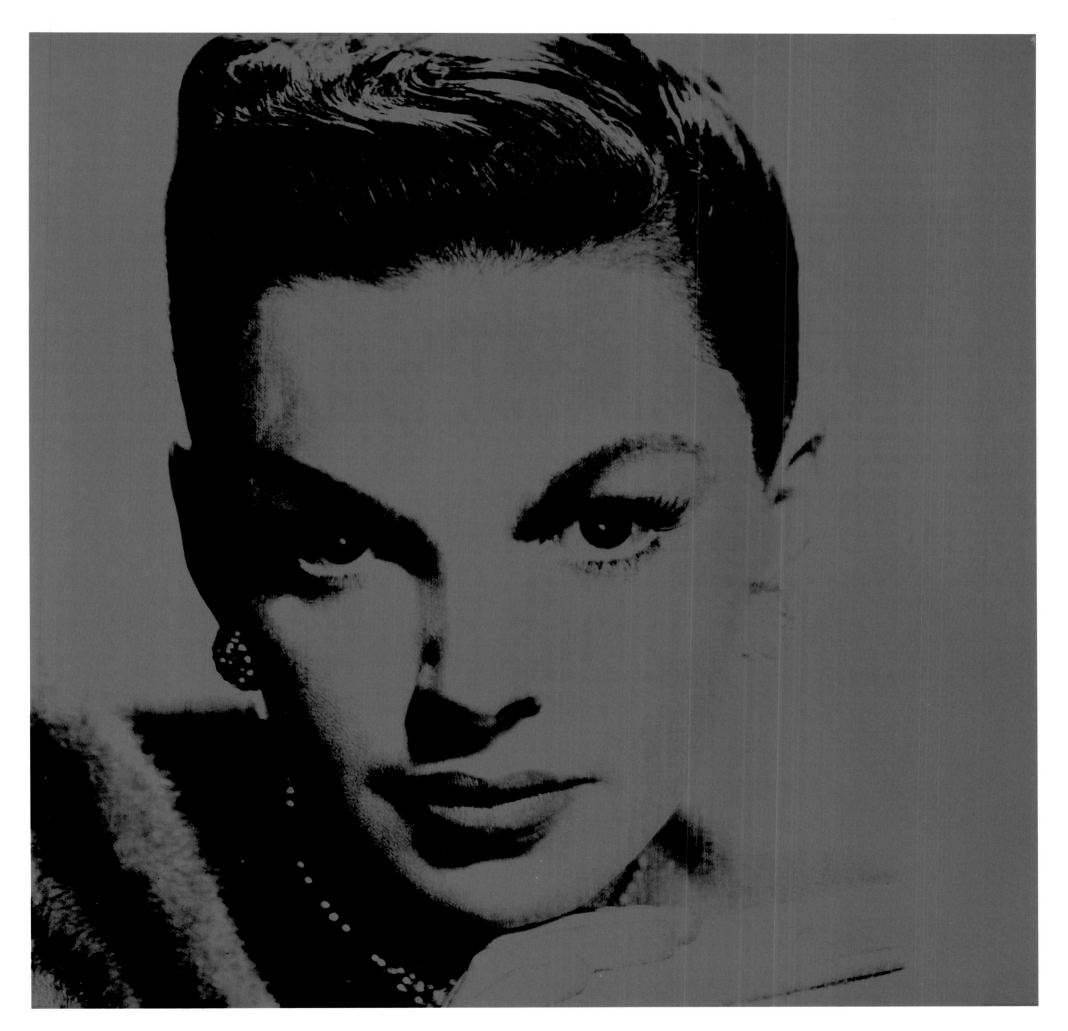

531

551

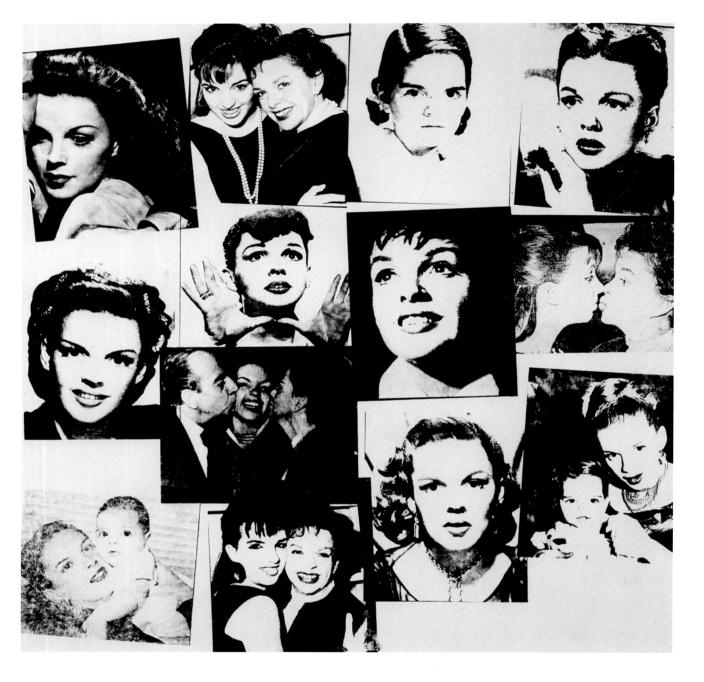

531 – February 1940 issue of *Movie Story*, with an illustrated synopsis of *The Bluebird*, starring Shirley Temple **551** – Publicity for *The Scarlet Empress*, starring Marlene Dietrich, John Lodge, Sam Jaffe and Louise Dresser
118 – *Judy Garland and Liza Minnelli*, about 1979

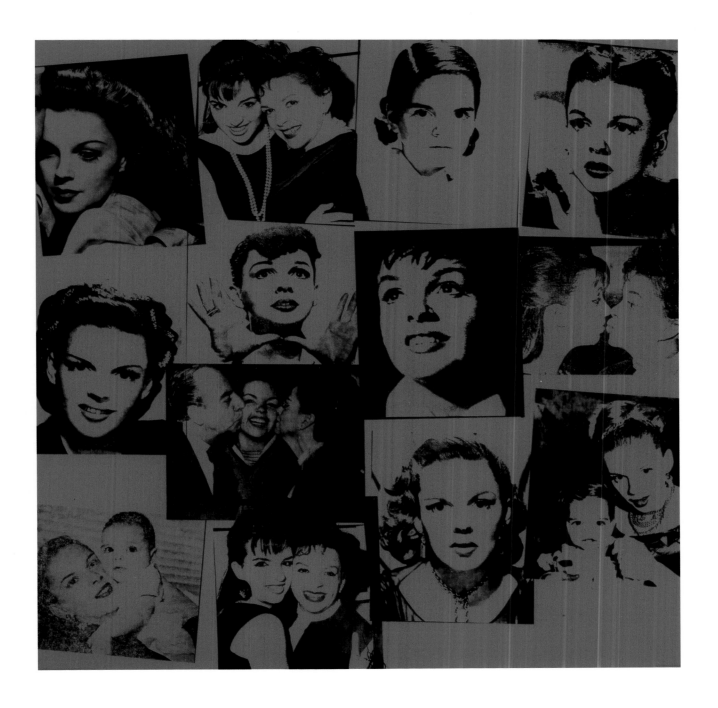

117 — *Judy Garland and Liza Minnelli*, about 1979

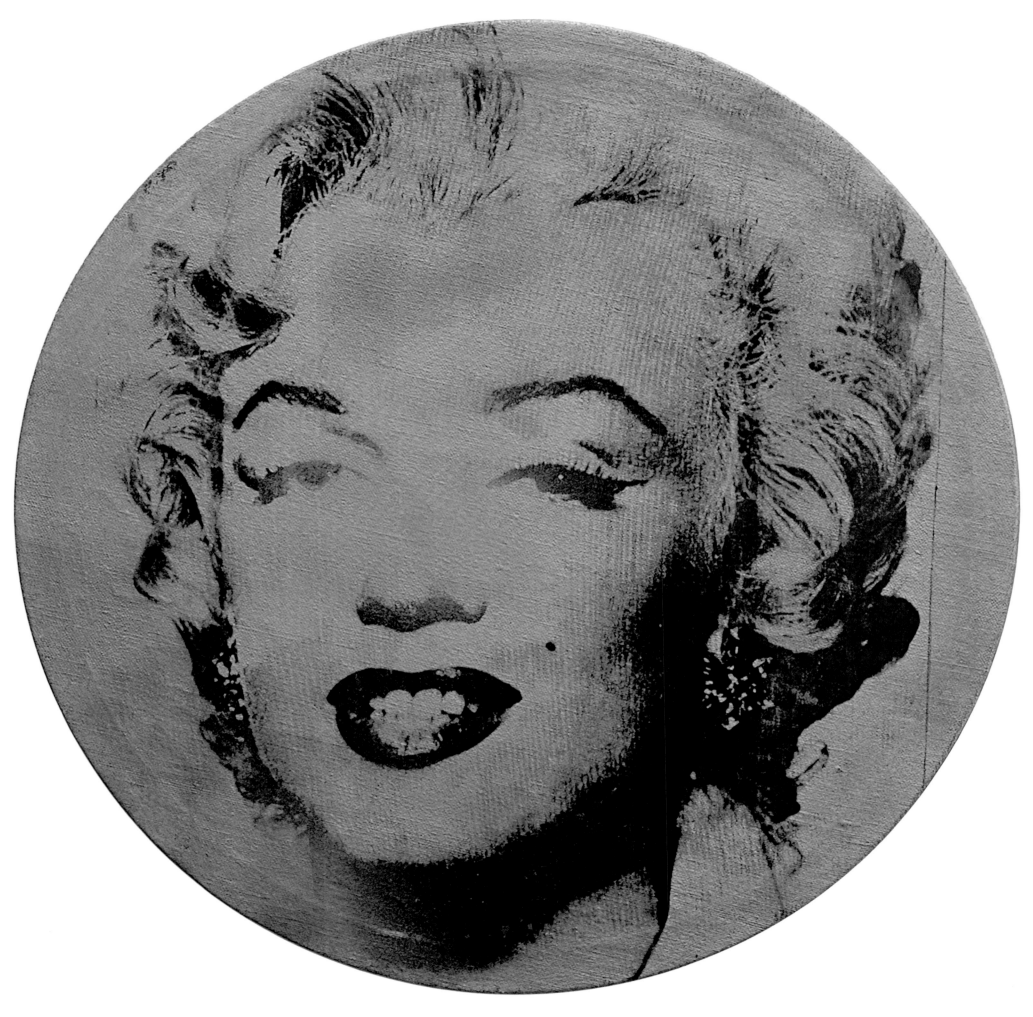

80 – *Round Marilyn (Gold Marilyn)*, 1962

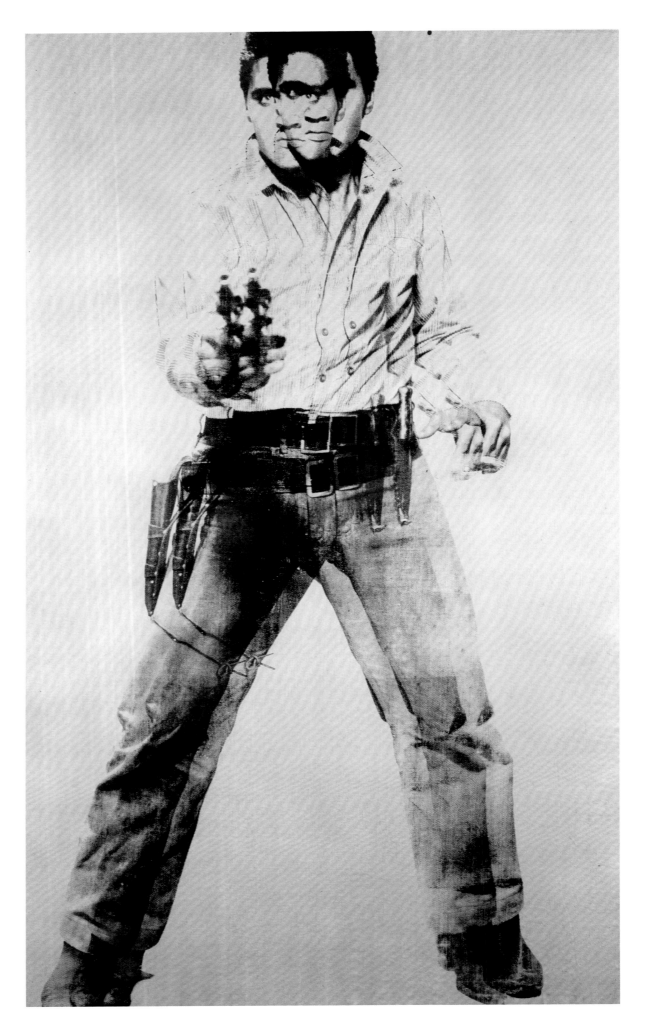

88 – *Double Elvis*, 1963

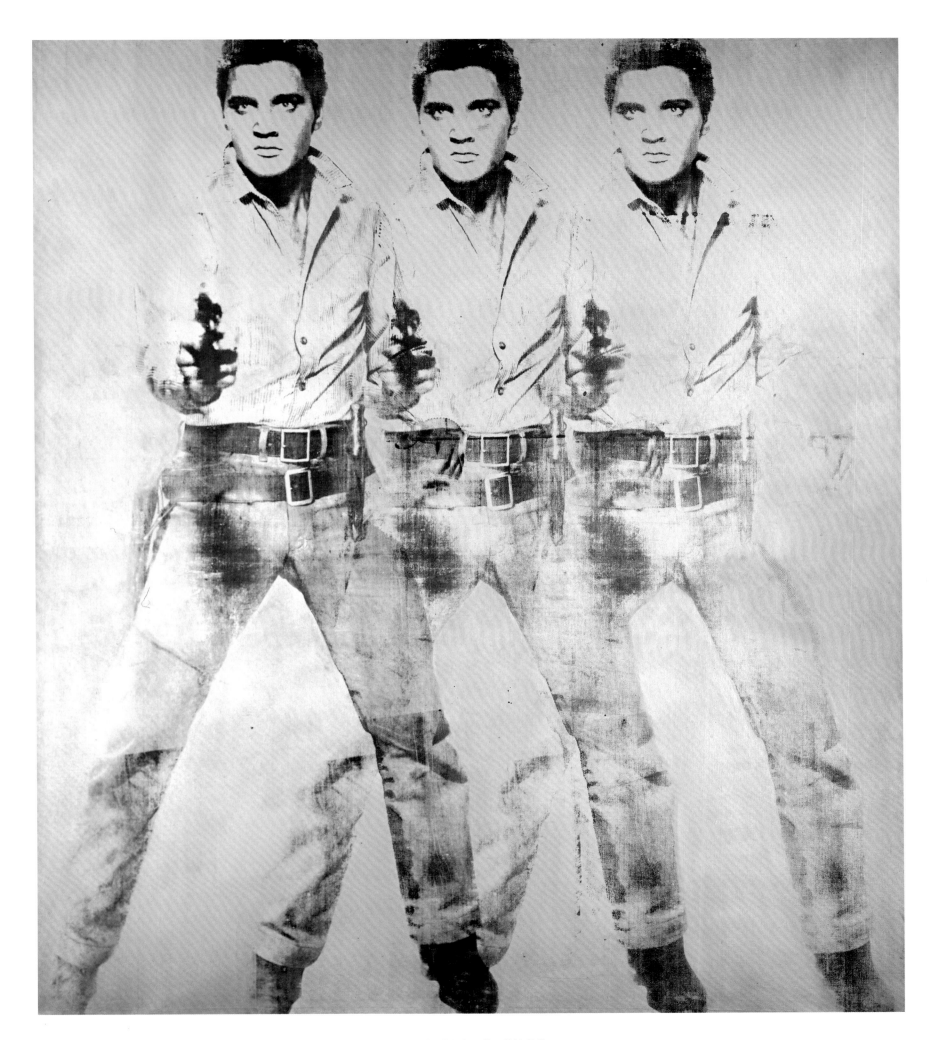

94 – *Triple Elvis (Large Three Elvis)*, 1963

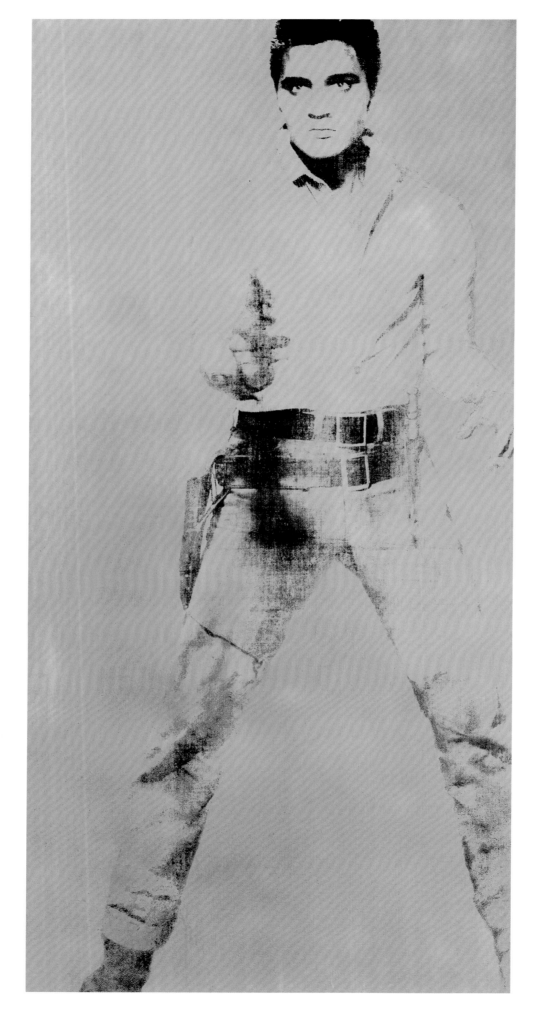

93 – *Single Elvis*, 1963

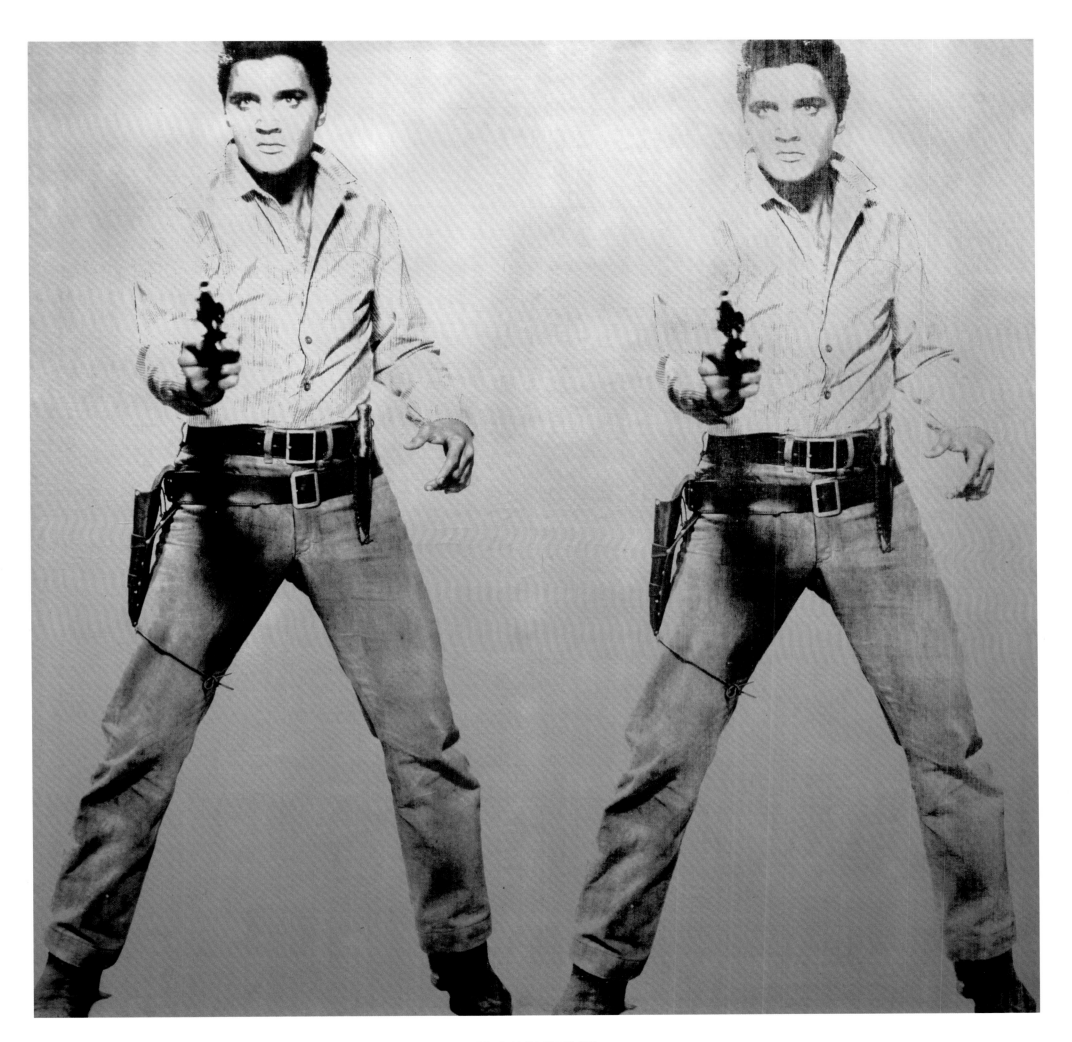

89 – *Double Elvis (Elvis III)*, 1963

SOPHISTICATED AMATEUR: WARHOL'S CLASSICAL TASTE Warhol's earliest contact with music occurred in the church he attended with his family, through the sacred music of Byzantine Rite Catholicism, which is exclusively choral and emphasizes the male voice. In the 1960s, Warhol may have found similarities between its droning chants and the avant-garde music of La Monte Young. Warhol's large music collection includes a recording of Sergey Rachmaninoff's magnificent *Vespers*, which is composed in the tradition of the artist's faith. As a student in Pittsburgh, Warhol attended the visual art exhibitions at Outlines art gallery, in addition to music performances and record-listening events hosted by the gallery, during which gallery attendees had a preview of the night's concert they were about to experience live at Syria Mosque and Carnegie Music Hall, two grand music halls in the vicinity. At the time, Pittsburgh's industrial wealth attracted many great soloists to its concert stages, and the Pittsburgh Symphony Orchestra (conducted by Fritz Reiner) was held in high regard. Over the years, Warhol's interest in the classics may have waned, but it was never extinguished, as it seems that opera fascinated him for some time. He was a season subscriber to the Metropolitan Opera for many years, and he also owned dozens of opera recordings; he even produced some illustrations for the Metropolitan Opera's *Opera News* program. Warhol's introduction to dance also occurred in his childhood, by way of the Hollywood musicals he saw in his neighbourhood cinemas. His favourite stars at the time included Shirley Temple, the curly-haired girl who tap-danced her way out of the troubles of the Great Depression. In 1941, Warhol asked for and received an autographed photo of the star. Later on, at Carnegie Tech, which had no dance school, Warhol was the only male member of the university's small Modern Dance Club, through which he encountered the work of Martha Graham and other modernists. In New York, he had an indirect link to the dance world, either through roommates or his landlord. His first exhibition, in 1952, was held at the Hugo Gallery, where the manager, Alexander Iolas, was a former dancer with the Ballets Russes. Iolas was also responsible for arranging Warhol's last exhibition, in 1987. Freddy Herko and Billy Linich, Warhol's associates of the 1960s, were both active in New York's avant-garde dance scene. Warhol often addressed the theme of dance in his work, which included illustrations for *Dance Magazine* in the 1950s; his *Dance Diagram* paintings from 1962; his Screen Tests and other 1960s films, such as *Paul Swan* and *Jill Johnston Dancing*; his series of *Shadows* paintings from 1979; and his many portrait paintings of dancers, including John Butler, Jock Soto, Martha Graham and Karen Kain. Shortly before he died, Warhol was considering creating a stage design for a contemporary dance company. **M.W.**

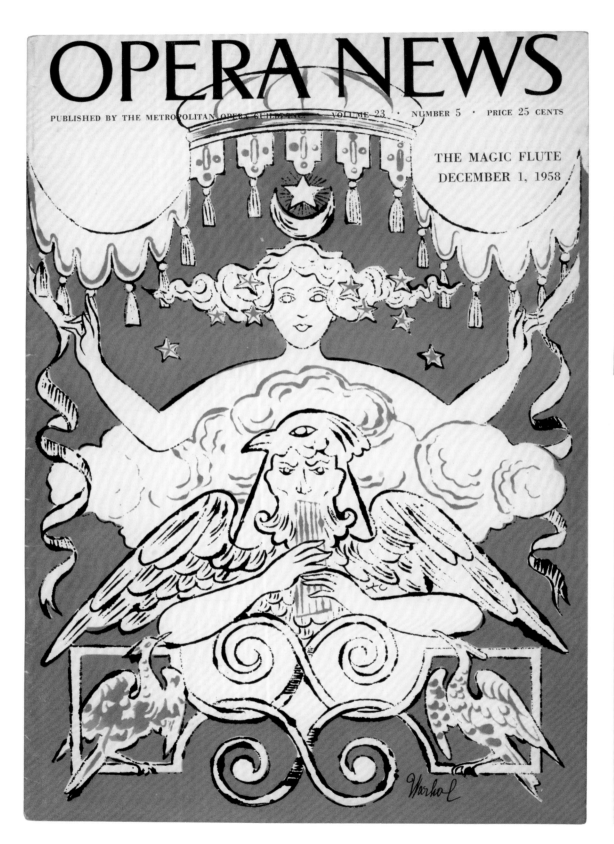

378

380

153

378 – Illustration on the cover of *Opera News*, December 1, 1958 **380** – Cover of the sheet music for Samuel Barber's *A Hand of Bridge: For Four Solo Voices and Chamber Orchestra*, 1960 **153** – *The Magic Flute*, about 1958

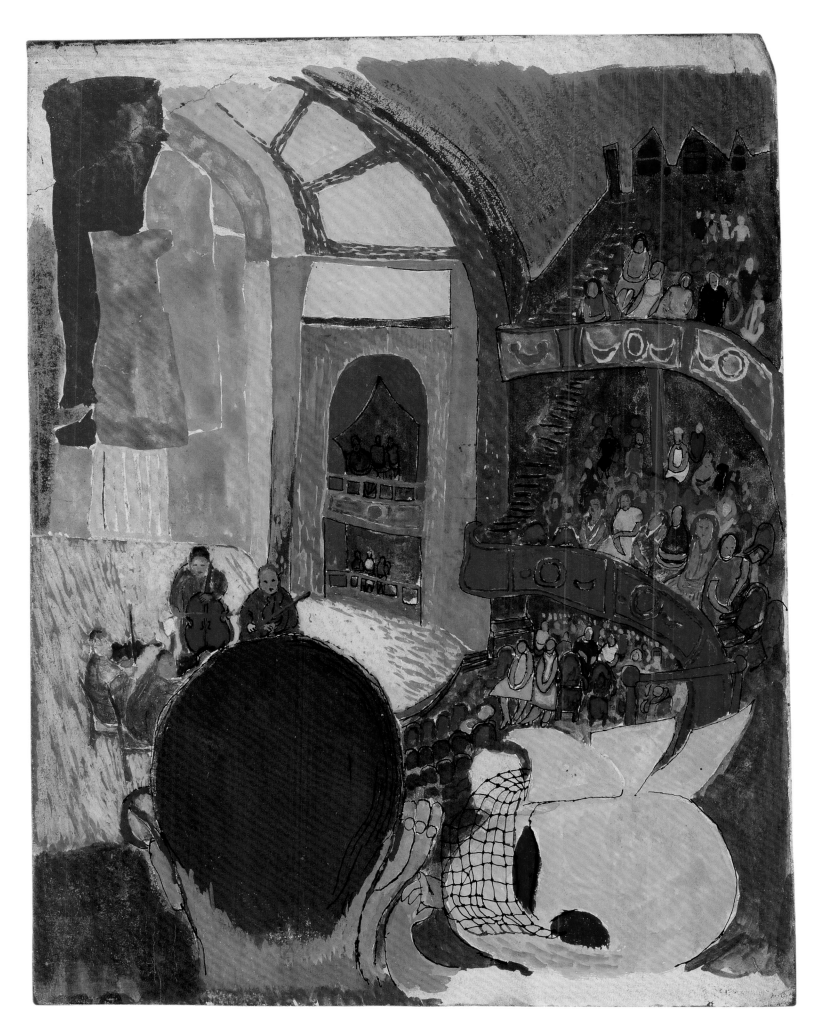

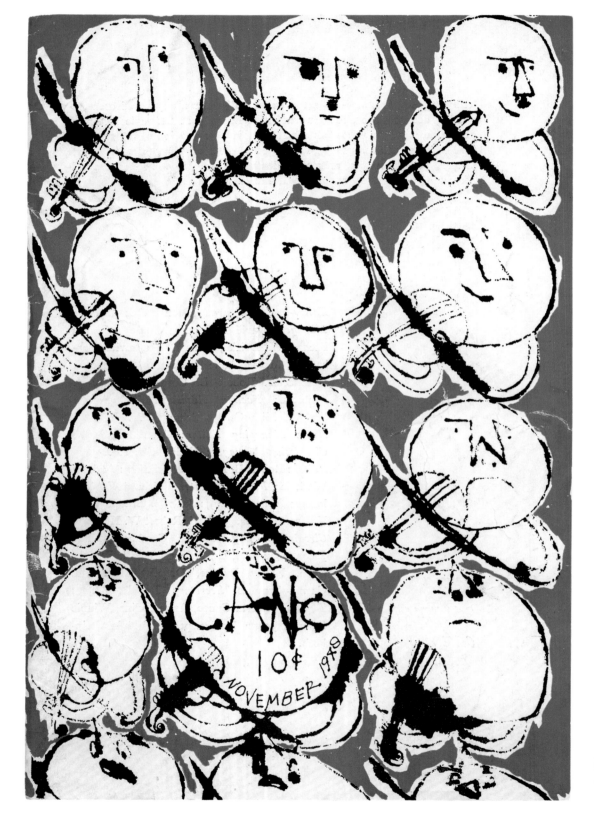

148

154

370

370 – Cover of the Carnegie Institute of Technology student magazine *Cano*, November 1948 **148** – *Sprite Heads Playing Violins*, 1948 **154** – *Piano Keys*, 1950s

151 – *Sprite Head Playing a Trombone*, late 1940s–early 1950s

125

569

376

376 – Cover of *Dance Magazine*, January 1958 125 – *Ballet Slippers*, 1981–82 569 – Christmas card from Warhol to George Klauber, December 1948

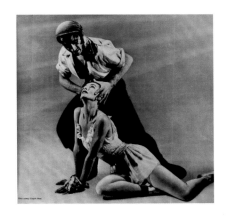

12 – Drawings illustrating the record cover of Ravel's *Daphnis and Chloé*, performed by the Boston Symphony Orchestra, conducted by Charles Munch, 1955

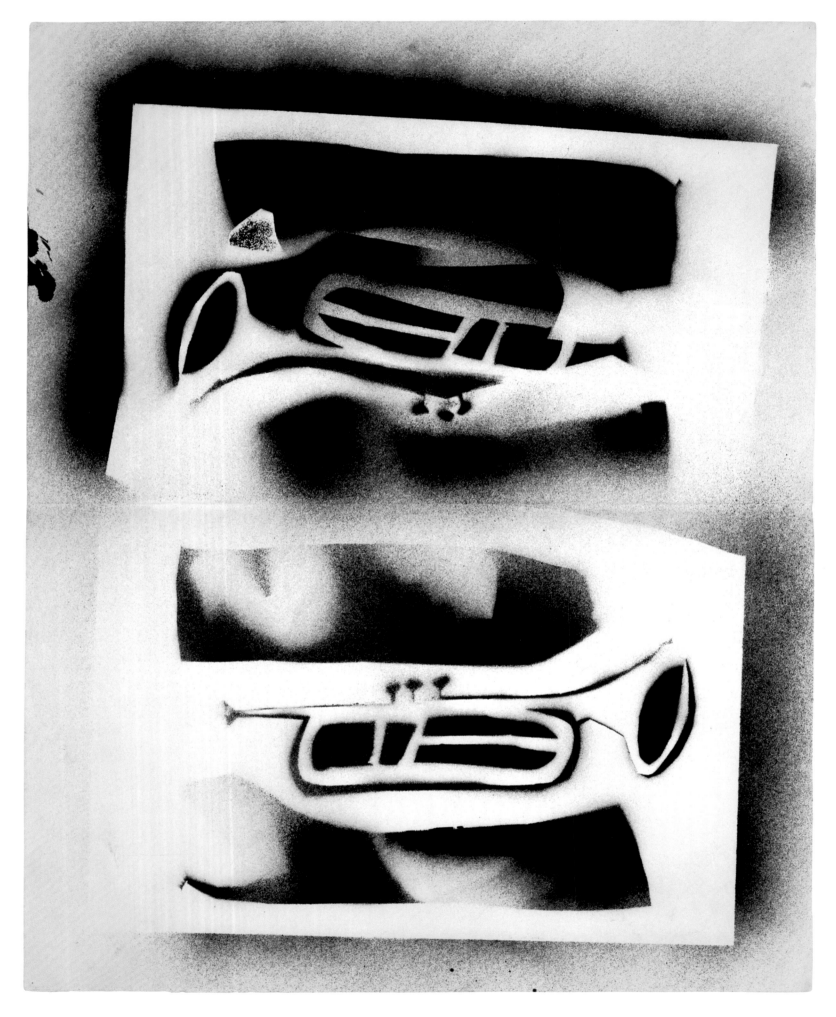

152 — *Two Horns*, about 1958

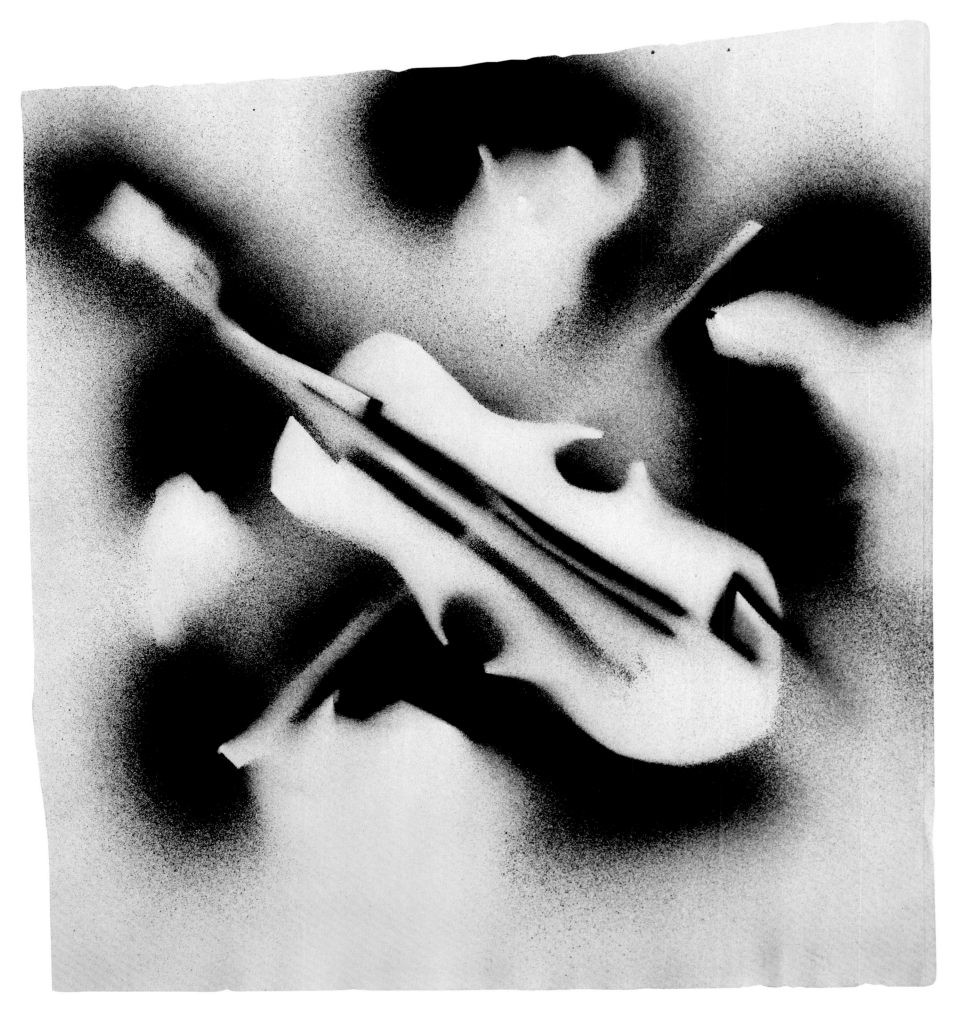

157 — *Violin and Bow*, 1950s

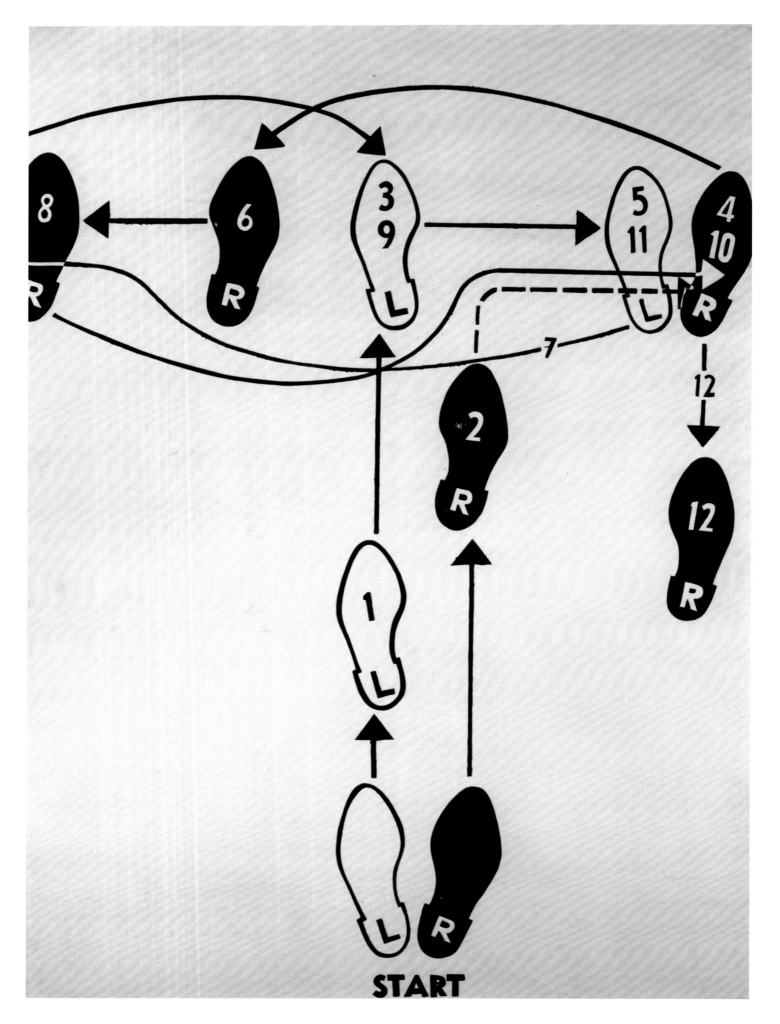

77 – Dance Diagram (2): Fox Trot—The Double Twinkle-Man, 1962

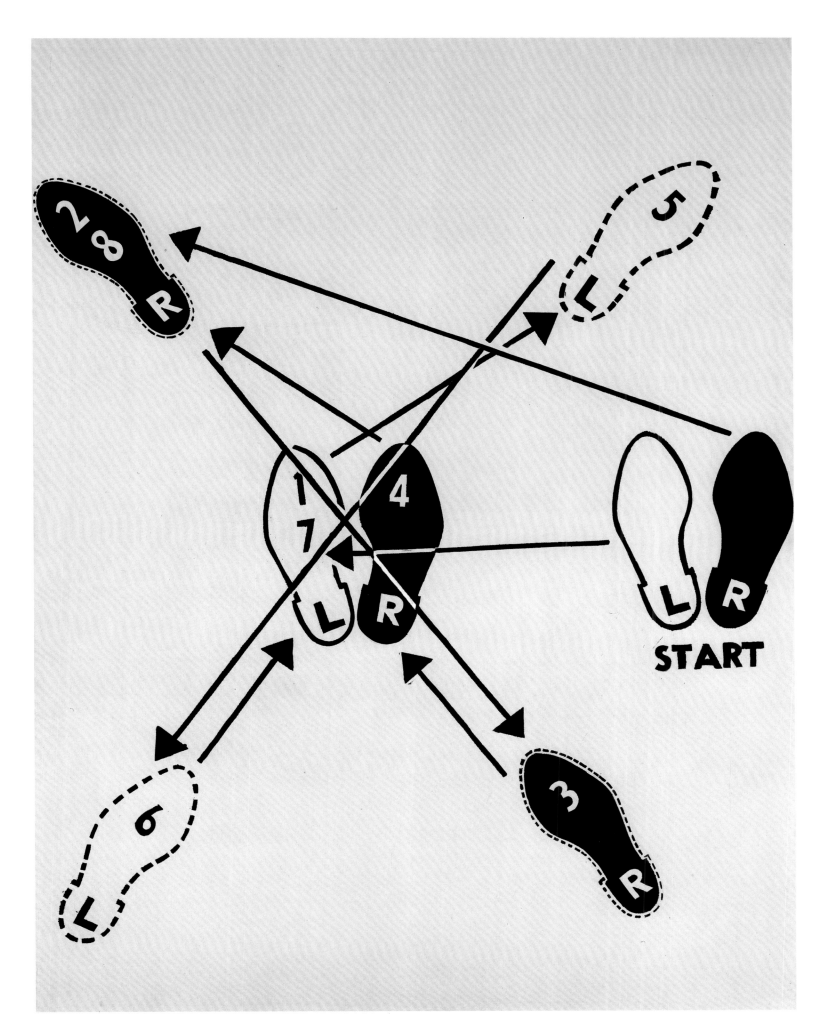

78 – *Dance Diagram (6): The Charleston Double Side Kick—Man and Woman*, 1962

532

535

4

87

84

85

86

84–87 – *Bobby Short*, 1963

history of opera and its illustrated documentation, particularly as it had unfolded at the Metropolitan Opera in New York. In 1954 Warhol drew Mildred Cook, who played Mrs. Peachum in a production of Kurt Weill and Bertolt Brecht's *The Threepenny Opera*, which took place in March at the Theatre de Lys on Christopher Street in New York. He identified the singer, opera and theatre in the drawing (fig. 4). He also owned a recording of this opera, which featured Lotte Lenya in the role of Jenny.[11] By 1954, therefore, Warhol was aware of, and conversant with, the venerable high-art form of opera and its "golden age" singers, as well as the deconstructive masterpiece of the twentieth century.

Andy probably entered the world of opera through the sophisticated gay subculture that became his natural milieu after he arrived in New York.[12] Nathan Gluck, who knew Warhol from 1950–51 onward and worked as his assistant for approximately fifteen years, mocked Warhol's "incredible naïveté" as he set about to enter New York's opera scene: "Here he was going off to the opera—and he bought good seats. And I think that Paul Cadmus would go to the opera; I'm not sure, but he must have met someone, and he went off to the opera."[13] Gluck also claimed that he would have to explain the plots to clueless Andy, who "was not adept at foreign languages" and would "come up with some stunning malaprops [*sic*] of an opera title," like "Ariadne Obnoxious," when he meant to say "Ariadne auf Naxos."[14]

Because Warhol loved this kind of wordplay and often indulged in it, the question arises whether he played the fool to Gluck's straight man as he learned all he could about opera. A hilarious passage from *a: A Novel* reaches zany heights with a host of opera-related malapropisms that greatly surpass "Ariadne Obnoxious." As is frequently the case with this "novel," tape-recorded live and subsequently transcribed, it is not clear who is speaking; most likely it captures a spirited repartee between three gay men, including Warhol and Ondine. The passage begins with the words **"I hadn't seen (Kenneth) for eight years,"** and continues:

Oh
Because I met him at the park at Reese Park
And I was on the swings winging Studa la Bampa
He came and said "Ah zoo chain ah"
And we became friends and then we both decided
 that Rita Stevens would make a very good Ah zoo
 chain ah
Who's Rita Stevens?
Rise Stevens
O Risa[15]

To the uninitiated this conversation will make little or no sense, but opera insiders will catch the references and be amused by the verbal hijinks. One would have to know the name of a reigning diva at the Metropolitan Opera from 1938 until 1961: mezzo-soprano Risë (not "Rita," pronounced "Risa") Stevens, whose name suggests the park ("Reese," actually Jacob Riis Park, Rockaway, Queens, with a famous gay beach) where the exchange occurred. "Studa la Bampa" is a madcap, but still recognizable, mangling of "Stride la vampa," an aria from Act II of Giuseppe Verdi's *Il Trovatore*, sung by the gypsy Azucena (pronounced in Italian as "Ah zoo chain ah"). Risë Stevens never sang

the role of Azucena at the Metropolitan Opera, or anywhere else, but opera queens love to speculate on roles never undertaken by favourite singers. She probably would have made a very fine Azucena as they surmised!

In addition to his Thursday-evening subscription, numerous other pieces of evidence indicate that Warhol's association with opera was far from casual. During his trip around the world with Charles Lisanby in the summer of 1956, the two friends spent four days in Rome. Lisanby had become very ill in Calcutta and insisted on cutting short the Asian portion of their trip. They flew to Rome and arrived on July 28. Although under an official health watch because of Lisanby's illness, Andy left Charles in their hotel room so he could attend a performance at the Caracalla Baths on July 29.[16] This summer festival, staged outdoors in the colossal ruins of the imperial Roman baths, had long been a destination for opera pilgrims to Italy, and Andy had no intention of missing this unique opportunity during his brief stay in Rome.

Back in New York, on October 29 Warhol attended what was probably his first opening night at the Metropolitan Opera. Callas was making her debut in Vincenzo Bellini's *Norma*. He obviously enjoyed this musical evening of glitter and society because he returned for opening night a year later, on October 28, 1957, to attend Pyotr Ilyich Tchaikovsky's *Eugene Onegin*, starring the American bass-baritone George London as the eponymous hero. Ticket stubs reveal that Warhol upgraded his seats for his second opening night from Dress Circle to Orchestra, which cost him more than twice the original price.[17] According to a notation in a later datebook, Warhol also attended opening night on October 10, 1977, of Modest Mussorgsky's *Boris Godunov*, with the Finnish bass Martti Talvela in the lead role. Circumstantial evidence suggests that he may also have been present for the opening night of Verdi's *Nabucco* on October 24, 1960.[18]

Warhol closely followed the unfolding of Leontyne Price's stellar career. On January 27, 1961, the soprano had made one of the most heralded house debuts in recent memory in Verdi's *Il Trovatore*. Subsequent performances in the spring won rave reviews, and she earned opera's plum prize of opening night for the Metropolitan Opera's new season in Puccini's *La Fanciulla del West*, on October 23. However, she had the misfortune of losing her voice in that performance, and had to withdraw after Act II. The problem was so severe that Price cancelled the next two scheduled performances of *Fanciulla* and did not sing again in public until November 21. Her indisposition gave rise to considerable speculation in the press, and gossip in the opera world was intense. Warhol, although still an unknown, contacted Price and wangled an invitation to her home on November 9.[19] Presumably, this was the occasion on which he drew her feet.[20] The following day, in a characteristic, ingratiating gesture of thanks, Andy sent Price flowers from the Madison Avenue Florist.[21] As a hard-core opera fan Warhol was aware of the diva's infirmity and took advantage of the opportunity it provided to him. He remained susceptible to the aura of opera stars throughout his life. After a flight from New York to Los Angeles many years later, he delightedly noted in his *Diary*, "Placido Domingo was on our plane and he was nice, he came over and talked. Beverly Sills was on, too."[22]

Andy attended the world premiere of Samuel Barber's *Vanessa* on January 15, 1958. At the unveiling of this important new production Eleanor Steber and Nicolai Gedda led a stellar cast. Dimitri Mitropoulos conducted, Cecil Beaton designed sets and costumes, and Gian Carlo Menotti was in charge of the production. After the performance, Warhol—playing the role of enthusiastic fan—sent a note of congratulations to Beaton, and enclosed a gift copy of his *Gold Book* based on *Golden Pictures*, an exhibition at the Bodley Gallery that had closed on December 24, 1957. Beaton replied, "thanks for your delicious book . . . so pretty and gay. I really adore your strange and personal world. I'm very pleased, too, if you like my contribution to *Vanessa*."[23]

Like most opera buffs, and many other gay men, Warhol regarded Maria Callas with particular awe. In *Popism* he indirectly revealed this admiration. First, he noted that Billy and Ondine loved her above all other singers: "They always said how great they thought it was that she was killing her voice and not holding anything back, not saving anything for tomorrow. They could really identify with that." Immediately after these sentences, Warhol added his own praise, comparing Callas with Freddy Herko, his favourite among the amphetamine queens in the Factory entourage, who "would just dance and dance until he dropped."[24] Freddy's mania led to his suicide in 1964, when he leapt

TRISTAM HAD TWO LOVES ISOLDE, ONE WAS KIND, THE OTHER SCOLDY, HE MARRIED THE LATTER, UNFORTUNATE GUY. HE LISTENED AWHILE, THEN DECIDED TO DIE.

FIG. 3 – "Tristam and Isolde," drawing in *Love is a Pink Cake* (about 1953), an illustrated portfolio by Andy Warhol

from the window of a friend's apartment into Cornelia Street while dancing to Mozart's *Coronation Mass*.[25] Years later Warhol paid Callas a strange but poignant tribute in an interview. "Punk has always existed. Callas was terribly punk," he claimed, positing an affinity between the unparalleled intensity of the diva's performances and a later genre of popular culture, as if it were a Baudelairean correspondence. He reminded his readers, "at the Factory, during the 1960s, we always listened to her."[26]

After a party at Julian Schnabel's in January 1985, Warhol recalled in his *Diary*, "all through dinner they played Maria Callas records! It was incredible. . . . And it was just like the sixties. I could almost see Ondine whisking around in the shadows."[27] Clearly, in Warhol's mind Callas evoked both the heyday of the 1960s and the setting of the first Factory. Everyone else did not share Andy's fond memories of her voice soaring throughout the studio. Ronnie Cutrone remembered the experience, indelicately, as "Callas up the ass until you were dead."[28]

There is a bittersweet postscript to Warhol's impression of Callas. Bob Colacello told the story without a shred of sympathy for the diva or, apparently, any awareness of Warhol's high esteem for her. He disparaged the nostalgia that held sway in 1973 and 1974; Callas's ill-conceived comeback tour embodied it, and he pronounced her performance at Carnegie Hall on April 15, 1974, "a flop."[29] Andy was there. Surely he was one of the few members of the audience who had witnessed both her triumphant debut at the Metropolitan Opera eighteen years earlier and this sad, final performance, in which her voice, self-confidence and magnetic radiance failed her. He had experienced firsthand the opening and closing chapters in the story of a monumental figure in the history of opera in New York.

Warhol was familiar with the entire Metropolitan Opera repertory of the 1950s and 1960s, as well as with a formidable array of singers. Several great artists whose performances he witnessed on opening nights or at galas have already been mentioned. Among the legendary performers that he heard in subscription performances were sopranos Licia Albanese, Régine Crespin, Lisa Della Casa, Eileen Farrell, Dorothy Kirsten, Zinka Milanov, Martha Mödl and Leonie Rysanek, as well as tenors Carlo Bergonzi, Jussi Björling, Franco Corelli and Wolfgang Windgassen. Like any devoted fan, he purchased extra tickets to hear a great artist not included in his subscription, for example, Joan Sutherland in Gaetano Donizetti's *Lucia di Lammermoor*.[30] If he were particularly interested in a production or revival, he would see it more than once in a season. He already had subscription tickets for the new production of Verdi's *Un Ballo in Maschera* with a superb cast on February 8, 1962, yet he chose to attend the January 25 premiere as well. The extent of his cumulative experience adds weight to his diary entry on the unhappy state of contemporary opera after John and Komiko Powers took him to Wagner's *Tannhäuser* with a mostly run-of-the-mill cast: "Boring. There are no great singers. I guess all the strong singers go into rock and roll now."[31]

Warhol sometimes noted which friends accompanied him to the opera but a reasonably complete list can be compiled only for the 1961–62 season. This overlaps with the single year that he kept a comprehensive datebook. His most frequent companion was Gene Swenson, the critic and art historian; followed by Ruth Ansel, then a designer for *Harper's Bazaar*; and John McKendry, aesthete, curator and collector.

Warhol rarely revealed anything personal, but there were exceptional moments—which always seem calculated—when he must have wanted to set the record straight. In the same interview in which he called Callas "terribly punk" he responded with uncharacteristic directness to a question about his musical preferences with "I love opera."[32] The first time he ever saw the interior of the Royal Opera House in London, he was obviously quite moved and noted, nostalgically, "Covent Garden was very beautiful, it looked like the old Met."[33]

FIG. 4 – Andy Warhol sketch: Mildred Cook in *The Threepenny Opera*, Theatre de Lys, New York, n.d.

One of the most revealing moments in Warhol's *Diary* relates to when his twelve-year relationship with Jed Johnson was unraveling: "I came home and waited around for the phone to ring and it didn't and I was depressed and I put my earphones in with *La Bohème*."[34] In a time of personal crisis, Warhol turned to an opera situation analogous to his own. Listening to Puccini's beautiful melodies in Acts III and IV, which convey with great poignancy the pain of quarreling with—and losing—a lover, Warhol found temporary solace.

What conclusions can be drawn from Warhol's involvement with opera? Following an established pattern, he effectively concealed his deep attachment, even as he left sufficient evidence for posterity to discern the truth. He wanted the historical record to be quite clear when he took his rightful place alongside such great, gay artists of the past as Donatello, Michelangelo, Cellini and Caravaggio.[35] In the 1950s, attending the Metropolitan Opera was one of the defining rituals of upper-class, gay male experience in New York, so Warhol gravitated to it naturally, but a steady interest that endured more than three decades cannot be explained away so easily. Exactly one month before his death, Warhol was back at the opera house, this time at La Scala in Milan, where he attended his final performance, Richard Strauss's *Salome*, directed by Robert Wilson, with costumes by Gianni Versace.[36] Certainly, his fascination with glamour and celebrity melded perfectly with opera's firmament, populated with personalities exponentially larger than life. Ultimately, opera filled an essential lacuna in Warhol's life, even though he avoided references to it in his mature art. Ordinarily, no matter how angry, upset, or hurt he might have been at a given moment, he did not allow himself to indulge in the extroverted emotions and gestures that are the essence of opera. While sitting in the opera house or listening to recordings, however, he could become a vicarious and enthusiastic participant in the catharsis that is unique to the experience of opera.

1. Additional ticket stubs and correspondence may still lie hidden in unopened Time Capsules at the Archives of the Andy Warhol Museum, Pittsburgh (hereinafter AWM Archives). According to the archivist of the Metropolitan Opera there are no records that could verify the full history of Warhol's subscription (letter of October 2, 2006).
2. Andy Warhol and Pat Hackett, *Popism: The Warhol Sixties* (San Diego; New York; London: Harcourt Brace Jovanovich, 1980), 64.
3. Billy Name, Dave Hickey and Collier Schorr, *All Tomorrow's Parties: Billy Name's Photographs of Andy Warhol's Factory* (London: Frieze, 1997), 21.
4. Patrick Smith, *Andy Warhol's Art and Films* (Ann Arbor, Michigan: UMI Research Press, [1981] 1986), 447.
5. Ibid., 432.
6. Opening night of the season, November 29, 1956. Ticket stubs F 209 and 211, Dress Circle (AWM Archives).
7. Ondine's acquisition was a pirated recording of Gioacchino Rossini's *Armida* made in the course of three performances by Callas at the Teatro Comunale in Florence, the first of which took place on April 26, 1952. She never again performed the role. Ondine's visit must have occurred shortly after the move to the new Factory on 33 Union Square West in February of 1968, after Jed Johnson first joined the scene, but before the attempt on Warhol's life by Valerie Solanas on June 3, after which such "drop-ins" by the old Factory regulars basically came to an end.
8. Series tickets C 524 and 526, Grand Tier, at the "Old Met" (Broadway and Thirty-ninth Street), through the 1965–66 season; series tickets C 2 and 4, Grand Tier, at today's Metropolitan Opera (Lincoln Center for the Performing Arts), beginning with the 1966–67 season (AWM Archives).
9. Victor Bockris, *The Life and Death of Andy Warhol* (New York: Bantam Books, 1989), 40.
10. Andy Warhol and Corkie Ward, *Love is a Pink Cake* (New York: private printing, 1953), n.p. Ward used the archaic, pre-Wagnerian spelling, "Tristam," and appended the following doggerel, taking irreverent liberties with the traditional narrative: "Tristam had two loves Isolde, One was kind, the other scoldy, He married the latter, Unfortunate guy, He listened awhile, Then decided to die."
11. Only one other opera recording remains among the materials currently preserved in the AWM Archives: Giacomo Puccini's *La Bohème*, with Richard Tucker and Bidu Sayo.
12. Wayne Koestenbaum, *Andy Warhol* (New York: Viking. Penguin Lives Series, 2001), 33: ". . . he begat himself as a member of New York's top-flight gay milieu; he attended the Metropolitan Opera and aspired to a queer identity defined by upper-crust men with Europhilic tastes."
13. Interview of October 17, 1978, in Smith, 33.
14. Nathan Gluck, "The Transition from Commercial Art to Pop Art," in John O'Connor and Benjamin Liu, interviewers, *Unseen Warhol* (New York: Rizzoli International Publications, 1996), 30. In this later interview Gluck suggested that Charles Lisanby was the gay friend who introduced Warhol to opera. (*Ariadne auf Naxos* is Richard Strauss's opera masterpiece of 1916.)
15. Andy Warhol, *a: A Novel* (New York: Grove Press, 1968), n.p. Andy obviously enjoyed this passage; he also published it as an excerpt in *Intransit. The Andy Warhol–Gerard Malanga Monster Issue* (Eugene, Oregon: Toad Press, 1968), n.p. (Warhol had heard Stevens sing at the Metropolitan Opera several times.)

16. A *foglio sanitario* names their Roman residence as Hotel Flora (AWM Archives). Also preserved in the AWM Archives are Andy's single ticket stub for that night's performance (opera unknown) and a pair of first-class tickets for the journey by rail to Florence on July 31, 1956.
17. M 25 and 27, Orchestra ($35 per ticket, as opposed to $15 in 1956) (AWM Archives). Warhol came to prefer the Grand Tier, which cost the same as Orchestra seats but had better acoustics and views.
18. Fred Guiles, *Loner at the Ball: The Life of Andy Warhol* (London: Bantam, 1989), 111. This often unreliable source, published without footnotes, quotes from a vituperative interview with Dick Banks, lover of Andy's friend Ted Carey. Banks ridiculed what he regarded as Warhol's total incomprehension of opera. He claimed that Andy attended an opening night without knowing the names of the opera, composer, or conductor. Banks said that he knew the conductor that night was "Thomas Schippers, Menotti's lover." *Nabucco* in 1960 was Schippers's first opening night, and he did not conduct another until 1966.
19. Datebook, 1961 (AWM Archives).
20. Warhol planned, but never completed, a book of drawings of the feet of celebrities. By his own admission he drew the feet of Cecil Beaton (Warhol and Hackett, 128) and Phyllis Diller (Andy Warhol, *The Andy Warhol Diaries*, edited by Pat Hackett [New York; Boston: Warner Books, 1989], January 7, 1979). Ted Carey added Tallulah Bankhead's feet to the list (interview of November 13, 1978, in Smith, 264). Only three days before visiting Price, Andy received a note from Tammy Grimes, saying "thank you for my feet" (AWM Archives); her meaning seems clear in this context. There are several undocumented references to his having drawn Leontyne Price's feet; this visit seems to confirm that he had.
21. Receipt, November 10, 1961 (AWM Archives).
22. *Diaries*, March 24, 1985.
23. Note of January 24, 1958 (AWM Archives). Warhol also made a drawing of male feet with the score of *Vanessa*.
24. Warhol and Hackett, 64.
25. Ibid., 85.
26. Andy Warhol interviewed in *Playboy* (French edition), December 1977, 32. Warhol may have spoken intuitively or with an insider's knowledge, but he was right on the mark. The Toll Brothers-Metropolitan Opera Saturday matinee live broadcast of February 16, 2008, featured an intermission interview with punk-rock diva Patti Smith, who spoke at length about Maria Callas's profound influence on her career and performance style.
27. *Diaries*, January 10, 1985.
28. Koestenbaum, 115.
29. Bob Colacello, *Holy Terror: Andy Warhol Close Up* (New York: Harper Collins, 1990), 193.
30. Ticket stubs for Orchestra, A 19 and 21, December 15, 1961 (AWM Archives).
31. *Diaries*, February 27, 1984.
32. *Playboy*, 34.
33. *Diaries*, July 23, 1979.
34. Ibid., November 8, 1980.
35. Angelo D'Arcangelo, *The Homosexual Handbook* (New York: Olympia Press, 1969), 278. Warhol owned a copy of this handbook in which his name appears along with these illustrious forebears.
36. *Diaries*, January 22, 1987.

2

SOUND
VISION

AND

DIALOGUE WITH JOHN CAGE Whenever Andy Warhol was asked about the possible relationship between his work and that of John Cage, he often merely gave the enigmatic and laconic reply, "yeah, I think so," enthusing that "I think he's really marvelous" and "great"[1] but neglecting to explain further the profound influence of and chord struck by Cage's ideas on some of his serial works and films. Although it is unlikely that Warhol attended the first lecture-recital given by Cage in Pittsburgh on April 6, 1943, it is possible that he was present at the second concert and dance performance by Cage and Merce Cunningham on June 24, 1945, three months before going to college. He disclosed, "When I was a kid . . . John Cage came—I guess I met him when I was fifteen or something like that . . . I didn't know about music."[2] It is probably safe to assume that Warhol went to a third lecture and concert given by Cage in Pittsburgh, with the pianist William Masselos. Warhol was thus already familiar with the thoughts of this revolutionary of contemporary music when he attended the full-length performance of *Vexations* by Erik Satie, directed by Cage, at the Pocket Theater in New York on September 9 and 10, 1963. The show lasted 18 hours and 40 minutes and was the first complete performance of the work for solo piano that Satie composed in 1893 with instructions to repeat a single, approximately 80-second, chordal passage 840 times "very softly and slowly." The piece, which Warhol maintained he had heard from start to finish, was played by a relay team of ten pianists; among them were Cage himself and the young John Cale, who had just arrived in New York. Although in September 1963 features of serialism were already found in a fair number of Warhol's works that used stamping and screen-printing techniques, the impact made by this concert was decisive and inspired the artist to the unprecedented, repetitive structure of his film *Sleep* (1963), itself based on the highly subtle repetition of loops and picture segments of the poet John Giorno asleep, as captured by Warhol's intrusive camera. The serial structure of the film produces an artificial rhythm that takes the place of the sleeping poet's natural breathing, a modulation reinvented by the artist, who thus created a new temporality lasting six hours. John Cage observed, "Andy has fought by repetition to show us that there is no repetition really, that everything we look at is worthy of our attention. That's been a major direction for the twentieth century, it seems to me."[3] Cage's thinking also permeates numerous other works by Warhol, from the Screen Tests—the silent, visual equivalents of the iconoclastic score *4'33"*—to the incantatory rhythm of the portraits he created of Cage's partner, Merce Cunningham. The Silver Clouds, the weightless sculptures created in 1966, became much more than merely part of the stage setting for Merce Cunningham's *Rainforest* choreography in 1968; they assumed the same level of importance as the dancers, the visual art performers of the music, wandering freely through the electronic landscape composed by one of John Cage's disciples, David Tudor. **E.L.**

1 Ruth Hirschman interview with Andy Warhol and Taylor Mead, "Pop Goes the Artist" (Transcription of KPFK radio broadcast, published in *Annual Annual,* 1965, the Pacific Foundation, Berkeley, California), repr. in Kenneth Goldsmith, ed., *I'll Be Your Mirror: The Selected Andy Warhol Interviews, 1962–1987* (New York: Carroll & Graf Publishers, 2004), 42. 2 Benjamin H. D. Buchloh, "An Interview with Andy Warhol" (*October Files 2: Andy Warhol,* May 1985), repr. in *I'll Be Your Mirror,* 323–324. 3 John Cage, quoted in Kynaston McShine, *Andy Warhol. A Retrospective* (New York: The Museum of Modern Art, 1989), 13.

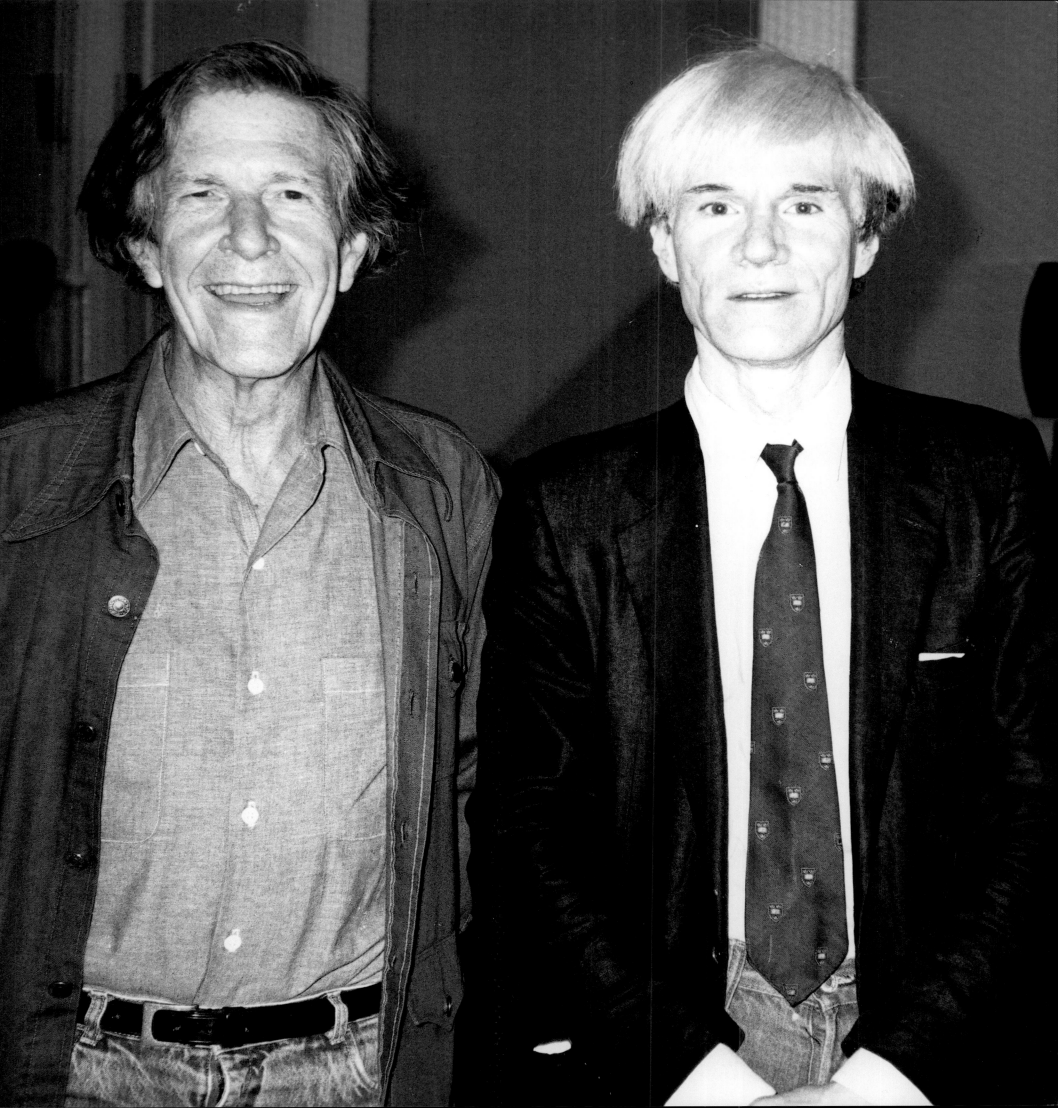

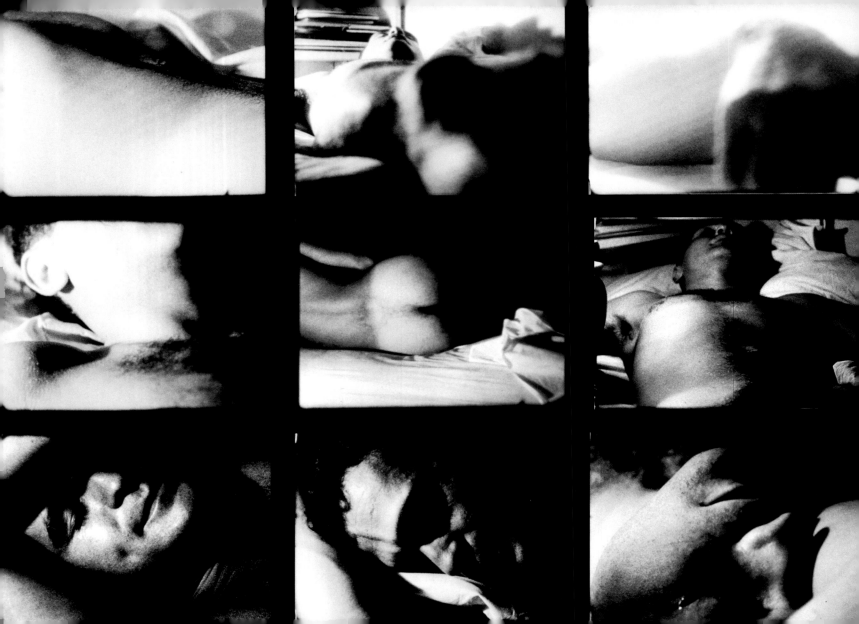

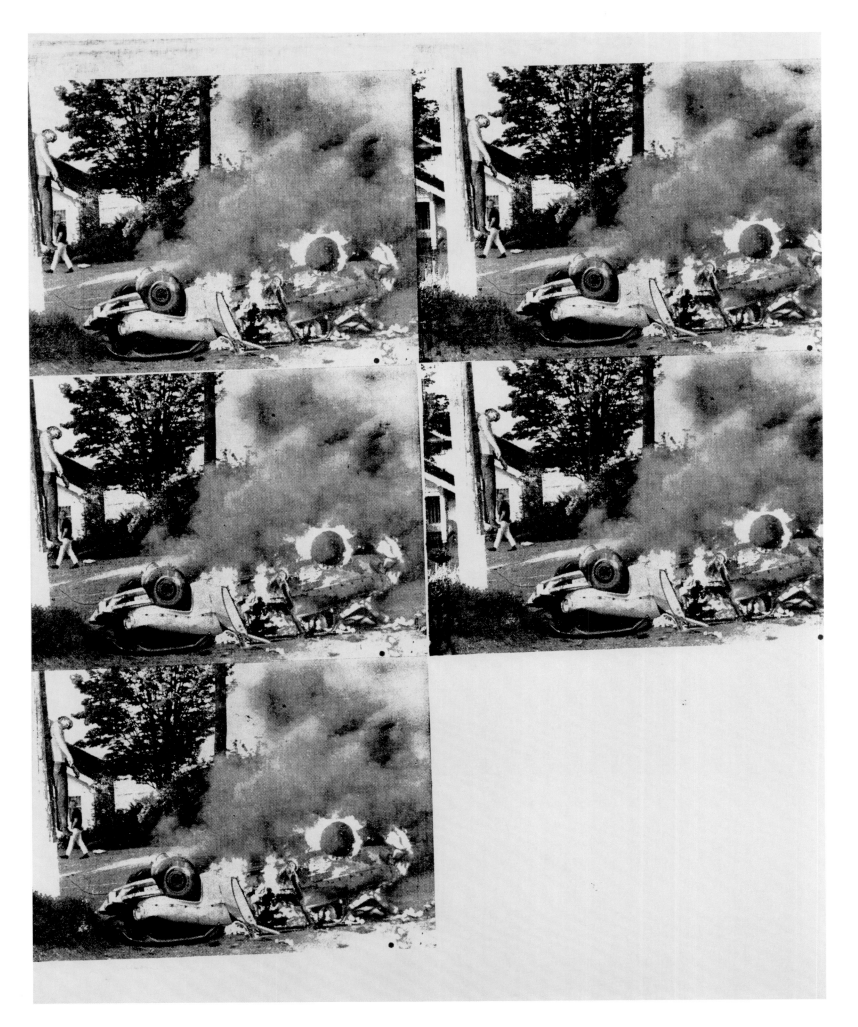

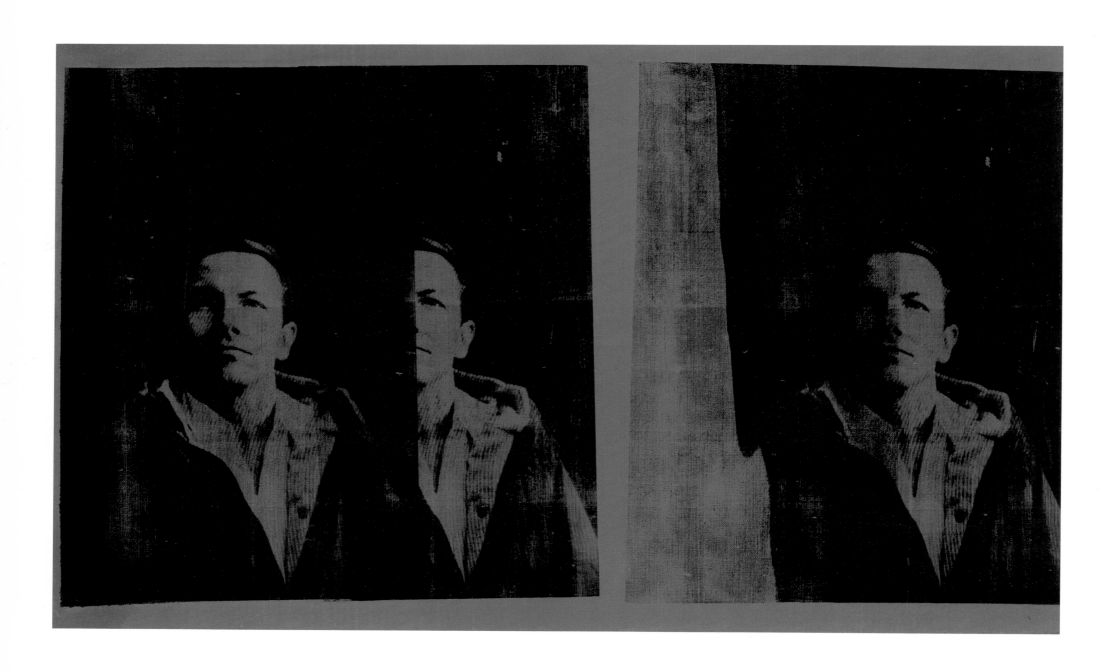

83 — *Triple Rauschenberg*, 1962

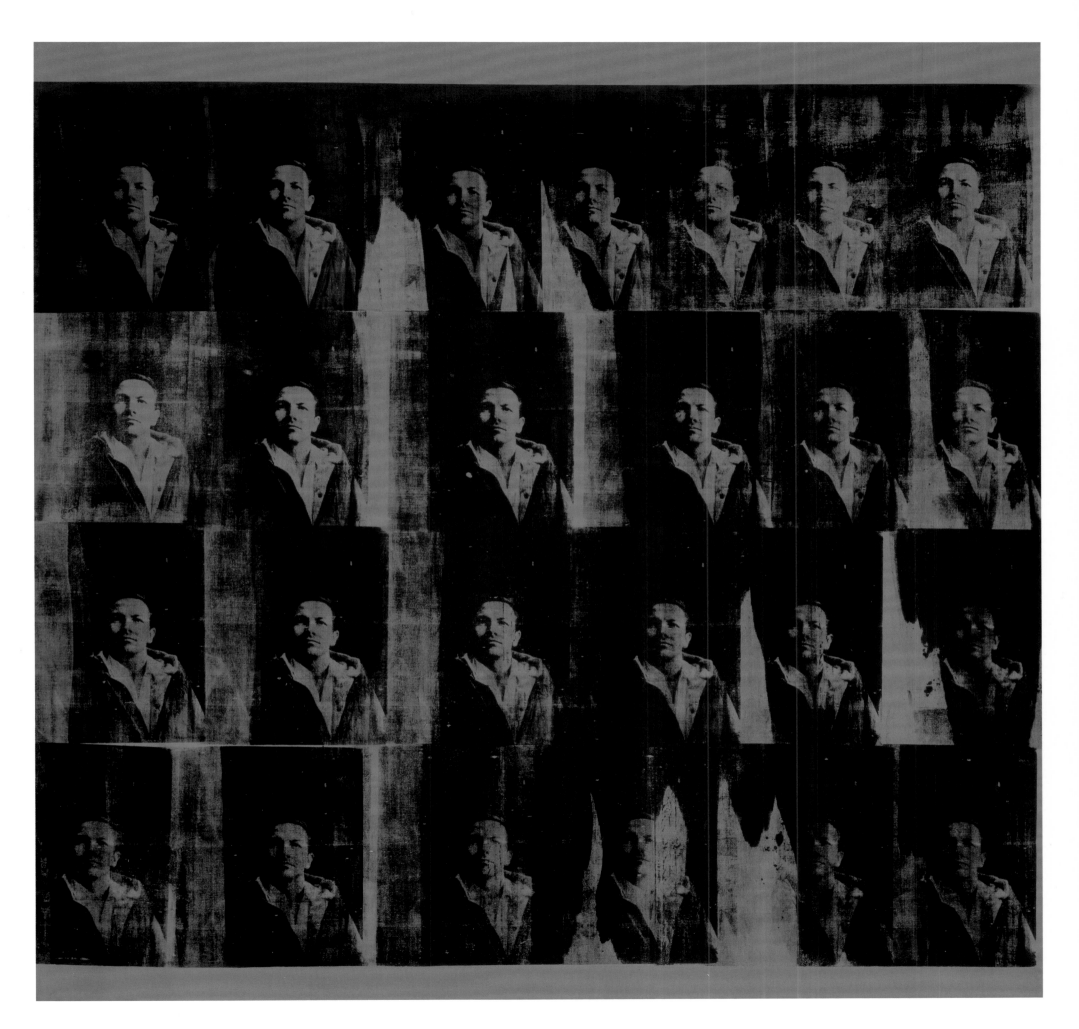

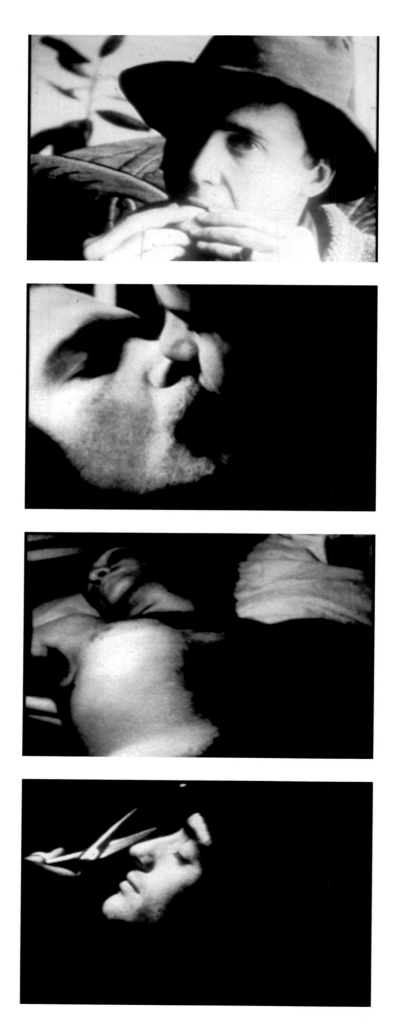

172 – New York Film Festival, 1964: simultaneous projections on four screens of 3-minute loops from the films *Eat* (1964), *Kiss* (1963–64), *Sleep* (1963) and *Haircut No. 2* (1963)

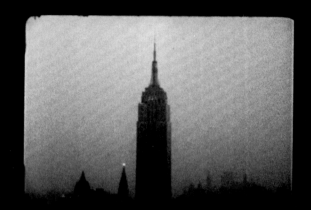

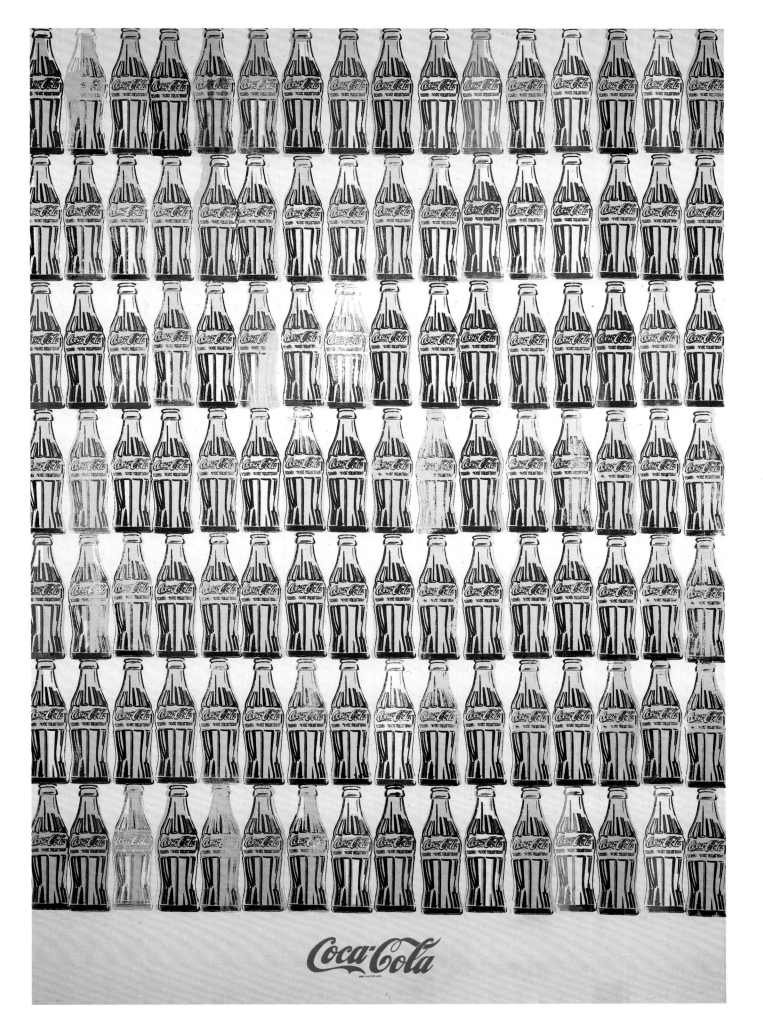

79 – *Green Coca-Cola Bottles*, 1962

WARHOL THE CHOREOGRAPHER: ENCOUNTERS WITH MERCE CUNNINGHAM Andy Warhol and the choreographer and dancer Merce Cunningham were associated artistically on two occasions, the first in early 1963. Warhol was then working on a limited number of paintings of Merce Cunningham, probably in preparation for a benefit show for the Foundation for Contemporary Performance Arts at the Allen Stone Gallery in New York, from February 25 to March 2, 1963. Jasper Johns, one of the organization's founders, recalls having seen a portrait of Merce by Warhol hanging there. However, the dancer never posed in person for the artist, who had worked from fashion photographer Richard Rutledge's contact sheets showing Cunningham performing a 1958 choreography, *Antic Meet.* Dressed in a black leotard with a wooden chair attached to the back—a costume designed by Robert Rauschenberg, artistic adviser to the Merce Cunningham Dance Company at the time—the dancer performed a series of movements that were both unusual body gestures and borrowings from the repertory of classical dance. These portraits gave Warhol the opportunity to continue in a completely new fashion with the exploration of serial composition that he had embarked on the previous year with the Campbell's soup cans. Up until then, he had only used a single image as the source of his compositions, but in the major serial portraits he had recourse to three distinct images from two different contact sheets. Warhol, whose interest in dance is well known, thus reorganized the original choreography into three successive movements: standing and leaning forward; taking a jump; and then bending at the waist, as at the end of a performance. This first connection also reveals the link between Warhol at the very beginning of the formation of his Pop aesthetics and the group of artists from, or affiliated with, the Black Mountain College (Asheville, North Carolina). In addition to Merce Cunningham, this group included the dancer's partner, John Cage, the painter Jasper Johns, and Robert Rauschenberg, whom Warhol also portrayed a number of times in the autumn of 1962, and to whom he owed his use of screen prints. Each, to a greater or lesser extent, called for the integration of everyday life, objects, sounds and movements into art. The second association between Warhol and Cunningham occurred a few years later. In April 1966, during his exhibition in the Leo Castelli Gallery, Warhol presented the Silver Clouds—Scotchpak pillows filled with helium—created with the assistance of engineer Billy Klüver. Merce Cunningham, who had visited the show, later asked Jasper Johns, who became the troupe's artistic adviser in 1967, to collaborate with Warhol on a future choreography. *Rainforest* premiered on March 9, 1968, at the Buffalo Arts Festival. The costumes were by Jasper Johns, the music by David Tudor, and the stage design by Andy Warhol. D. A. Pennebaker and Richard Leacock filmed this historic performance. **S.A.**

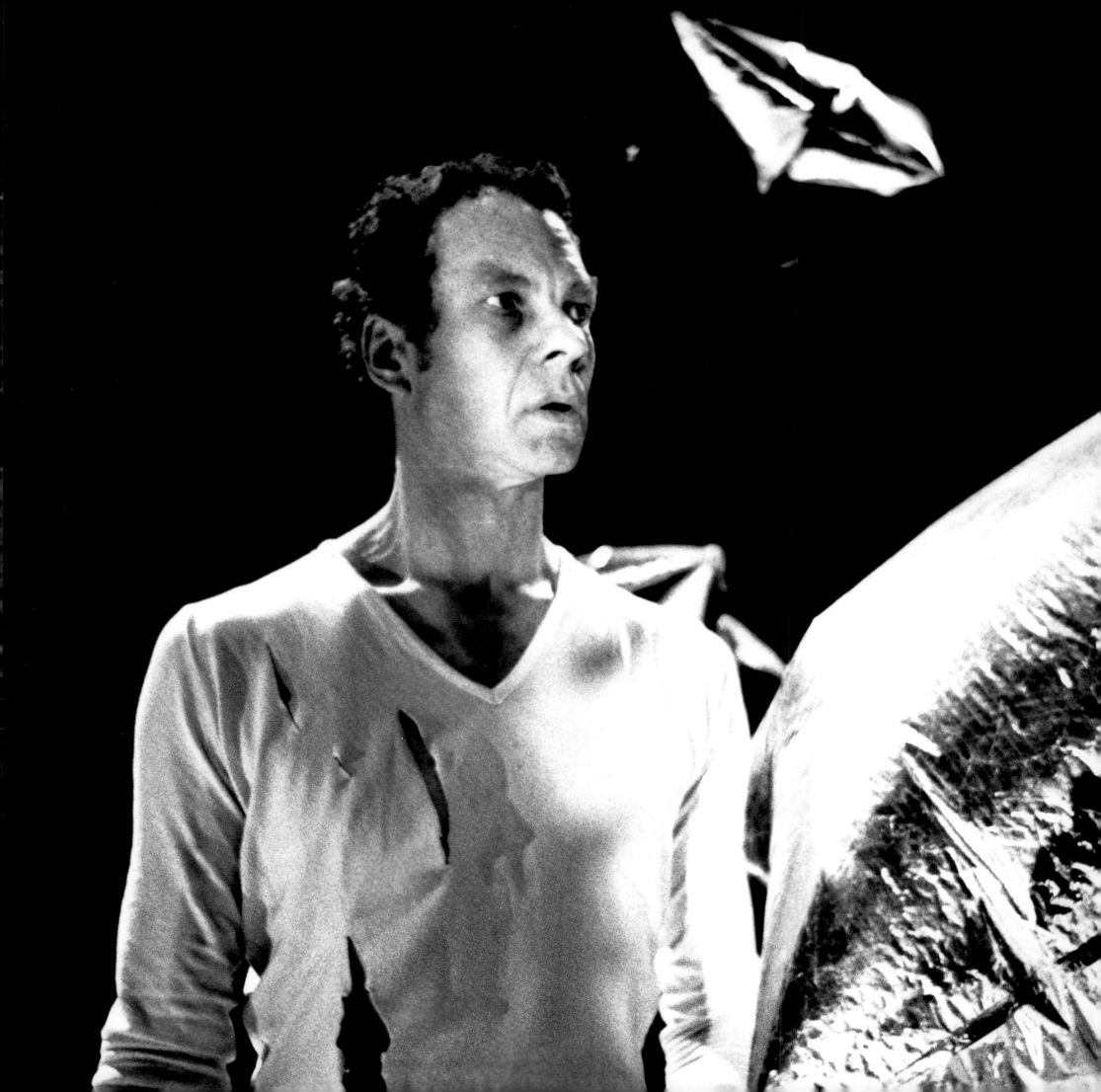

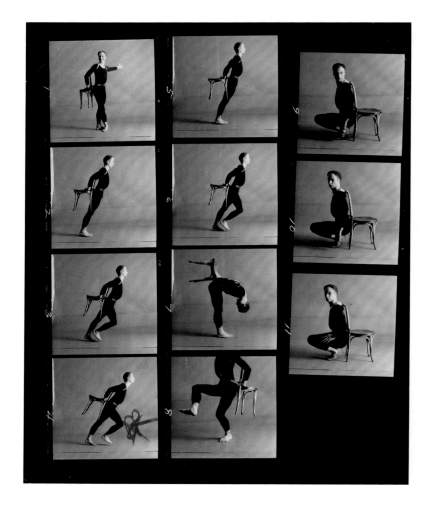

437

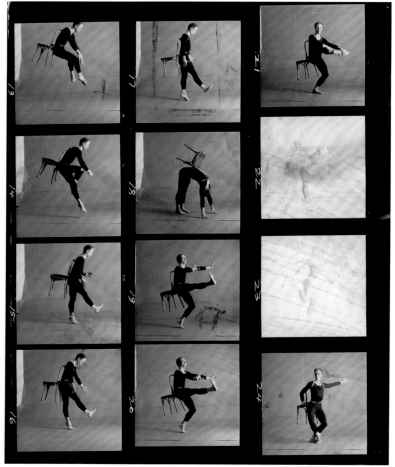

438

557

437, 438 – Contact sheets of Merce Cunningham dancing *Antic Meet*, 1958. Photo Richard Rutledge 556 – Card from Merce Cunningham to Andy Warhol, about 1964

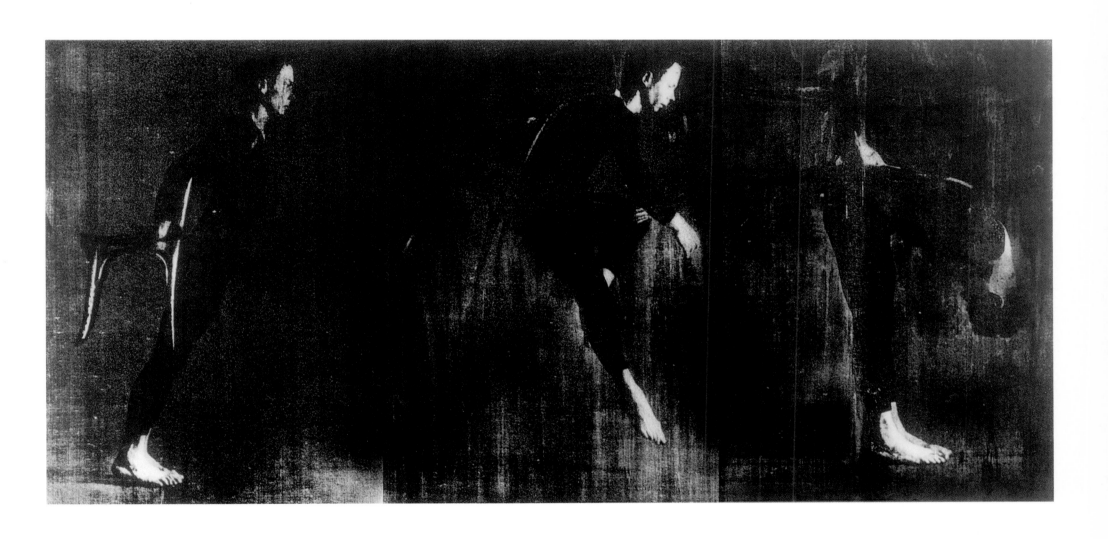

91 — *Merce Cunningham*, 1963

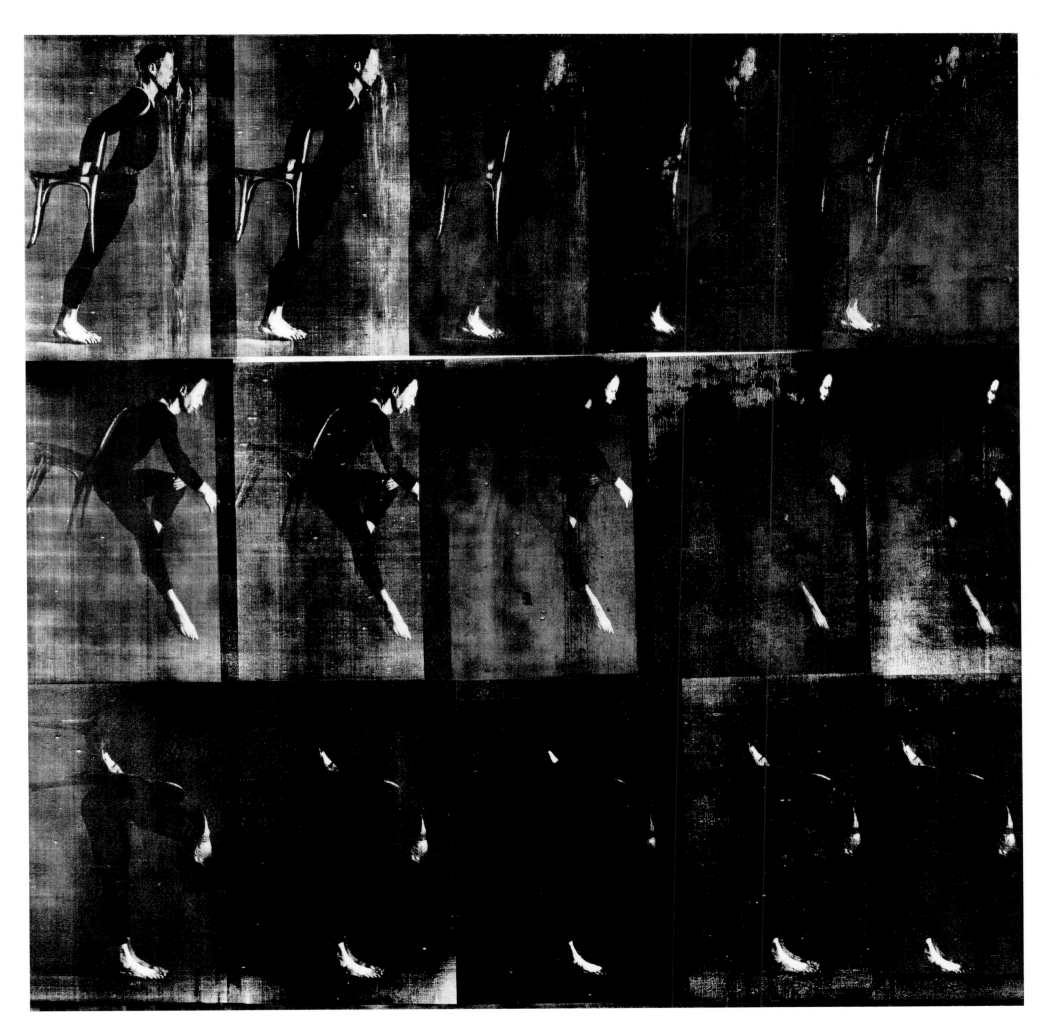

5 — Merce, 1963

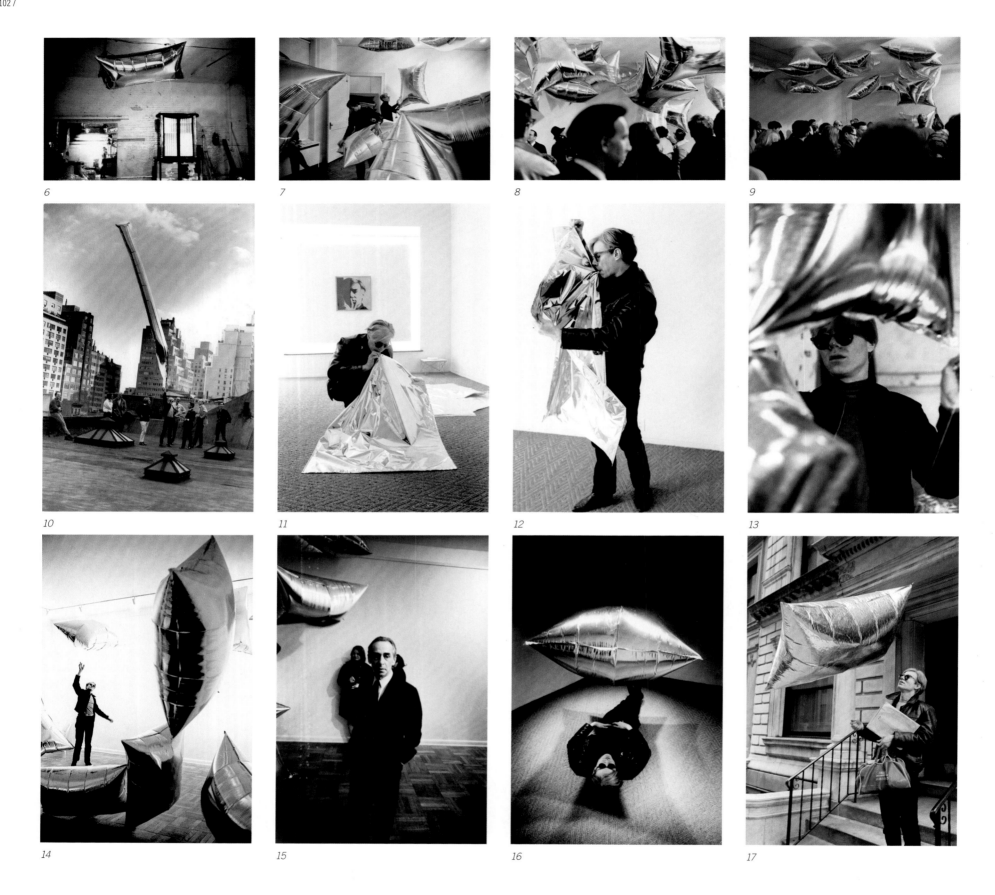

6 – Stephen Shore photographing Silver Clouds at the Silver Factory, 1965–66. Photo S. Shore 7 – Andy Warhol and his Silver Clouds at the Leo Castelli Gallery, May 1966. Photo Nat Finkelstein 8 – Silver Clouds at the Leo Castelli Gallery, May 1966. Photo Nat Finkelstein 9 – Silver Clouds at the Leo Castelli Gallery, April 1966. Photo Stephen Shore 10 – Andy Warhol and his *Infinite Sculpture* on the roof of the Silver Factory, October 4, 1965. Photo Billy Name 11 – Andy Warhol at the Ferus Gallery, Los Angeles, 1966. Photo Steve Schapiro 12 – Andy Warhol blowing up a Silver Cloud at the Ferus Gallery, Los Angeles, 1966. Photo Steve Schapiro 13 – Andy Warhol with his Silver Clouds at the Leo Castelli Gallery, May 1966. Photo Nat Finkelstein 14 – Andy Warhol at the Ferus Gallery, Los Angeles, 1966. Photo Steve Schapiro 15 – Leo Castelli with Silver Clouds at the Leo Castelli Gallery, May 1966. Photo Nat Finkelstein 16 – Andy Warhol at the Leo Castelli Gallery, 1965. Photo Steve Schapiro 17 – Andy Warhol outside the Leo Castelli Gallery, 1965. Photo Steve Schapiro

169 – A performance of Merce Cunningham's *Rainforest,* with Andy Warhol's Silver Clouds, 1968

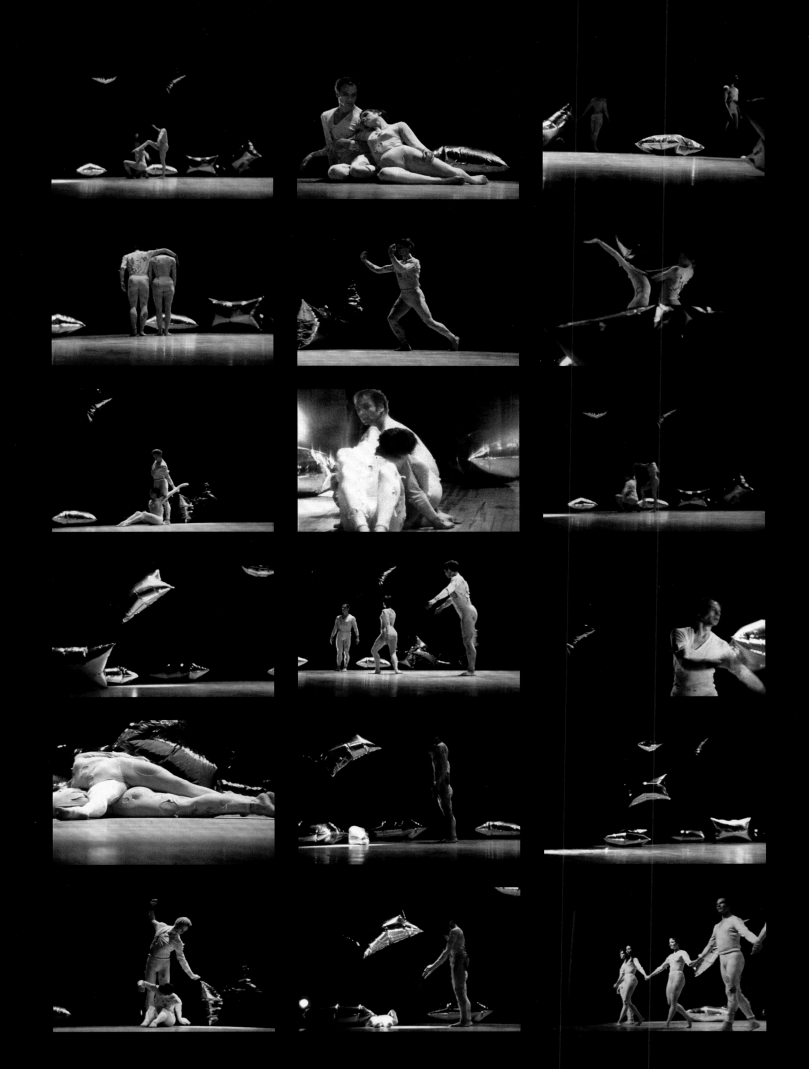

THE SILVER FACTORY Much of Warhol's creativity is traditionally situated within his Silver Factory, even though he occupied it for a period of just under four years, from late January 1964 until December 1967. This near-mythic space was an open-plan loft on the fourth floor of a small building intended for light industry, located at 231 East Forty-seventh Street, near the United Nations Headquarters. Before the Factory, Warhol had occupied a townhouse in Manhattan's Carnegie Hill, on the Upper East Side, in which he used the domestic-scaled rooms for a painting studio, and later rented a nearby abandoned firehouse (the former home of Hook and Ladder Company 13) from the city. However, the large open spaces of the firehouse were unheated and the roof leaked, thus forcing him to move on, and his datebook for 1964 records that he moved into the Forty-seventh Street loft on January 28. Billy Linich (aka Billy Name) was responsible for the decor of the new studio space. After seeing his apartment completely decorated in silver (with a combination of paint, aluminum foil and mirrors), Warhol asked him to do the same thing to his new studio. The project was so labour-intensive that Linich soon moved in. He climbed ladders to reach the ceiling, and used the freight elevator to haul up dusty abandoned furniture from the basement, all of which was given a shiny coat of aluminum paint. The party to celebrate Warhol's new exhibition of *Box* sculptures at the Stable Gallery was held in the new silver space, which was the first time it was opened to the public, just months after Warhol moved in. Nathan's Famous Hot Dogs of Coney Island, instead of wine and cheese, provided the Pop catering for the event. The fresh look for Warhol's workspace signalled his new attitude toward his work and outlook as an entrepreneur. The Boxes were among the first works created in the Silver Factory. They required an assembly-line technique borrowed from industrial mass production, hence the name Factory. The vast space of the loft lent itself to multiple uses: it served as Warhol's film studio, the Velvet Underground's practice space, a painting and sculpture studio and, very importantly, a place to socialize. An open-door policy ensured a never-ending stream of visitors, which occasionally hampered work from getting done, but Warhol was to become adept at mixing business with pleasure. As an ongoing informal performance, the Factory scene embodied the Dionysian ideal prevalent in the arts of the 1960s and was richly documented by photographers such as Billy Linich, teenager Stephen Shore and Nat Finkelstein. Warhol himself shot nearly five hundred Screen Tests of visitors there, as well as a great number of other films that used the space as a set and incorporated its elements, including the famous curved couch. It was also where Warhol began to create his archive of audio recordings of the events around him, initiated with cassette tapes of Ondine, Edie Sedgwick and others in the summer of 1965. **M.W.**

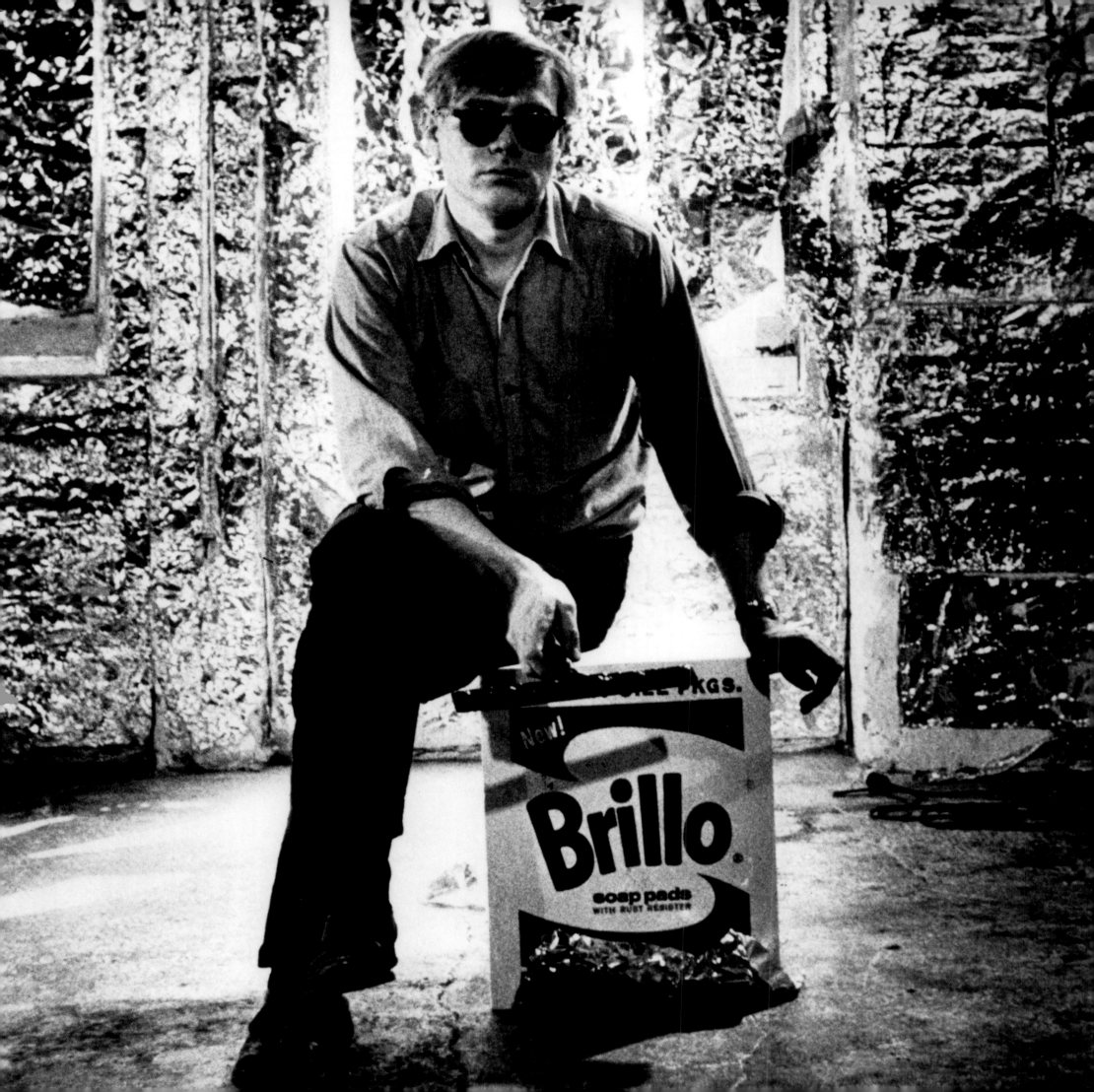

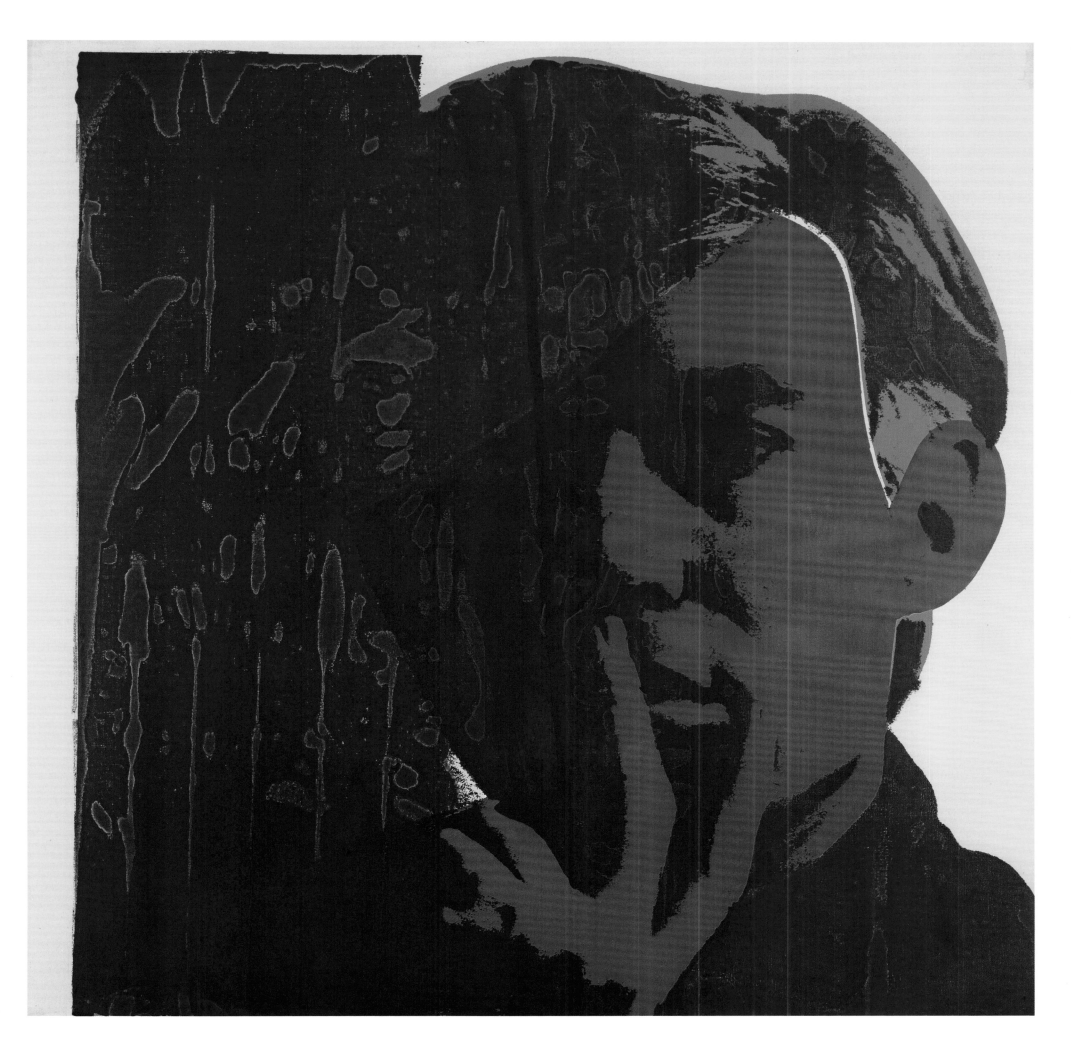

103 — *Self-portrait*, 1967

102

101

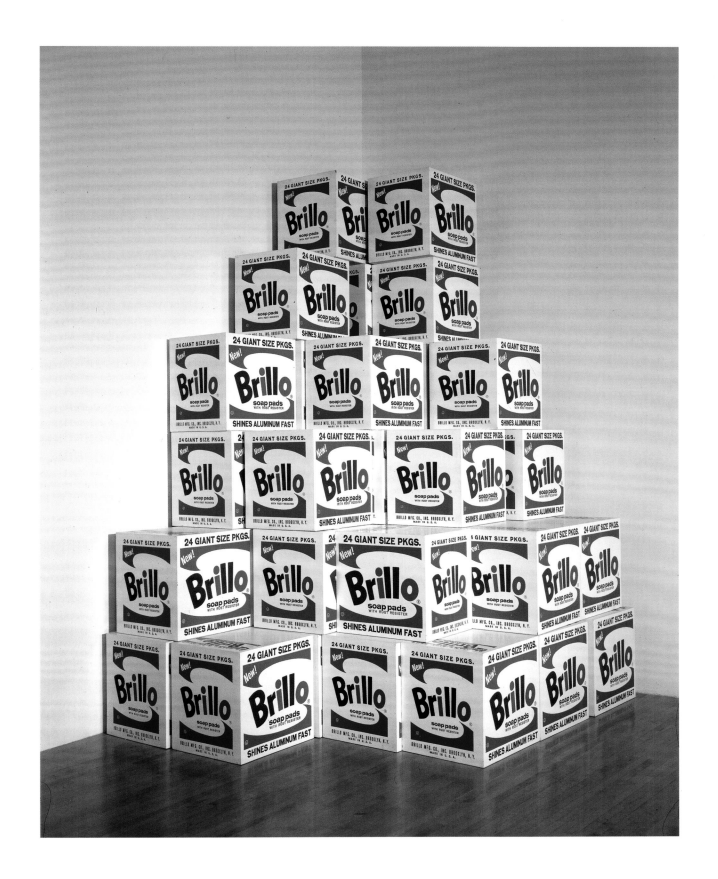

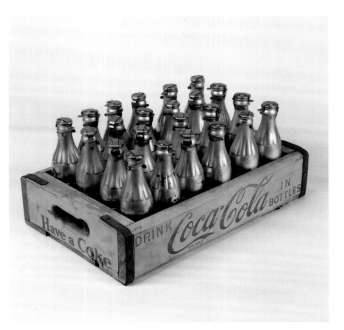

168

166

166 – *Brillo Boxes,* 1964, 1969 version 168 – *You're In,* 1967

96 – *Flowers*, 1964

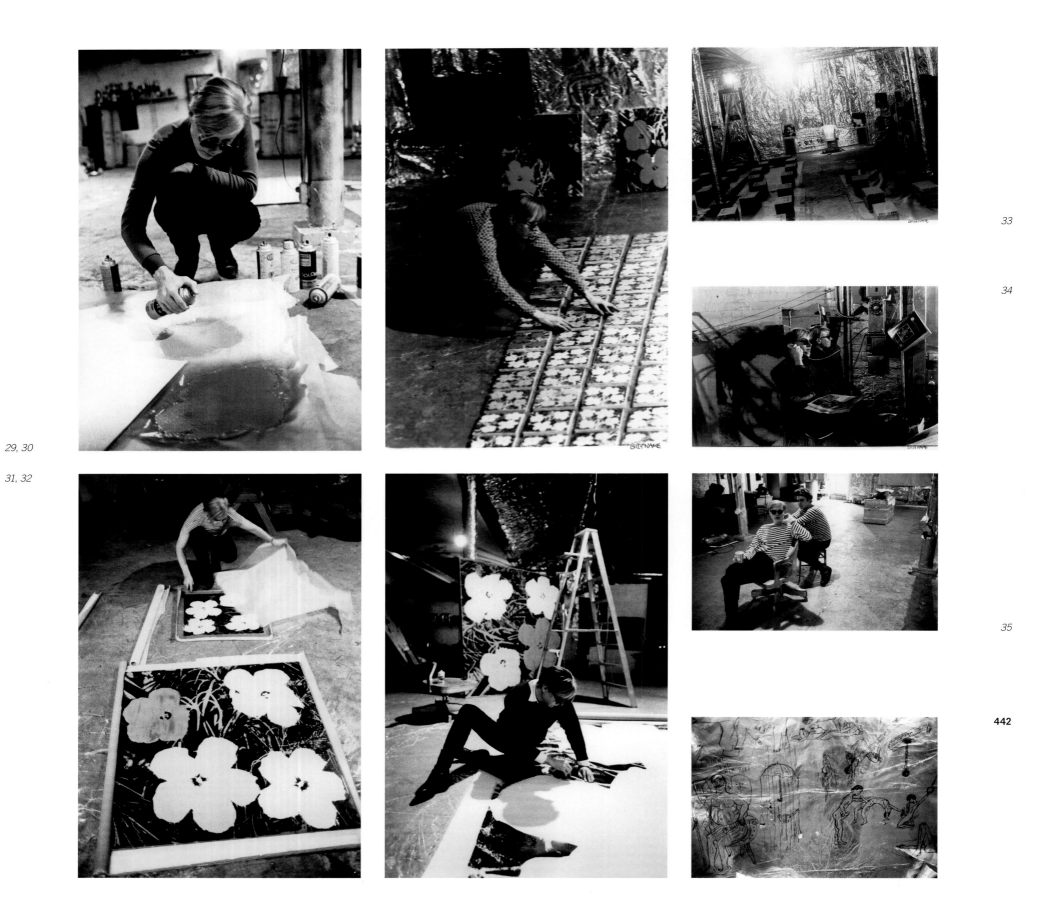

29, 30

31, 32

33

34

35

442

29–31 – Andy Warhol at the Silver Factory, working on his Flowers series, 1964–65. Photos Billy Name 32 – Andy Warhol at the Silver Factory, working on a Flowers painting, 1965. Photo David McCabe 33 – The Silver Factory in 1964, with various works in progress, including Campbell's Tomato Juice boxes and Jackie paintings. Photo Billy Name 34 – Andy Warhol on the telephone at the Silver Factory, with a Most Wanted Men painting in the background, 1964. Photo Billy Name 35 – Andy Warhol and Gerard Malanga at the Silver Factory, 1965. Photo Stephen Shore **442** – Bathroom wall at the Silver Factory, 1965–67. Photo Stephen Shore

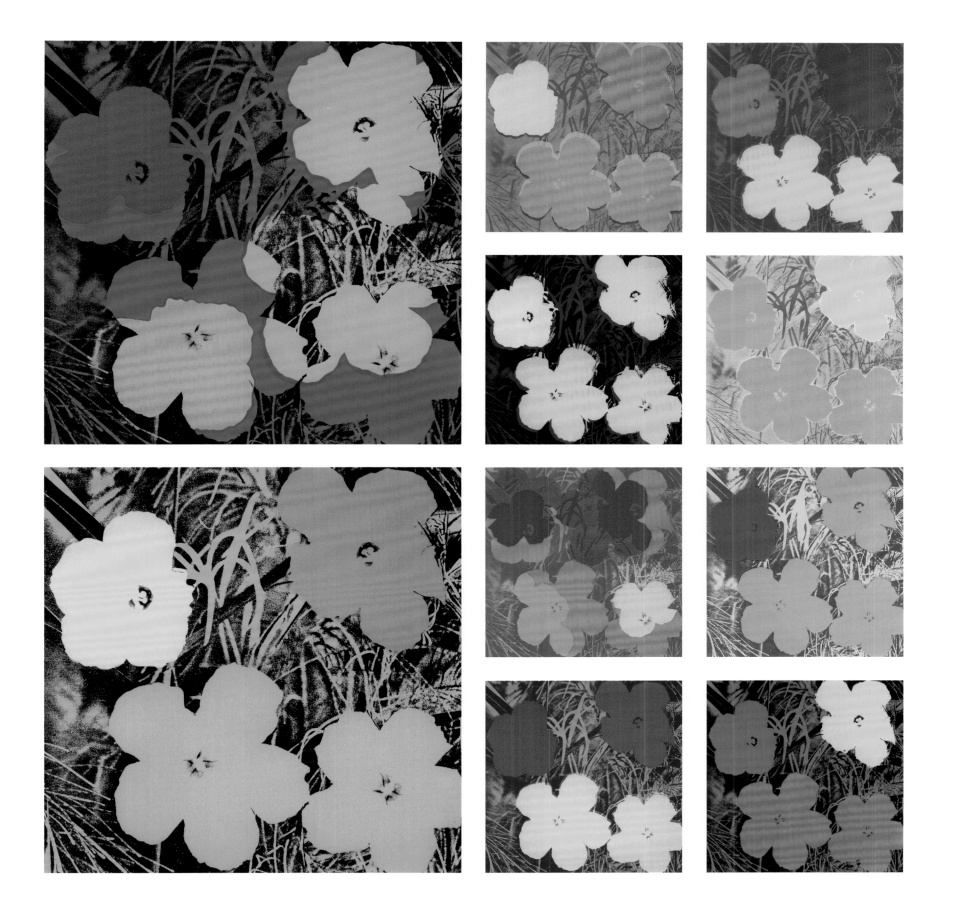

36 – Flowers, portfolio of 10 screen prints, 1970

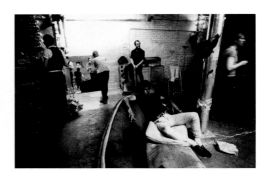

38, 39

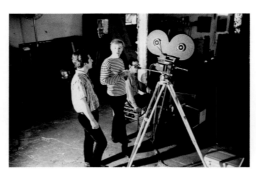

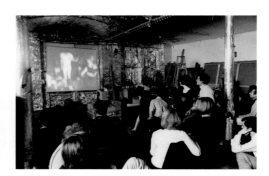

40, 41

37

37 – Andy Warhol filming Pat Hartley at the Silver Factory, during the making of *Prison*, 1965. Photo Stephen Shore *38* – Chuck Wein and Andy Warhol at the Silver Factory, 1965. Photo Stephen Shore *39* – Edie Sedgwick (at the mirror) and Andy Warhol (to the right) at the Silver Factory, 1965. Photo Stephen Shore *40* – Gerard Malanga, Andy Warhol and Buddy Wirtschafter at the Silver Factory, with an Auricon 16mm camera, during the filming of *Prison*. Photo Stephen Shore *41* – Film screening of *Vinyl* at the Silver Factory, Fifty Most Beautiful People party, 1965. Photo David McCabe

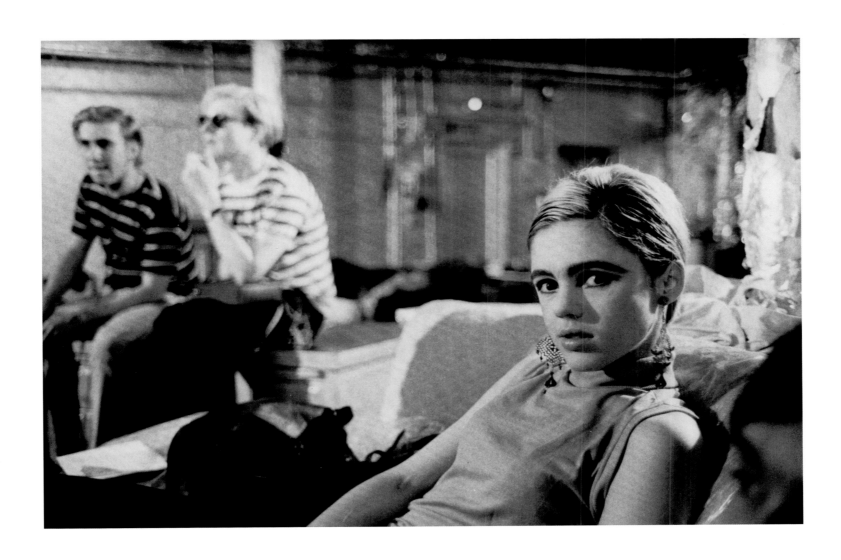

42 – Chuck Wein, Andy Warhol and Edie Sedgwick at the Silver Factory, 1965. Photo Stephen Shore

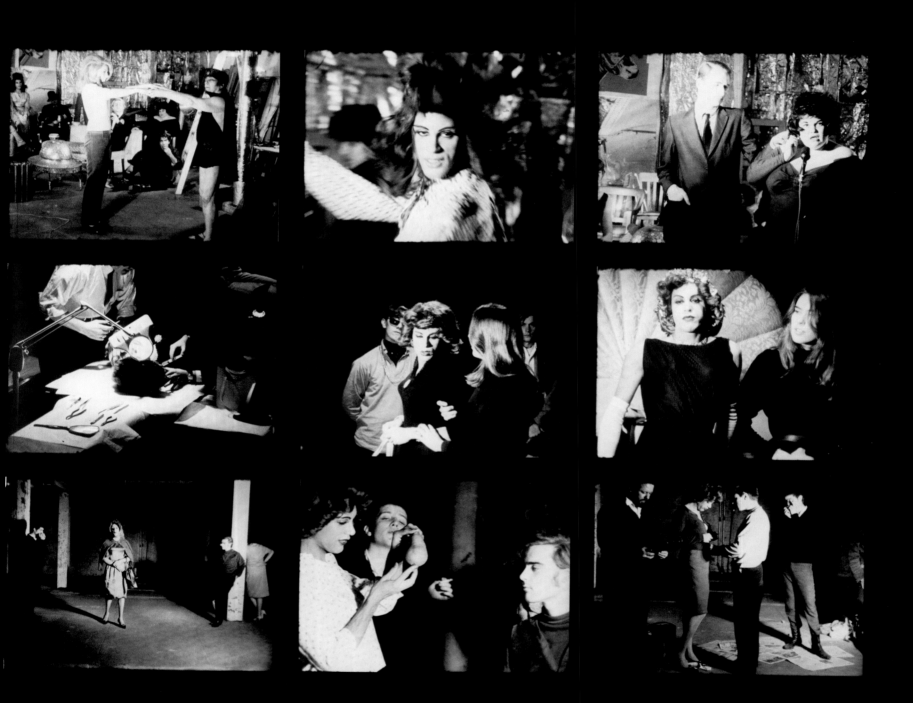

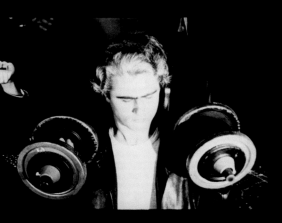
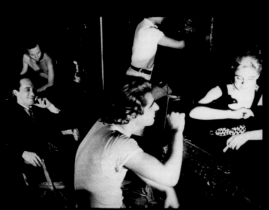

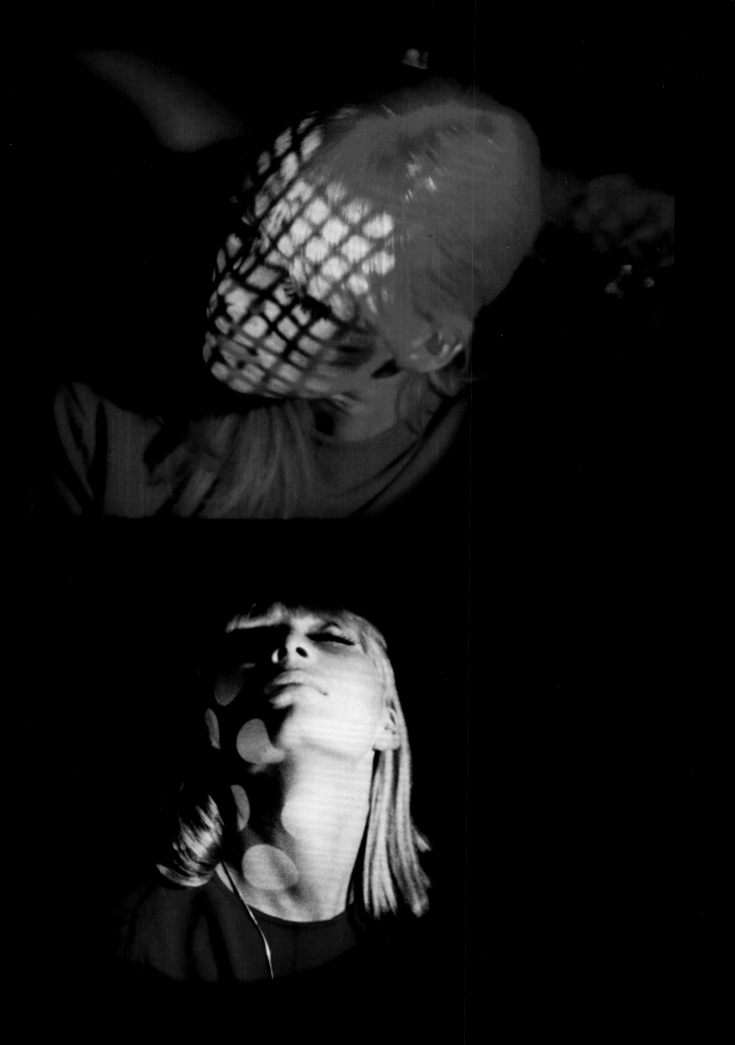

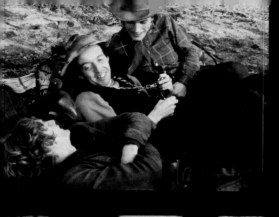
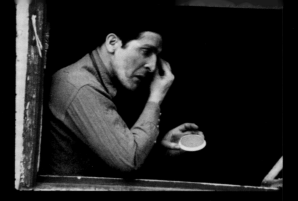
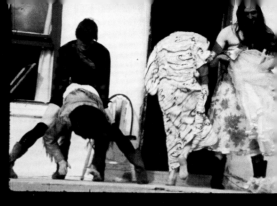

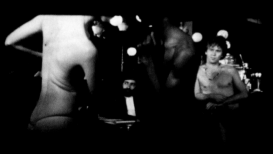
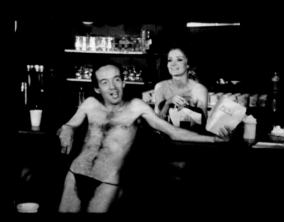
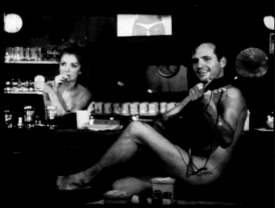

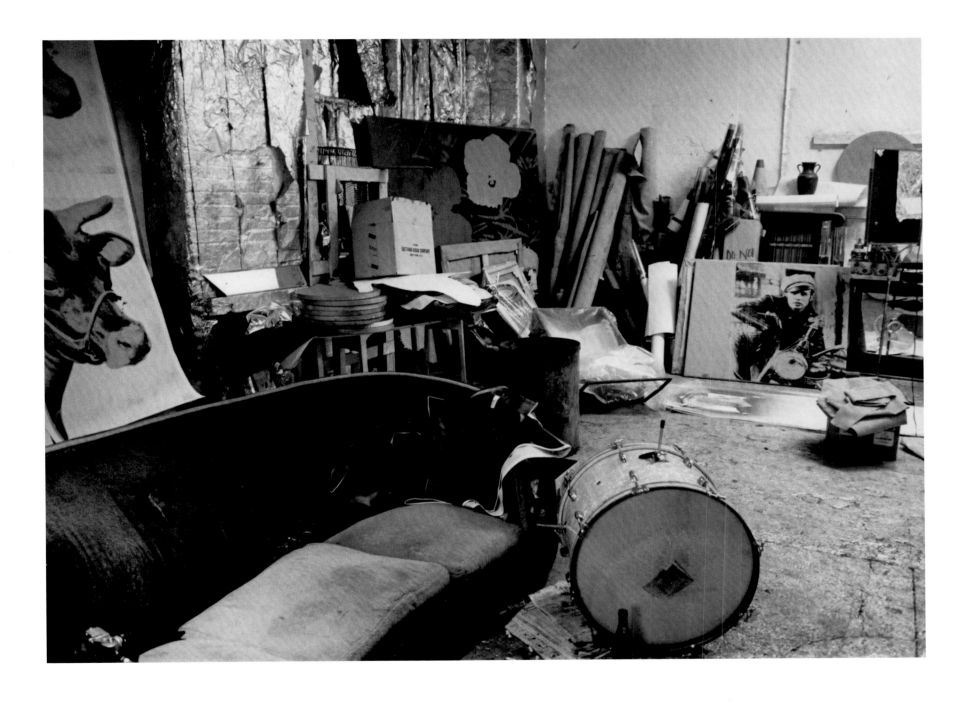

43 – The Factory at rest: with rolled paintings and artworks strewn about, including *Cow Wallpaper, Flowers* and *Marlon Brando,* 1966–67. Photo Nat Finkelstein

DACRON IS GOOD, PLASTIC IS GREAT AND THE MUSIC IS ALL. —LOU REED

In a 1977 interview in *High Times*, Andy Warhol told Glenn O'Brien about forming a rock band. Although O'Brien, formerly a staff writer for *Rolling Stone*, was well aware of Warhol's musical connections, he seemed unprepared for this aspect of the backstory to Warhol's initial encounter with Lou Reed of the Velvet Underground:

Warhol [Reed] was playing at the Cafe Bizarre, and Barbara Rubin, a friend of Jonas Mekas, said she knew this group. Claes Oldenburg and Patti *[sic]* Oldenburg and Lucas Samaras and Jasper Johns and I were starting a rock and roll group with people like La Monte Young and the artist who digs holes in the desert now, Walter De Maria.
O'Brien You started a rock band?
Warhol Oh yeah.[1]

The band was called the Druds. In actuality, Claes Oldenburg seems to have been peripherally involved. Patty Oldenburg (now Mucha), a participant in many of Claes's happenings, was the group's lead singer; Johns was credited with lyrics; and Warhol and Samaras sang backup. The "all-star cast," as Patty Oldenburg called it, also included—in addition to Young on tenor saxophone (which he borrowed from Larry Rivers) and, likely at Young's suggestion, De Maria on drums—the painter Larry Poons, on lead guitar.[2] De Maria, an accomplished musician, would later take part in two other mid-1960s bands: the Primitives, a precursor to the Velvet Underground that included Reed, John Cale and Tony Conrad, and the Insurrections, led by "concept" artist Henry Flynt.[3] Young rapidly became disillusioned with the Druds and withdrew after one or two rehearsals. As he explained, "I was very interested in very high-tech music like jazz and Indian raga and so forth, and these guys weren't musicians. I mean, I brought the only musician to the thing, Walter De Maria. . . . They were just little songs that somebody was making up. I can't remember the words. I was thinking more about music than words. . . . They had something in mind they wanted to do; I just lost interest in it very quickly."[4]

In 1977, Warhol mischievously maintained that the Druds had met ten times, although in all likelihood they actually convened closer to the three or four times recalled by Patty Oldenburg. Unbeknownst to O'Brien, Billy Klüver recorded one of the group's meetings.[5] The date was likely March 1963, the same month Klüver recorded interviews for the record that served as a catalogue for the *Popular Image Exhibition* at the Washington Gallery of Modern Art in Washington, DC.[6] The setting was Claes and Patty Oldenburg's East Fourth Street apartment in New York. Present were Poons, Samaras, Warhol and Patty Oldenburg, Young and De Maria having apparently already abandoned the project. Johns was also there, making suggestions, helping work out lyrics, and adding occasional voice-over, while Klüver silently manned the tape recorder. The evening would be invigorated by the late arrival of Gloria Graves, a familiar figure on the happenings circuit, and finally by Claes Oldenburg, who returned toward the end of the session.

Klüver's machine was initially deployed to record "No More Apologies," the lyrics for which were expressly attributed to Johns. Beginning with whistling and Poons's guitar, Johns (although in performance it was supposed to be Warhol) declared in a tone of mock-plaintiveness, "Oh Patty, I'm sorry," to which Patty responded, "I knooowww," before launching into the song:

No more apologies,
No more astrologies,
No more apologies,
For meeeeeee

"Goodbye, Patty," Johns interjects before she continues, backed by Samaras and Warhol:

No more these goodbye bets,
No more these sweet regrets,
No more, but I'll say "Let's . . .
Go ooooon

Patty Oldenburg recalls that the idea for the Druds, who were ultimately destined never to appear in public, was Warhol's. By the time of their recording, Warhol had been (or had posed as being) hooked on pop records for some time. "[O]ne of the important things to remember," Ivan Karp declared about his earliest visits to Warhol's studio, "is that rock and roll music was playing constantly in the background. It was just one record and it played over and over again so that you had to yell to talk to him. It was always the case when I visited him. The music was blasting away while he worked. There was only one song for one day and he played it many times."[7]

FIGS. 1–4 – Keith McCormack, *Cute Little Frown* (1963), The Sherrys, *Pop Pop Pop Pie* (1962), Brian Lord and the Midnighters, *The Big Surfer* (1963), Kathy Brandon, *Surfin' Doll* (1963)

FIG. 5 – Taylor Mead as Tarzan, in *Tarzan and Jane Regained . . . Sort Of* (1963)

Karp was by no means averse to Warhol's interests, being something of a rock and roll enthusiast himself. As Warhol recounted, "Ivan got a bunch of us hooked on going out to the Fox Theater in Brooklyn to see Murray the K's rock-and-roll shows—Martha and the Vandellas, Dion, Little Stevie Wonder, Dionne Warwick, the Ronettes, Marvin Gaye, the Drifters, Little Anthony and the Imperials, and everybody else you could imagine. . . . I can't remember if there was a band or if they all lip-synced to their own records, which was actually the way the kids liked it best, with every sound exactly the way it was on the records."[8]

The single Karp remembers from Warhol's studio was Dickey Lee's "I Saw Linda Yesterday," "a very impressive, innocent kind of song," as Karp not inaccurately described it, which reached number fourteen on the charts in 1963. Lee's almost rockabilly lament about glimpsing a lost love has a nonsensical refrain ("Hep, hep, dum-de-dodie-dodie") that proves difficult to forget upon a single listening, let alone daylong repetition. Other forty-fives found in Warhol's archive are comparable: Bryan Keith's twangy, Texas-accented "Cute Little Frown" (1963, fig. 1); "Pop Pop Pop Pie," released in October 1962 by manufactured Philadelphia girl group the Sherrys to capitalize on a dance craze called "the Popeye" (fig. 2); the Capitol Records release of Brian Lord and the Midnighters' "The Big Surfer" (1963, fig. 3), a novelty song written by Frank Zappa that boasted a John F. Kennedy imitator judging a dance contest; and Kathy Brandon's "Surfin' Doll" (1963, fig. 4), the second-to-last release on Crystallette Records, the mere sight of which caused British rock critic Jon Savage to exclaim, "Oh, that's camp!"[9]

Judging from these titles, Warhol aimed to exemplify Max Kozloff's denigration of Pop artists as a "contemptible style of gum chewers, bobby soxers, and worse, delinquents."[10] Yet, however campy, Warhol's collection proves a not inaccurate reflection of the contemporary state of rock music. Although 1964 would be a banner year in rock's evolution, in 1963 the United States was still recovering from the decade's musical doldrums. In 1961, as recently characterized by Julian Cope, the world of rock music "was anything but a forward-thinking place to be. The plane crashes, car accidents, deaths, divorces, humiliations and public exposés that had beset rock 'n' roll's first wave of pioneers of the late '50s had now all conspired to return popular culture to that same world of light entertainment that had so transfixed society in the early post-war years."[11]

While rock was on the brink of recovery in 1963 (Beatlemania being in full bloom across the Atlantic), the situation in the United States had not yet fundamentally transformed. "This was the summer before the Motown sound got really big," Warhol recalled, "and it was also the last summer before the English Invasion. The show at the Fox had the Ronettes, the Shangri-Las, the Kinks and Little Stevie Wonder. Also, we were watching Murray the K before he got to be super-famous for being the American disk jockey who had the best rapport with the Beatles."[12]

The Druds were formed to participate in the Washington, DC, Pop Festival, a month-long program of events coinciding with the *Popular Image Exhibition* that included Robert Rauschenberg's *Pelican*, a lecture/concert by John Cage, and choreography by the Judson Dance Theater. Claes Oldenburg presented the happening *Stars*, the title of which derived not from celebrities (although "movie stars" would be a peripheral reference) but "from seeing very clear stars in the sky" during a visit to Washington and the manner in which they resonated with "the patriotic motif" of the American flag and "the radiated way the streets are built" in a city organized around traffic circles.[13] Among its many activities were moments when Patty Oldenburg was to play and/or sing along with rock, gospel, country and even Hawaiian music, most if not all of which had been released that year: Esther Phillips's "Release Me," Chet Atkins's "Alley Cat," Gloria Gibbs's "I Will Follow You," and Little Peggy March's "Wind-up Doll," among others.

Unlike happenings such as *Stars* and many examples of Judson dance, the Druds did not use pop music as merely one material among many within a heterogeneous, collage-like structure. Aligned more closely with a single genre, that of the rock group, the Druds arguably formed the first "art band," with an incomplete and evidently artificial cultural troping that likely approached the camp appropriation strategies of Jack Smith's *Flaming Creatures* (1962–63) and Warhol's *Tarzan and Jane Regained . . .*

Sort Of (1963, fig. 5).[14] As explained by Warhol's lead actor, Taylor Mead, his enactment of a something-less-than-macho man of the jungle did not aim to be a seamless or successful approximation of pop-culture icons: "[W]e aren't doing Tarzan exactly as Lee Barker or Weismuller would do it." Produced instead was an inadequate and almost allegorical palimpsest of Tarzan "mixed," as Mead put it, "with Taylor Mead."[15]

By May of 1963, after the Druds had likely folded, Warhol's musical affections had apparently turned from Dickey Lee to Elvis Presley. As reported in *Time* magazine, "In [Warhol's] studio a single pop tune may blare from his phonograph over and over again. Movie magazines, Elvis Presley albums, copies of *Teen Pinups* and *Teen Stars Albums* litter the place."[16] While in Los Angeles shooting *Tarzan*, Mead also commented on Warhol's penchant for "playing Elvis Presley records, and listening to them."[17]

In May, Warhol had just started work on the series of Elvis paintings for the Ferus gallery in Los Angeles, works that reference Hollywood both via their invocation of the "silver screen" and via the use of a still from the movie *Flaming Star* (1960). Although it has been noted that Warhol's choice of the Presley image seems atypical, less attention has been paid to how little Presley himself resembled the "the king of rock and roll" in 1963. At the time, Presley was associated less with the concert stage than with an apparently unending series of increasingly ludicrous movies. Churned out with escalating frequency, the films contained plots so contrived and production values so low that they nearly constitute an avant-garde aesthetic of their own. As Greil Marcus has written about *G.I. Blues*, a film that appeared the same year as *Flaming Star*, "[Elvis] walks through the flick with the same air of What-Am-I-Doing-Here bemusement he employs in most of his other movies. When he strums his acoustic guitar, an electric solo comes out. When bass and guitar back him, you hear horns and electric piano. When he sings, the soundtrack is at least half a verse out of sync. . . . The movies are so tacky no one else could possibly get away with them—and still make money. Someday, French film critics will discover these pictures and hail them as a unique example of *cinéma discrépant*."[18]

As Marcus's larger argument makes clear, such formal slippages overlay a more consequent set of contradictions within Presley's music and cultural image. A poor white Southerner who sought to transcend the limitations of family, geography, class and religious background, Presley had been the prototypical figure of rock and roll's capacity for subjective reinvention. In the 1950s, Presley's music encapsulated something of the conflicts and antagonisms of class in the United States (as, of course, they also intersected with those of race). Striving for and simultaneously disdaining the power and possessions held by the upper class, Presley engaged and reflected these contradictions in part through his embrace of some of the crassest symbols of American commercial culture. For Marcus, this dynamic can be discerned in Presley's reference to the pink Cadillac in the 1955 single "Baby, Let's Play House": "The Pink Cadillac was at the heart of the contradiction that powered Elvis's early music; a perfect symbol of the glamour of his ambition and the resentments that drove it on. When he faced his girl in 'Baby, Let's Play House' . . . Elvis sang with contempt for a world that had always excluded him; he sang with a wish for its pleasures and status. Most of all he sang with delight at the power that fame and musical force gave him: power to escape the humiliating obscurity of the life he knew, and power to sneer at the classy world that was now ready to flatter him."[19]

It is tempting to speculate on Warhol's depiction of Presley on the basis of a similar desire to overcome his own far from affluent upbringing and an analogous set of limitations imposed by family, geography, class and religion, as well as those of sexuality and ethnic background. Presley, however, was just as apt to represent something for Warhol to despise as to emulate. For, in 1963, Presley would no longer primarily have signified transgression of the confines of upbringing and class, but rather the opposite: a bland, false utopia proffered by an affirmative mass culture, with Presley in increasingly compromised appearances on both celluloid and vinyl selling just this tainted bill of goods. "This is really the last word of our mainstream," writes Marcus about this aspect of Presley's output and cultural meaning, "its last, most seductive trap: the illusion that the American dream has fulfilled itself, that utopia is complete in an America that replaces emotion with sentiment and novelty with expectation."[20]

In the spring of 1963, the Presley recording most likely to have graced Warhol's turntable would be "One Broken Heart for Sale," released as a single that January and in April on the soundtrack for *It Happened at the World's Fair*. Just over a minute and a half long, it contains little residue of the contradictions that marked Presley's earlier achievements. Sleepwalking through the recording session, Presley merely plays at being Elvis, a couple of vocal inflections, at one point almost a growl, being the only hints at anything beyond rote rehearsal. Even these moments, however, are clearly staged, not so much breaking through the song's artificial surface as prolonging it in a manner that approaches self-parody. Regardless of which Presley song Warhol played in 1963—"(You're the) Devil in Disguise" would have been a better choice—all would have similarly evinced another contradiction in Presley's musical legacy: what was most "authentic" in Elvis has always been inextricably bound up with artifice. As Hugh Barker and Yuval Taylor have argued: "By embellishing country music's plainspoken style with all sorts of mannerisms, Elvis deliberately moved his music away from the this-is-God's-truth mode of country delivery and the cult of authenticity that went with it. His casual delivery and the way he slurred his words are reminiscent of Dean Martin's later records. But while much of Martin's charm lay in the fact that he sounded just as drunk as he appeared to be, Elvis sounded like a cartoon version of a drunk."[21] As Barker and Taylor contend, Presley's engagement with artifice was typical of rock music as a whole until that moment when, in the mid-1960s, it too would pursue "the cult of authenticity": "In other words, rock 'n' roll was at its core self-consciously inauthentic music. It spoke of self-invention: if Elvis could reinvent himself, so could others; if he could assume a mask, so could anyone. Its inauthenticity gave it staying power."[22]

In the early 1960s, this process of subjective refashioning, especially with regard to Presley, had been fully co-opted. If Presley reinvented himself once—in those early recordings in which, as Marcus contends, "even the lyrics avoid any possibility of camp"[23]—the pop/Hollywood system now put him through a series of ever more vapid guises: inmate (*Jailhouse Rock*), gunslinger (*Flaming Star*), G.I. (*G.I. Blues*), would-be writer (*Wild in the Country*), heir to a pineapple plantation (*Blue Hawaii*), homesteader (*Follow that Dream*), fisherman/nightclub singer (*Girls! Girls! Girls!*), racecar driver (*Viva Las Vegas*), kidnapped American actor in the fictitious Middle Eastern kingdom of Lunarkand (*Harum Scarum*), and so forth. Ever attentive to the artifice of Presley's public appearance, Warhol would include an image of him as the last of these characters to illustrate Lou Reed's "The View from the Bandstand" in *Aspen* magazine.[24]

Warhol's Elvis paintings cannot be said to address such complexities with any specificity. Nevertheless, just as the interrelation of glamour, desire, tragedy and death would prove inextricable from Warhol's portraits of Marilyn Monroe, and connotations of beauty, stardom, crisis and scandal would surround his depictions of Elizabeth Taylor, some constellation of allure, rebellion, co-optation and disillusionment remains inseparable from his silkscreen portrayals of Presley. More importantly, if Warhol's portraits of Elvis can be said to be allegorical (not unlike Mead's portrayal of Tarzan), it is not only on account of Warhol's strategy of appropriation, but also because, in their falseness and inauthenticity, certain moments of popular culture (as Jack Smith, let alone Greil Marcus, knew well) can approach something like the structure of allegory themselves.

It was precisely this arena of popular culture that Warhol sought to engage with the project of forming a rock band. While the Druds never invoked Elvis, much the same realm of cultural and commercial associations—the endemic relations and slippages between authenticity, artifice, image and commodification—would form the very material of their artistic appropriation. Implicit in "No More Apologies" and the rock band format in general, such associations came more clearly to the fore in the other songs recorded at the Oldenburgs' apartment: "The Coca-Cola Song," "The Alphabet Song," "Movie Stars" and "Hollywood." As their titles alone make clear, all were more self-consciously related to Pop art, referencing Johns's grids of stencilled letters (fig. 6) and already by then signature Warholian motifs (fig. 7).

Both "The Coca-Cola Song" and "Movie Stars" shared a similar structure: a simple repeated background vocal over which the group extemporized lyrics. In "The Coca-Cola Song," Lucas Samaras sang in a parodic Spanish or Caribbean accent over a chorus of "Coca-Cola":

> I told my momma,
> To go buy me a bottle,
> Of Coooo-ca-Cola,
> And she said,
> "OK, boy, I'll buy you a bottle from the market."
> So, after an hour,
> She came home with a bottle of Coca-Cola.
> I said, "Mommy, that's the bottle for me!

As Samaras continues, Patty Oldenburg begins interjecting in a staccato manner with deliberate pauses: "Coca-Cola . . . in a green bottle . . . with a gre-en top." Samaras continues:

> Oh mommy, oh mommy, that's the bottle, yes.
> So I took up an opener,
> And I drank up the bottle,
> And I opened it,
> And I poured it in a glass . . . and it fizzed.
> Ummm, momma, that's the bottle for me!

Patty continues singing: "Coca-Cola . . . comes in a gre-en bottle . . . with a me-tal top (my favourite part!)." By this point Warhol is rapidly repeating "Coca-Cola" in a manner somewhat like calling a cat, while another male voice, likely Poons, begins chanting the word "Coke" with an insistence that tips the reference over into that other "pause that refreshes," cocaine. Patty: "Green top . . . metal top . . . my favourite soda pop . . ."

"Movie Stars" would not be sustained nearly as long or as successfully. Warhol suggested it, demonstrating the backup vocals' repetition of "movie stars, movie stars" with a cadence that recalls "Lollipop" by the Chordettes. The evidently campy lyrical additions, mainly provided by Johns and repeated by Patty Oldenburg, began with "Oh Lord God, Greta Garbo" and continued, at least on this occasion, with merely the names of other Hollywood actors: Joan Crawford, Alice Faye, Shirley Temple, Cary Grant, Betty Grable. Warhol suggests Peter Lorre; someone else interjects Myrna Loy. Despite Warhol's persistent background singing, the number fails to gain momentum until, after more loose improvisation, the chorus transforms into the interjection "in Hollywood," and the lyrics, once again sung by Samaras, become an ode to monster movies (and, potentially, Hollywood agents):

> Once I was a vampire, in a city,
> In Hollywood
> And there were lots, lots of necks floating around,
> In Hollywood
> I sink my teeth on their necks,
> In Hollywood
> And godless vultures . . .[25]

"The Alphabet Song" had an even simpler structure. In unison, all members of the group sang through the alphabet at a regular pace, twice, each time ending with a repeated "Z, Z, Z, Z, Z, Z, Z." Going through the alphabet a third time, slightly slower, brought forth a bit more improvisation, but the sequence once again concludes with the repeated series of "Z"s before less restrained improvising takes over and the song, like the others before it, sputters to a close.[26]

FIG. 6 – Jasper Johns, *Gray Alphabets*, 1956

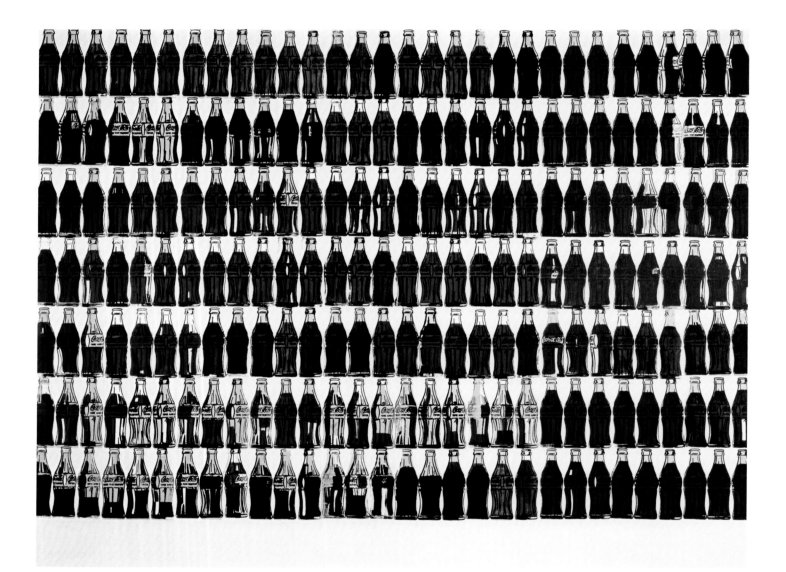

FIG. 7 — Andy Warhol, *210 Coca-Cola Bottles*, 1962

It is even more obvious from these songs that, even in their final form, the Druds would not have given a particularly polished concert. They were certain never to have fulfilled the expectations greeting performers at the Fox Theater, where, as Warhol recounted, audiences craved fidelity to the commercial recordings—"like if they were seeing, say, the Crystals, they'd expect to hear every little rattle in the Phil Spector production."[27] In their inadequate, if not outright parodic rendition of ersatz pop songs and the added distance accorded by references to Pop art, the Druds were set to exacerbate and play upon a series of rock and roll's then prevalent attributes: inauthentic performance, manufactured celebrity, unabashed construction and opportunism (recall the Sherrys cashing in on "The Popeye"), and thinly disguised commercialism.[28] The result would almost certainly have been to heighten each of these attributes into a self-reflexivity (however haphazard), fully evident to the audience before them. In this, the Druds would have exemplified an aspect of Warhol's aesthetic that would otherwise only be realized in his films and collaboration with the Velvet Underground. Appropriating mass-culture motifs with what the artist Dan Graham has called "lassitude," the Druds would have "eliminate[d] the conventional complicity of audience identification with the protagonists."[29]

In what remains one of the most comprehensive critical discussions of Warhol's oeuvre, Benjamin H. D. Buchloh has argued that Pop art, in general, and Warhol, in particular, effected a "shift from the strategic games of high art to those *real rituals of participation* [author's emphasis] within which mass culture contains and controls its audiences."[30] For Buchloh, this move formed part of an effective and thoroughgoing negation of the transcendental pretensions of Modernist painting and the utopian, if not naive, attempts to revive art's ritual function and relation to cult value within such genres as happenings. Yet, whereas a project such as the Druds would have conflated the realm of high art with that of popular culture to an unprecedented degree, it would certainly have proven no more identical to the latter than *Flaming Creatures* or *Tarzan and Jane Regained . . . Sort Of* resembled the Hollywood vehicles of the 1940s they invoked. While Warhol's participation in the Druds clearly furthered his engagement with commercial culture, taking him outside the cordon of high art that his abstract expressionist-sized canvases still assured him, it also initiated a strategy of self-reflexively inhabiting such pop-culture "rituals" in order to engage in their deconstruction. As Graham would later argue about Warhol's artistic legacy, perhaps the only counter to a late-capitalist epoch in which any- and everything can be appropriated, packaged and resold, including the aura of high art, may be a mimetic self-reification that "represents media's representation, which is already a second-hand relation to 'reality.'"[31]

This article is dedicated to Matt Wrbican.

1 Glenn O'Brien, "Andy Warhol: Interview," *High Times* (August 1977), repr. in Kenneth Goldsmith, ed., *I'll Be Your Mirror: The Selected Andy Warhol Interviews* (New York: Carroll and Graf, 2004), 245.
2 Victor Bockris, *Warhol* (New York: Da Capo, 1997), 147.
3 On the one recording session of the Primitives, see author's *Beyond the Dream Syndicate: Tony Conrad and the Arts after Cage* (New York: Zone Books, 2008). The music of the Insurrections has been released as Henry Flynt and the Insurrections, *I Don't Wanna*, Locust CD 39.
4 Legs McNeil, "La Monte Young Interview—Part Three—Tape Three," unpublished interview with La Monte Young and Marian Zazeela, May 23, 1995, 7–9. My thanks to McNeil for providing me with a copy of this interview.
5 "No More Apologies and Others," cassette tape in the collection of Julie Martin. My thanks to Nadja Rottner for making me aware of this tape, to Julie Martin for allowing me to hear and transcribe it, and to Patty Mucha for sharing her recollections of it with me.
6 The *Popular Image Exhibition* was held at the Washington Gallery of Modern Art from April 18 to June 2, 1963. Transcriptions of the interviews were later published as Billy Klüver, *On Record: 11 Artists 1963* (New York: Experiments in Art and Technology, 1981).
7 John Wilcock, *The Autobiography and Sex Life of Andy Warhol* (New York: Other Scenes, 1971), n.p.
8 Andy Warhol and Pat Hackett, *Popism: The Warhol Sixties* (New York: Harcourt Brace Jovanovich, 1980), 18.
9 Jon Savage made his remark to the author in the Archives of the Andy Warhol Museum in the spring of 1995.
10 Max Kozloff, "'Pop' Culture, Metaphysical Disgust, and the New Vulgarians," in Steven Henry Madoff, ed., *Pop Art: A Critical History* (Berkeley: University of California Press, 1997), 32.
11 Julian Cope, *Japrocksampler: How the Post-War Japanese Blew Their Minds on Rock 'n' Roll* (London: Bloomsbury, 2007), 73. Although Cope is, perhaps, not the most scholarly of references, the irreverent tone of his writing captures well the essence of its subject.
12 Warhol and Hackett, 29. My thanks to Jay Reeg for emphasizing the differences in music that existed between England and the United States in 1963.
13 Claes Oldenburg, *Raw Notes* (Halifax: The Press of the Nova Scotia College of Art and Design, 1973), 3 and 20.
14 Although *Flaming Creatures* would only premiere at the end of April, 1963, Smith's aesthetic had already been outlined in "The Perfect Filmic Appositeness of Maria Montez," *Film Culture*, 27 (Winter 1962–63), repr. in J. Hoberman and Edward Leffingwell, eds., *Wait for Me at the Bottom of the Pool: The Writings of Jack Smith* (London: Serpent's Tail, 1997), 25–35.
15 Taylor Mead, in Ruth Hirschman, "Pop Goes the Artist," in Goldsmith, ed., *I'll Be Your Mirror*, 62.
16 "Pop Art—Cult of the Commonplace," *Time* (May 3, 1963), 72.
17 Taylor Mead, in Hirschman, 32.
18 Greil Marcus, *Mystery Train: Images of America in Rock 'n' Roll Music*, 3rd revised ed. (New York: Plume, 1990), 166.
19 Ibid., 160. As Marcus reports, Presley added the Cadillac reference to Arthur Gunter's original song.
20 Ibid., 170.
21 Hugh Barker and Yuval Taylor, *Faking It: The Quest for Authenticity in Popular Music* (New York: W. W. Norton and Co., 2007), 148. On authenticity in rock music, see also Simon Frith and Howard Horne, *Art into Pop* (London: Methuen and Co., 1987).
22 Barker and Taylor, 149. It is interesting to consider that, according to Ivan Karp, Warhol wore and made visitors to his studio wear masks while he played rock and roll. Karp, in Wilcock, n.p.
23 Marcus, 146.
24 Lou Reed, "The View from the Bandstand," *Aspen*, 1, no. 3 (December 1966).
25 Samaras's improvisation trails off after "vultures"; Gloria Graves adds a couple of lines—"I used to be a movie star / In Hollywood, I shone from afar"—before the song breaks down.
26 On the tape, Warhol and Johns can also be heard discussing "I Left You Because You Loved Me," a title they had agreed upon but for which there was apparently neither music nor lyrics. When Claes Oldenburg arrived home, he (or possibly Poons) improvised a faux-country ode to Klüver entitled "Billy, the Cowstar Kid."
27 Warhol and Hackett, 18.
28 In 1963, the closeness between rock and roll and corporate advertising alluded to in "The Coca-Cola Song" would hardly have needed desublimation. The Coca-Cola corporation was just embarking on its "Things Go Better with Coca-Cola" campaign, which deployed radio-only ads that were introduced and masqueraded as pop songs—until unexpectedly arriving at the jingle—by a host of performers including Jan and Dean, the Everly Brothers, Ray Charles, Roy Orbison, the Four Seasons, the Supremes and more. For more on this campaign, see Douglas Wolk, "(The Soda) Pop Explosion," paper delivered at the Experience Music Project "Pop Conference," Seattle, Washington, April 15, 2005. My thanks to Douglas Wolk for providing me with a copy of his lecture.
29 Dan Graham, "Dean Martin / Entertainment as Theater," in Brian Wallis, ed., *Rock My Religion: Writings and Art Projects, 1965–1990* (Cambridge: MIT Press, 1993), 60.
30 Benjamin H. D. Buchloh, "Andy Warhol's One-Dimensional Art: 1956–1966," in Annette Michelson, ed., *Andy Warhol* (Cambridge: MIT Press, 2001), 14.
31 Dan Graham, "The End of Liberalism," in *Rock My Religion*, 73.

IMPULSE, TYPES AND INDEX: WARHOL'S AUDIO ARCHIVE
Melissa Ragona

ANDY USED TO MARVEL AT THE NUMBER OF CATEGORIES, AS HE
CALLED THEM. WE MIGHT DECIDE ONE DAY TO DO AMERICAN PAINTINGS,
AND WE WOULD SEE CHASES AND SARGENTS AT PLACES LIKE
IRA SPANIERMAN AND DIDI WIGMORE; THE NEXT DAY WE MIGHT DO
CLASSICAL ANTIQUITY OR NINETEENTH-CENTURY SCULPTURE.
ANDY USED THE AUCTION HOUSE SYSTEM IN CATEGORIZING ART HISTORY.
— STUART PIVAR, *SOTHEBY'S ANDY WARHOL COLLECTION 1988*
AUCTION CATALOGUE

SO IN THE LATE 50s I STARTED AN AFFAIR WITH MY TELEVISION WHICH
HAS CONTINUED TO THE PRESENT, WHEN I PLAY AROUND IN MY BEDROOM
WITH AS MANY AS FOUR AT A TIME. BUT I DIDN'T GET MARRIED UNTIL
1964 WHEN I GOT MY FIRST TAPE RECORDER. MY WIFE. MY TAPE RECORDER
AND I HAVE BEEN MARRIED FOR TEN YEARS NOW. WHEN I SAY "WE,"
I MEAN MY TAPE RECORDER AND ME.
— ANDY WARHOL, *THE PHILOSOPHY OF ANDY WARHOL*
(FROM A TO B AND BACK AGAIN) (1975)

IMPULSE

In the mid-1950s, Warhol acquired his first tape recorder, a Sony portable reel-to-reel. By the early 1960s, Warhol also had a Sony portable cassette recorder, and later, in 1965, a state-of-the-art Norelco tape recorder given to him by *Tape Recording* magazine. *TDK* made him their poster child, providing him with an endless supply of blank tapes. Thus equipped for sound, Warhol began recording his everyday life—not just in terms of important events or particular conversations, but minute details of ambient sound, conversational exchanges, as well as the sound and process of tape recording itself—the flip of a cassette, on and off modes, the recorder's relationship to other technologies such as film, or the telephone (figs. 1, 2). Warhol's tape-recording projects were constructed with similar durational strategies, which he would come to use more decisively in filmmaking, silkscreening and, later, in diary writing with Pat Hackett. The model of the 24-hour movie (initial articulations of this model include *Sleep/Eat/Kiss* [1963–64]) was born out of the aesthetic structure of his early tape-recording experiments. His tape-to-text projects, *a: A Novel* (1968), as well as *Interview* magazine (1969), mark a new direction in Warhol's work, one characterized by a focused interest in sound, as well as image. In Warhol's recordings, an inventive serialism emerges, which would take his project of reproducing like objects into cataloguing overheard speech, distorted text and hyperbolic, as well as faux, identity plays. Warhol's audio recordings consist of an archive of over three thousand tapes (cassette and reel-to-reel) of which only several hundred have been converted into research dubs housed at the Andy Warhol Museum in Pittsburgh. The Time Capsules notwithstanding (fig. 3), this audio collection is one of the most impressive archival feats of Warhol's career. Indeed, it is one of the most challenging durational projects of his oeuvre.[1] The inventory of these tapes begins in the summer of 1951 with Warhol's recording of Maria Callas's Mexico City performance of Verdi's *Aida*, and ends with a 1985 recording of the painter Jean-Michel Basquiat interviewing filmmaker Emil de Antonio for Warhol's *Interview*.[2]

Warhol's impulse to archive—his propensity to collect, file and save events, conversations and objects with equal valence—lies at the centre of his aesthetic approach. His audio recordings mirror his recording strategies in filmmaking: he would simply let the tape roll and record every sound produced. Warhol was keenly aware of the power of the archive, of its ability to preserve and repeat, as well as mirror mnemonic faculties: "I have no memory. Every day is a new day because I don't remember the day before. Every minute is like the first minute of my life. I try to remember but I can't. That's why I got married—to my tape recorder. That's why I seek out people with minds like tape recorders to be with. My mind is like a tape recorder with one button—*Erase* [author's stress]."[3]

While Warhol satirizes the parallel between the mind's ability or inability to remember and a tape recorder's mnemonic capabilities in terms of recording and erasing, he also fully understands the discursive power of an "electronic archive." His play on "marrying" the tape recorder also foregrounds his awareness of the proliferation of relational possibilities the archive generates over time by multiplying potential exchanges. Indeed, Warhol thought of *a: A Novel* as an "electronic book," a record of daily events. Warhol's recordings point to several levels of his archival project. One is characterized by an ongoing effort to explore aesthetics of reproducibility by looking at the relationships between old and new technologies (silkscreening and photography, painting and film, writing and sound recording). Another is to construct a record of transfer processes, a database for future research. The resulting archives themselves, however, become complex works of art. They confound the relationship between information and artwork, as well as immaterial effect (affective, psychological) and technical substrate (the site of archival records).[4]

Most critical literature argues that Warhol's impetus to "record" everything around him was a desire to communicate with others. For example, Paul Morrissey called Warhol's approach "epistolary": "Basically, Andy's always felt his films are an extension of home movies, you know, a record of friends, either a record of your family or a record of your friends or a record of your travels. It goes back to the epistolatory [*sic*] novel which was the first novel, letters back and forth between friends."[5] In *Andy Warhol, Poetry, and Gossip in the 1960s*, Reva Wolf also states that it is about communication: "Warhol's work often served as a means by which he not only recorded the people around him but

communicated with them, and they in turn communicated with him in their own work."[6] This revisionist Warhol history—the attempt to turn Warhol back into the friendly guy he really was, someone who "had strong feelings for the people around him,"[7] reduces the complexity of Warhol's aesthetic palette. The "talkers" in Warhol's life were indeed important to him, but not simply because he could communicate with them or "reach out." Indeed, ultra-loquacious stars like Brigid Berlin, Ondine, Andrea Feldman, Ingrid and Viva allowed him to play his role as archivist of the Zeitgeist series: he could just turn on his tape recorder and they would fill it up for hours and hours, allowing him both to receive and eventually transmit this rich material.

Making a narrative out of recordings, however, was not Warhol's main concern. Indeed, as Pat Hackett makes clear, many of Warhol's recordings, especially in the 1970s, when *Interview* magazine played a major role in Warhol's career, were not made with the intention of creating a play or film soundtrack, but of using them as published open-ended interviews for the magazine. Warhol understood extremely well the complexity of narrative and non-narrative structures in art, and was well read in both classical and experimental poetry and fiction. He also collaborated with writers on visual arts projects.[8] But rather than taking an interest in "dialogue" or "communication" or integrating "poetry and painting," Warhol's aesthetic approach across various media includes a precocious knowledge of the relationship between algorithm and database. As Lev Manovich argues, a database "represents the world as a list of items, and it refuses to order this list."[9] The application of an algorithm, or set of rules, is one way of proceeding through or ordering data. Narrative structures are simply one form of algorithm, and Warhol was acutely aware of this and played on the multivariate forms of algorithms available to him across media. Plays, novels, thermo-faxed poems on paintings, television shows, films, interviews and ambient recordings express the various aesthetic "rules" suggested by the distinctive limits and potentials of the different media and technologies at his disposal. Conversations do not humanize his "machine," but increase the knowledge base of its operations. Indeed, a conversation, especially one conducted on the telephone, was a personal comfort to Warhol. But a conversation converted immediately into data by a tape recorder was even more satisfying—on all levels. Warhol could both savour immediate audio presence (provocation, intimacy, quip, sarcasm, disconnection, background noise, talk performance) and revel in the possibility of playback (to have it again, to categorize, to analyze, to accompany).

Warhol's vision was two-sided—he was concerned with both "production and reception."[10] In a sense, his recordings set up this diptych: the tape recorder could perform, with its mechanics of electronic production (a tape, an audio performance), as well as project direct reception (instant audio playback). Warhol knew how production and reception are conflated by electronic recording technologies. Early film projectors served as both cameras (receivers) and display devices (producers). He repeated this double function across the media with which he experimented: for example, silkscreening "read" the photographic image, and video "watched" the audio recording. In the 1970s, he was known not only as someone who already had a tape recorder running long before interviewers could even set up their equipment, but also as someone who would often videotape the audio recording session of the interview.[11]

TYPES

Warhol's impulse to collect material, whether in the form of photographs, sound recordings, films, objects, or people, developed into a sophisticated approach to ideas on category making. Through his archival projects, he studied the performative nature of categories within popular culture, art market circles and the institution of the museum. Warhol's collections of shoes, knives, umbrellas, Native American art, Americana, baskets, ceramics, photographs, silver, butterflies, guns, toys, dogs, furniture and cookie jars suggest particular themes for his work, and by cross-referencing or simply storing these objects together in one room, new categories emerge for particular projects (fig. 4). The sheen or patina of each category is what interested Warhol most deeply—the "gloss" on how a category came to be—and often, the category's "cover" is what Warhol would use to produce a work of art.

His interest in the interrelatedness of cultural objects carried over to people as well. Warhol collected the people who walked into the Factory as he would items, whether

they be the delivery boy, superstar or, later on, celebrity. He was interested not simply in "types," as in, for example, the descriptive qualities of a "hustler," but in the more complex notion of typology, in other words, how a certain "personality" or "product" could be classified by recurring sets of relations (for instance, "hustling"). Warhol observed that "it was fun to see the Museum of Modern Art people next to the teeny-boppers next to the amphetamine queens next to the fashion editors."[12]

Not surprisingly, "AW" is one of the most fluid types in the sound archives. It stands for, above all, Andy Warhol. But in intoning both the concepts of author and sound designer, through taped and "typed" repetition (as in *a: A Novel*), AW points not to the person Andy Warhol but to the extremely complex category that this brand name has come to represent. AW stands in for something and someone else. In the same way that Paul Johnson was made into Paul America, or Joe Campbell into Jim Beam, in *a: A Novel*, Andy Warhol becomes AW, a marketing tool, a prosthetic, a valued commodity, an industry.[13] AW, as a category, lies at the centre of Warhol's audio archive. By incorporating the knowledge deployed in reference to it, the archive is expanded exponentially. Its repetition and its distance from itself throw it into analytic mode. It is constantly processing the relationship between past and future. Warhol's frequent referencing of himself in the third person is a key strategy in his relational aesthetics, as the following dialogue between Ondine and Warhol demonstrates:

Warhol Wait, I've gotta mark this A.W.
Ondine Oh my, A . . .
Warhol Yes.
Ondine Oh my crud, A.W. stands for
Andy Warhol too.
Warhol Didn't you know that?
Ondine No, I just got—(laughter).
It also means "all woman." And, "all witch."
What is all this here?
Warhol That is . . . the new camera. The new
camera for our television serial.[14]

It is no coincidence that the introduction of AW into the audio archive is coupled with the arrival of new technology (here, the latest Sony video camera). It is only through forms of media that we come to know the category "Andy Warhol." Likewise, his discovery of Pop happened by observing the reflexivity, the transparency of American "types"—a differentiation that also connoted the interrelatedness of signs or indices. Warhol's attention to literal "signs" on the roadside of America also carries with it an awareness of the indexical: "Once you 'got' Pop, you could never see a sign the same way again. Once you thought Pop, you could never see America the same way again."[15] Rather than being a utopian equivalence of groups or products, it is precisely this "outsideness" of a category (expressed most poignantly with his own acronym, AW), its relational quality, that Warhol's archival collections (and archival voyeurism) could reveal to him.[16] The relationship of "chance" to "type" is a trope throughout the tapes, and can be situated historically in several different aesthetic paradigms already at work around Warhol during this period (and beginning as early as the 1950s). One such model existed in the field of electronic music and sound. Experimentation with tape recorders, loudspeakers, mixing boards, synthesizers and radio across the works of John Cage, Pierre Schaeffer, La Monte Young and Steve Reich spurred Warhol to rethink relationships of time and space, sound and text, and recorded event and score.[17]

INDEX

Warhol's *Index (Book)* (1967), *a: A Novel* (1968), Screen Tests, Time Capsules, private object and art-based collections, photographs and audio recordings are products of an aesthetics of the index that had a strong impact on Warhol's work in the mid-1960s. While Warhol certainly played with an art of bureaucracy or, as he liked to say, "art as business," it wasn't the act, per se, of cataloguing that fuelled his imagination, but rather the displacement of aesthetic response that the index could bring to something that seemed impossible to order or name. As Rosalind Krauss reveals in her "Notes on the Index" (1977), "By index I mean that type of sign which arises as the physical manifestation of a cause, of which traces, imprints, and clues are examples."[18] In other words, it is something that promises a physical presence, "like a weather vane's registration of the wind," but unlike a weather vane, which "acts culturally to code a natural phenomenon,"[19] or a file folder that gathers and marks information to be filed, the index remains uncoded. Warhol says the same about his concept of the superstar or hyperstar: "whatever you can call all the people who are very talented, but whose talents are hard to define and almost impossible to market."[20] Indeed, his *Index (Book)* (1967)—a compilation of interviews, art inserts, pop-ups, photographs, a flexi disc, and descriptions of life at the Factory—conceptually maps the various databases (textual, audio, filmic, photographic, ethnographic) that Warhol had created over the course of his career up until the late 1960s. It also served as a template for future projects, offering a preview of other time-based, indexical projects such as his recorded novel.[21]

At least two interrelated models of the index exist from this period. One model is exemplified here by Warhol, but many others that intersected and followed may also be included, such as Ed Ruscha's photographs of collections of gasoline stations, parking lots, and so on (1962–78), Claes Oldenburg's *Mouse Museum / Ray Gun Wing* (1972), Christian Boltanski's *Storehouse* (1988), and Fred Wilson's *Mining the Museum* (1992–93), to name a few in which notions of the archival and the museum collection are overturned by critical frames that recognize the power of naming, categorizing and contextualizing knowledge within the purview of the museum, gallery and other art contexts, and, as Warhol's archival work has demonstrated, in larger cultural and social spheres. The other model of the index that is most prevalent in postwar art is equally cognizant of the discursive power of knowledge organization, but mimics more directly the kind of cataloguing systems associated with businesses, governments and libraries. For instance, the conceptual group Art and Language's *Index 01* (which made its debut in documenta 5 in 1972) was comprised of eight metal filing cabinets filled with documents and arranged according to a posted index designated to articulate the relationships between eighty-six texts authored by Art and Language.[22] Like Warhol, Art and Language self-catalogued the breadth and depth of their own art production, thus confounding the definitions between art and criticism, private and public forms of organization, and embodied and disembodied information. Through very different approaches, the two models pointed the way towards aesthetics of reference, index and collection that began to be mapped in both conventional and unpredictable ways.

In a sense, the indexical relationships that emerge from Warhol's recordings beginning in the mid-1950s inform the more public mode of "transfer" that he displays through his photo-stencilled silkscreen prints that begin in the early 1960s. The notion of "deferred portraits"—images produced by casting one medium onto another—is both referred to by those being recorded and commented on by Warhol as he is recording. It is no coincidence that Brigid Berlin asks Warhol about the transfer of Polaroid to film,

FIG. 1 – Telephone, 1982 (cat. 290) FIG. 2 – Andy Warhol recording Brigid Berlin on the telephone, early 1970s. Photo Billy Name FIG. 3 – The Time Capsules, housed at the Andy Warhol Museum Archives, Pittsburgh. Photo Richard Stoner

FIG. 4 – Andy Warhol's dining room shortly after his death, 1987. Photo Evelyn Hofer

or that Ondine, in *a: A Novel*, suggests that the "book could be a tape," or that instead of installing a mirror in her bedroom, Warhol encourages Andrea Feldman to let him do a ceiling painting for her.[23] In fact, Warhol's audio archive documents the history of intermedia experiments performed in and outside the Factory from its inception to its end. The tape recorder, phonograph, telephone, television, video camera and monitor, novel, magazine and advertisement all make recurring appearances, often in light of one another, in the service of transmitting a new kind of image or sound. One consistent "type" of work that these technologies record and reproduce is the "portrait." Indeed, Victor Bockris calls *a: A Novel* a series of voice portraits: "This way, the interviewer will get the most accurate and revealing image of the subject via the topics he or she chooses to discuss, as well as the grammar, syntax and vocabulary used. If a tape is transcribed very accurately with each 'uhm,' 'err' and 'but' included, what is redacted is a voice portrait."[24]

Indeed, these early "voice portraits" need to be read along with critical accounts of the 1970s celebrity portraits, especially since they were presented, side by side, in early issues of *Interview*.[25] But to retain a kind of formal comparison between "these two portrait forms," as Bockris does, is to reduce Warhol's deconstruction of the very category of "portraiture." By radically rethinking the traditional media (paint, graphite, photography) and aim of portraiture (a likeness) through sound, Warhol was pointing towards audio recording in the same way Krauss was thinking about photography in the 1970s. That it was—against all odds—becoming the new abstraction. Warhol's ability to pose radical excess against extreme evacuation encouraged the collapse of the definitive lines of portraiture. As he presents to the public in his *Index (Book)*, the excess product of all his procedures has a profound relationship to an ultimately unpopulated "blank" page. Black, blank pages are juxtaposed against overly saturated texts with photographs and Pop graphics. This visual tableau is repeated in audio form on the *Index* flexi disc, which, in its running time (4 min 33 s), intones John Cage's important redefinition of silence as ambient sound as demonstrated in his composition *4'33"* (1952).[26] But, it is not only the silence that Cage is rethinking through ambient sound or duration, but also a reflexive brutality, a quiet negation located in the process of naming, of indexing itself.

This brief essay is excerpted from the author's larger, forthcoming book-length project, Readymade Sound: Andy Warhol's Recording Aesthetics.

1 On the Andy Warhol Museum website, the Time Capsules are described as "this serial work, spanning a thirty-year period from the early 1960s to the late 1980s, consists of 610 standard-sized cardboard boxes, which Warhol, beginning in 1974, filled, sealed and sent to storage. Warhol used these boxes to manage the bewildering quantity of material that routinely passed through his life. Photographs, newspapers and magazines, fan letters, business and personal correspondence, artwork, source images for artwork, books, exhibition catalogues, and telephone messages, along with objects and countless examples of ephemera, such as announcements for poetry readings and dinner invitations, were placed on an almost daily basis into a box kept conveniently next to his desk." http://www.warhol.org/collections/archives.html
2 Emil de Antonio also interviewed Warhol in his renowned film *Painters Painting* (1972), in which Willem de Kooning, Jasper Johns, Robert Rauschenberg, Helen Frankenthaler, Frank Stella, Barnett Newman, Hans Hofmann, Robert Motherwell, Larry Poons, Jules Olitski, Philip Pavia and Kenneth Noland also appear.
3 Andy Warhol, *The Philosophy of Andy Warhol: From A to B and Back Again* (New York: Harcourt Brace, 1975), 199.
4 Jacques Derrida, *Archive Fever: A Freudian Impression* (Chicago: University of Chicago Press, 1996), 25.
5 Reva Wolf, *Andy Warhol, Poetry, and Gossip in the 1960s* (Chicago: University of Chicago Press, 1997), 7.
6 Ibid.
7 Ibid., 1.
8 Ibid., 8.
9 Lev Manovich, *The Language of New Media* (Cambridge, Massachusetts: MIT Press, 2001), 225.
10 Benjamin Buchloh, *Neo-Avantgarde and Culture Industry: Essays on European and American Art from 1955 to 1975* (Cambridge, Massachusetts: MIT Press, 2000), 466.
11 One of the most extensive sections of Warhol's audio archive includes phone conversations between Warhol and Brigid Berlin (aka Brigid Polk). Berlin, herself an avid recorder, sometimes incorporated the tapes into her performances. As Warhol recalls, "the running joke between Brigid and me was that all our phone calls started with whoever'd been called by the other saying, 'Hello, wait a minute,' and running to plug in and hook up." Andy Warhol and Pat Hackett, *Popism: The Warhol Sixties* (New York: Harvest Books, 1980), 367.
12 Ibid., 162.
13 As Victor Bockris notes in his glossary to *a: A Novel,* Billy Name, instructed by Warhol, changed many proper names in the "novel" and disguised them with Warhol Factory names or other playful monikers. For instance, Joe Campbell is changed to Sugar. At other times his full name, while spoken in exchanges on the original tapes for *a: A Novel,* is changed in the text to either Sugar Plum Fairy (his Factory name) or Jim Beam (by referring to America's top-selling bourbon at the time). Similarly, Paul Johnson is renamed Paul America. The play on substituting commodity brands or country names for people's identities underscores Warhol's skill and interest in constructing categories.
14 Ondine and Warhol in conversation on one of the tapes used by Warhol for *a: A Novel* (New York: Grove Press, 1968): Archives of the Andy Warhol Museum, Pittsburgh, Tape 1223, A (New York: 1966).
15 Ibid., 39.
16 I am thinking of Gilles Deleuze's use of C. S. Pierce's notion of Thirdness as a way of defining the "outside-ness" of a category or typology: "Thirdness perhaps finds its most adequate representation in relation; for relation is always third, being necessarily external to its terms" (*Cinema 1: The Movement Image* [Minneapolis: University of Minnesota Press, 1986], 197.)

17 Warhol was familiar with experiments in overtone as practiced by La Monte Young. As Branden Joseph has noted in this volume and elsewhere, Warhol was in an early band with Young, and Young's *Composition, 1960 #9* accompanied a quartet of Warhol's durational films in 1964 at the New York Film Festival at Lincoln Center. For a more in-depth discussion of this early collaboration between Warhol and Young, see Branden Joseph's "'My Mind Split Open': Andy Warhol's Exploding Plastic Inevitable," *Grey Room*, no. 8 (Summer 2002), 80–107. In the author's forthcoming book manuscript, *Readymade Sound: Andy Warhol's Recording Aesthetics*, she argues that Warhol was also aware of Steve Reich's tape-phasing projects as exemplified in his early works *It's Gonna Rain* (1965) and *Come Out* (1966). In *Music as a Gradual Process* (1968), Reich advocates the use of compositional processes that are clearly audible to the listener. He argues that in order to facilitate closely detailed listening, a musical process must happen extremely gradually, like the movement of the minute hand on a watch or the slow trickling of sand through an hourglass. The first type of gradual process that Reich explored was that of moving a rhythmic pattern out of phase with itself. This idea developed out of Reich's experiments with taped music. In 1965 *(It's Gonna Rain)* he recorded the voice of a black preacher in San Francisco, and later in the studio selected a short phrase and ran two tape loops of it on supposedly identical tape machines. Because of minute differences between the two machines, the phrase was heard marginally out of synchronization with itself. In *Readymade Sound*, the author argues that Warhol uses a phasing model to think about his experiments in transfer and relay across silkscreening and audio recording.
18 Rosalind E. Krauss, "Notes on the Index: Part 2" (1977), in *The Originality of the Avant-Garde and Other Modernist Myths* (Cambridge, Massachusetts: MIT Press, 1996), 211.
19 Ibid.
20 Warhol 1975, 92.
21 Martin Wattenberg, Ben Fry, Warren Sack and Christian Nold all engage, to some extent, in the emerging field of Information Visualization—the practice of mapping overwhelming amounts of information into comprehensible visual forms. In the larger scope of *Readymade Sound*, the author intends to show how Warhol was already experimenting with this mode of visualization well before extensive computer technology. For a more developed discussion of Information Visualization within contemporary art, see Warren Sack, "Aesthetics of Information Visualization," in Christiane Paul, ed., *Context Providers* (Minneapolis, Minnesota: University of Minnesota Press, forthcoming).
22 Ibid., 11.
23 "Well, why can't you just transfer [a Polaroid] onto a reel of movie film? And then just put it through a projector?" Brigid Berlin in a telephone conversation with Andy Warhol. Archives at the Andy Warhol Museum, Pittsburgh, Tape 3384, 9/9 (New York: 1968). In another phone conversation with Andrea Feldman (on the same tape), Warhol promises to paint Feldman a "blonde landscape with a little river running through it." Ondine, in *a: A Novel* (1968), refers to Warhol's purported 24-hour recording of him as a "book tape."
24 Victor Bockris, "Andy Warhol: The Writer," in Colin McCabe, ed., *Who Is Andy Warhol?* (London: British Film Institute, 1997).
25 Liz Kotz makes a similar argument in "An Aesthetics of the Index?" in *Dia's Andy* (New York: Dia Art Foundation, 2005), 6.
26 See the flexi disc in *Andy Warhol's Index (Book)* (New York: Black Star Books, 1967).

3

PROD

UCER

ALL HERE AND NOW AND THE FUTURE . . . THEN: ANDY WARHOL'S EXPLODING PLASTIC INEVITABLE The origin of Andy Warhol's foray into the world of expanded cinema and multimedia happenings can be traced to a night in late December of 1965, when Warhol first met the Velvet Underground following one of their performances at Café Bizarre, in Greenwich Village; he immediately offered them rehearsal space at the Factory and his services as manager. Warhol imposed the German pop chanteuse Nico on the band, making her its singer/front person, and on January 13, 1966, the Velvet Underground and Nico played their first show to the unlikely audience of 350 members of the New York Society for Clinical Psychiatry. The sensory assault on this black-tie affair consisted of the music of the Velvets, the dancing of Edie Sedgwick and Gerard Malanga, and the aggressive interrogation and filming techniques of filmmakers Barbara Rubin and Jonas Mekas. Aiming movie cameras and lights in the faces of the audience members, Rubin and Mekas asked the psychiatrists pointed questions about their sex lives and provoked them with confrontational statements. Andy Warhol Up-Tight was born that evening. The second event of the projected Up-Tight series ran for a week in early February at the Film-Makers' Cinematheque; shows subsequently continued through March with appearances at Rutgers University in Camden, New Jersey, and the University of Michigan in Ann Arbor. Press releases and posters announcing these performances indicate that films, including *Lupe, Vinyl* and *More Milk, Yvette,* were screened before the band played. Rubin and associates continued to provoke the crowd and film their reactions while the Velvets were on stage. The Exploding Plastic Inevitable (EPI) debuted in New York at the Dom, a Polish meeting hall on St. Mark's Place that Warhol had rented for the entire month of April. The evolution of the Up-Tight performances into the EPI was directly related to Barbara Rubin's departure from the entourage and to Warhol's push for an even more excessive visual overload. The antagonistic personal confrontations that were integral to the Up-Tight shows evolved into a more impersonal inter-action in the EPI. Films were now projected simultaneously, and the use of bombastic light work increased. Older films such as *Eat, Harlot, Couch, Mario Banana, Sleep, Empire, Kiss, Hedy* and *Blow Job* were shown along with new EPI material, which included *Whips I* and *Whips II, The Velvet Underground, The Velvet Underground Tarot Cards* and dozens of Screen Test portraits of the band members. Warhol compiled numerous EPI Background reels using these short portraits. Danny Williams helped orchestrate the light show with strobes, spotlights and assorted coloured gels, and mattes; Jackie Cassen created hand-made psychedelic slides; Gerard Malanga, Mary Woronov and Ingrid Superstar added more sadomasochistic theatrics to their dance routines; and the Velvet Underground and Nico continued performing their proto-punk songs and avant-rock improvisations at ear-splitting volume. In May of 1966, the EPI hit the road, becoming the first travelling cinema-band. They presented their collective media chaos to audiences in Los Angeles, San Francisco, Chicago, Detroit, Columbus, Cleveland, Cincinnati, Philadelphia, Boston, Provincetown and Providence. Their final shows were held at home in New York in the spring of 1967 at the Gymnasium, on the Lower East Side, in April, and at Steve Paul's midtown club, the Scene, in May. **G.P.**

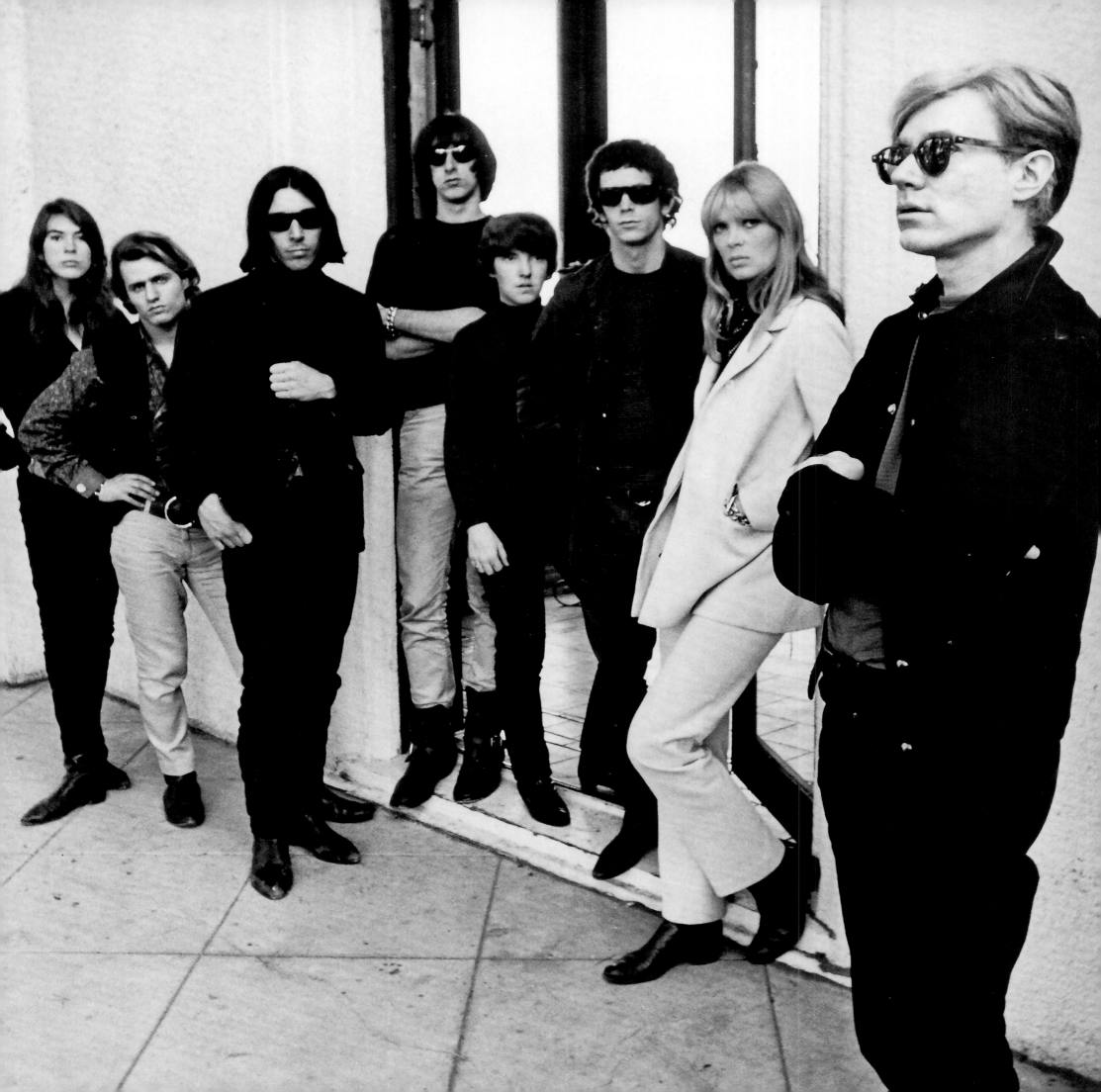

THE BAND

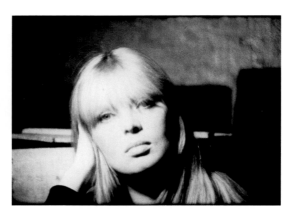

191

189

186

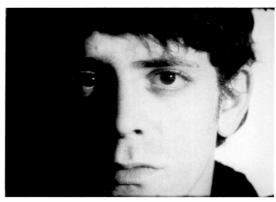

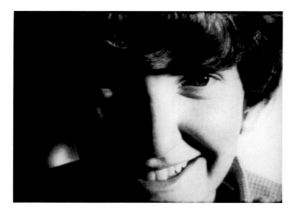

184

188

191 — *Screen Test: Sterling Morrison*, 1966 **186** — *Screen Test: Lou Reed*, 1966 **184** — *Screen Test: John Cale*, 1966 **188** — *Screen Test: Maureen Tucker*, 1966 **189** — *Screen Test: Nico*, 1966

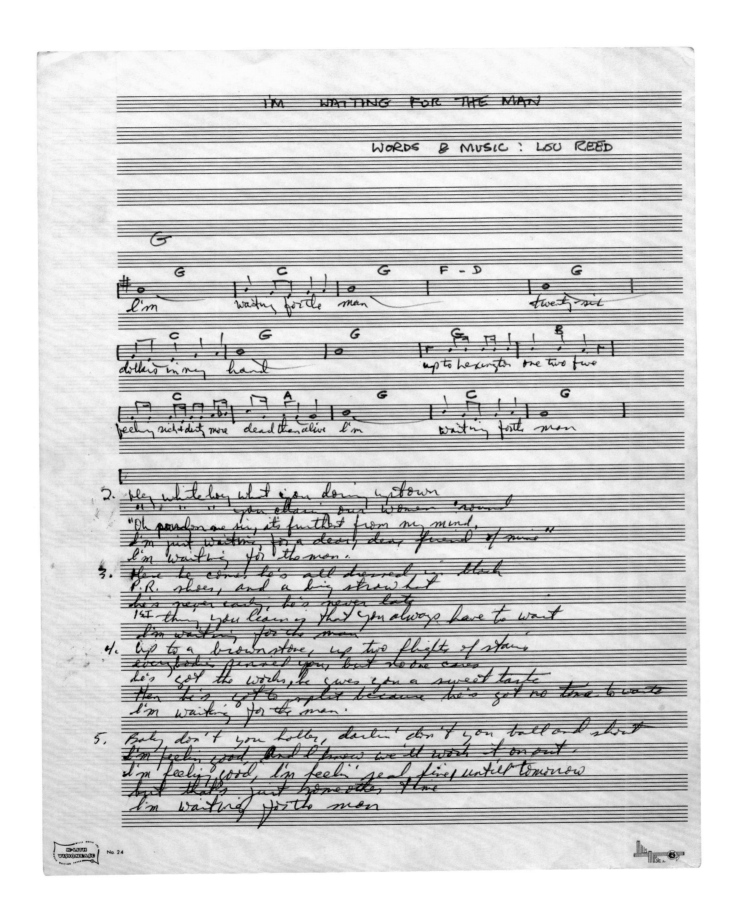

472 – Lou Reed's handwritten music and lyrics for "I'm Waiting for the Man," on the album *The Velvet Underground & Nico* (1967)

THE SOUND

451

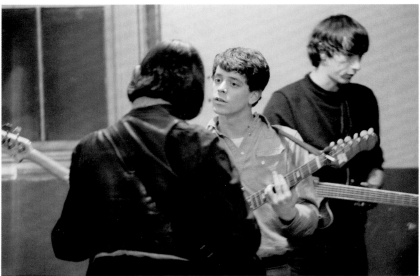

448

447

449

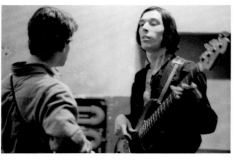

450

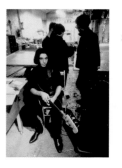

44

45

452

46

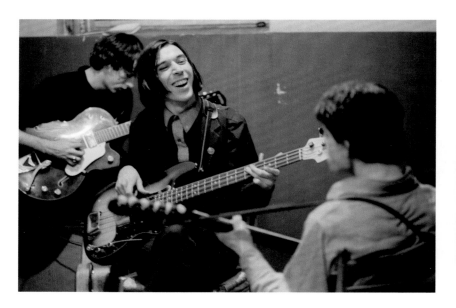

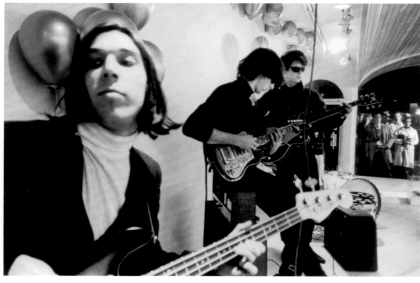

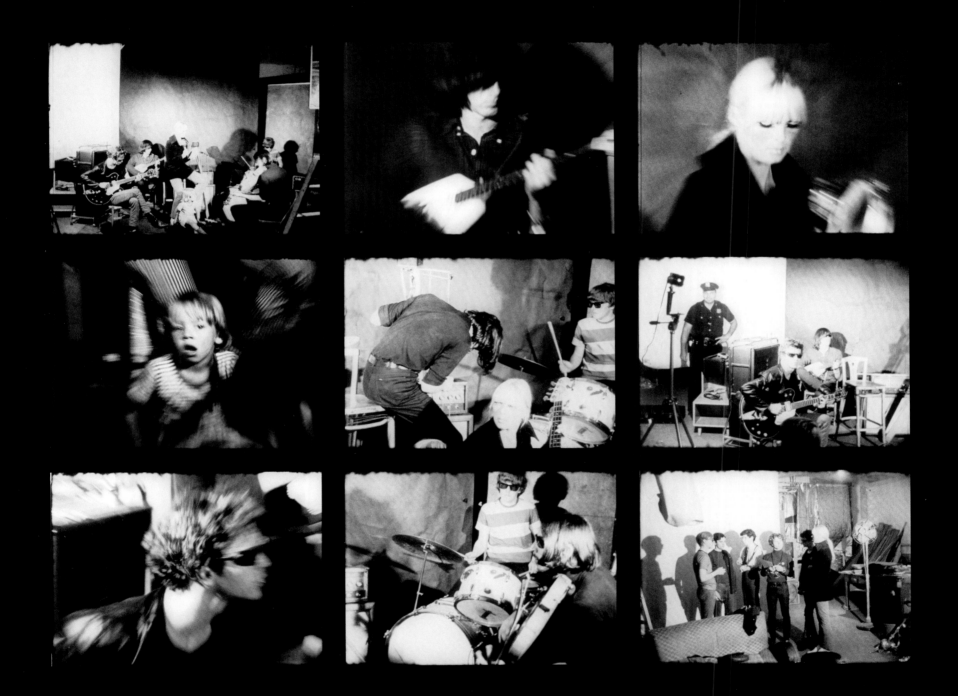

322–369 – Slides used in the light shows at Warhol's Exploding Plastic Inevitable events, about 1967–68

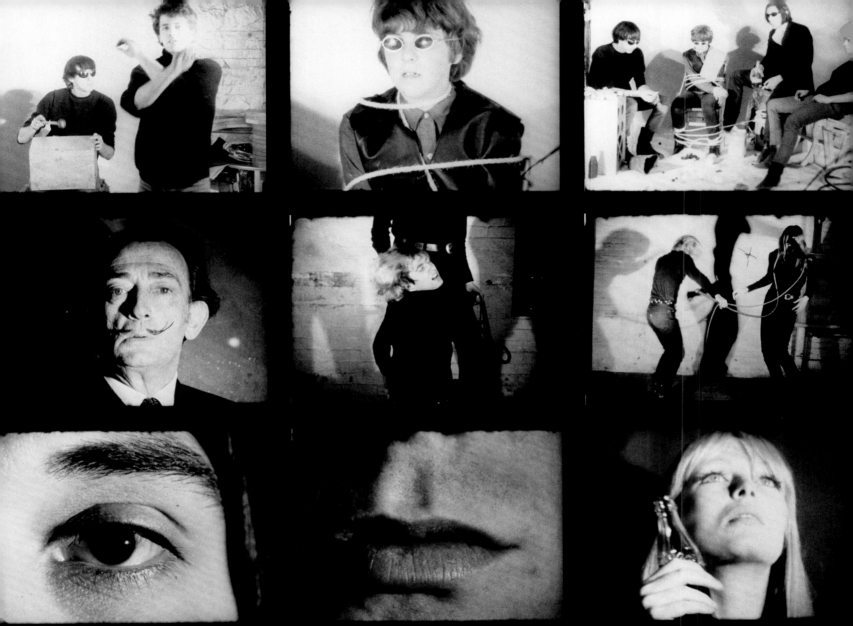

The Velvet Underground and Nico, 1966 **183** EPI Background, Original Salvador Dalí, 1966 EPI Background, Velvet Underground, 1966 **185** Screen Test: John Cale (Eye) **187** Screen Test: Lou Reed (Li

343 — A slide used in the light shows at Warhol's Exploding Plastic Inevitable events, about 1967

354 – A slide used in the light shows at Warhol's Exploding Plastic Inevitable events, about 1967

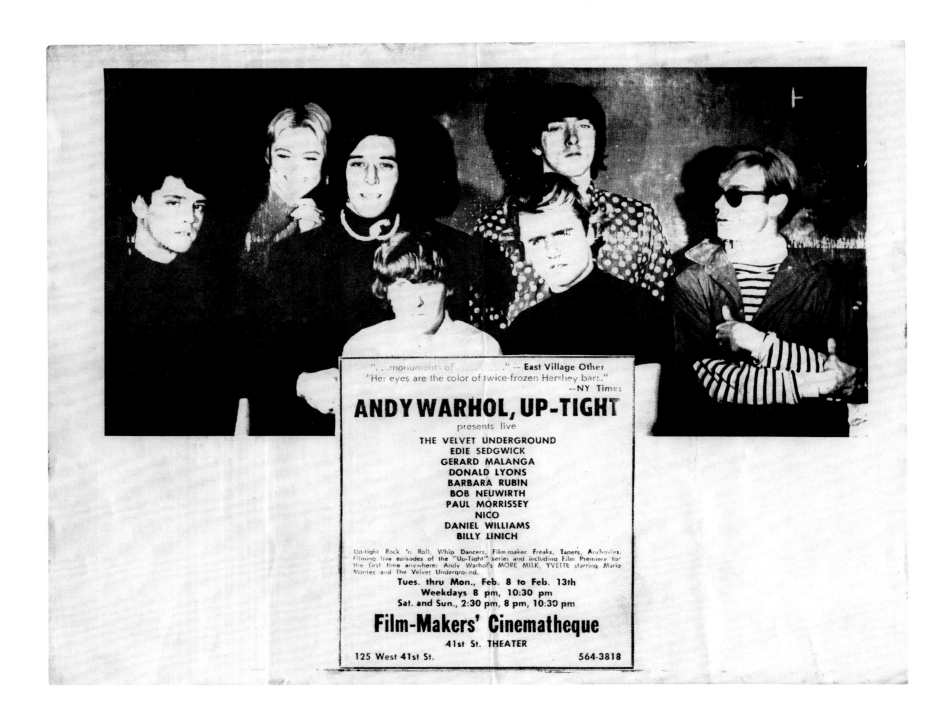

The Velvet Underground text:

"...monuments of" — East Village Other
"Her eyes are the color of twice-frozen Hershey bars."
—NY Times

ANDY WARHOL, UP-TIGHT

presents live

THE VELVET UNDERGROUND
EDIE SEDGWICK
GERARD MALANGA
DONALD LYONS
BARBARA RUBIN
BOB NEUWIRTH
PAUL MORRISSEY
NICO
DANIEL WILLIAMS
BILLY LINICH

Up-tight Rock 'n Roll, Whip Dancers, Film-maker Freaks, Tapers, Anchovies. Filming live episodes of the "Up-Tight" series and including Film Premiere for the first time anywhere: Andy Warhol's MORE MILK, YVETTE starring Mario Montez and The Velvet Underground.

Tues. thru Mon., Feb. 8 to Feb. 13th
Weekdays 8 pm, 10:30 pm
Sat. and Sun., 2:30 pm, 8 pm, 10:30 pm

Film-Makers' Cinematheque

41st St. THEATER

125 West 41st St. 564-3818

60 – Concert announcement for Andy Warhol's Up-Tight at the Film-Makers' Cinematheque, New York, February 8–13, 1966

59 — Concert poster for the Exploding Plastic Inevitable at the Dom, 23 St. Mark's Place, New York, 1966

75

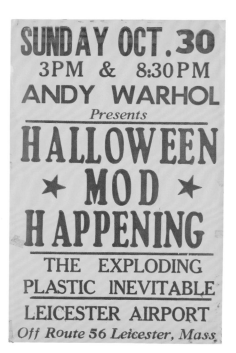

63

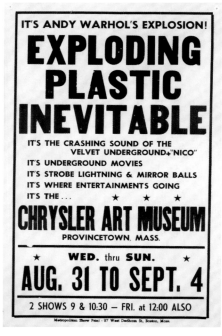

65

64

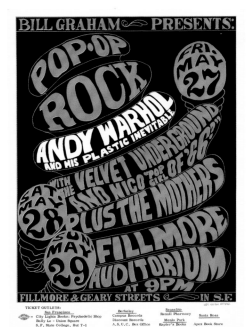

66

69

70

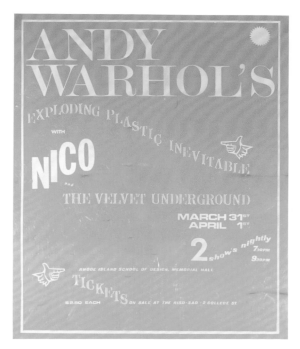

71

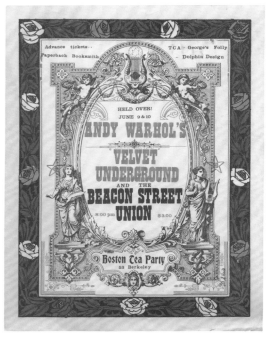

Concert posters for the American tour of the Exploding Plastic Inevitable with the Velvet Underground and Nico: San Francisco, Chicago, Provincetown, Leicester, Philadelphia, Rhode Island, Boston, 1966—67

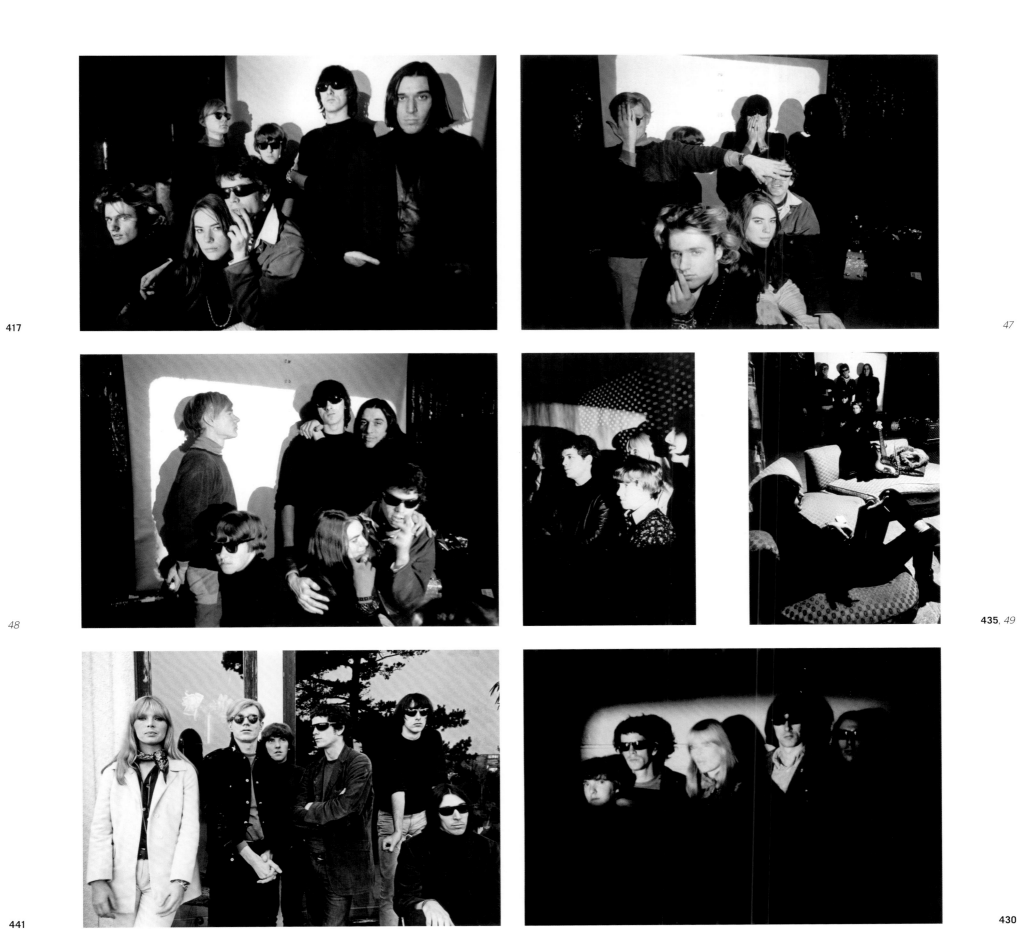

417 – Gerard Malanga, Mary Woronov, Andy Warhol, and the Velvet Underground, 1966. Photo Nat Finkelstein 47 – The Velvet Underground with Andy Warhol, Gerard Malanga and Mary Woronov, 1966. Photo Nat Finkelstein
48 – The Velvet Underground with Andy Warhol and Mary Woronov, 1966. Photo Nat Finkelstein 435 – The Velvet Underground and Nico, about 1967. Photo Billy Name 49 – Sterling Morrison on Factory couch, about 1966. Photo
Nat Finkelstein 441 – Nico, Warhol and the Velvet Underground, Los Angeles, 1966. Photo Steve Schapiro 430 – The Velvet Underground and Nico, 1966–67. Photo Billy Name

THE SHOW

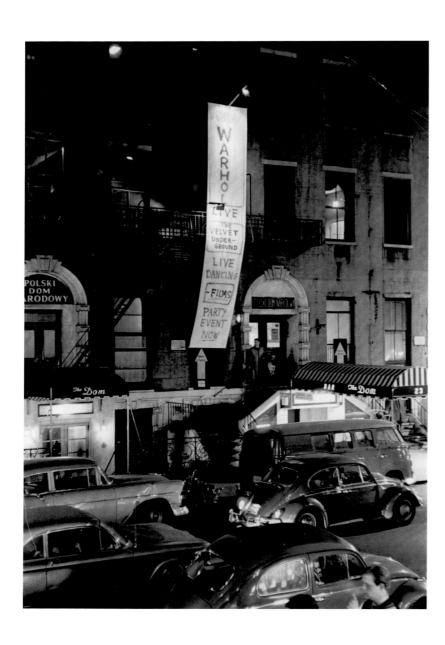

50 – The Dom (Polski Dom Narodowy), 23 St. Mark's Place, presenting a Velvet Underground show produced by Andy Warhol, March 31, 1966. Photo Fred W. McDarrah **557** – *The Dom (April 1966)*, sketch attributed to Ingrid Superstar: Exploding Plastic Inevitable show at the Dom, with (from l. to r.) Mo "Mu" [Tucker], John Cale, "Stella" [Morrison], "Lois (LuLu)" [Reed], Nico and Andy Warhol, in what appears to be the projection booth overlooking them all

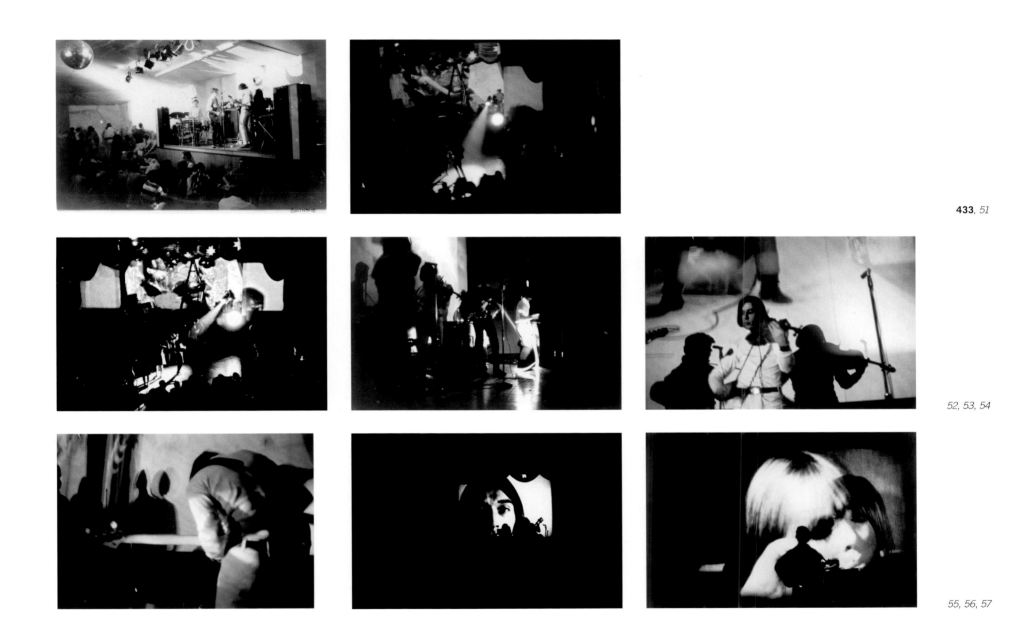

433, *51*

52, *53*, *54*

55, *56*, *57*

433 – The Velvet Underground at the Gymnasium, New York, 1967. Photo Billy Name *51* – Danny Williams at light projector, the Dom, 1966. Photo Nat Finkelstein *52* – Danny Williams at light projector, the Dom, 1966. Photo Nat Finkelstein *53* – The Velvet Underground on stage, about 1966. Photo Nat Finkelstein *54* – John Cale with electric viola, Rutgers University, New Jersey, 1966. Photo Nat Finkelstein *55* – John Cale at Rutgers University, New Jersey, 1966. Photo Nat Finkelstein *56* – Projection of John Cale's face, the Dom, 1966. Photo Nat Finkelstein *57* – Projection of Nico's face, the Dom, 1966. Photo Nat Finkelstein

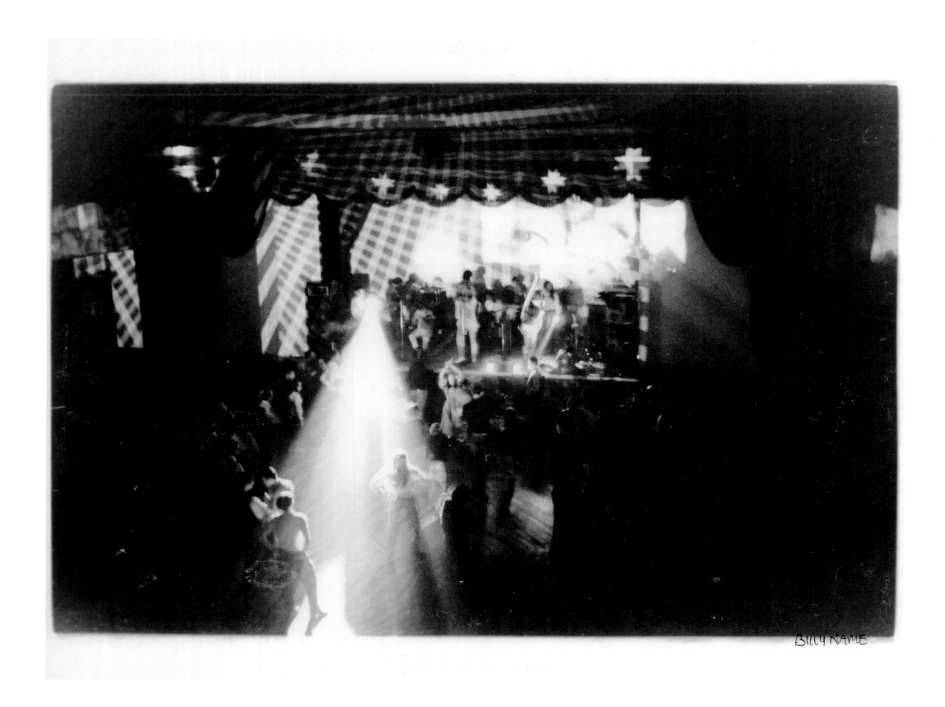

425 – The Velvet Underground and Nico at the Dom, 1966. Photo Billy Name

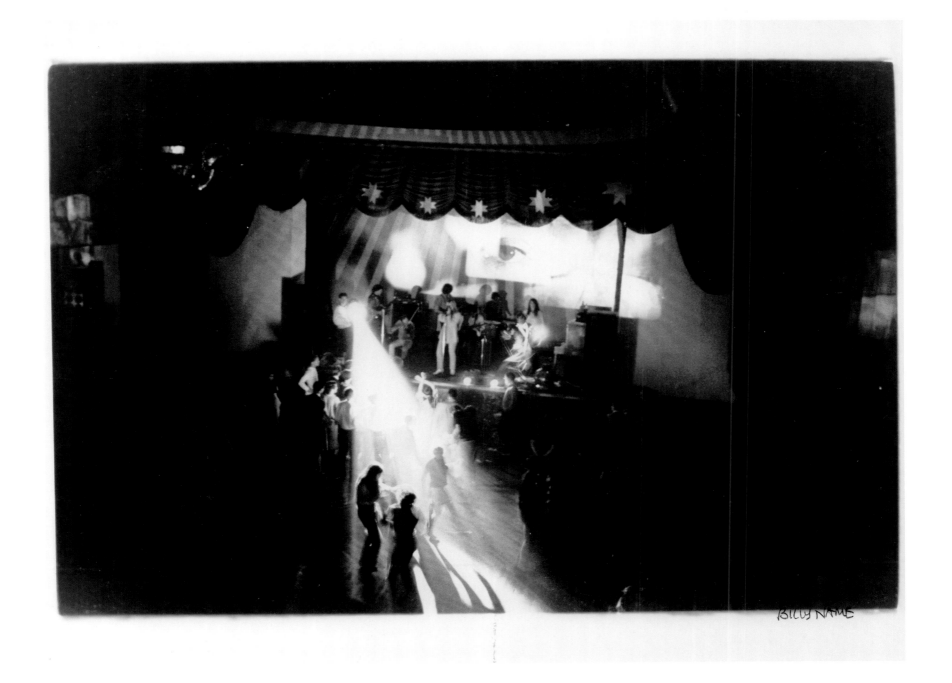

426 – The Velvet Underground and Nico at the Dom, 1966. Photo Billy Name

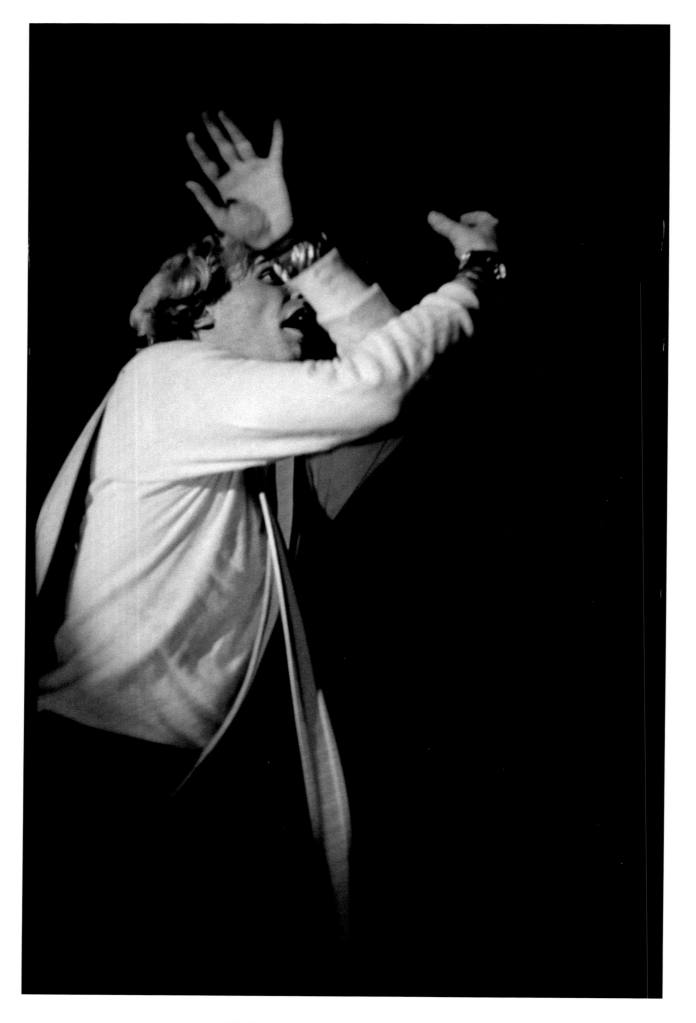

58 – Gerard Malanga dances, about 1966. Photo Nat Finkelstein

59 – John Cale at Rutgers University, New Jersey, 1966. Photo Nat Finkelstein

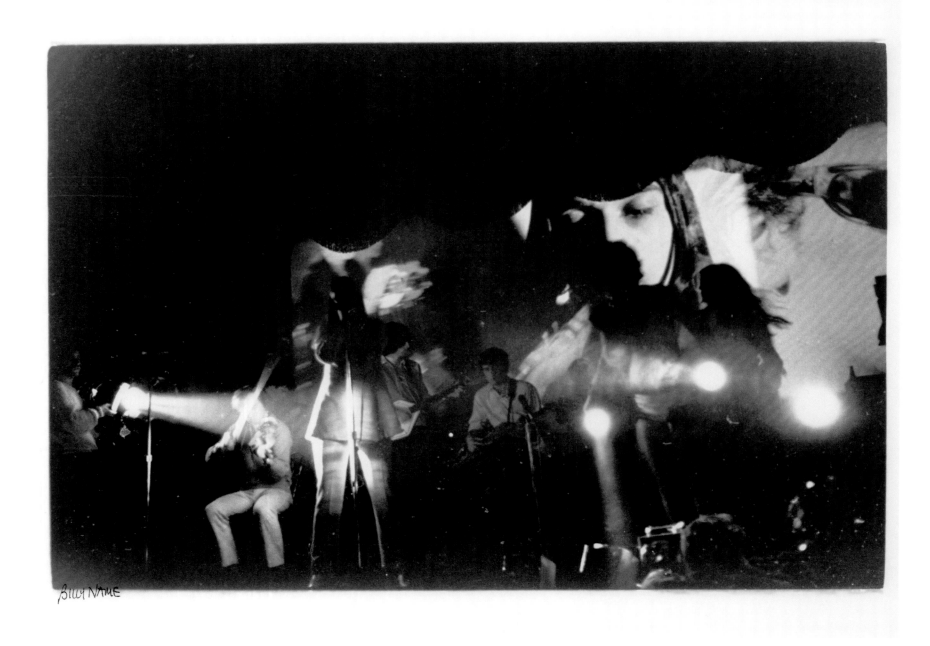

60 – The Velvet Underground and Nico at the Dom, 1966. Photo Billy Name

61 — Mary Woronov and the Velvet Underground on stage at the Dom, 1966. Photo Nat Finkelstein

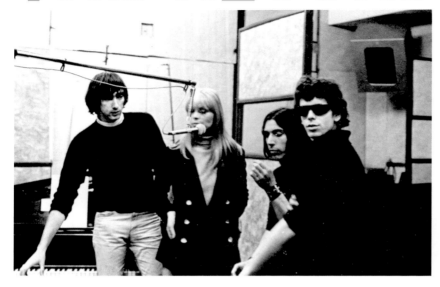

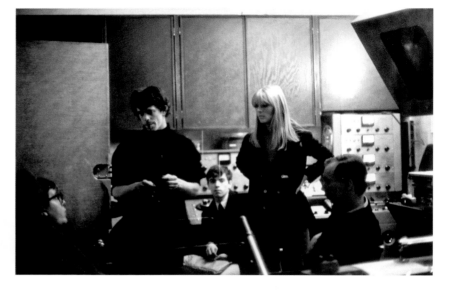

62

63

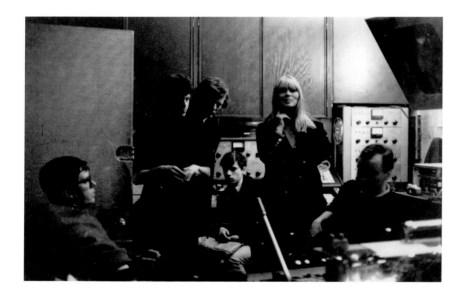

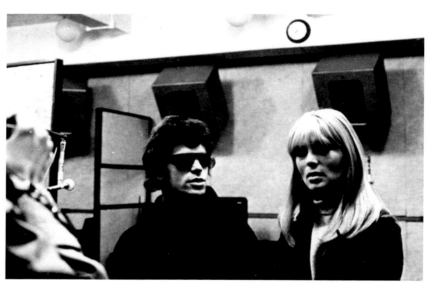

418

64

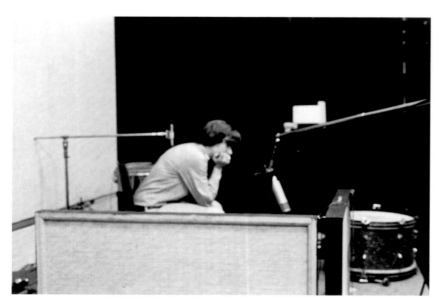

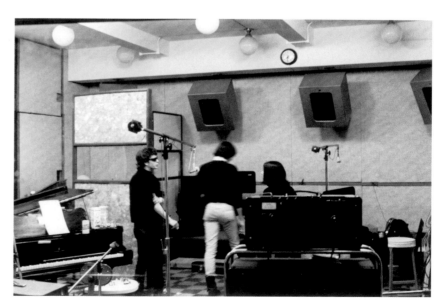

65

66

Recording of the album *The Velvet Underground & Nico*, Los Angeles, 1966: "*All Tomorrow's Parties*" 64 – Lou Reed, Nico 65 – Maureen Tucker 62 – Sterling Morrison, Nico, John Cale, Lou Reed 66 – Lou Reed, Sterling Morrison, John Cale (?) 63 – Lou Reed, Nico Photos Nat Finkelstein **418** – Lou Reed, Paul Morrissey and Nico listening to the recording of

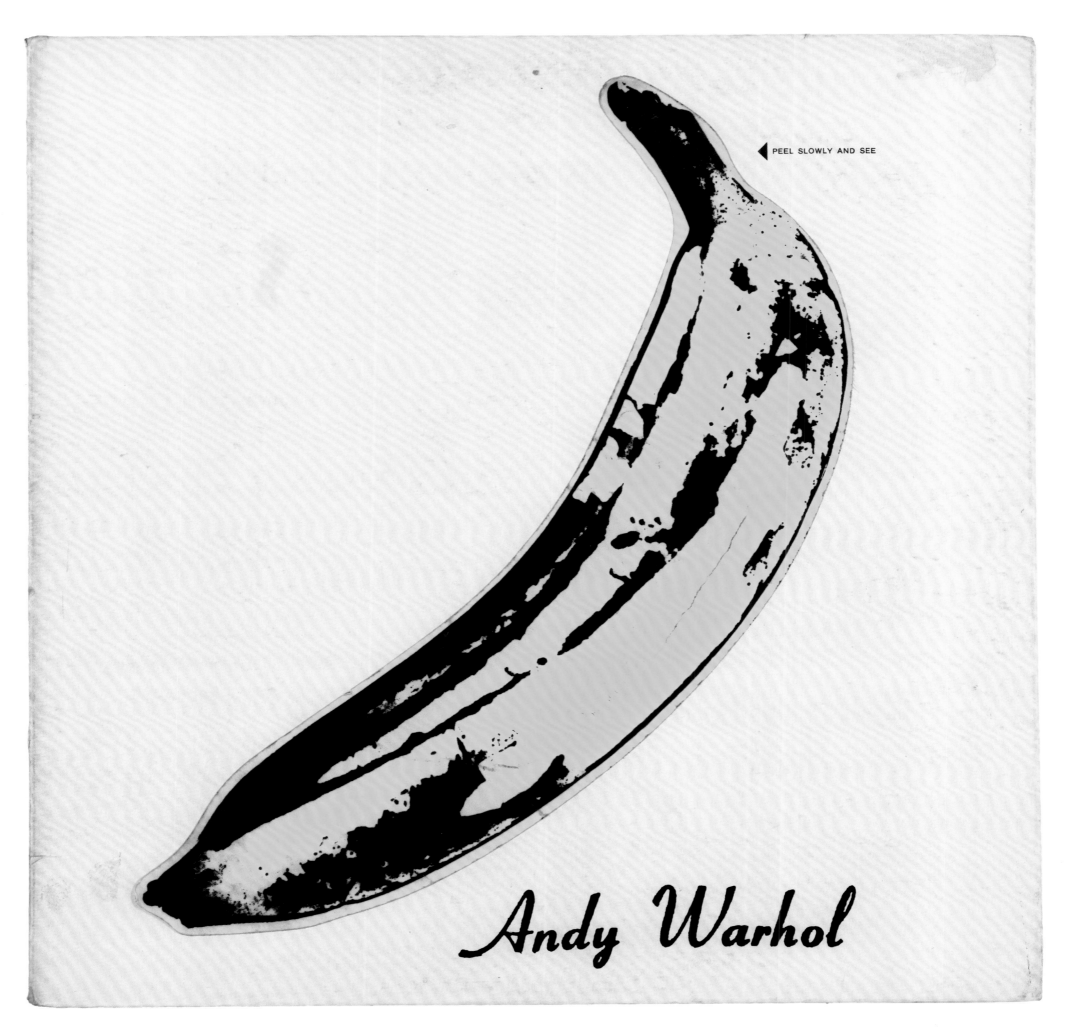

PEEL SLOWLY AND SEE

Andy Warhol

32 – *The Velvet Underground & Nico* record cover, 1967 (recto)

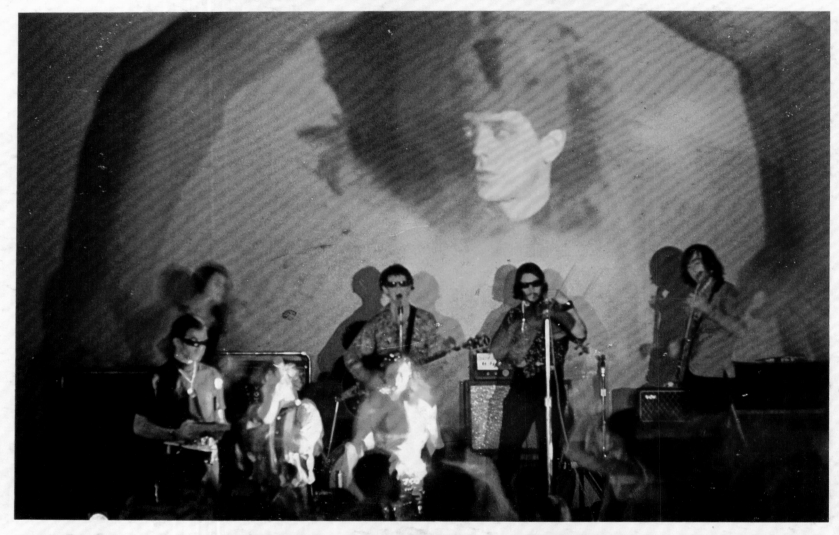

THE VELVET UNDERGROUND & NICO
PRODUCED BY ANDY WARHOL

®© Metro-Goldwyn-Mayer Inc./Printed in U.S.A.

V-5008

32 – *The Velvet Underground & Nico* record cover, 1967 (verso)

475 – Three unused Banana stickers for *The Velvet Underground & Nico* (1967) record cover, designed by Andy Warhol, about 1967 *67 – Banana*, 1966

WARHOL AND ROCK 'N' ROLL
Matt Wrbican

As a college student in the 1940s and throughout most of the 1950s, Andy Warhol developed an interest in many forms of music, including musical theatre, classical and opera. He had his first exposure to avant-garde music while he was a student, during one of John Cage's three visits to Outlines, Pittsburgh's only contemporary art gallery of the time.

Warhol's music library from the 1950s contains many recordings of Broadway tunes sung by Judy Garland, cabaret songs by Mabel Mercer and Eartha Kitt, classical composers such as Chopin and Brahms, opera, cha-cha, European popular music, and other styles. As the new music of rock and roll grew in popularity among American teenagers, Warhol gradually became a fan, reflecting his passion for youth culture. His music collection also includes early LPs by Elvis Presley, the Coasters, Fabian, the Shangri-Las, Bo Diddley and many other young stars of rock 'n' roll. A very rare publication in Warhol's archives is *Who's Who in Rock 'n Roll* (fig. 1), printed in 1958; it is a fairly comprehensive document listing and describing the stars of the day.

His first known artwork related to the new musical genre is an obscure painting from the mid-1950s of a pigtailed teenage girl joyfully listening to an important source for the new sound: her boxy radio with a large dial typical of the era. Simply titled *Rock and Roll,* it was commissioned by a corporation involved in the music business and is executed in a combination of Warhol's blotted line technique and oil paint on canvas. By 1963, Warhol filled the front room of the Ferus Gallery with his silkscreened silver full-length portraits of the King of rock and roll, Elvis Presley. Warhol's archives include several early publicity photos of Elvis, and the sheet music for Doc Pomus's song *Little Sister,* with Presley's image on the cover. A similar image was used by Warhol for a different portrait of Elvis, his face repeated in a nearly all-over grid screened in black on red; it was exhibited in Warhol's first Pop show in New York in 1962. Another object in Warhol's archives is a wall calendar for 1963 (fig. 2), with each month featuring the portrait of a different rock-and-roll star: Chubby Checker, Elvis and a few Europeans, as it was printed for the German market.

At the same time, Warhol attended star-studded concerts hosted by disc jockey Murray (the K) Kaufman, king of the New York City airwaves. A few years later, in 1965, Warhol was approached by the famous deejay to provide entertainment for a new club in New York; Warhol's search ended with the Velvet Underground. They were playing shows in a Greenwich Village tourist café, but the band was scaring away the customers, who were shocked by Lou Reed's repertory of songs such as "Heroin." The café's owner threatened to fire them if they performed "The Black Angel's Death Song" again, so obviously they broke into a truly inspired version of the offensive tune, and were hired by Warhol then and there. Their sound was a fusion of rock and roll and the avant-garde. Violist John Cale was classically trained but had recently worked with La Monte Young and was also one of the many pianists who had performed Erik Satie's *Vexations* in 1963. Guitarist Sterling Morrison loved rhythm and blues, and drummer Maureen Tucker was passionate for the drums of Babatunde Olatunji. Reed was a fan of old doo-wop vocal groups, the jazz saxophonist Ornette Coleman, and the poetry of his college mentor, Delmore Schwartz.

Warhol decided that they needed a contrasting element and added Nico as a singer. The band members resented this and did what they could to prove it was a bad idea. Nico—a German native who had recently recorded a forty-five single of a Bob Dylan song on Immediate Records, operated by Andrew Loog Oldham, the manager of the Rolling Stones—had been a fashion model and actress. Nico had also recently met Bob Dylan, who gave her one of his songs. She had difficulty with Reed's lyrics and staying in tune, but remained with the band that year before turning to a solo career, during which she became an iconic figure for the later Goth music scene. Initially, she sang along with an instrumental tape recording made by the band members, and then a series of guitarists, including Jackson Browne, were hired to accompany her until she discovered her instrument of choice, the harmonium. Over the following years, she recorded many LPs, several of which were beautifully produced by her old Velvets bandmate John Cale.

The Velvets were the focus of Warhol's attention in 1966, appearing in his films and especially his club shows. In January, they first gave an aggressive performance for a dinner of the New York Society for Clinical Psychiatry, with filmmakers Barbara Rubin and Jonas Mekas shoving cameras and bright hot lights into the faces of the society's formally attired members and inquiring about the details of their sex lives. This evolved into Andy Warhol Up-Tight, then the Exploding Plastic Inevitable, and the Gymnasium. The astute observer of pop culture phenomena Marshall McLuhan included a two-page spread of a photo of one of their live shows in his influential book, *The Medium is the Message.*

1

2

FIG. 1 – *Who's Who in Rock 'n Roll*, 1958 (cat. 542) FIG. 2 – *Teenager-Kalendar*, 1963

The Velvets' association with Warhol got them a recording contract with MGM/Verve in early May 1966, and also a product endorsement and equipment from Vox. Warhol of course designed the cover of their first LP, the famous banana of *The Velvet Underground and Nico* (1967), which was delayed in release because of legal action brought by Eric Emerson, one of Warhol's film Superstars. He failed to appear in court and the suit was dropped, but the damage to the band was done. MGM had tried a variety of ways to keep the recording in stores as the suit remained pending: they covered the offensive photo (which showed a film image of Emerson hovering above the band on stage—he claimed that he wasn't asked for permission) with stickers, and eventually airbrushed his image.

Warhol's concept was used for the Velvet Underground's second LP, *White Light/White Heat* (1968). An all-black cover actually reveals on closer inspection the printed image of a skull, a detail from one of Billy Name's photos of a man's tattoo; most of the LP's later printings eliminated the subtle black-on-black content. Their third album, *The Velvet Underground* (1969), was not designed by Warhol, but instead bears another of Billy Name's photos of the band members relaxing on a couch at Warhol's Factory.

With David Dalton, Warhol co-edited an issue of *Aspen* magazine in 1966. *Aspen* justifiably called itself "the magazine in a box"—Warhol's issue was printed to look like a box of "Fab" laundry detergent, and it was mainly devoted to rock and roll. It included three essays presenting different aspects of the rock scene: Lou Reed's "From the Bandstand (Life Among the Poobahs)," "From The Critic's Desk (Orpheus Plugs In)" by Robert Shelton of the *New York Times,* and "From The Dance Floor ('it's-the-on-ly-ra-dio-sta-tion / that's ne-ver-off-the-air . . .')" by Bob Chamberlain. The backs of each of these multi-page essays were printed with concert posters for James Brown, the Beatles, and photos of Bob Dylan, Phil Spector, the Beach Boys and Bo Diddley, as well as press clippings for the Rolling Stones. There was also a flexi-disc recording of some feedback titled *Loop* attributed to the Velvet Underground. The following year, Random House published *Andy Warhol's Index (Book),* which included some photos of the Velvets, as well as a flexi disc of Nico's reactions as she looks over a pre-press copy of the book.

Starting publication in 1969, Warhol's pop culture magazine *Interview* published casual discussions with music stars: Sting, Michael Jackson, Patti Smith, Madonna, the Germs, Stevie Wonder, Marc Bolan, Cyndi Lauper, Tina Turner, Ozzy Osbourne, Joan Jett, Grace Jones and Afrika Bambaataa. Many of these artists also made the cover; Mick Jagger was its newsstand face five times (fig. 3). When Jim Morrison visited the Factory, the lead singer of the Doors was photographed reading a copy of *Interview,* and the photo was printed as an ad in the next issue. In addition to keeping its readers aware of the latest trends in music, reviews of new recordings and recent performances of the hottest bands from reggae to punk to rap were featured in regular columns such as Glenn O'Brien's "Beat" and Lance Loud's "Loudspeaker."

In 1964, Superstar and fashion model Baby Jane Holzer (fig. 4) introduced Warhol to the Rolling Stones, which led to a friendship that lasted more than twenty years. Jane herself later had a brief pop music career, recording two songs and appearing on the TV show *Hullabaloo.* A painted illustration from *Esquire* magazine in 1967 illustrates the connection between them: she is positioned in the middle between the Stones on the left and Warhol to the right (fig. 5). The Stones gave Warhol backstage access to their North American tours in 1972 and 1975; in the latter year the band rented his remote Long Island home as a rehearsal space to prepare for the tour. Warhol made many tape recordings of them at the two concerts, including some backstage moments, and also of Mick Jagger without his bandmates. On one occasion, Warhol and Jagger were recorded sketching ideas for a stage design that included large neon signs of iconic American popular culture symbols such as Coca-Cola. Warhol also created a suite of ten portraits of Mick Jagger, in silkscreened fine art prints, as well as unique paintings and drawings, all based on a large series of his original photographs of the star. The beautiful interior of Jagger's Manhattan home was later designed by Warhol's former partner, Jed Johnson. After Warhol's death in 1987, Jagger continued to send poinsettias at Christmas to his old friend's heirs, the Andy Warhol Foundation.

3

FIG. 3 – Mick Jagger on the cover of *Interview,* February 1985 (cat. 406)

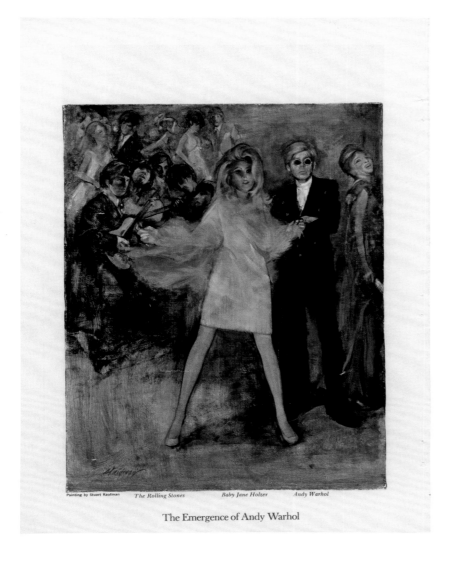

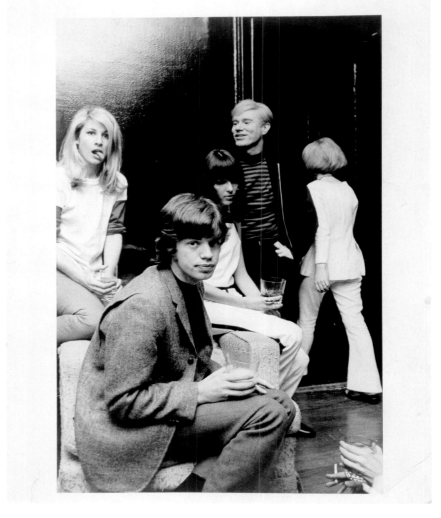

FIG. 4 – Stuart Kaufman, *The Emergence of Andy Warhol* (the Rolling Stones, Baby Jane Holzer and Andy Warhol at the Gymnasium), painting illustrating an insert in the magazine *Esquire*, December 1967 (cat. 458) FIG. 5 – Baby Jane Holzer, Mick Jagger, Peggy Moffitt and Andy Warhol at Jane Holzer's Park Avenue apartment, New York, 1964—65. Photo David McCabe

6 7 8

FIG. 6 – The Rolling Stones piled on to a bench (from l. to r.: Bill Wyman, Mick Jagger, Keith Richards and Brian Jones, Charlie Watts on the ground), about 1964. Photo Cyrus Andrews (cat. 412) FIG. 7 – Andy Warhol's design for the cover illustration of Geoffrey Stokes' book, *The Beatles*, published in 1980 by Rolling Stones Press Books / Time Books FIG. 8 – Portrait of Sid Vicious by Andy Warhol, illustration for the cover of *File, Art & Text*, special issue "Sex, Drugs, Rock 'n' Roll," 1986 (cat. 410)

Continuing his graphic work for the recording industry that began in 1949, Warhol designed covers for three of the Stones' albums. The first, for a "Greatest Hits" record, was never published, possibly because the image was unacceptable. His archives have a photo that is marked by Warhol to be enlarged to the size of an LP cover. It shows the young rockers on a public bench in about 1962, lying on top of each other with eyes closed—the image appealed to Warhol, as it also would have to the band's young female fans (fig. 6). Warhol later complained that his idea for the cover was stolen, although there is no relationship between this photo and the published work; the octagonal-shaped *Through the Past, Darkly* (1969) shows the band members peering through a shattered glass window. Perhaps Warhol suggested that idea when the bench photo was rejected.

In 1972, Warhol's concept for *Sticky Fingers* was nominated for a Grammy award and banned in two countries, giving it early stature as an enduring classic. His third design, for *Love You Live* in 1977, shows the band members biting each other in a parody of the cannibalistic double entendre of the title, and also evokes the shocking new punk sensibility. The cannibal reference may also have been influenced by the recently revealed story of the survivors of a jet crash in the high Andes. Other Stones graphics referenced Warhol's art, including ads for the single *Street Fighting Man* (1968), the cover of *Some Girls* (1978), and others that use gender-bending imagery, such as the picture sleeve for the forty-five single *Have You Seen Your Mother, Baby, Standing In The Shadows?* (1966), and the cover of *Goats Head Soup* (1973).

In the early 1970s, young glam rocker David Bowie recorded tributes to Warhol and the Velvet Underground on his album *Hunky Dory*. Bowie's manager sent Warhol the typewritten lyrics to "Andy Warhol," and reference recordings of the LP and the single, signed "To Andy With Respect, Bowie." Bowie had attended the infamous London performances of Warhol's play *Pork* in 1971. Members of its cast (Tony Zanetta, Wayne County and Cherry Vanilla) later became the American management of his production company, MainMan, during which Iggy Pop and the Stooges were signed on to the label, and also as Bowie produced Lou Reed's solo LP *Transformer*. When Bowie visited the Factory to meet his hero in 1972, Warhol is said to have been afraid to meet him, being cautious of fans wanting to get too close. Warhol's videotape of the moment, from his *Factory Diaries* series, makes this clear. Many years later, Bowie fulfilled a dream by playing the role of Warhol in a film dramatizing the life of painter Jean-Michel Basquiat.

Danny Fields was a frequent visitor to the Factory before 1970; he sat for a Screen Test in the 1960s and wrote the notes for the Velvets' *Live at Max's Kansas City* album (1972). Later, he became a music-industry executive, and got the MC-5, the Stooges and the Ramones signed to their first recording deals. He later managed the Modern Lovers, whose front man, Jonathan Richman, had sent fan mail to Warhol in the 1960s, including an example of his silkscreen art.

Recognizing Warhol's affinity for contemporary music, record labels commissioned him to create record covers for his old associate John Cale, soul diva Aretha Franklin, Billy Squier, Paul Anka, Diana Ross, the Japanese doo-wop revivalists Rats & Star, and a posthumous release by John Lennon, *Menlove Ave.* He also created a portrait of the Beatles for the cover of a book devoted to the iconic band (fig. 7). These two projects developed from his friendship with Lennon and Yoko Ono in the early 1970s, after they moved to New York, although Warhol had been familiar with Ono's work since the early 1960s, when she worked with the Fluxus group of artists. Yoko invited Warhol to collaborate on her exhibition *Water* at the Everson Museum of Art in Syracuse, New York. The celebrity couple also made a gift to Warhol of a copy of *The Beatles Christmas Album* (an LP compilation of the songs recorded annually for members of the band's official fan club); Warhol's copy is signed by both John and Yoko, and includes a small moustache added to a photo of Paul McCartney. After Lennon's horrific murder in 1980, Warhol became close to his young son Sean, attended his birthday parties, and painted his portrait—even suggesting that it become an annual practice. After resuming her music career, Yoko appeared on the cover of *Interview,* and later was one of three friends who delivered a eulogy at Warhol's memorial in April 1987. Other music stars who had their portraits painted by Warhol include Prince (for *Vanity Fair* magazine), Ryuichi Sakamoto, Dolly Parton and Michael Jackson (for *Time* magazine).

In the late 1970s, Warhol returned to the management of a musician, electronic violinist Walter Steding, on his new Earhole music label. Steding frequently performed at CBGB—one of the central venues for punk in New York, where he opened for Blondie, Suicide and the Ramones. Steding later toured with Blondie, whose lead singer, Debbie Harry, was a great friend of Warhol. The blonde beauty was one of the iconic faces of the time, and Warhol knew her long before she rose to be a star, when she was a waitress at Max's Kansas City, the artists' bar that was his hangout on Union Square between 1965 and 1970. He painted her portrait both in his silkscreen technique and on a computer (in his brief foray into digital art in the late 1980s); she made the cover of *Interview* magazine, and appeared often on Warhol's TV shows.

In 1978, *Punk* magazine cast Warhol in the role of the mad scientist in their "Mutant Monster Beach Party," a photographic comic that also starred Debbie Harry and Chris Stein of Blondie, Joey Ramone, and others. For the Canadian arts group General Idea's *File* magazine, Warhol created a posthumous portrait of Sid Vicious of the Sex Pistols (fig. 8). Teenaged Courtney Love, far in advance of her fame as the leader of the band Hole, was possibly the most interesting of the rock musicians to appear on Warhol's TV shows. He also produced music videos for the Cars ("Hello Again"), Curiosity Killed the Cat ("Misfit"), and a few others.

Inter/TUBE: **ANDY WARHOL'S MAGAZINE / ANDY WARHOL'S TELEVISION** **"*Interview* magazine was an extraordinary document of its times and a crucial influence on all manner of media." — Glenn O'Brien, editor of *Interview* magazine** Andy Warhol founded *Inter/VIEW: A Monthly Film Journal* along with Gerard Malanga, Paul Morrissey and noted underground newspaper publisher John Wilcock in the fall of 1969, over a year after the shooting by Valerie Solanas forced Warhol to halt his incessant film production. The magazine was passionately devoted to the high and low forms of the art of cinema, past and present, and featured interviews with personalities as diverse as Agnès Varda, Emile de Antonio, George A. Romero, Ingrid Bergman, Bruce Baillie, Henri Langlois and Busby Berkeley, as well as a variety of articles, including "Gravediggers of 1969" and "The Fucking Film Festival." It also contained monthly movie reviews written by such talent as Donald Lyons, Ondine, Molly Haskell, Candy Darling and Gregory Battcock. Warhol purchased a portable video camera in 1970 and used it to tape himself, his mother and his friends. Pleased with the immediacy of the format, he bought a second camera and asked assistants Michael Netter and Vincent Fremont to record interesting people and activities in and outside of the Factory. The equipment was also used to record conversations with celebrities, which were then transcribed and printed in the magazine; some of the earliest examples featured Cybil Shepherd, Dennis Hopper, Marisa Berenson and Monique van Vooren. Almost two dozen video interviews were recorded and published between 1971 and 1976, including those with Ken Russell, Manhattan Transfer, Jackie Curtis, Carol Kane and Monty Python's Terry Gilliam and Eric Idle. The name change from *Inter/VIEW* to *Andy Warhol's Interview* in 1972 signalled a change of focus for the magazine. It began to embrace and celebrate other forms of popular culture besides film that year. Music, fashion, art, television and celebrity nightlife, and all the glamour and style that defined them, were now featured between the publication's covers. Interviews that were once limited to movie stars were henceforth also conducted with the pop stars, fashion designers and wealthy socialites of the day. Fashion was introduced with a spread in the May issue and an interview with designer Zandra Rhodes in October. As the magazine underwent a transformation, Warhol's interest in video grew. He and Vincent Fremont worked on several video soap operas featuring his Superstars as well as models who had appeared on the pages of *Interview*. In 1979, Warhol produced a television series called *Fashion*. In a 1980 article in the *Soho News*, he summed up his first foray into the world of television with: "The whole idea is just to do a fashion magazine on TV. . . . We're trying to make the video magazine just like an *Interview* magazine." His next television series, *Andy Warhol's TV* (*AWTV*), was also a video magazine. Interestingly enough, however, there was no overlap between the content of the show and the magazine until the fourteenth episode, in which an *Interview* cover shoot with Mariel Hemingway was presented along with her interview by Warhol and Brigid Berlin. The photo and interview were published in the April 1982 issue. After that, the association between the two media ventures grew closer. Up until January 1984, more than fifteen subjects were shared between *AWTV* and *Interview* magazine, including a session with rock star Sting. **G.P.**

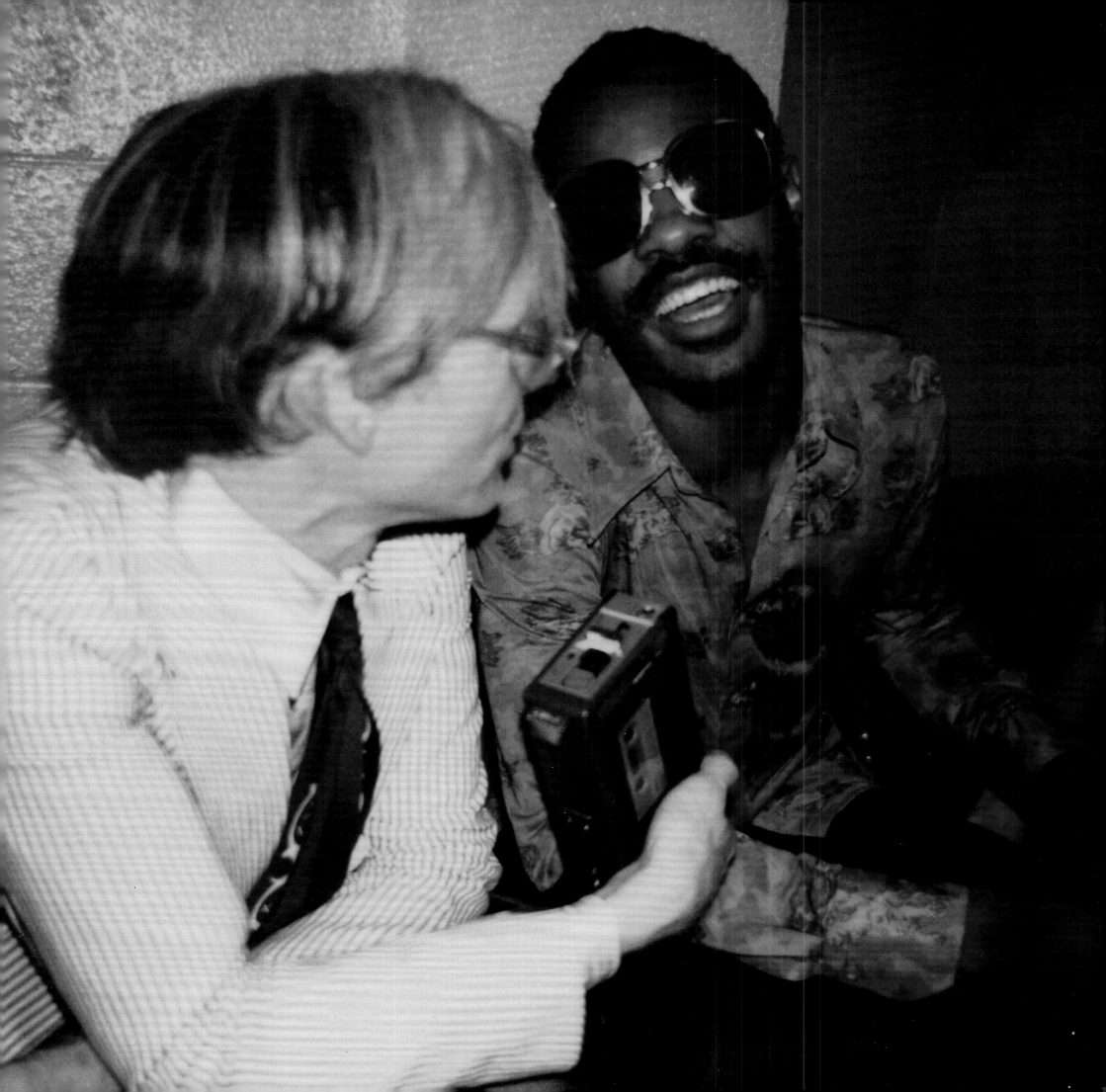

385, 386

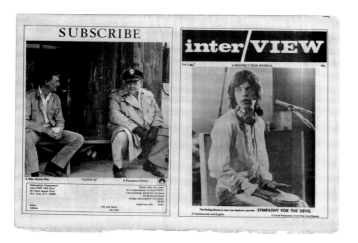

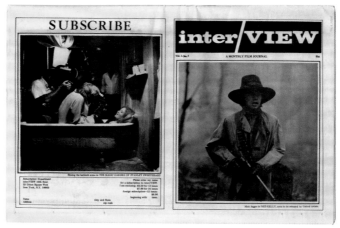

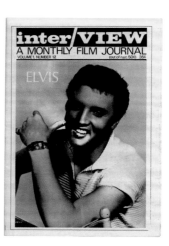

389, 391

387

392

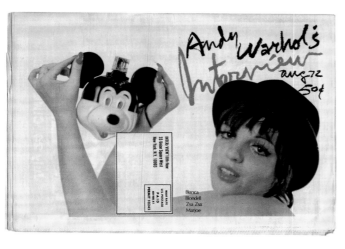

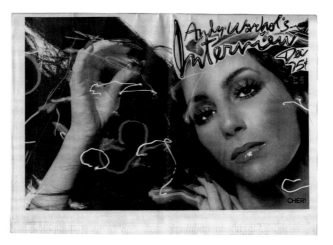

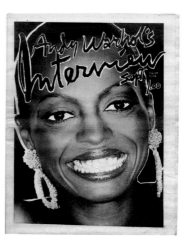

Covers of *Interview* magazine, between 1970 and 1976: **385** – Cover with Mick Jagger in Jean-Luc Godard's *Sympathy for the Devil*; back cover with Richard Harris in *A Man Called Horse*, 1970, no. 7 **386** – Cover with Mick Jagger in *Ned Kelly*; back cover with Don Johnson in *The Magic Garden of Stanley Sweetheart*, 1970, no. 8 **387** – Elvis Presley, special issue, 1970, no. 12 **389** – Liza Minnelli, August 1972 **391** – Cher, December 1974 **392** – Diana Ross, September 1976

393

383

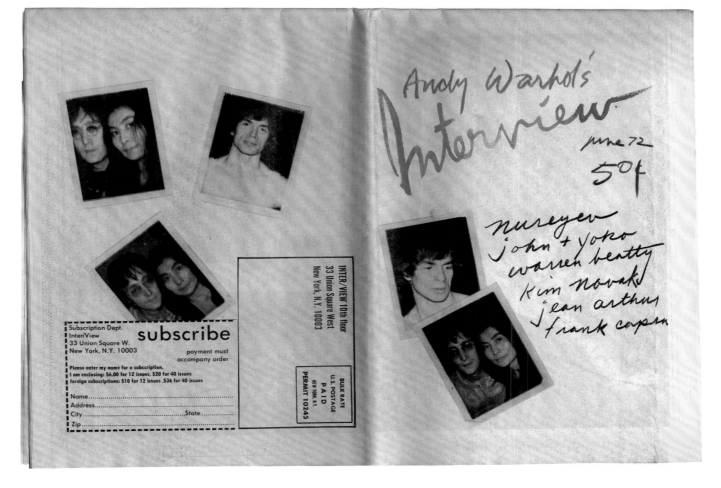

393 — *Interview*, December 1977, cover with Mick Jagger as Santa Claus Yoko Ono and Rudolf Nureyev **383** — *Interview*, 1969, no. 2, cover with Mick Jagger in Cecil Beaton's *Performance* (cat. 383) **388** — *Interview*, June 1972, Warhol photos of John Lennon,

396, 397

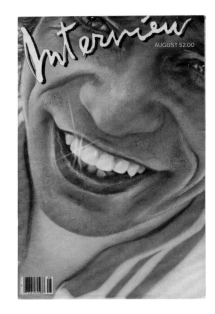

398, 399

400, 401

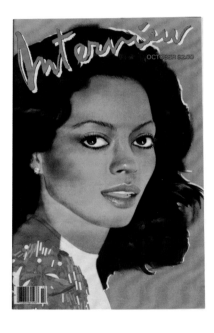

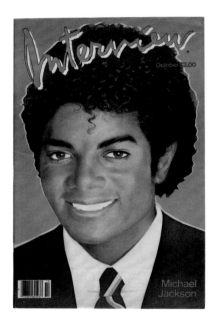
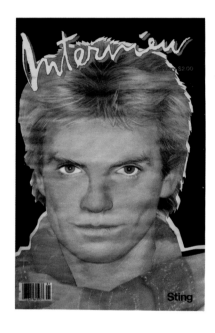

402, 403

405, 407

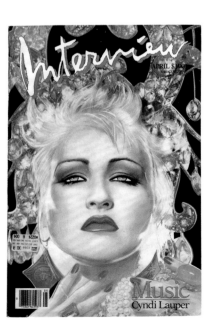

408, 411

Covers of *Interview* magazine, between 1979 and 1986 (from l. to r.): Steve Rubell, Debbie Harry, Liza Minnelli, Mick Jagger, Diana Ross, Cher, Michael Jackson, Sting, Yoko Ono, Annie Lennox, Nick Rhodes, Cyndi Lauper

December $2.00

U.K. £2.10

198

199

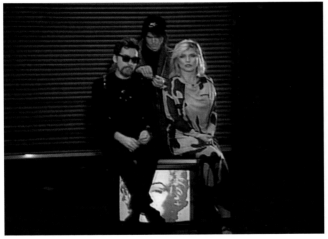
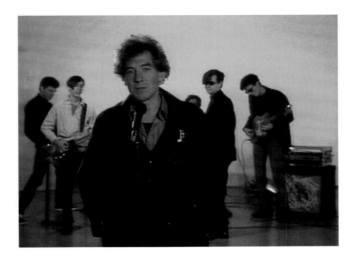

205 — *Andy Warhol's Fifteen Minutes (Episode 3)*, 1987 **206** — *Andy Warhol's Fifteen Minutes (Episode 4)*, 1987

"HIS EAR WAS HIS EYE"
Interview with Glenn O'Brien by Matt Wrbican

Matt Wrbican Warhol is often described as a sponge, always seeking new ideas and information. Was this true with your "Beat" column at *Interview,* or with your television show?

Glenn O'Brien Andy read *Interview*, although never until it came back from the printer. I think he did watch my cable show *TV Party* if he happened to be home. He came to a taping once and I'm pretty sure that *TV Party*'s notoriety is what interested him in doing his own cable show, *Andy Warhol's TV.*

Andy was interested in bands that I interviewed or wrote about if there was a picture of them and they were cute. A lot of his interest in pop music had to do with the attractiveness of the performers. He was always interested in what was new although he balanced that curiosity with a certain reticence, fear of being asked for something or stalked. He trusted my judgment as far as who was good. I was at the Factory when David Bowie came up to visit (fig. 1). It was before *Ziggy Stardust* and he had long hair and floppy clothes with Mary Jane shoes and two different colour socks. He was with his manager Tony DeFries and he wanted to sing "Andy Warhol" to Andy. Andy had never heard of him. I told him that he was famous in England and that was enough for Andy, so he let Bowie do a sort of Lindsay Kemp mime routine and then sing his song. I think Andy wasn't sure if the song was a put-down or praise, so he was a little diffident in his signature way. "Gee, that was great," said utterly without emotion.

Later when Bowie played Carnegie Hall, we went and Andy seemed to enjoy the show, although I think he enjoyed the people enjoying the show as much as the show itself. A lot of people were smoking pot and Andy said later that he hated pot but he really liked the smell. I think maybe he had a contact high. He liked David Bowie the same way he liked Liberace—they're both extravagant and famous.

MW Warhol's play, *Pork,* played something of a role in Bowie's early career. He attended the London run, and several cast members later ran Bowie's US production company, MainMan—Tony Zanetta, Cherry Vanilla and Wayne County.

GO We were all amazed by what happened when MainMan opened in New York. All of a sudden the starving cast of freaks from *Pork* were all executives with offices on Park Avenue, limousines and expense accounts. It was spectacular in a fishy kind of way. We were all mystified about where the money was coming from.

MW Is it possible to describe Warhol's taste in music? His record collection is fairly eclectic, and morphed over the years, but is weighted to the music of youth culture, from Elvis and the Shangri-Las (figs. 2, 3) to the Ramones. He also owned many boxed sets of operas, plus Broadway musicals (figs. 4, 5).

GO When I first got to the Factory there were tons of opera records around the old-fashioned console stereo, but I never saw Andy listen to opera. I think that was more about Billy Name's taste than Andy. Billy was locked up in the back, and nobody ever played those records, at least during the daytime. Maybe Billy came out at night and played them.

MW Some of Warhol's personal tapes from 1965 record Ondine singing along with Maria Callas. We have lots of the bootleg tapes that were played in the Factory, all labelled by Billy Name. However, Warhol's archives tell us that he was very interested in opera in the 1950s, and again in the 1980s. He had a season ticket to the Met the same year that he produced the Velvets; he must have kept it quiet.

GO I think he was interested in opera for a variety of reasons. You can't discount the society aspect of it. And Callas.

As for Andy's record collection, it is probably eclectic because so many different kinds of musicians gave him free records. I don't think he was big on shopping for music. I think Andy liked whatever was popular, whatever was on the radio. If he liked anything it was probably soul music—Motown, the Supremes. I seem to recall that he liked the Jaynetts' "Sally Go Round the Roses." I can see him liking "I'm in with the In Crowd."

FIG. 1 – *Factory Diary*: David Bowie and group at the Factory, September 14, 1971 (cat. 197)

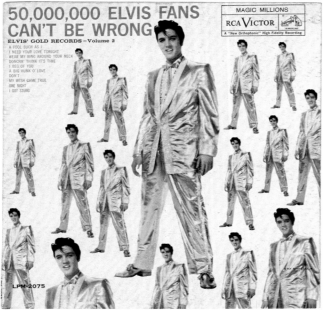

2

3

4

5

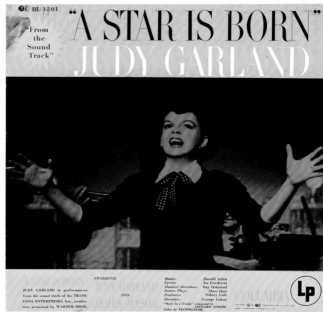

Records in Andy Warhol's music collection: FIG. 2 – *Elvis Presley, Elvis' Gold Records, Vol. 2*, 1960 (cat. 498) FIG. 3 – Giacomo Puccini, *La Bohème* (cat. 483) 4 – The Shangri-Las, *I Can Never Go Home Any More*, 1965 (cat. 504)
FIG. 5 – Judy Garland, "*A Star is Born*," 1954 (cat. 491)

MW After *Interview* became really big, many musicians gave him promos, though his older seventy-eights and LPs of classics, musicals and early rock and roll were played to death, covered in scratches, and stored in mismatched sleeves.

There's very little jazz in his collection, just a few female vocalists, and a beautiful boxed set of Charlie Parker—unopened. It's from the mid-1980s, so it was probably a gift from Jean-Michel Basquiat, who idolized Parker.

Patti Smith has a story about him and soul music. She was at the Factory one day, and "You Make Me Feel Brand New" by the Stylistics came on the radio. He heard her quietly singing along with it and he said, "Oh Patti, sing it for me!" When it ended, he insisted that she sing it again.

GO I think he liked the music of people he liked. I don't think that with Andy it was about a sound capturing his fancy. I think you'd have to say about Andy's taste in music—he liked it when he saw it. His ear was his eye. I think Andy saw music. Like when he hooked up with the Velvet Underground I think it was probably because he liked the way their show looked. Of course he also would have known that it was dark and strange and violent, but his main reaction would have been to the visual and to the sensibility.

Andy liked the people. Andy really liked Lou Reed and John Cale. He was a fan, but he had that kind of scepticism about them that he had about a lot of people. Lou was somebody who could hurt Andy's feelings easily. John too. I think he really respected their talent. He just thought of them as prodigals. It was very on and off. It's funny but I don't recall Andy being involved with Patti Smith. I think he used to hide when she and Mapplethorpe came around. But of course I wasn't always there.

MW Shortly after it came out in 1973, Warhol and Reed were discussing a staged production of his record *Berlin.* The idea went nowhere, until 2006. We have a tape recording of them talking about it—Lou was very excited. We also have some papers that seem to be a script in progress.

GO I think Andy really loved Lou, and Lou really loved Andy, but they had a stormy relationship (fig. 6). It was almost like a father/son, love/hate thing. They both had a bit of a cruel streak and were always miffing one another. Andy was really hurt that Lou didn't invite him to his wedding. They were all about "you only hurt the one you love."

Andy told me that before he hooked up with the Velvets he had been rehearsing in a band with Patty Oldenburg, Larry Poons, Lucas Samaras, Jasper Johns, La Monte Young and Walter De Maria.

MW The Druds! I always thought he was starting a myth or pulling your leg when he mentioned them, until I read Branden Joseph's essay about them.

GO Apparently they rehearsed about ten times and there were a lot of fights between Lucas and Patty over the music. Andy said he was "singing badly." When he had a chance to take over the Cinematheque, "happenings" were big and I think he thought that having a band would pull together the films and lights and slides. So he found the Velvet Underground. I think Andy judged bands by their aura. He was definitely very impressed by Dylan, Jim Morrison, the Rolling Stones, and later with Blondie. And of course later he was Walter Steding's manager. I don't know what that really meant. I think it meant that he would tell Walter to sweep up the studio. But he also made Walter's music videos.

MW What do you recall about Warhol and Mick Jagger? They knew each other since about 1965, when Baby Jane Holzer introduced them.

GO I don't recall Mick ever coming up to the Factory when I was there. Andy often talked about him. I think Andy thought he was very cool although he used to say he was cheap. I think he thought Mick got the better of him on their business deals, like the *Sticky Fingers* cover. Of course Andy was thrilled when Mick was hanging out with him in Montauk.

MW OK, I've read and heard that there were at least three people who posed for *Sticky Fingers*: you, Corey Tippen and Jay Johnson. And the Polaroids for it definitely show different people. So, who's in those Levi's?

FIG. 6 — Andy Warhol and Lou Reed, 1965–67. Photo Stephen Shore

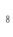

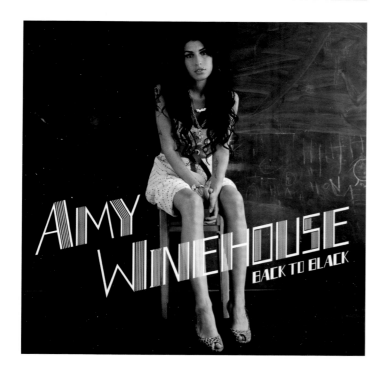

GO Bobby Dallesandro also posed. I think the jeans that wound up on the cover were Jay Johnson. I'm in the underwear inside. I can tell by the body hair and the brand of the underwear.

MW Was Bianca Jagger around a lot?

GO I remember her coming to the office. She was really stylish in a very individual way. I think the 1973 cover of *Interview* she appeared on is one of the very best. Then when Mick and Bianca broke up it seemed like Andy inherited Bianca. She was his date "on the rebound."

 I *was* there the day Bob Dylan came up with Laurie Sebastian, the ex of John Sebastian. That was kind of tense, because there had been a bit of bad feeling after Edie, but everyone was really pretty nice. After he left, Andy went on and on about how he gave Dylan an *Elvis* and then Dylan had traded it to Albert Grossman for a sofa that had belonged to Janis Joplin.

 Shortly after that we saw Dylan at Mick Jagger's big birthday party at the St. Regis Roof, where Andy had Geri Miller jump out of a birthday cake sort of nude. Andy was mad because he was sitting with Dylan and took some pictures; there was a joint on the table so Dylan's bodyguards confiscated his film. That really made Andy mad.

MW His portraits of Debbie Harry and Dolly Parton are slightly larger than most that he did, supposedly because he thought they were bigger stars. Warhol knew Debbie for a long time too, since her days as a waitress at Max's Kansas City, so he must've been especially happy when she became a star.

GO Yeah, Andy really loved Debbie. He had a huge party for her at Studio 54 when she was on the cover of *Interview*. I felt a little left out because I was best friends with Chris Stein and Debbie (fig. 7) and I was kind of shunted off to the side. You know, maybe the portraits of Debbie are bigger because she has a big head. She must wear a size eight hat. But Debbie has a really wry sense of humour and I know Andy really loved that she was beautiful and funny.

MW Walter opened a few of Blondie's shows back in the day; he's still performing. He told me that he wrote a musical called *The Time Capsules,* taking the title from Warhol's huge series of boxes.

GO There's another funny relationship, Andy and Walter. Walter was from Pittsburgh and I think he reminded Andy of himself in a way, that sort of Midwestern awkwardness combined with brilliance. Andy was managing Walter, but Walter was sort of the janitor of the Factory. He'd be there wearing Dickies overalls with his name sewn on, "Walter," almost like a mechanic in a body shop. Andy would fire him once in a while. It was another love/hate thing, like Andy and Lou. Andy would get very frustrated by Walter's passivity and lack of, how would you put it . . . greed?

MW You mentioned that Warhol had "a funny attitude and interest in music." That might cover a lot of ground, but can you describe it in more detail?

GO I think Andy's interest in music was mainly an interest in musicians. He showed no real signs of being interested in music itself. I just found a copy of the "music issue" of *Interview* from April 1986. My "Beat" column opens the magazine instead of its usual position closing it. The headline is a quote from Andy, "To tell the truth, I don't really like music—I like the people who make it." I think that he may have had what's called a tin ear. I have known several visual artists who had no real interest in music. But maybe that made musicians even more interesting to him, artists like Bob Dylan. I saw quite a few performances with Andy. He always seemed to respond more to the visual side, even with someone like Miles Davis. I saw Miles with Andy and Jean-Michel, and Jean-Michel was talking about the music and the band, and Andy was more interested in what Miles was wearing and how he related to the audience, or didn't.

FIG. 7 – Chris Stein and Debbie Harry, 1982 (cat. 282) FIG. 8 – Amy Winehouse, *Back to Black* (2006)

MW That visual relationship would explain some of his interest in opera, as well as in the spectacle of nightclubs like Studio 54.

Warhol's brothers say that he took violin lessons when he was a kid, but quit because the teacher was mean; maybe he just couldn't play, or even hear the music.

Did you have the opportunity to see Jackie Curtis's musicals?

GO I saw Jackie's *Vain Victory* and I'm sure Andy did. I'm sure Andy saw Wayne County, and the Dolls, and Ruby Lynn Reyner's band Ruby and the Rednecks, and Eric Emerson's band the Magic Tramps. Andy was pretty curious, although as the 1970s went on he was less inclined to visit downtown venues.

MW Warhol videotaped one of Eric's performances. I think that he also had a very small role in one of Curtis's musicals—he sort of stood off to the side of the stage. How about *Cabaret in the Sky*, Curtis and Holly Woodlawn's show?

GO Andy was not one of those Broadway-musical queens. I think he liked cabaret but only if it was a really happening event.

MW His record collection includes Mabel Mercer and Eartha Kitt—two pretty happening cabaret stars. And he did an early portrait of Bobby Short.

GO He wasn't going around singing show tunes. He was friends with John Wallowitch, who was a singer/pianist and cabaret performer, and he did a great album cover for Wallowitch, which preceded his Velvets covers—made with photobooth pictures. I think that was in 1964. I just found a copy of it. It's the best cover he ever did. He also did a great one for John Cale that was all Kodak slides.

I think that probably the music that interested Andy the most was theatrical music, whether it was musical theatre or theatrical rock bands.

Andy came to see my short-lived band Konelrad play at CBGB with Fred Hughes and he raved about it. Andy said I was better than Bryan Ferry, whom he'd just seen. He couldn't have been talking about music. We did have good words, but I think actually that he liked my outfit better. And the fact that I was with Grace Jones.

MW So, can you describe your costume in Konelrad?

GO We sometimes wore black pyjamas, like the Vietcong, because we were the first "Socialist Realist" rock band. But sometimes I just wore a black t-shirt and bright coloured pants with a white dinner jacket.

MW Grace Jones was a favourite subject for Warhol's camera, and he had several of her records. They went as a couple to the wedding of Arnold Schwarzenegger and Maria Shriver.

GO I dated Grace for a while. Then I introduced her to Jean-Paul Goude. She loved Andy and I think he liked her because she was wild and unpredictable, and a little bit like a drag queen. I was in Barbados with her and everyone thought she was a guy.

MW This is probably corny, and may have no answer, but can you guess what music Warhol would be interested in today; would he be more conservative in his old age?

GO I don't think Andy would have been conservative at all. He might have even liked what happened with hip-hop because of all the jewellery. I think Andy would love Kembra Pfahler's *The Voluptuous Horror of Karen Black*. Rufus Wainwright, Jarvis Cocker. Maybe the Scissor Sisters, and pretty definitely he would like something about Stephen Merritt. I'm sure he would have loved the Dandy Warhols and appreciated the psychodrama of the Brian Jonestown Massacre.

Andy had a real nose for talent and legends. I'm sure he would have loved Amy Winehouse (fig. 8) and Pete Doherty. And I'm sure he would have continued to follow Lou and John. He would have been touched by *Songs for Drella,* and I think he would have loved *Eat/Kiss*—the soundtrack album Cale made for those early films. It's really good.

MW He had Courtney Love on his TV show in the mid-1980s, before anyone heard of her. But he was also a member of the Julio Iglesias fan club—for real. I think he'd love Antony and the Johnsons, and Björk.

GO But I don't see him plugged into an iPod. Ever.

MW It's surprising to hear that he wouldn't have an iPod today, since he owned so many Walkmen.

GO Andy didn't listen to his Walkman unless it was playing back something he recorded.

MW To go to the other extreme, do you recall him ever speaking of John Cage? They knew each other somewhat, and Warhol made paintings of his partner Merce Cunningham in the early 1960s.

GO I think Andy had an appreciation for Merce and John Cage, the same way he appreciated the dance scene and the poets. I'm sure some of Andy's dumbness strategies were inspired by Cage. Of course that affinity took a backseat when he became involved with Hollywood celebrity and big business, but I think Andy always had a soft spot for the world of dance and a certain idea of the avant-garde.

LADIES AND GENTLEMEN, MICK JAGGER! **"Mick opened the door . . . He showed me their new album [*Some Girls*] and the cover looked good, pullout, die-cut, but they were back in drag again, isn't that something?" — Warhol's *Diary,* Monday, June 5, 1978** Andy Warhol met Mick Jagger in 1964 at a dinner party thrown by Baby Jane Holzer, model and Factory Superstar. The occasion marked the start of a friendship that was to last for more than twenty years, and that manifested itself in numerous ways. In 1969, Warhol dedicated the cover of the second issue of his magazine *Interview* to Jagger. The rock star was featured no fewer than a record five times. The Stones granted Warhol backstage access to their North American tours in 1972 and 1975; in the latter year the band rented his remote Long Island home as a rehearsal space for the tour. On another occasion the Jaggers (Mick, Bianca and their daughter Jade) rented Warhol's Montauk home. The beautiful interior of Jagger's Manhattan residence was later designed by Warhol's former partner, Jed Johnson. After Warhol's death in 1987, Jagger continued to send poinsettias at Christmas to his old friend's heirs, the Andy Warhol Foundation. Warhol also created a suite of ten silkscreen portraits of Mick Jagger as well as paintings and drawings, all based on a large series of his original photographs of the rock star. Jagger entrusted Warhol with the cover design of three Rolling Stones albums. Although the first commission, referred to by Jagger in a letter dated April 21, 1969, did not materialize, the others are regarded as two of Warhol's master-pieces in the field. Warhol's concept for *Sticky Fingers* (1971) was nominated for a Grammy award, giving it early stature as an enduring classic. The strong sexual overtones of Warhol's cover art were partly responsible for its being banned in two countries, Singapore and Spain. His third design, for *Love You Live* (1977), shows the band members biting each other in a parody of the cannibalistic double entendre of the title, simultaneously evoking the shocking new punk sensibility. The completed covers point directly to Warhol's fascination with the ambiguous sexuality of Jagger's rock-star image. That same fascination recurs in the series of portraits of drag queens, *Ladies and Gentlemen*, of 1975, executed shortly after the Jagger portraits to which it forms a counterpart. This series extended Warhol's interest in drag as subject matter, which began in the 1950s. **M.W.**

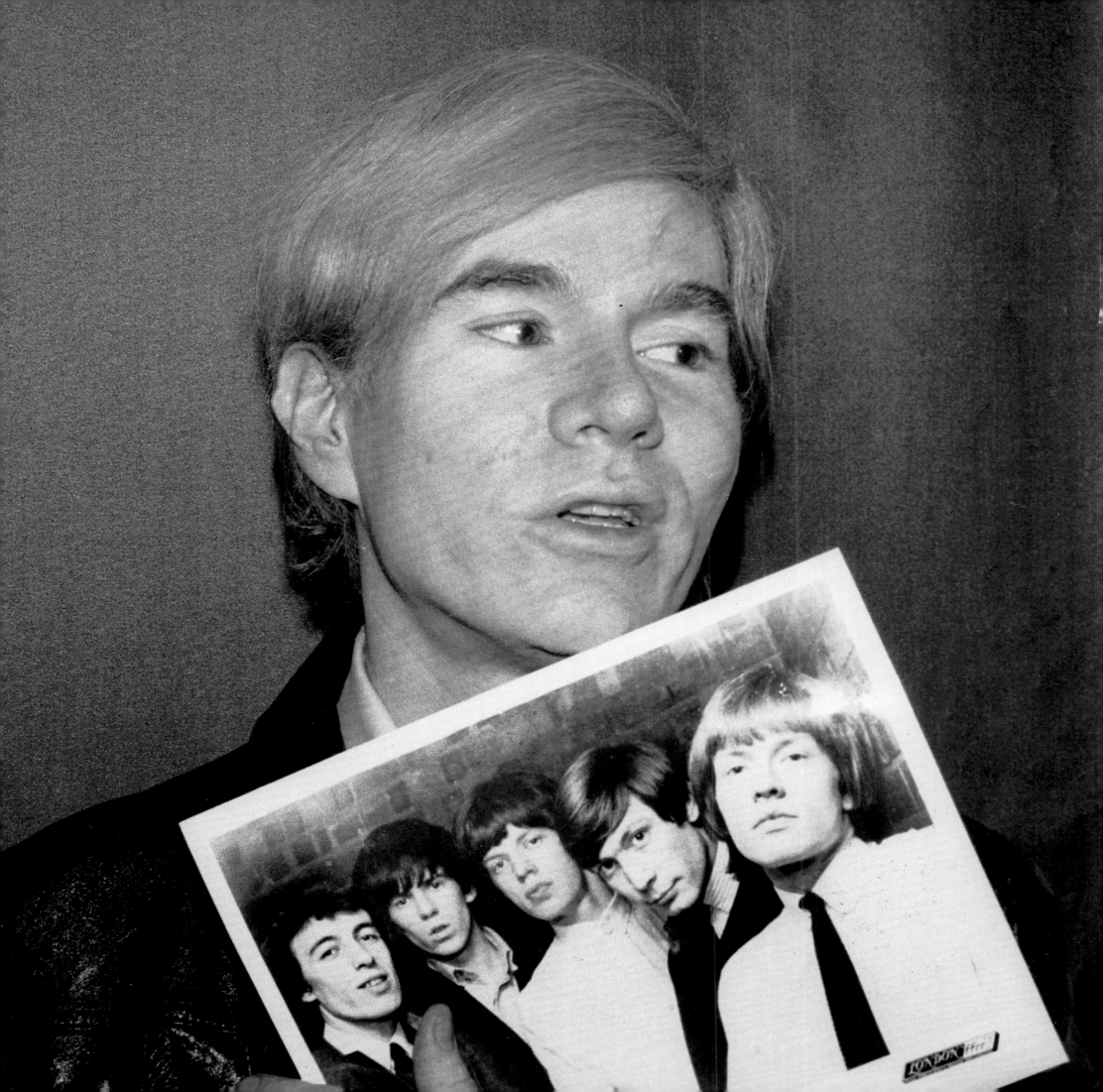

THE ROLLING STONES LTD
46A MADDOX STREET W1
TELEPHONE 01 629 5856

21st April, 1969.

Andy Warhol,
33 Union Square,
W.N.Y.10003,
<u>NEW YORK</u>

Dear Andy,

I'm really pleased you can do the art-work for
our new hits album. Here are 2 boxes of material
which you can use, and the record.

In my short sweet experience, the more complicated
the format of the album, e.g. more complex than just
pages or fold-out, the more fucked-up the reproduction
and agonising the delays. But, having said that, I
leave it in your capable hands to do what ever you
want..........and please write back saying how much
money you would like.

Doubtless a Mr.Al Steckler will contact you in New
York, with any further information. He will probably
look nervous and say "Hurry up" but take little notice.

Love,

MICK JAGGER

571 — Letter from Mick Jagger to Andy Warhol, dated April 21, 1969, about artwork for a record cover (probably *Through the Past, Darkly*)

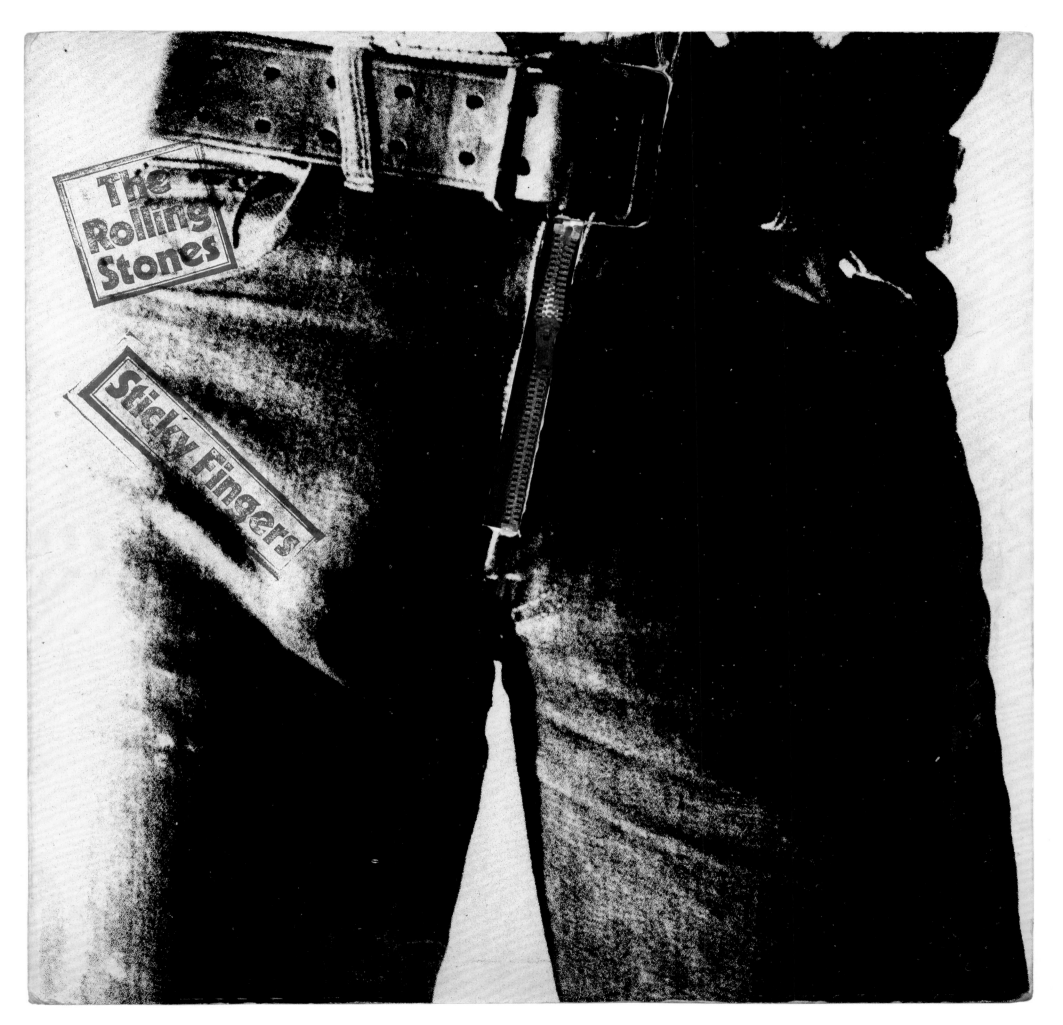

34 – The Rolling Stones' *Sticky Fingers* record cover, 1971

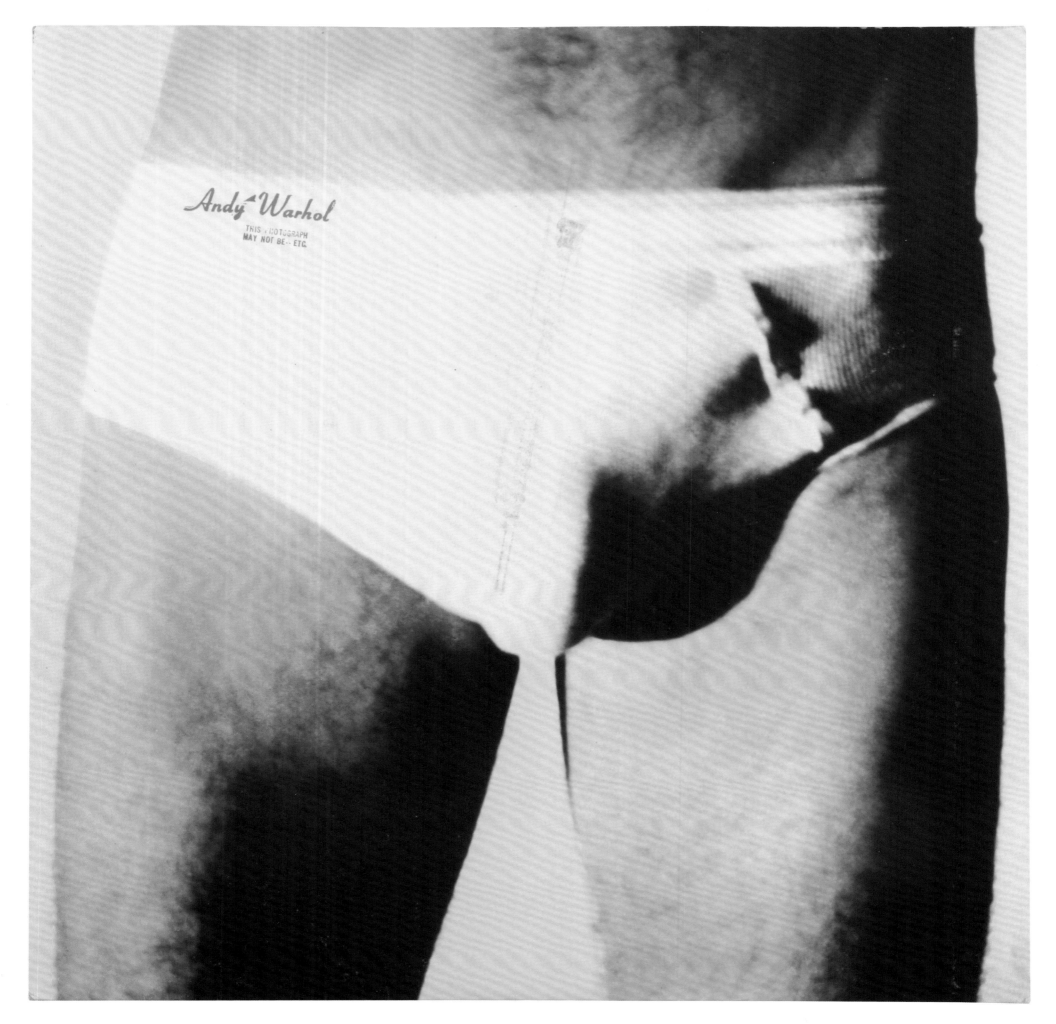

68 – *Sticky Fingers* (1971): seen here in its entirety, the photo reproduced under the cover photo

209, 219, 212

210, 218, 211

213, 215, 216

209–219 – *Sticky Fingers* (1971): Warhol's Polaroid photos of various models, 1970–71

221

222

223

221–223 – *Sticky Fingers* (1971): Camera-ready photostat copies, based on Warhol's original Polaroid photographs, 1970–71

214, 220 — *Sticky Fingers* (1971): Warhol's Polaroid photos of various models, 1970—71

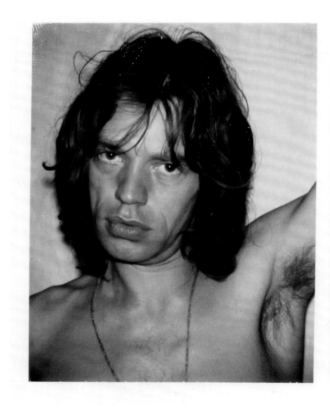

238 – Mick Jagger, a Warhol Polaroid photo, 1975

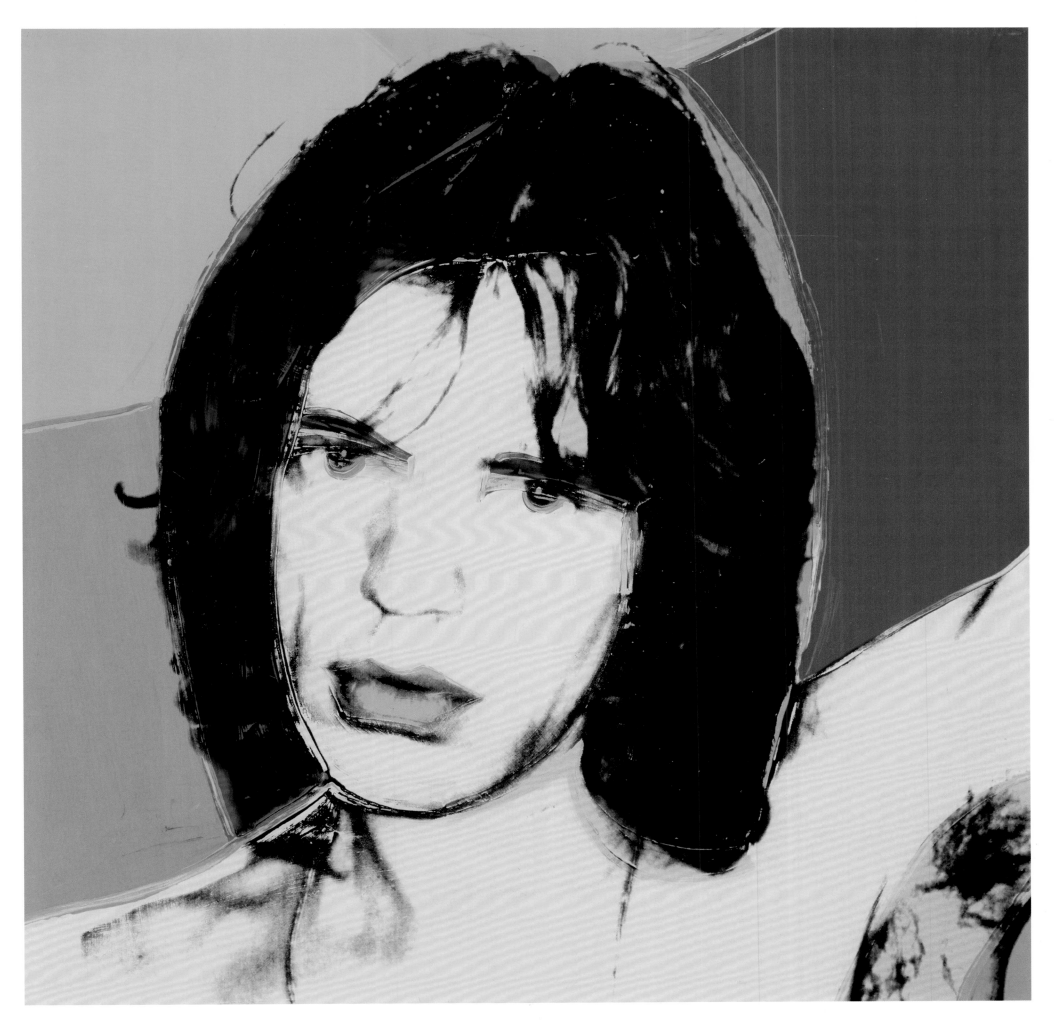

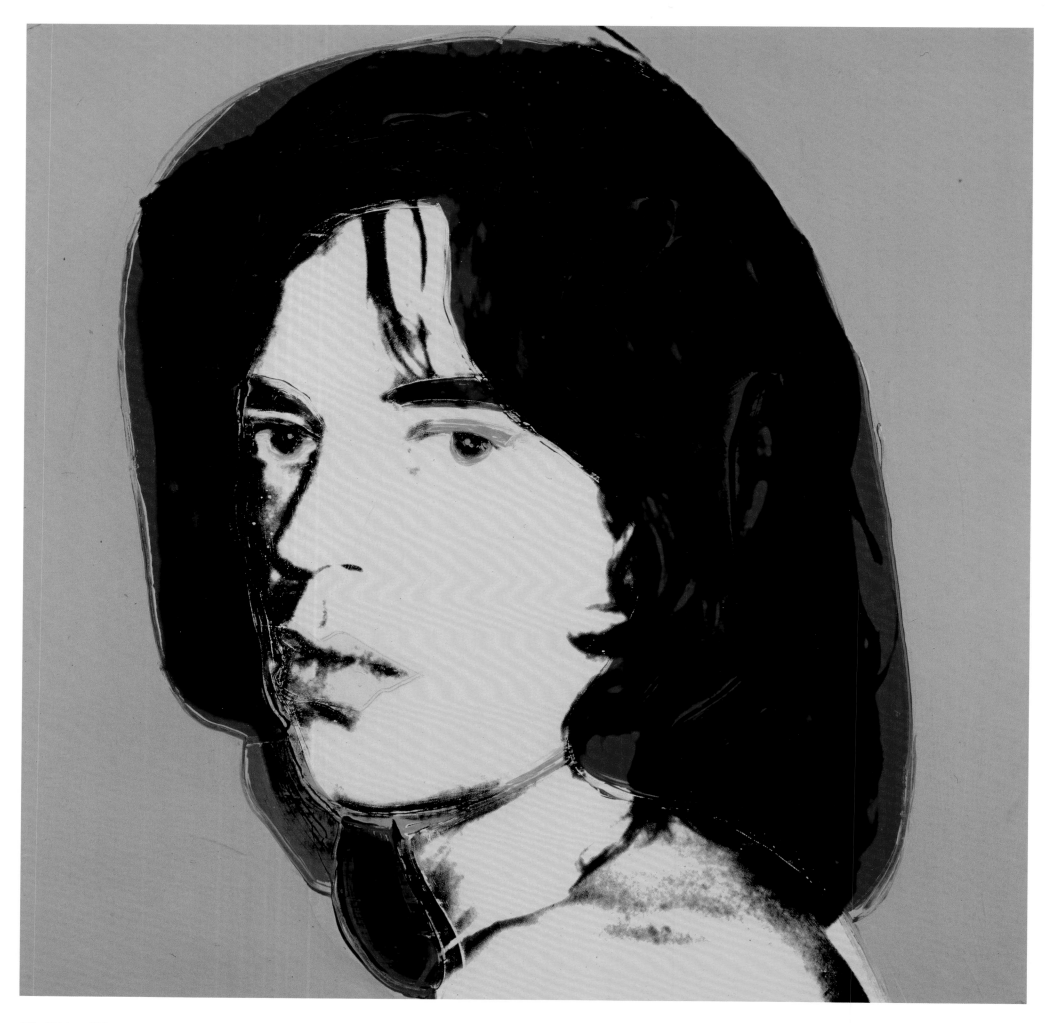

105 — *Mick Jagger*, 1975

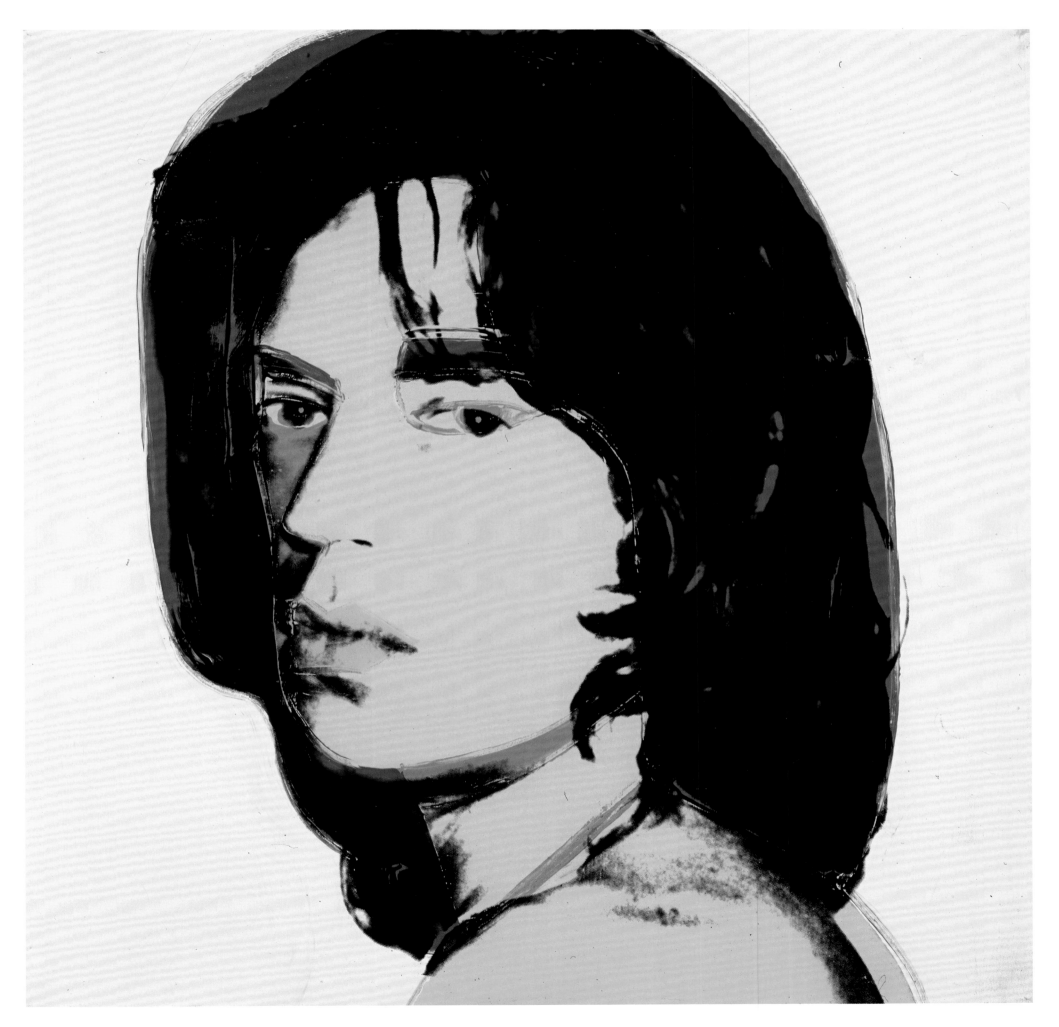

106 — *Mick Jagger*, 1975

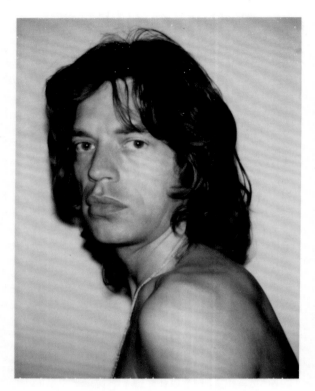

235

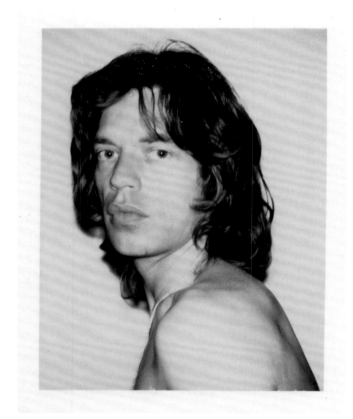

237

231

236

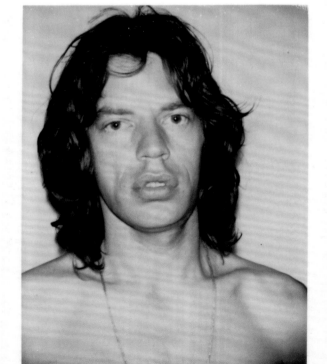

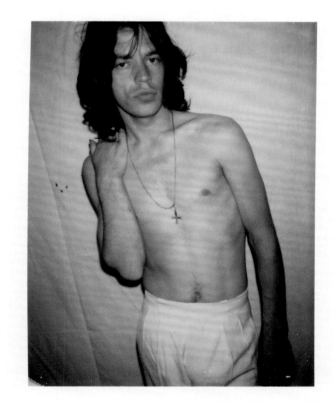

229–237 – Mick Jagger, Warhol's Polaroid photos, 1975

234

230

232

229

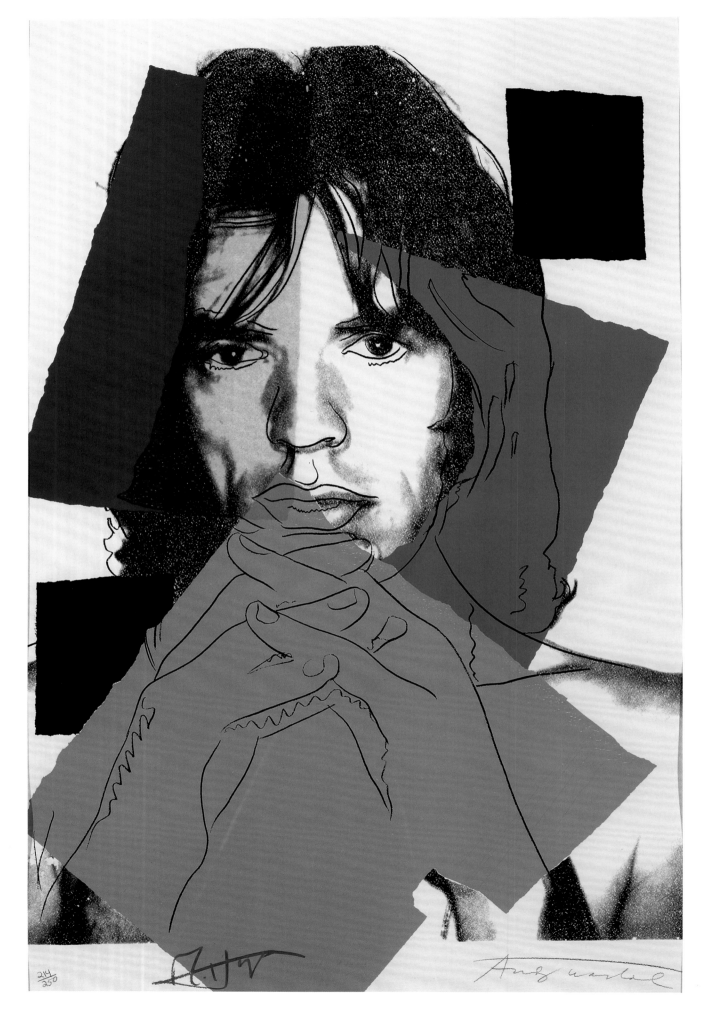

160 – *Mick Jagger*, portfolio of 10 screen prints, 1975

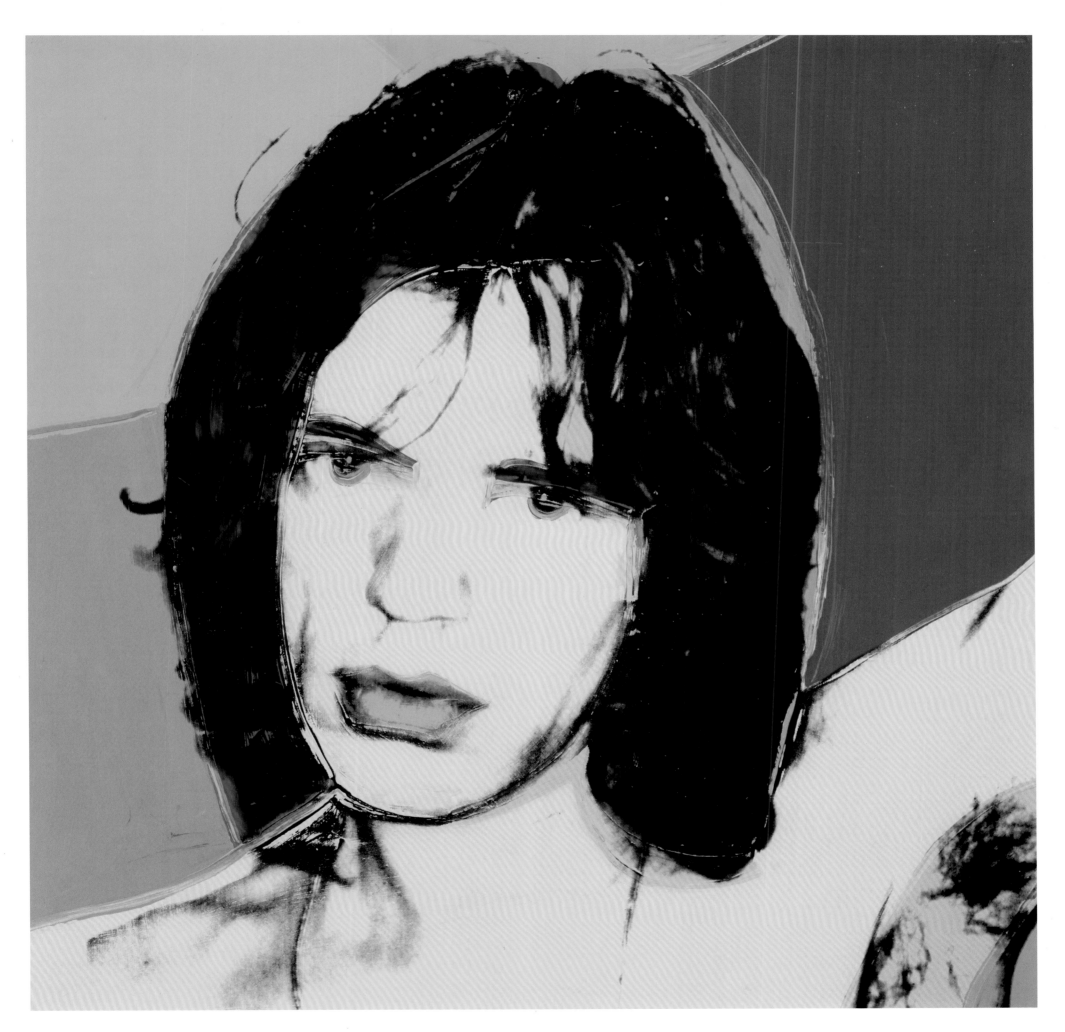

104 – *Mick Jagger*, 1975

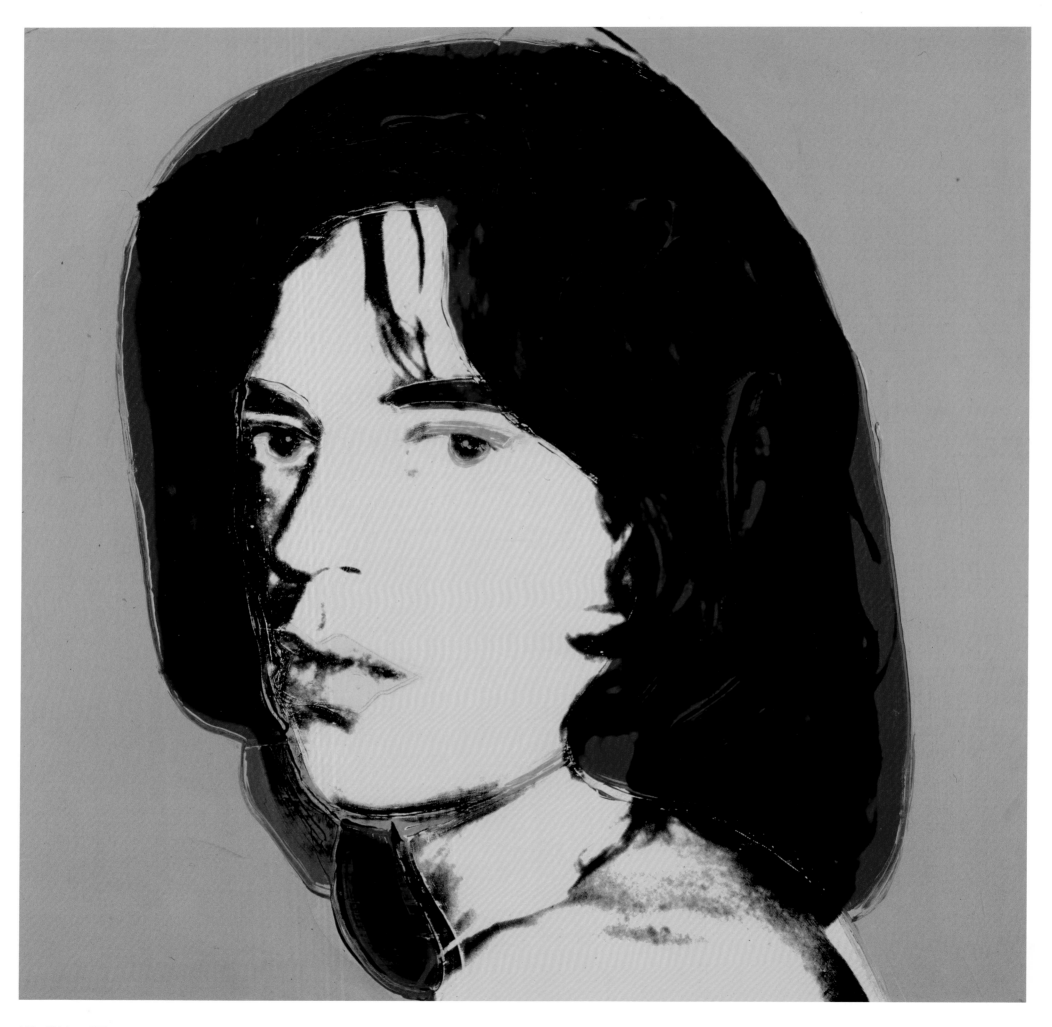

105 – *Mick Jagger*, 1975

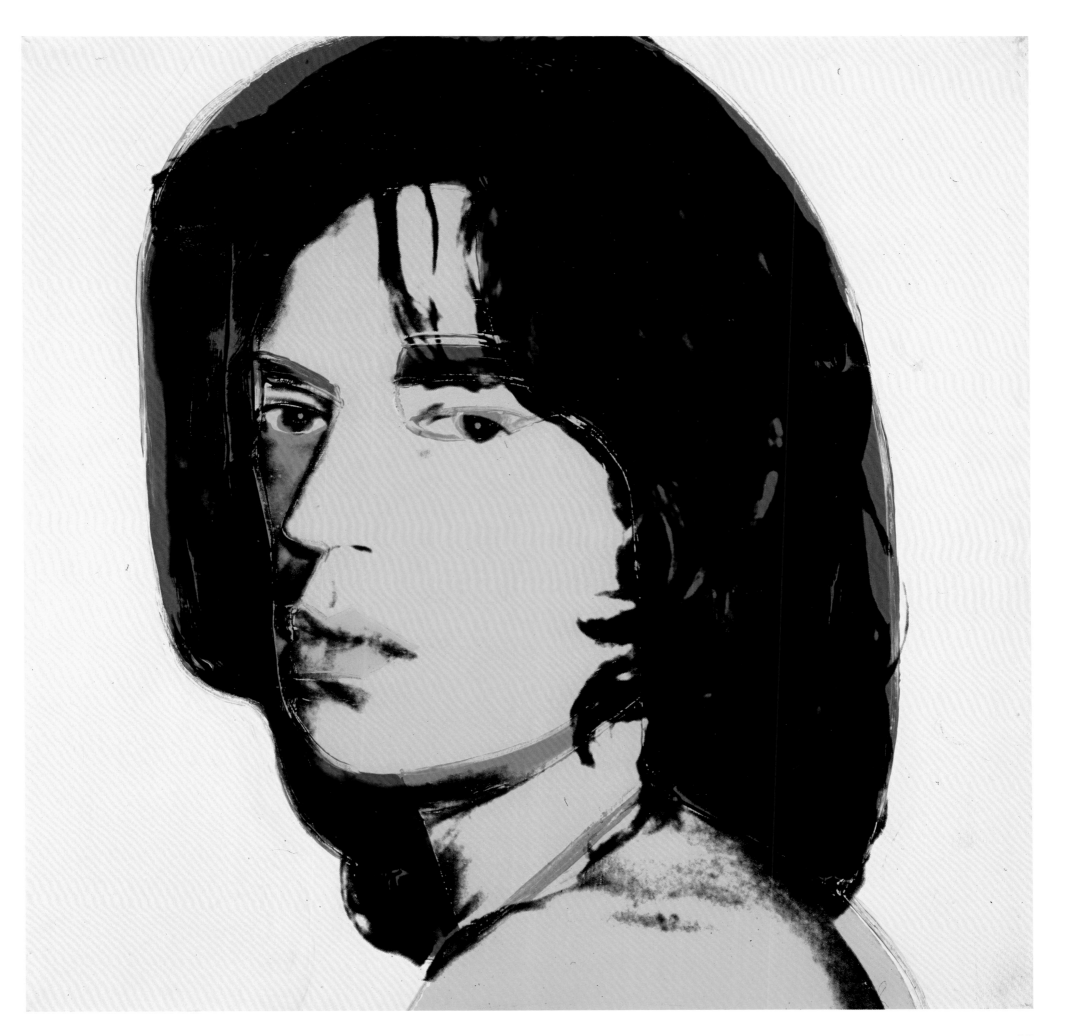

106 – *Mick Jagger*, 1975

235

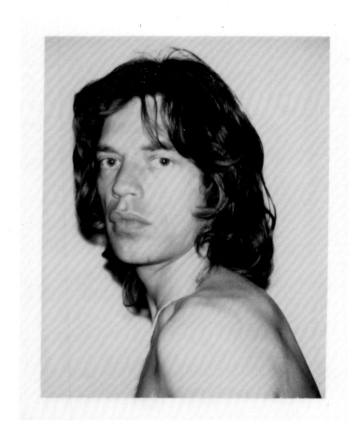

237

231

236

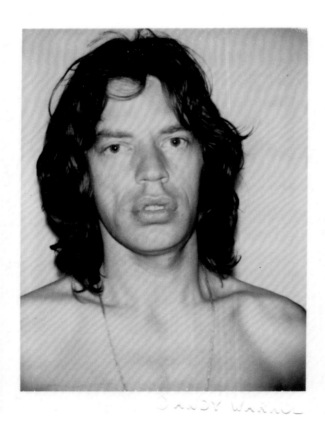

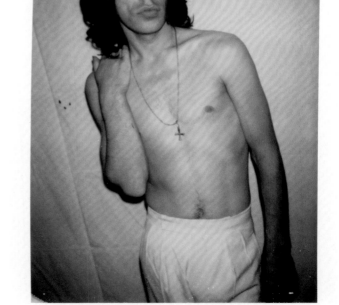

229–237 – Mick Jagger, Warhol's Polaroid photos, 1975

234

230

232

229

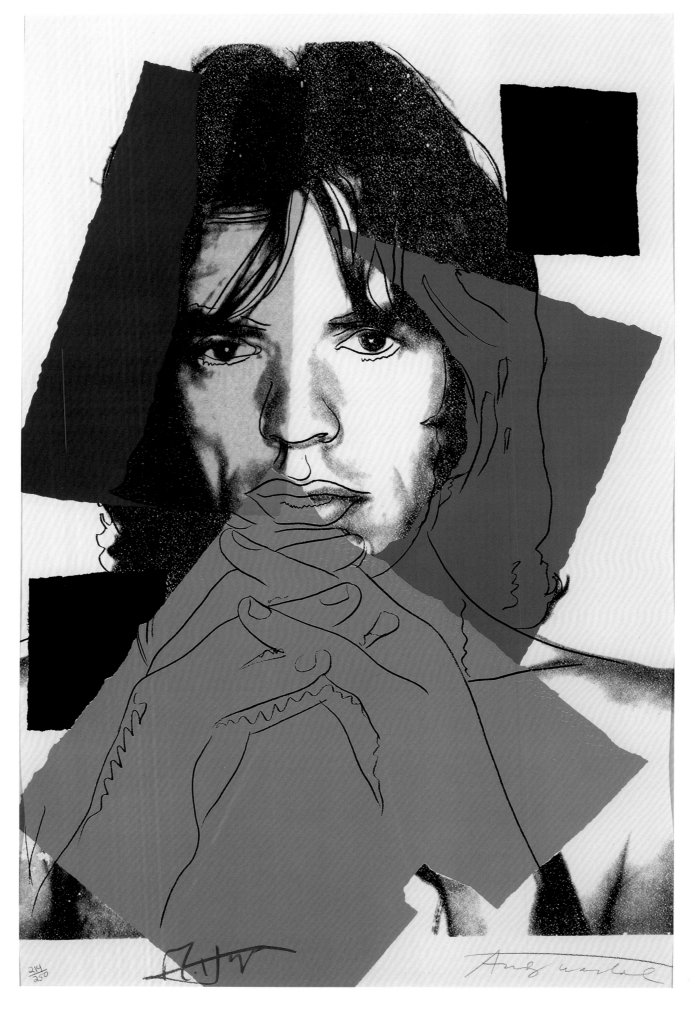

160 – *Mick Jagger,* portfolio of 10 screen prints, 1975

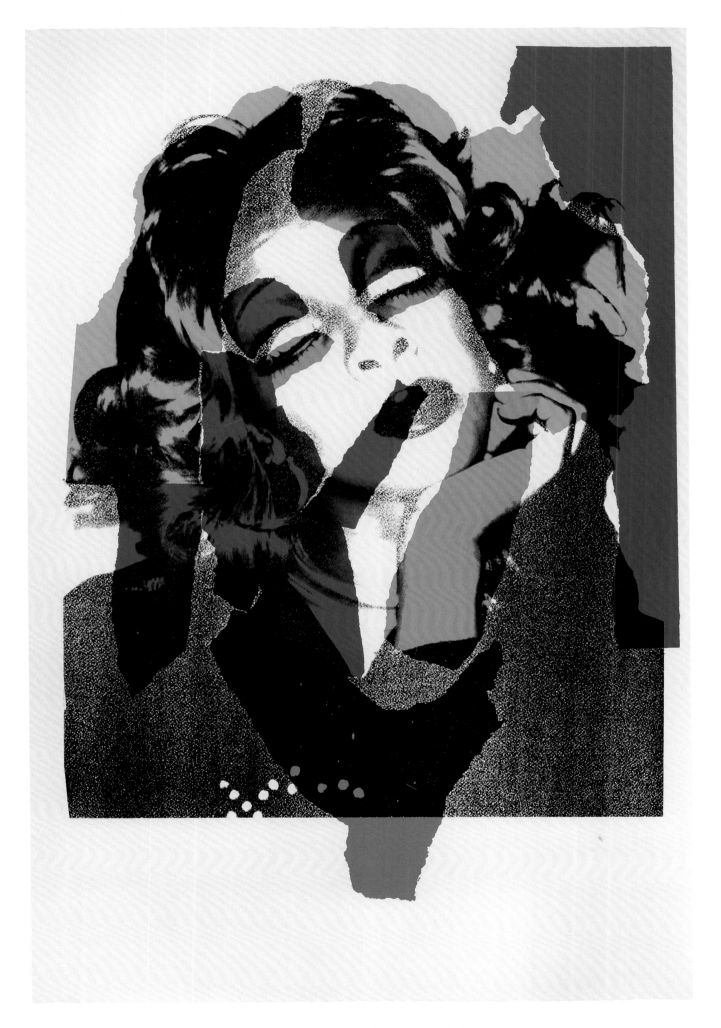

159 – *Ladies and Gentlemen*, portfolio of 10 screen prints, 1975

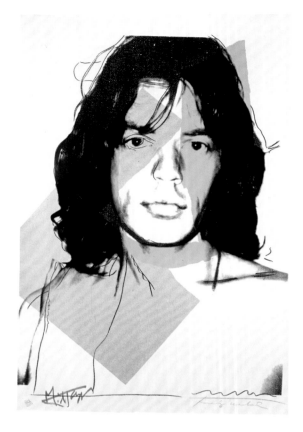
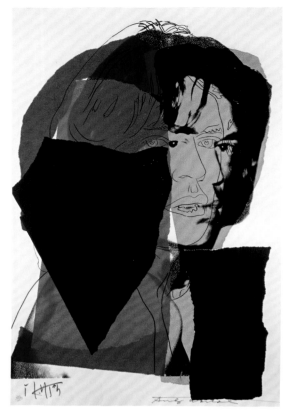
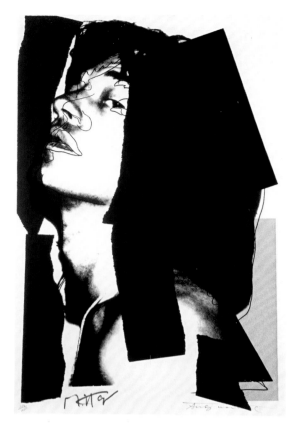

160

160

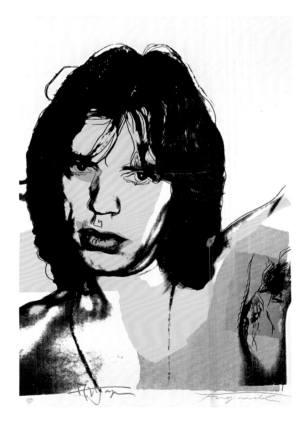
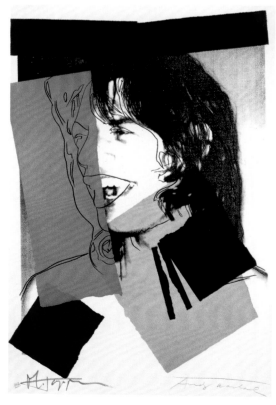
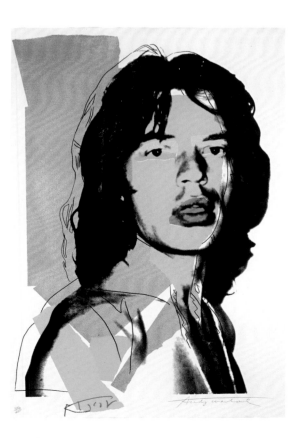

160 — *Mick Jagger*, portfolio of 10 screen prints, 1975

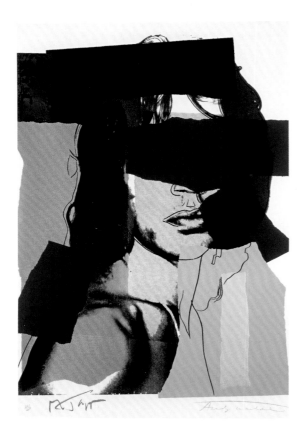
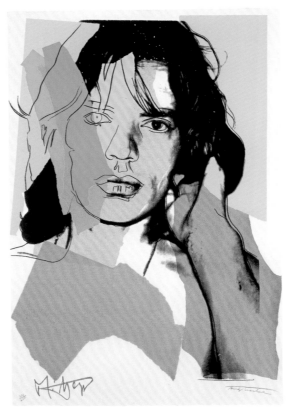
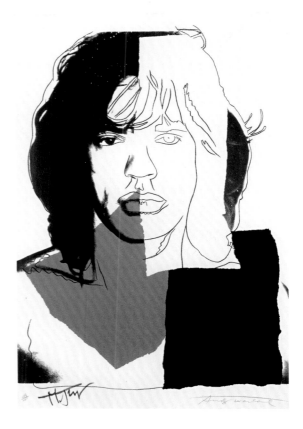

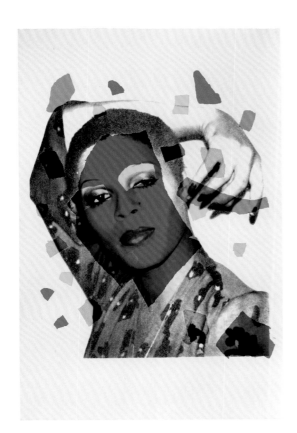

159 – *Ladies and Gentlemen*, portfolio of 10 screen prints, 1975

228, 226
227, 208

514, *69*
517

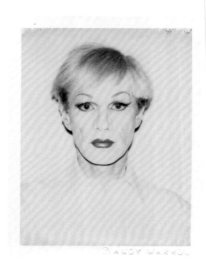
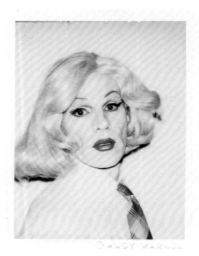
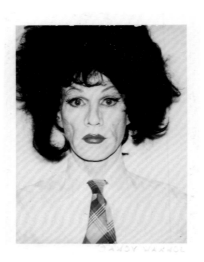
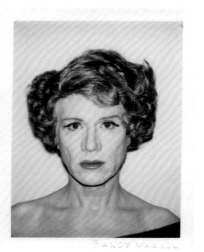

277, 278
274, 265

228, 226, 227 – Drag queens: Warhol's Polaroid photos used for the series *Ladies and Gentlemen* (1975), 1974 **208** – Candy Darling, 1969 **514** – The Rolling Stones' *Goats Head Soup* record cover, 1973 *69* – Advertisement for the Rolling Stones' "Have you seen your mother, baby, standing in the shadow?" in *Billboard*, October 1, 1966 **517** – The Rolling Stones' *Some Girls* record cover, 1978 **277, 278, 274, 265** – Self-portraits in drag, Polaroid photos, 1981

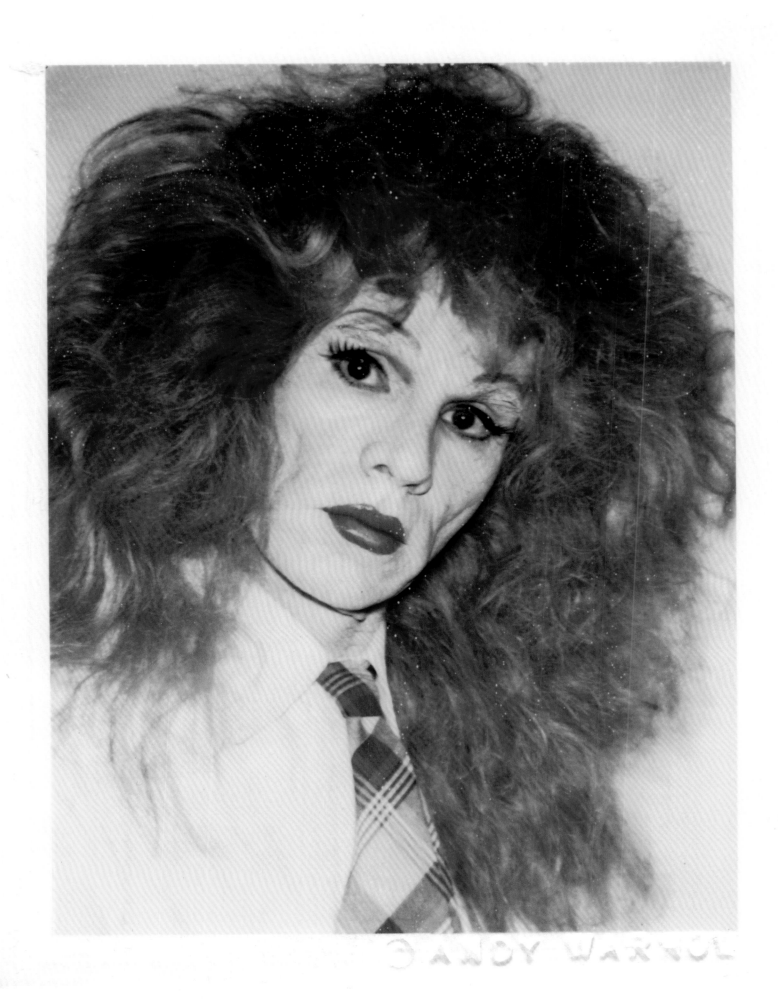

276 – Self-portrait in drag, Polaroid photo, 1981

36

38

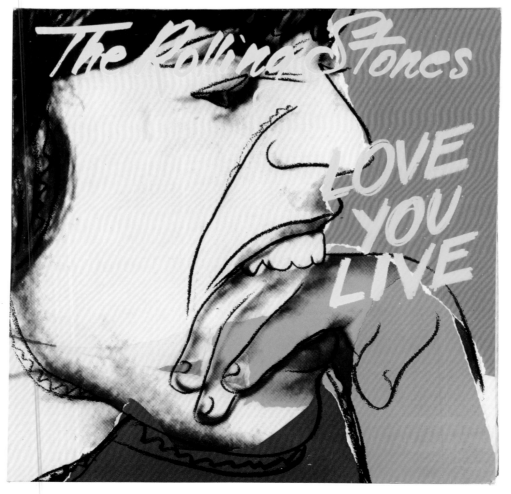

36 – Record cover mock-up for the Rolling Stones' *Love You Live* (1977), 1976–77 **38** – The Rolling Stones' *Love You Live* record cover, 1977

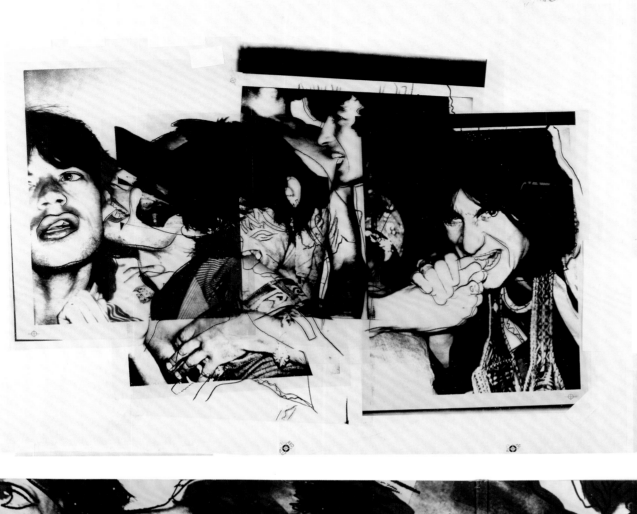

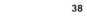

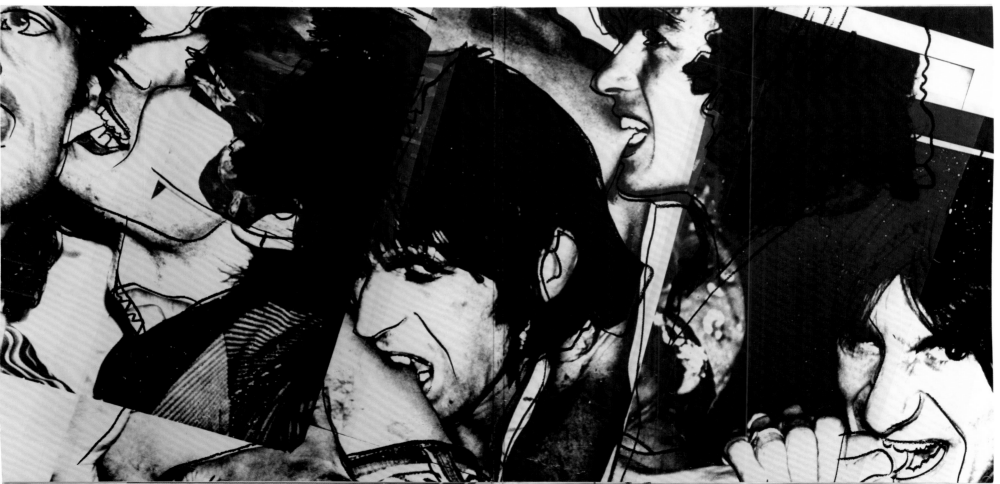

161 – *Rolling Stones—Love You Live*, 1975 **38** – Interior of the Rolling Stones' *Love You Live*, 1977

251, 249, 252

245, 246, 250

244, 248, 247

244–252 – Polaroid photos used for the Rolling Stones' *Love you Live* (1977) record cover

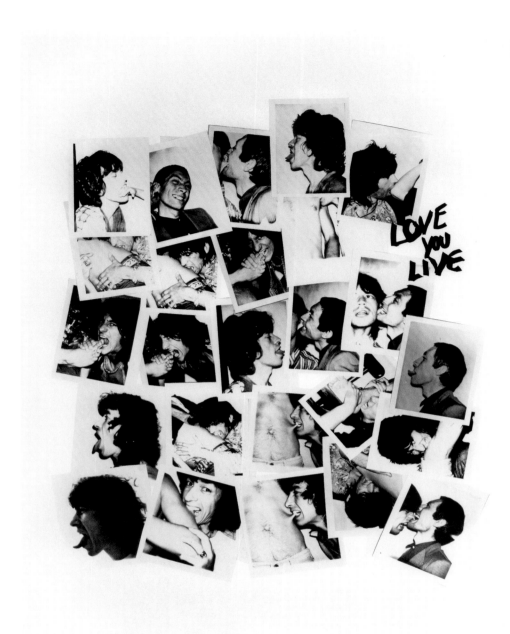

73

285, 286

74

73 – Poster used to decorate the walls of Traxx, New York, at the record launch of the Rolling Stones' *Love You Live* (1977) **285, 286** – Polaroid photos used by Warhol for the movie poster for Rainer Werner Fassbinder's *Querelle* (1982)

74 – Movie poster for Rainer Werner Fassbinder's *Querelle* (1982)

NIGHTCLUBBING Music and nightclubs are inseparable, and New York City has always had more than its share of both. The city's clubs and cafés provided Warhol with a social scene and served as venues for his work and social life. By the late 1970s, the appointment books he kept for his evening dates were so filled with invitations (not including those for parties and events he had no interest in attending) that they were impossible to close. In the 1950s, Warhol was associated with Serendipity 3, a café on the Upper East Side known for its desserts. It was where he showed and sold his work, among its Tiffany lamps, and is said to have hosted parties there during which his friends coloured his works. He even made a series of portrait drawings of one of its owners, Stephen Bruce. Also for much of the decade, he lived above a bar called Shirley's Pin-Up, where cabaret singers performed. In 1965, Mickey Ruskin opened a bar and restaurant on Union Square known as Max's Kansas City. It became a hangout for Warhol, his Superstars, and most of the New York art world. Ruskin and the artists were friends, and he would allow them to settle their tabs by exchanging artwork. Warhol had a big table in the backroom, directly under a red fluorescent light sculpture by Dan Flavin. Superstar Andrea "Whips" Feldman often performed her notorious "Showtime" (a unique version of "Everything's Coming up Roses") on Max's tables, on one occasion specially for Jane Fonda. The Velvet Underground performed their final shows with Lou Reed there in 1970, and the bar hosted many more bands, including the New York Dolls and Bruce Springsteen. Punk rock burst onto the scene in the mid-1970s and became a major movement. It was based at Hilly Kristal's CBGB & OMFUG on the Bowery, and at the Mudd Club. Patti Smith Group, Television, the Ramones and Talking Heads were some of punk rock's pre-eminent bands, many of which had drawn inspiration from the Velvet Underground. Punk's polar opposite was disco, and its famous epicentre was Studio 54, a huge club at 254 West Fifty-fourth Street, founded by Steve Rubell. Beneath the giant *Man in the Moon* (with a huge cocaine spoon poised at his nose), high society mingled with low on the dance floor. Getting past the doorman was extremely difficult: as Warhol succinctly put it, it was "a dictatorship at the door, a democracy on the floor." To the artist, the discotheque became a second studio of sorts, a new Factory. He said of it, "Studio 54 is a way of life. People live there. They dance there. They drink there. They make friends there. They make love there. They break up there. They become stars there. They do business there. They sleep there. Sometimes, when it's really fun, I can't help but think somebody will be murdered there. We've never had an earthquake in New York, but if we did, it would be at Studio 54."[1] With its loud music, strobe lights and frenzied dancing, Studio 54 also embodied Warhol's artistic quest for a total art form uniting sound, vision and the body in motion, as in his Exploding Plastic Inevitable. The club closed in 1980, but others survived—including Danceteria and the Ritz—and still others opened, such as Area, the Saint, the World, Paradise Garage and Palladium (which featured enormous banks of video monitors for playing the latest hits, and the Mike Todd Room). Warhol captured the people and events at these clubs through portraiture, his still camera and his television shows. **M.W.**

1 *Andy Warhol's Exposures* (New York: Andy Warhol Books / Grosset and Dunlap, 1979), 48.

Opposite: *Celebrity Collage*, 1978 (cat. 163) (detail)

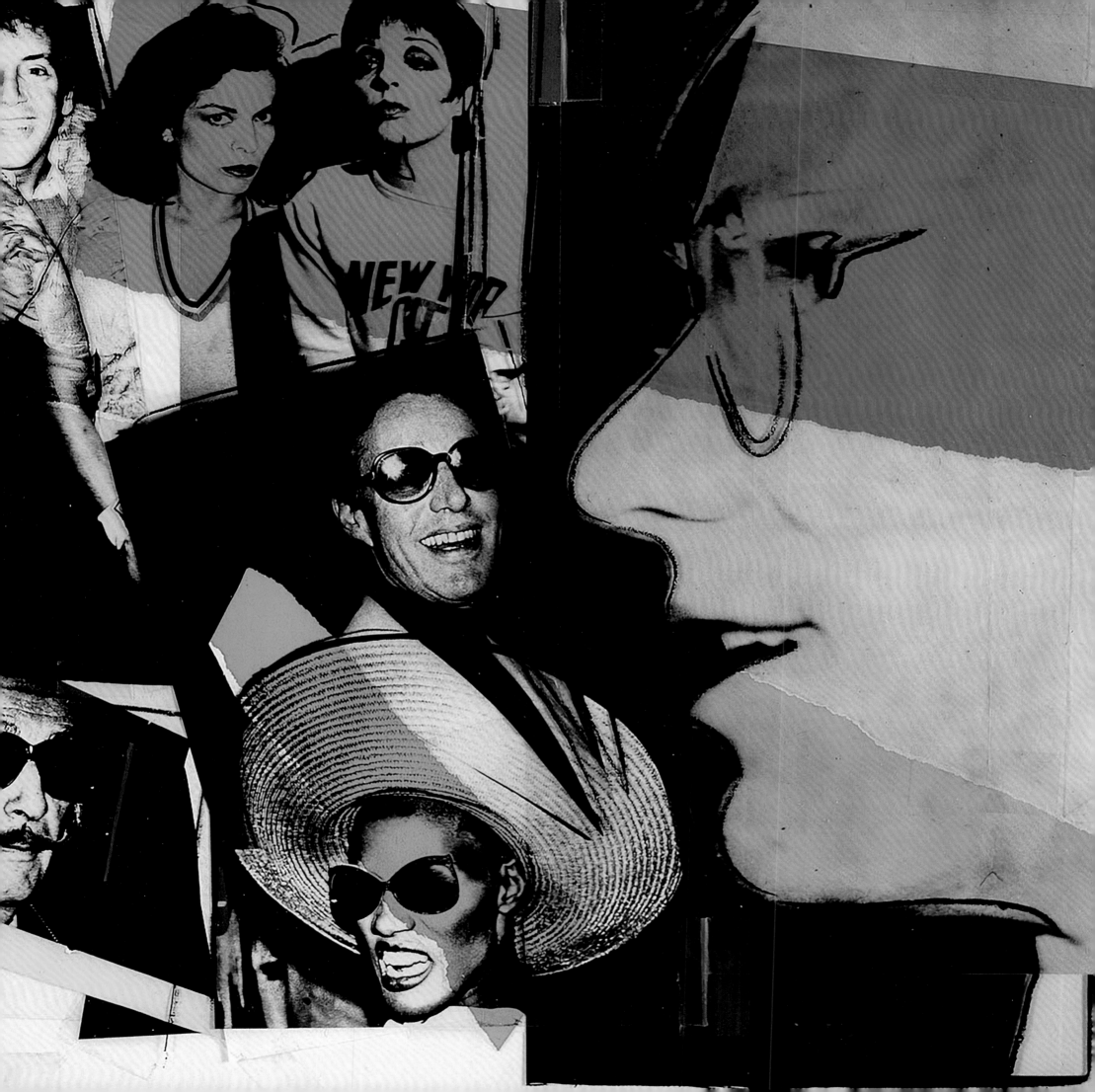

256

267

259

266

306

320

256 – Liza Minnelli, 1978 **267** – Liza Minnelli, Rudolf Nureyev and Martha Graham, about 1980 **259** – Steven Tyler and Bebe Buell, 1979 **266** – Steve Rubell and Bianca Jagger, 1980 **306** – David Byrne, n.d.
320 – Ella Fitzgerald and Vincent Minnelli, n.d.

273 – Martha Graham and Andy Warhol, 1981

109

110

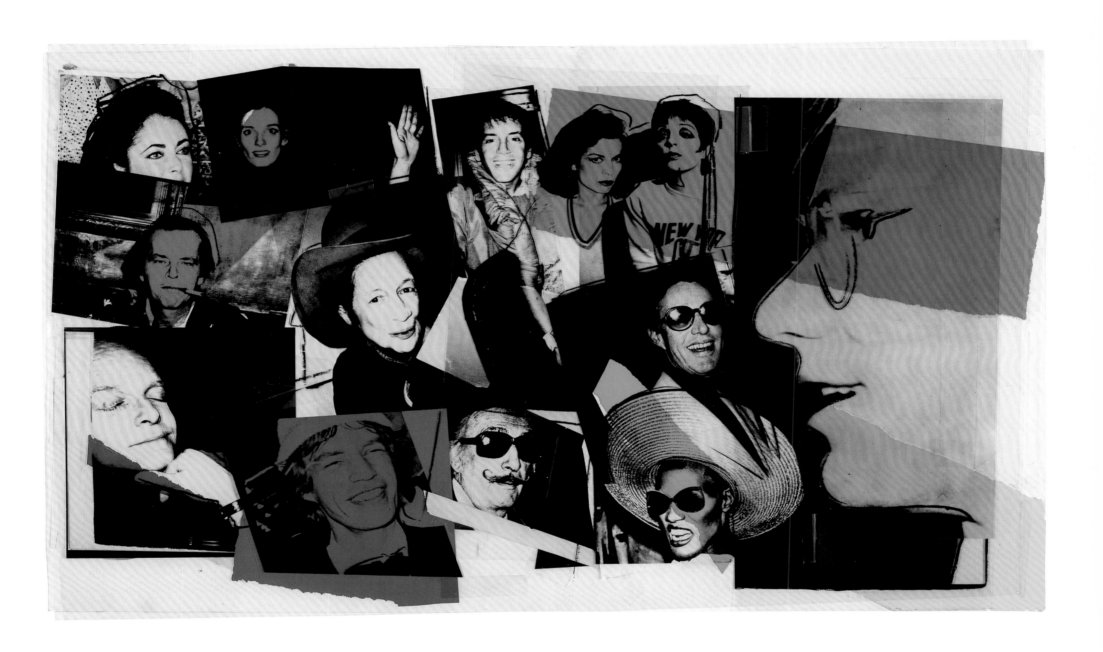

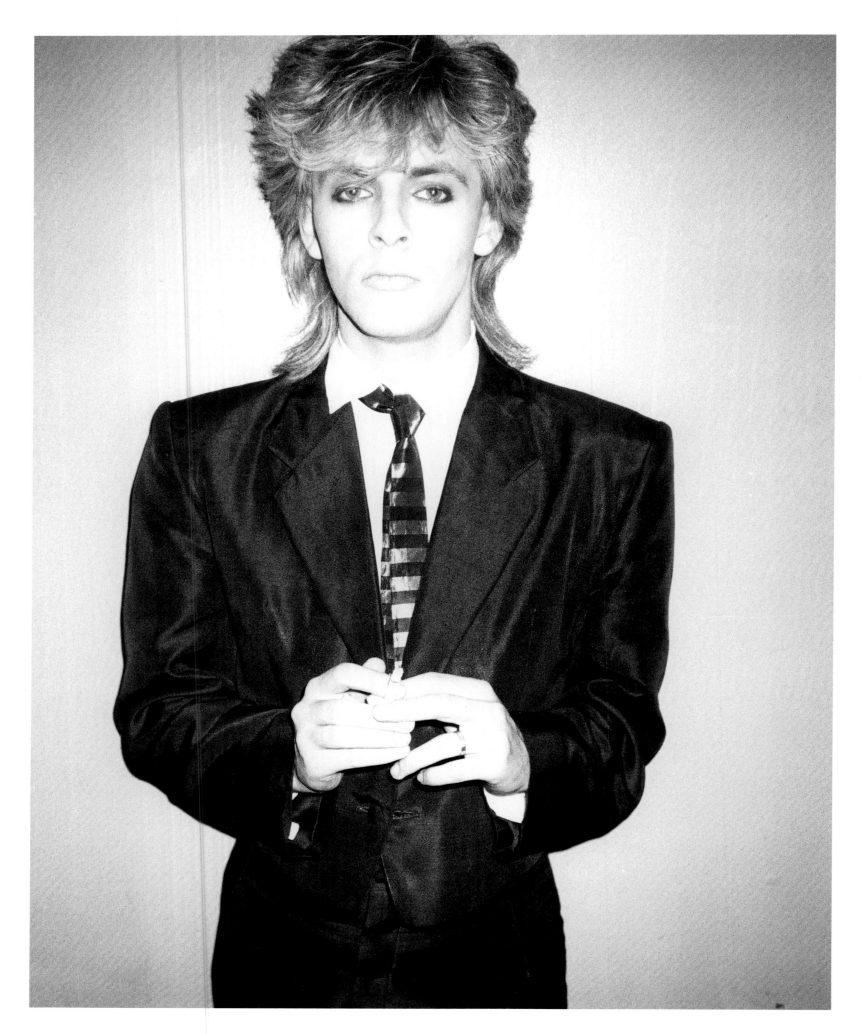

317 — Nick Rhodes, n.d.

314, 309, 300

310, 289, 303

 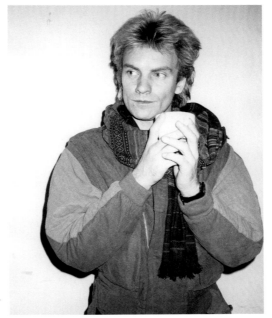 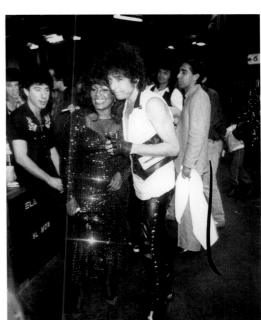

314 — Michael Monroe and Andy McCoy of Hanoi Rocks, n.d. **309** — Joan Jett, n.d. **300** — Anthony Kiedis of the Red Hot Chili Peppers, about 1985 **310** — Joey Arias, n.d. **289** — Sting, 1982 **303** — Bob Dylan, 1986

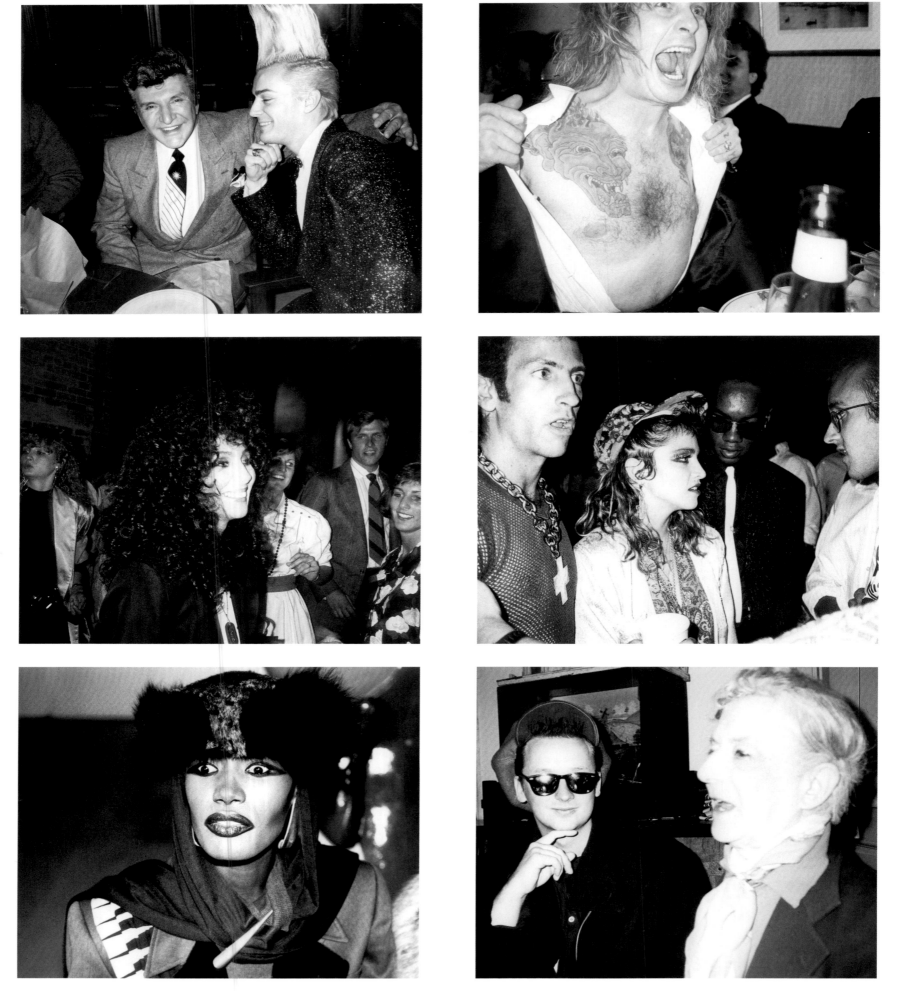

296 – Liberace and John Sex, 1984 **318** – Ozzy Osbourne, n.d. **297** – Cher, 1984–85 **294** – Kenny Scharf, Madonna, Juan Dubose and Keith Haring, about 1983 **301** – Grace Jones, 1985 **281** – Boy George and Quentin Crisp, 1982

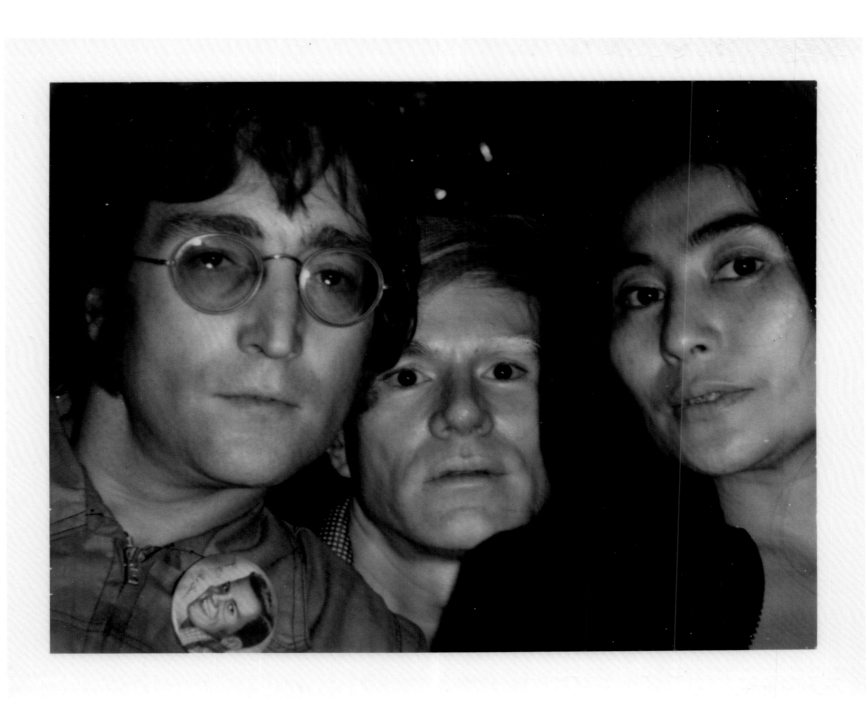

224 – Self-portrait with John Lennon and Yoko Ono, 1971

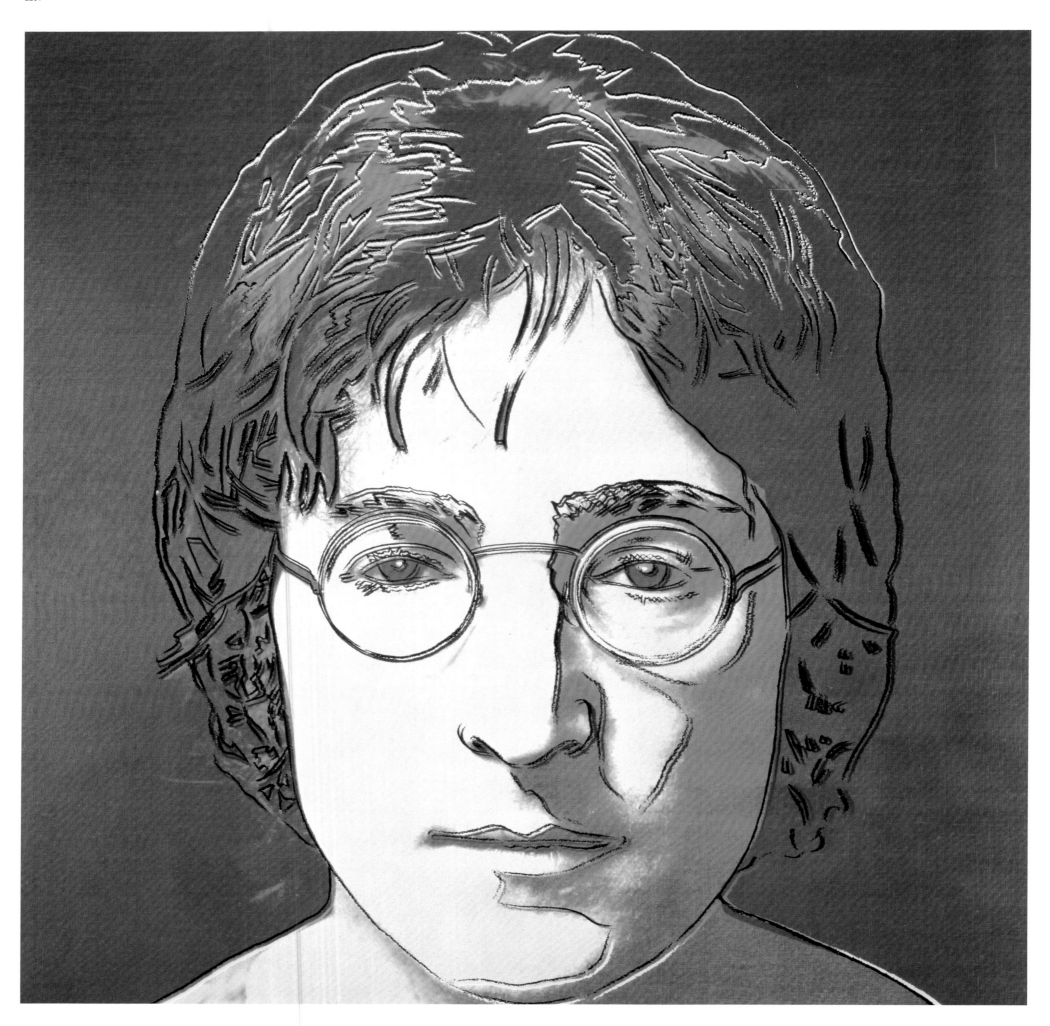

70 – *John Lennon*, 1985–86

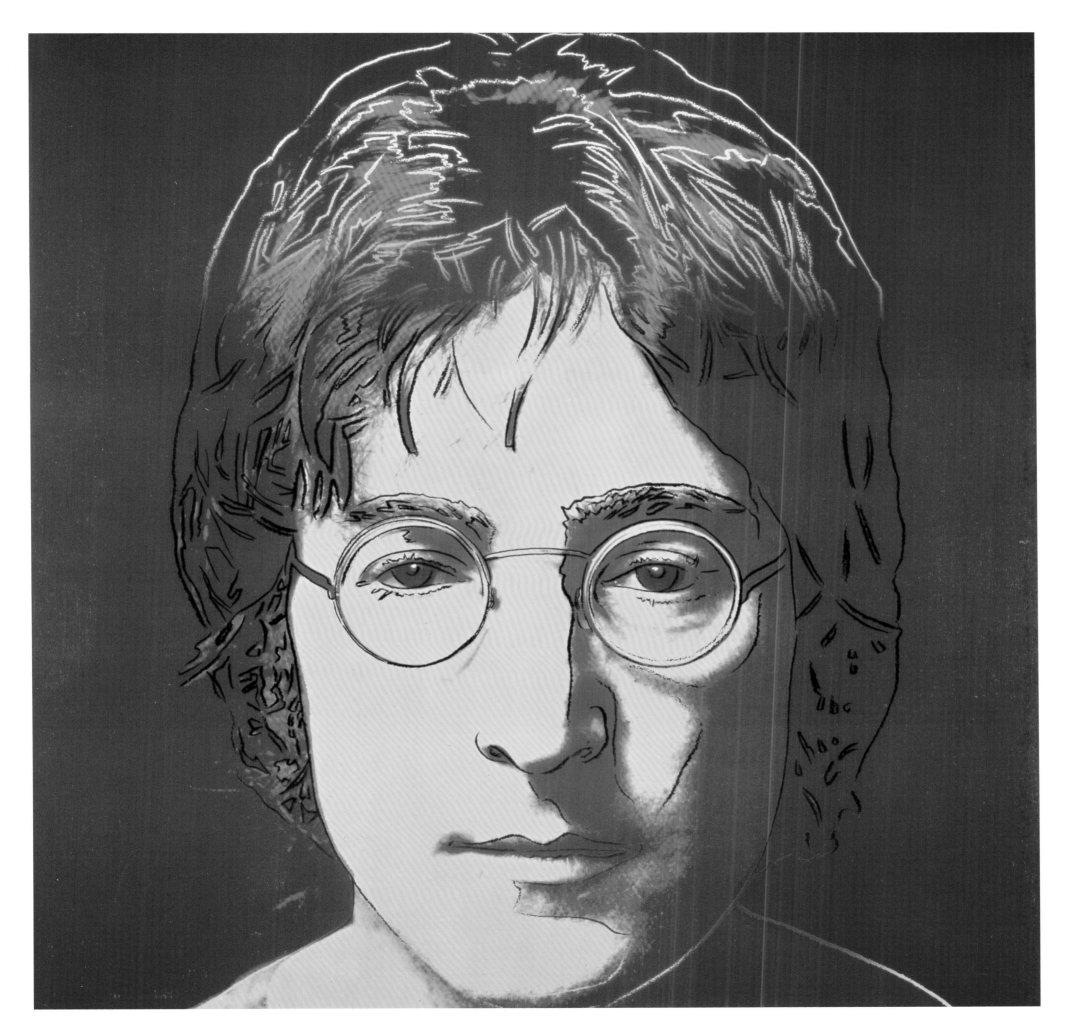

71 – John Lennon, 1985–86

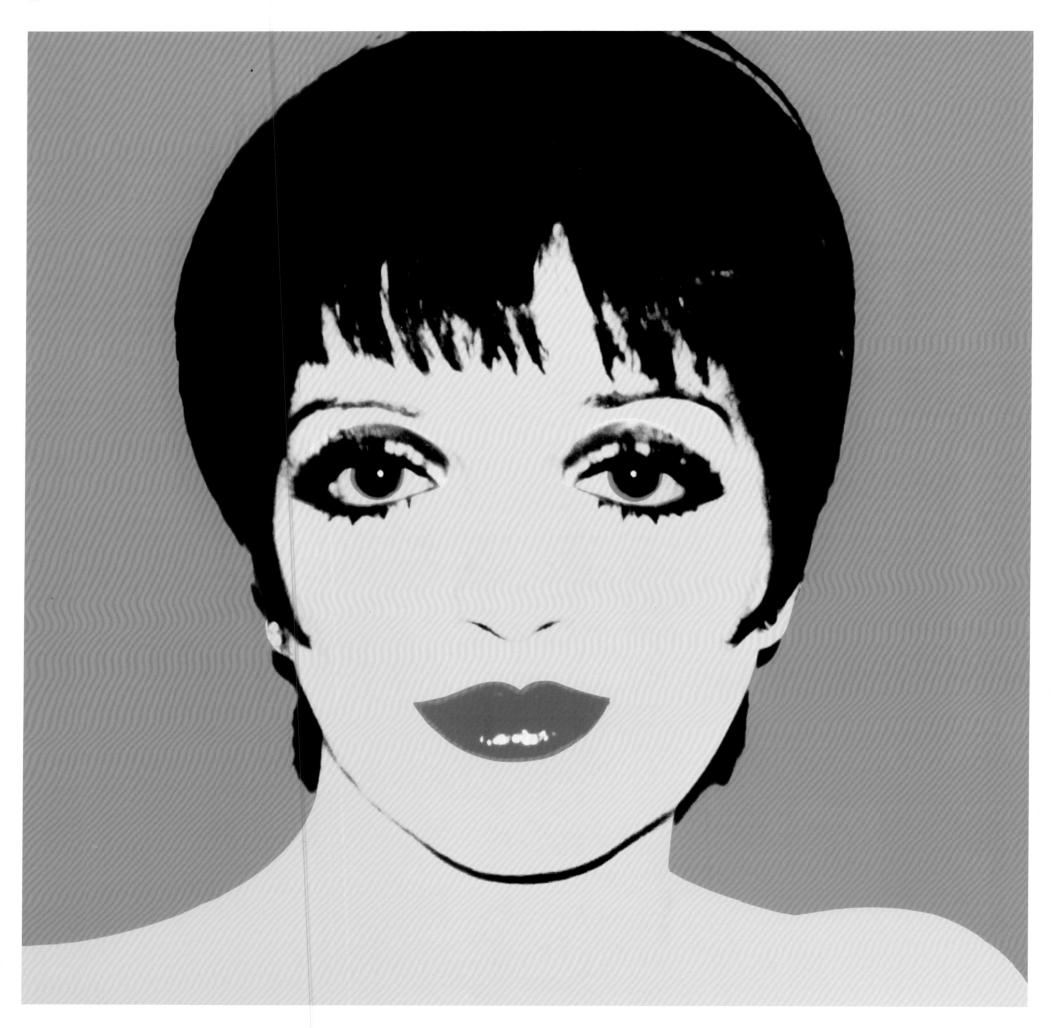

112 – *Liza Minnelli,* 1979

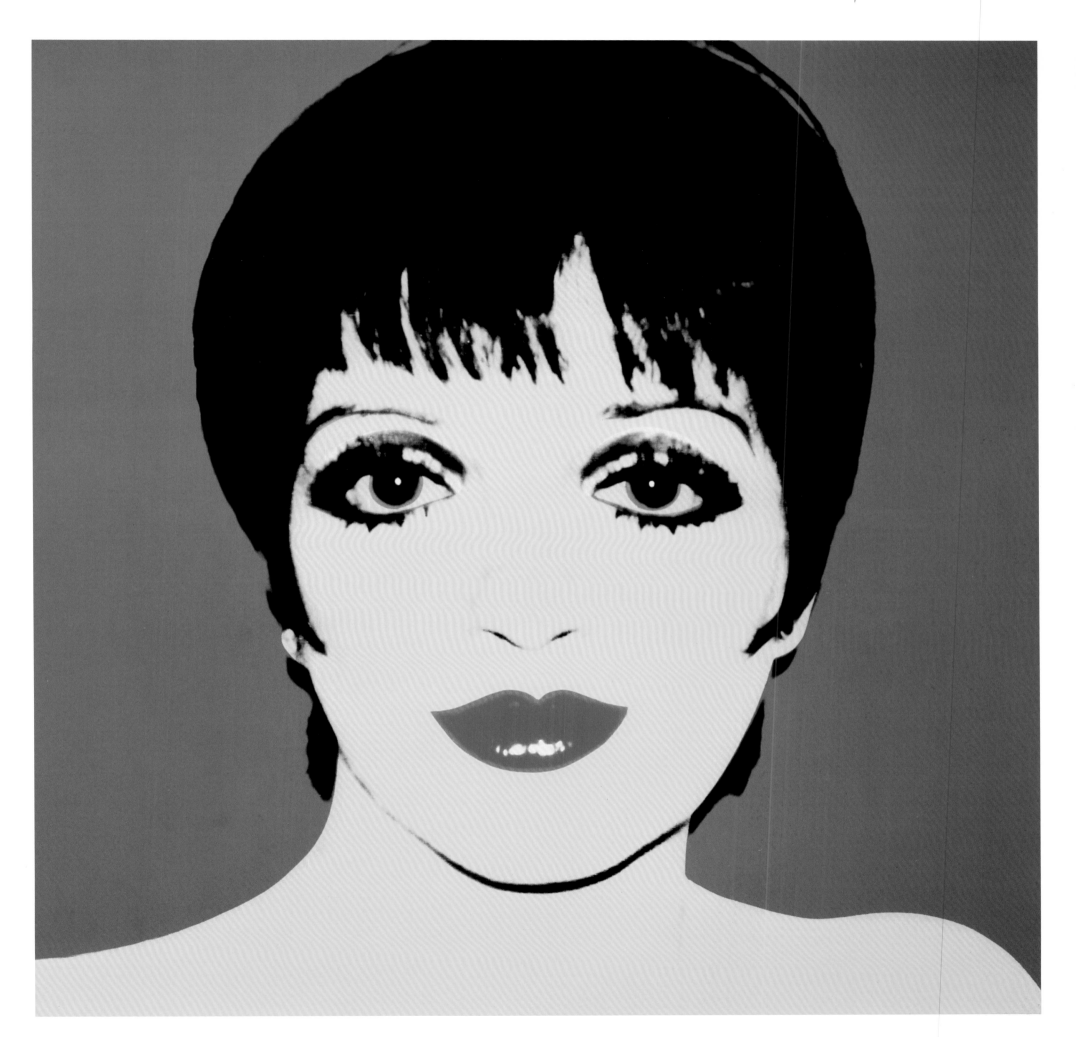

111 – *Liza Minnelli*, 1979

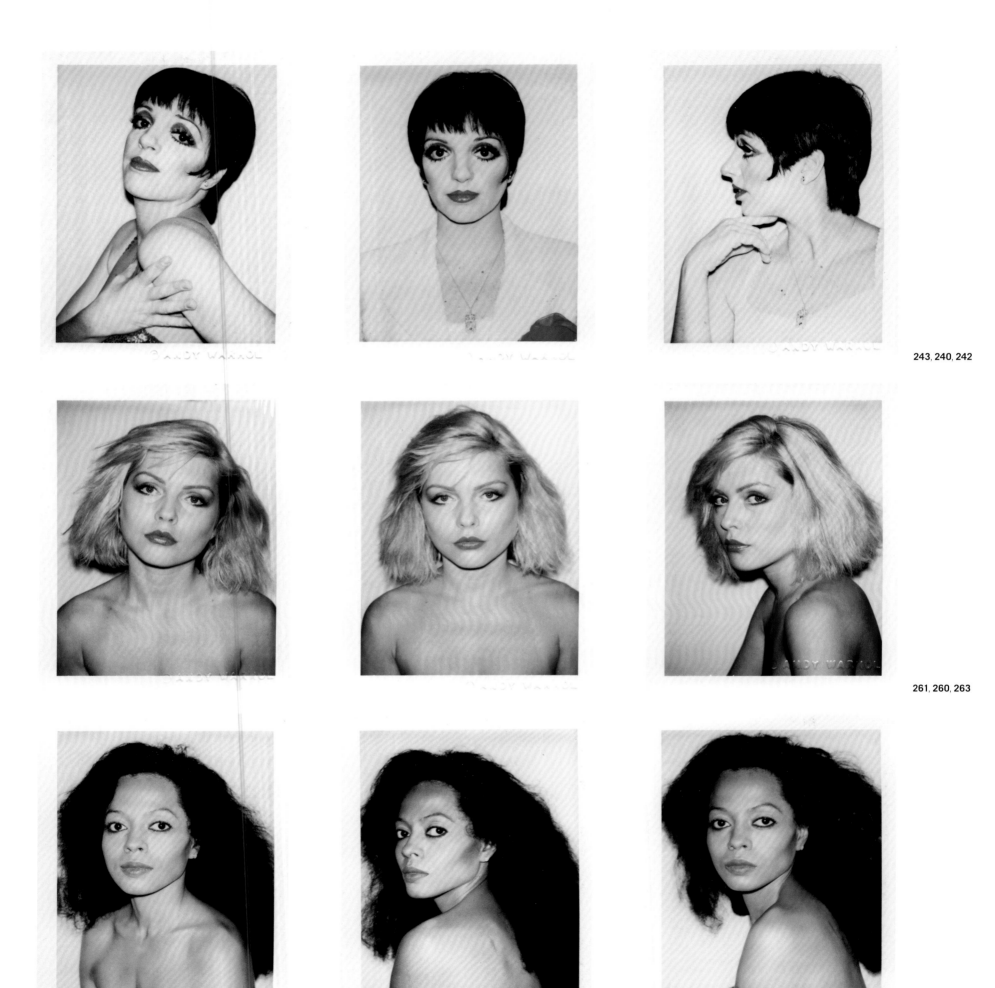

243, 240, 242

261, 260, 263

268, 270, 269

Polaroid photos: **243, 240, 242** – Liza Minnelli, 1977 **261, 260, 263** – Debbie Harry, 1980 **268, 270, 269** – Diana Ross, 1981

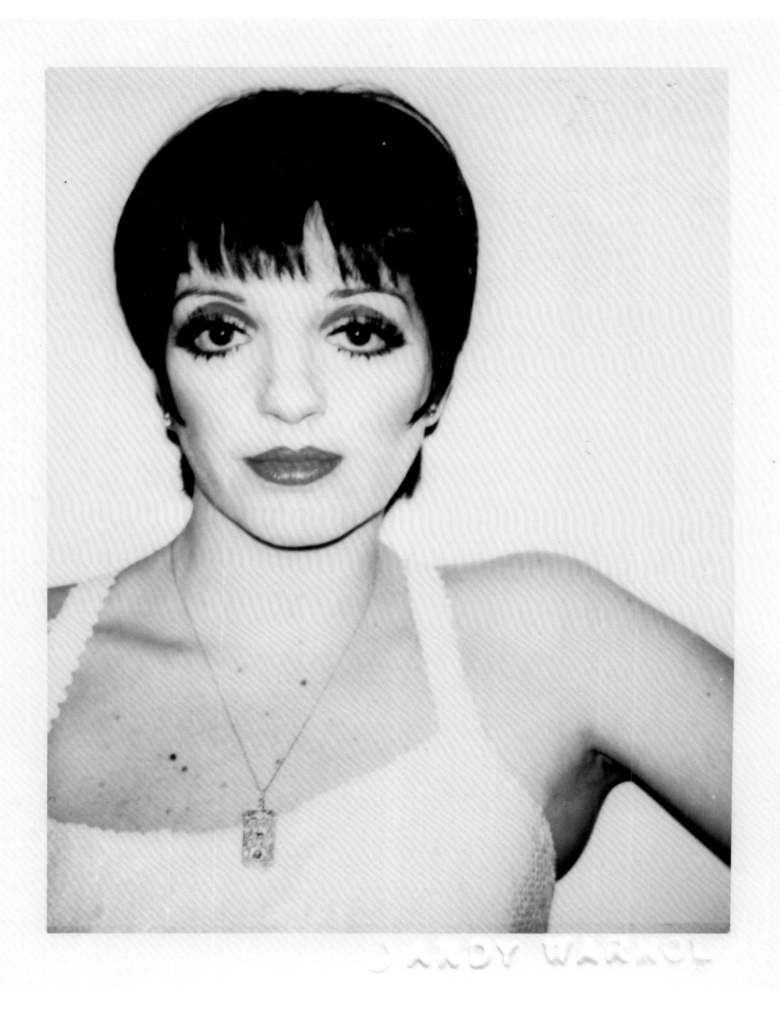

241 – Liza Minnelli, Polaroid photo, 1977

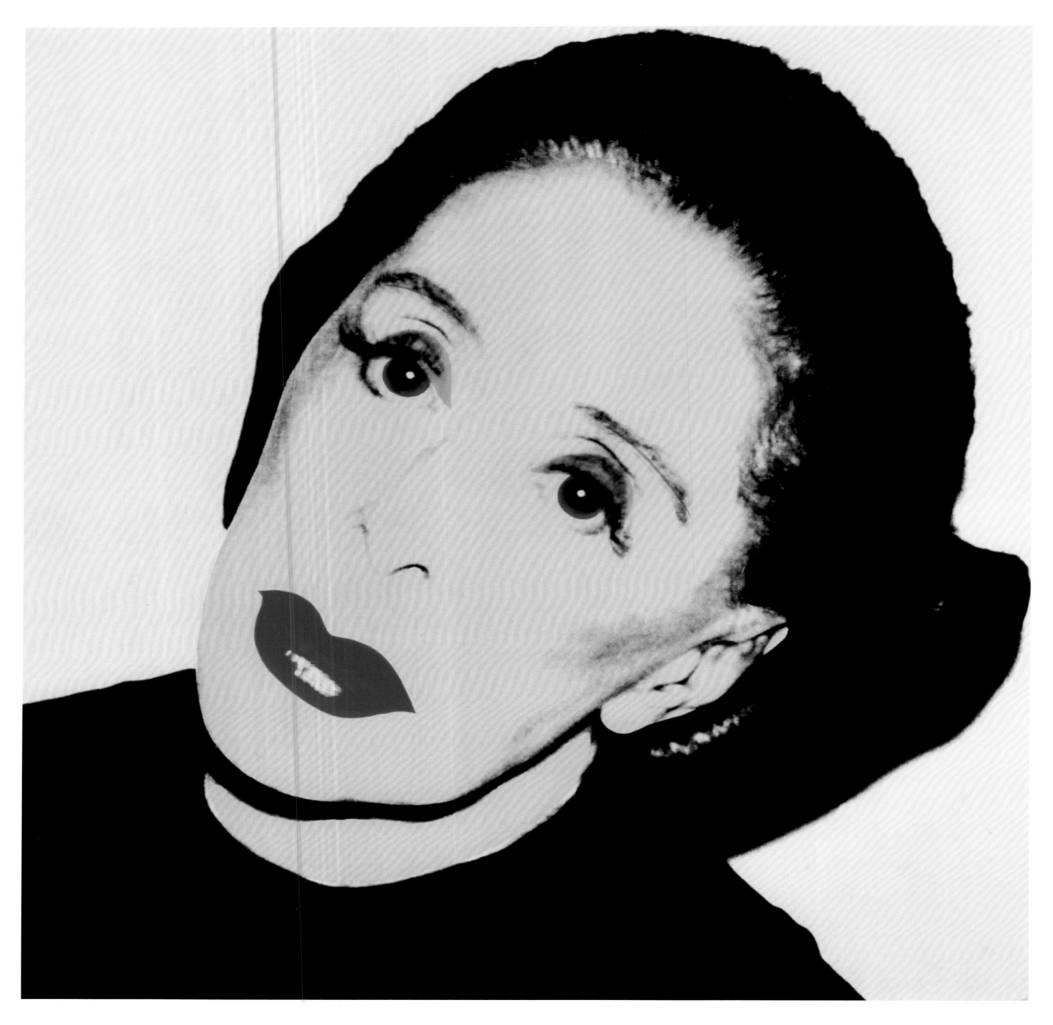

121 — *Martha Graham,* 1980

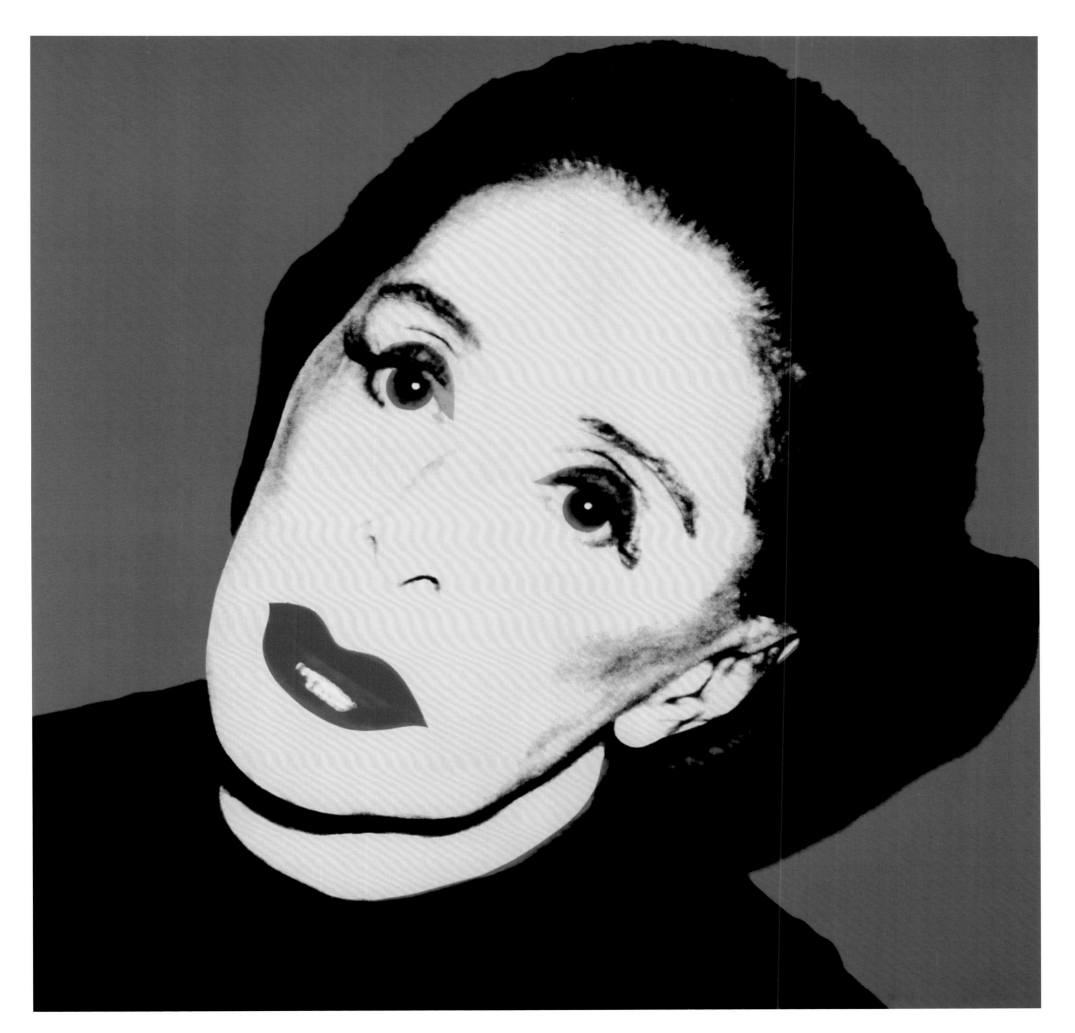

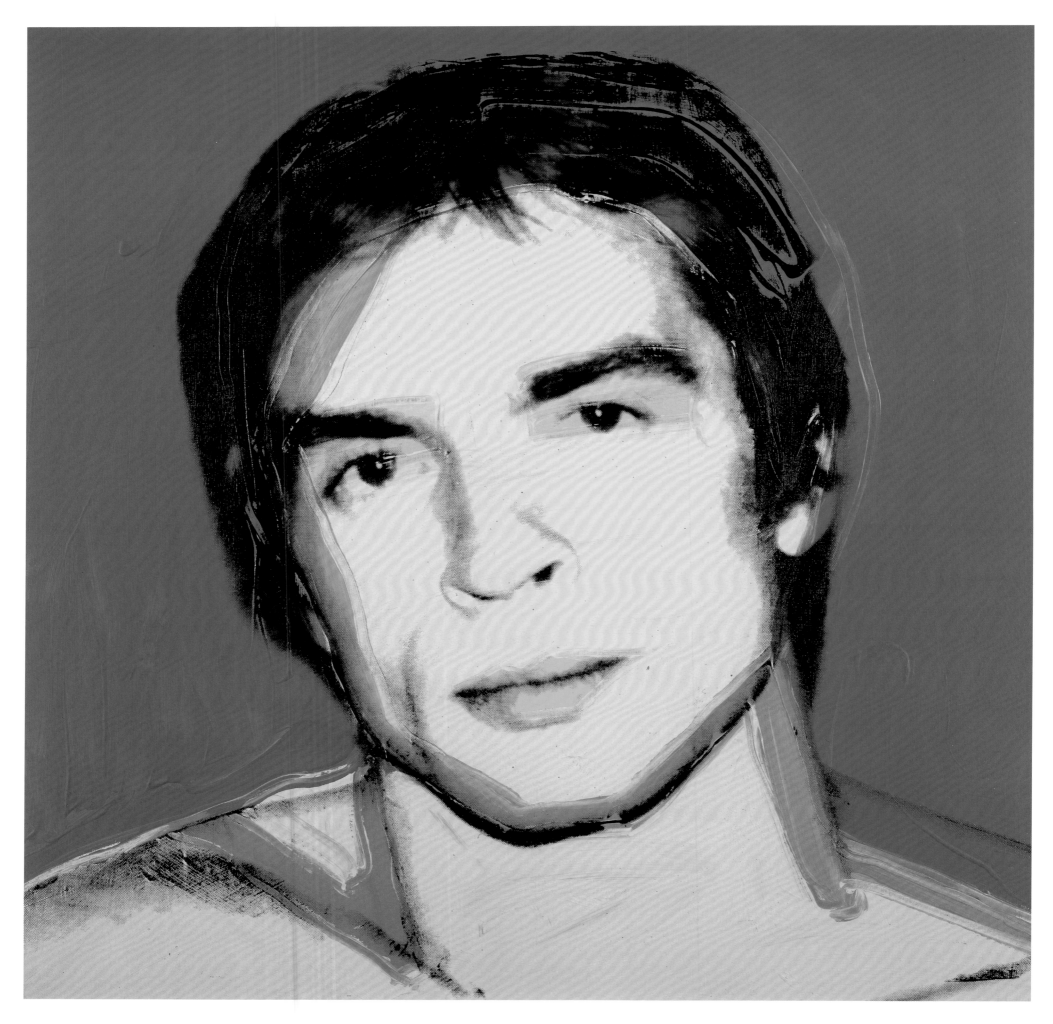

72 – *Rudolf Nureyev*, about 1975

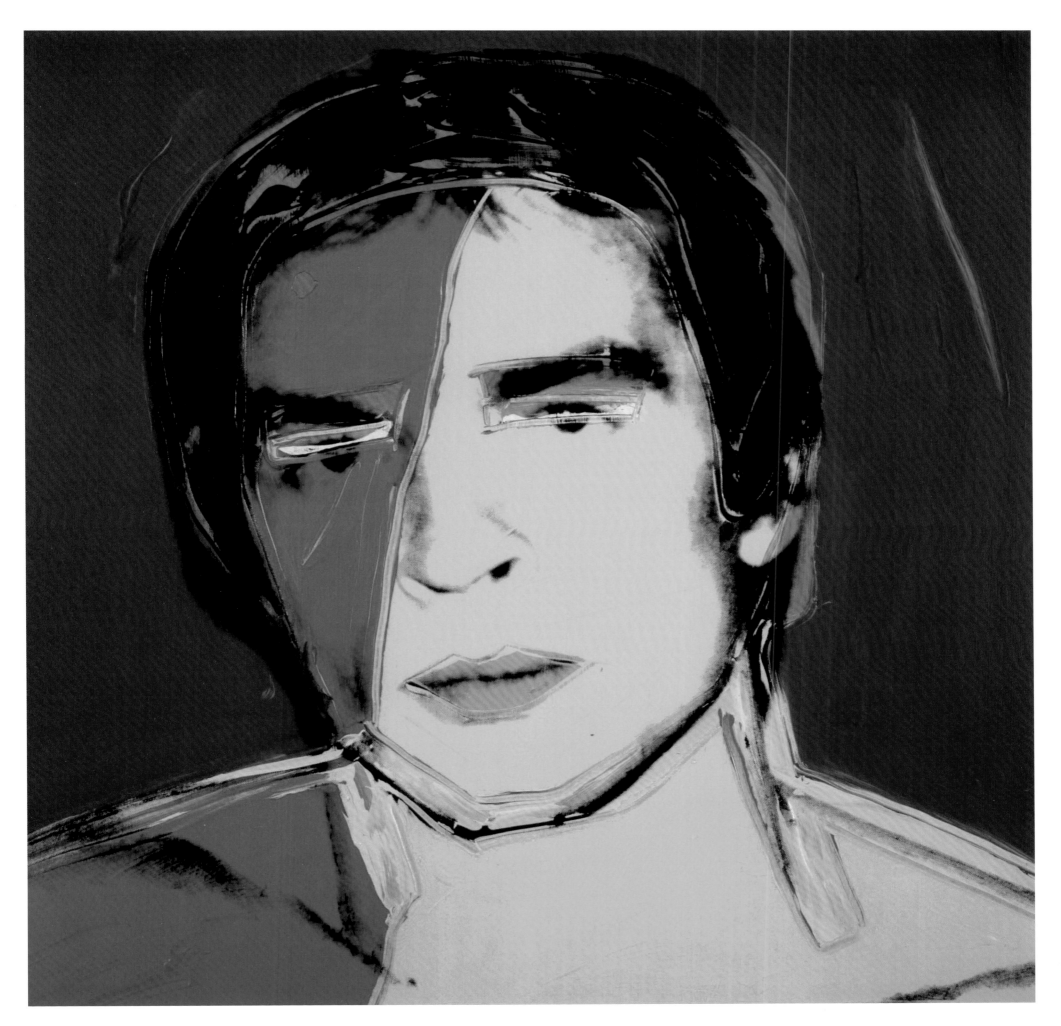

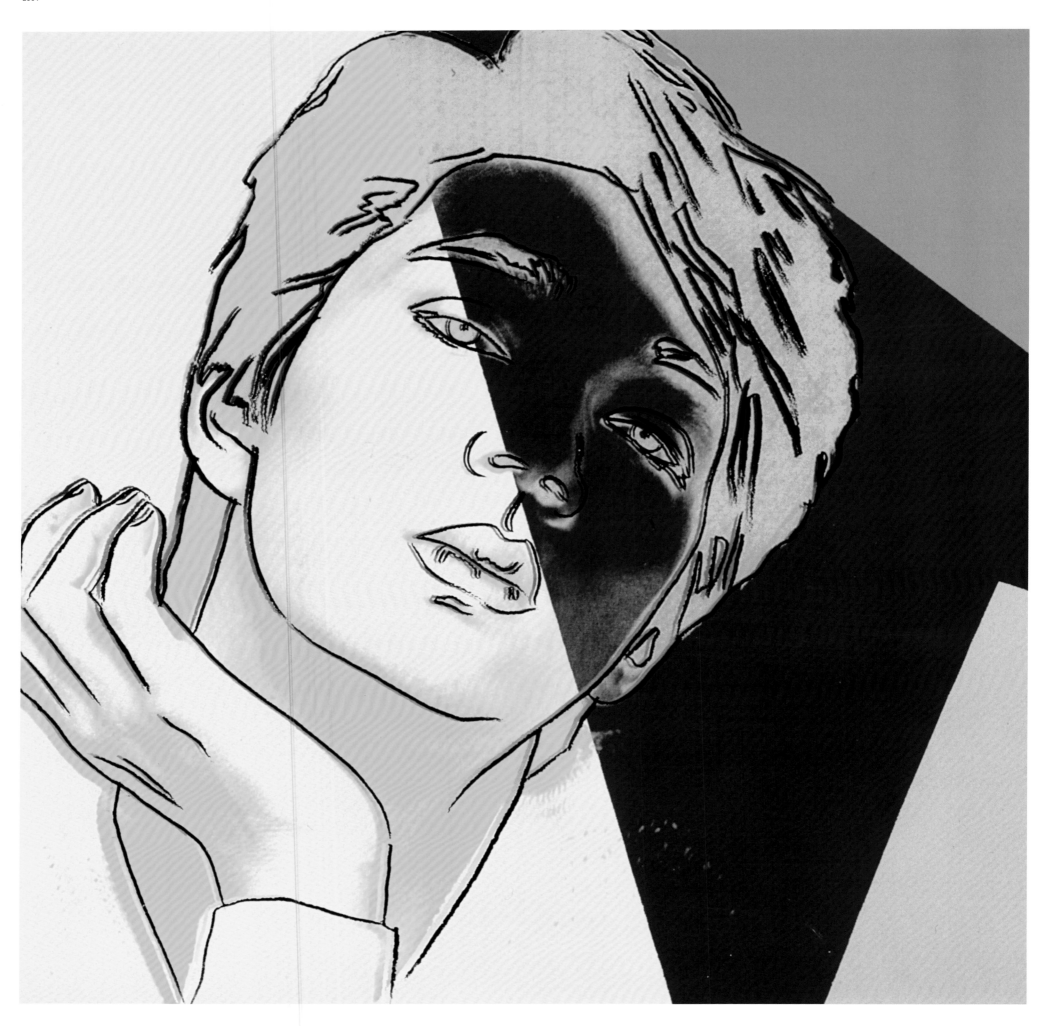

130 – *Ryuichi Sakamoto*, 1983

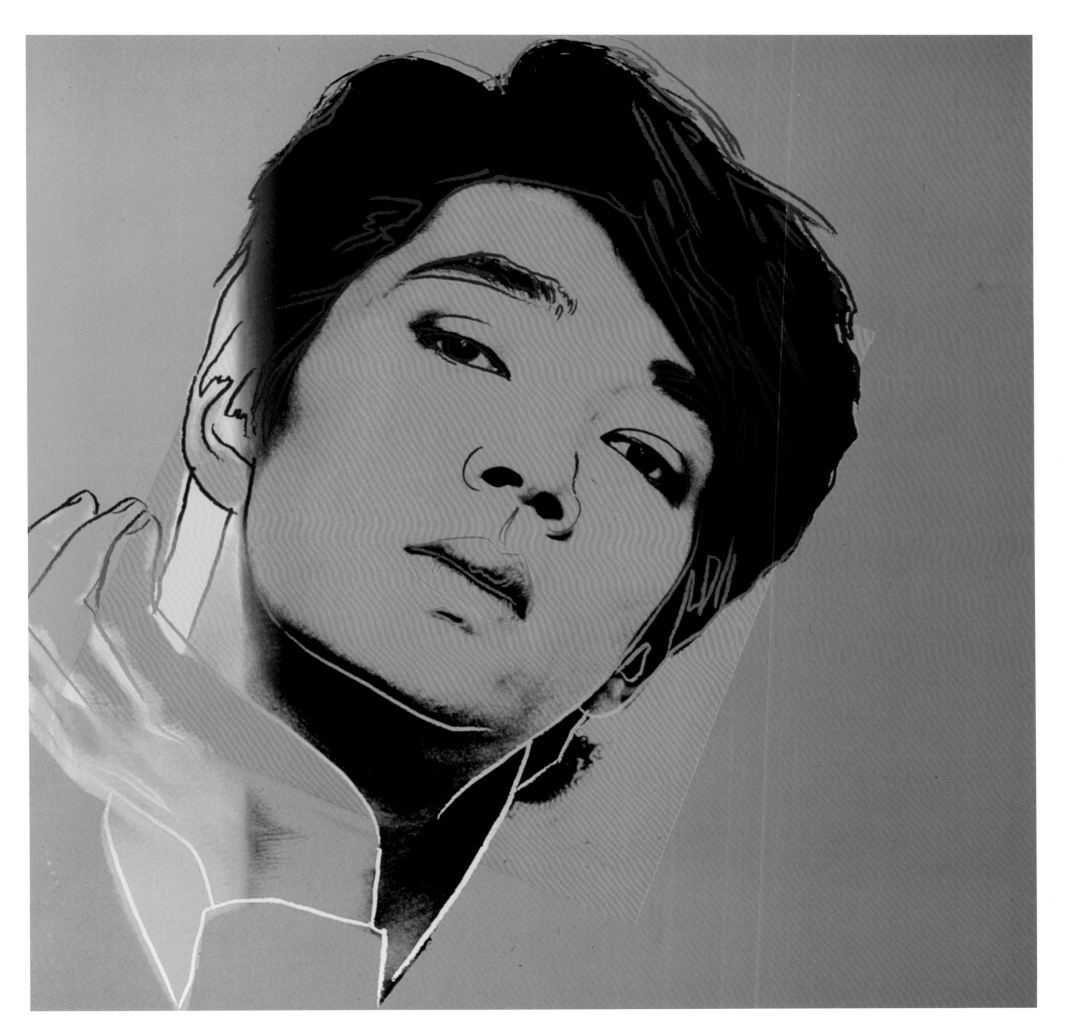

131 – *Ryuichi Sakamoto*, 1983

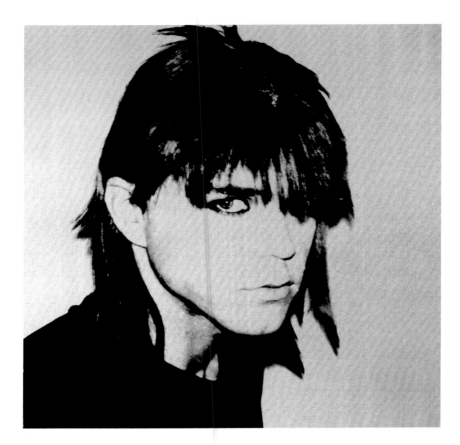

134

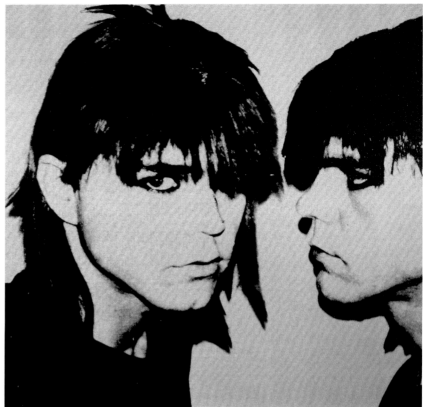

135

126

127

134, 135 – *Stephen Sprouse*, 1984 **126, 127** – *Miguel Bosé*, 1983

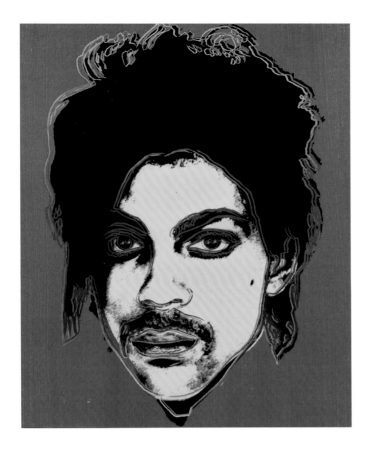

136

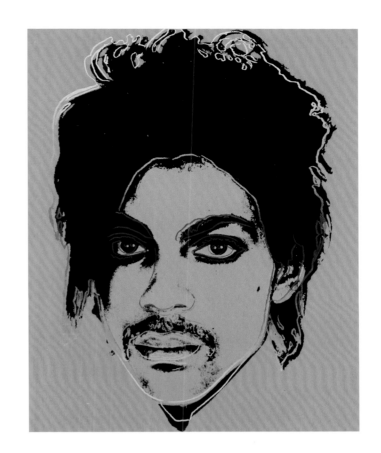

137

132

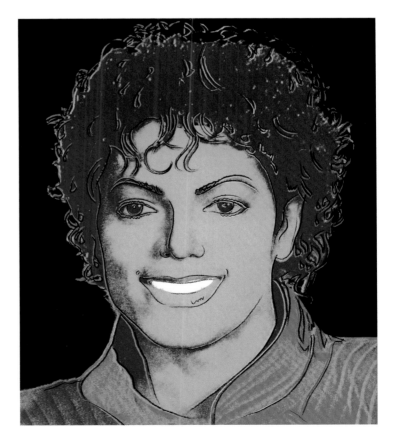

133

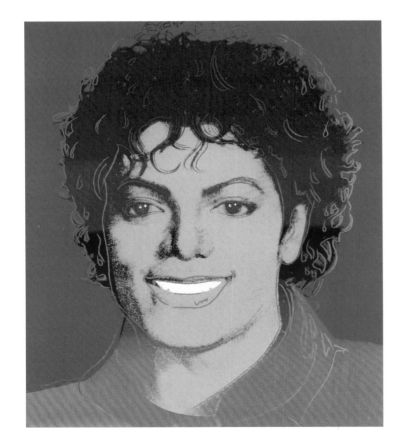

136, 137 – *Prince*, about 1984 **132, 133** – *Michael Jackson*, 1984

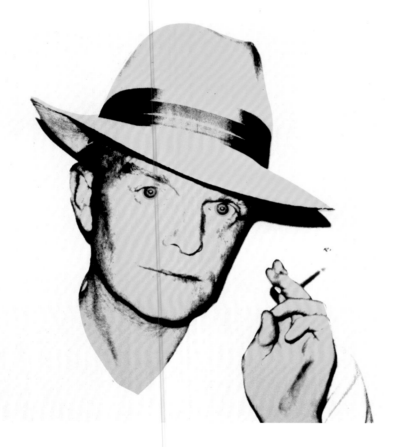

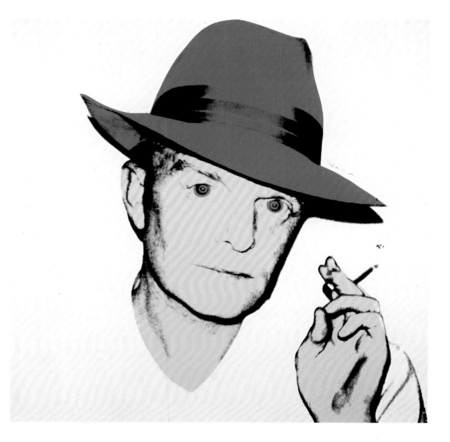

113

114

113, 114 – *Truman Capote*, 1979

128

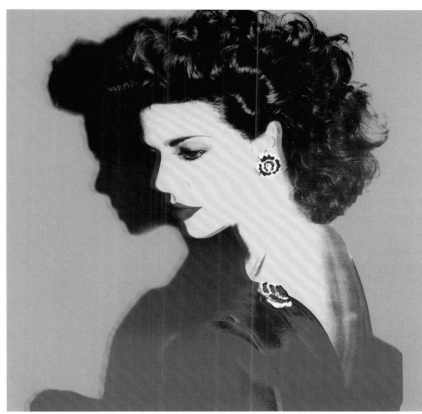129

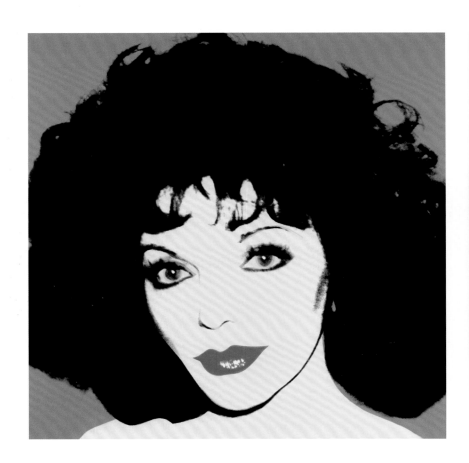141

142

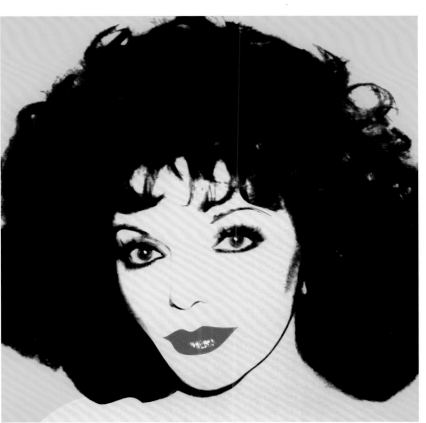

128, 129 – *Princess Caroline of Monaco,* 1983 **141, 142** – *Joan Collins,* 1985

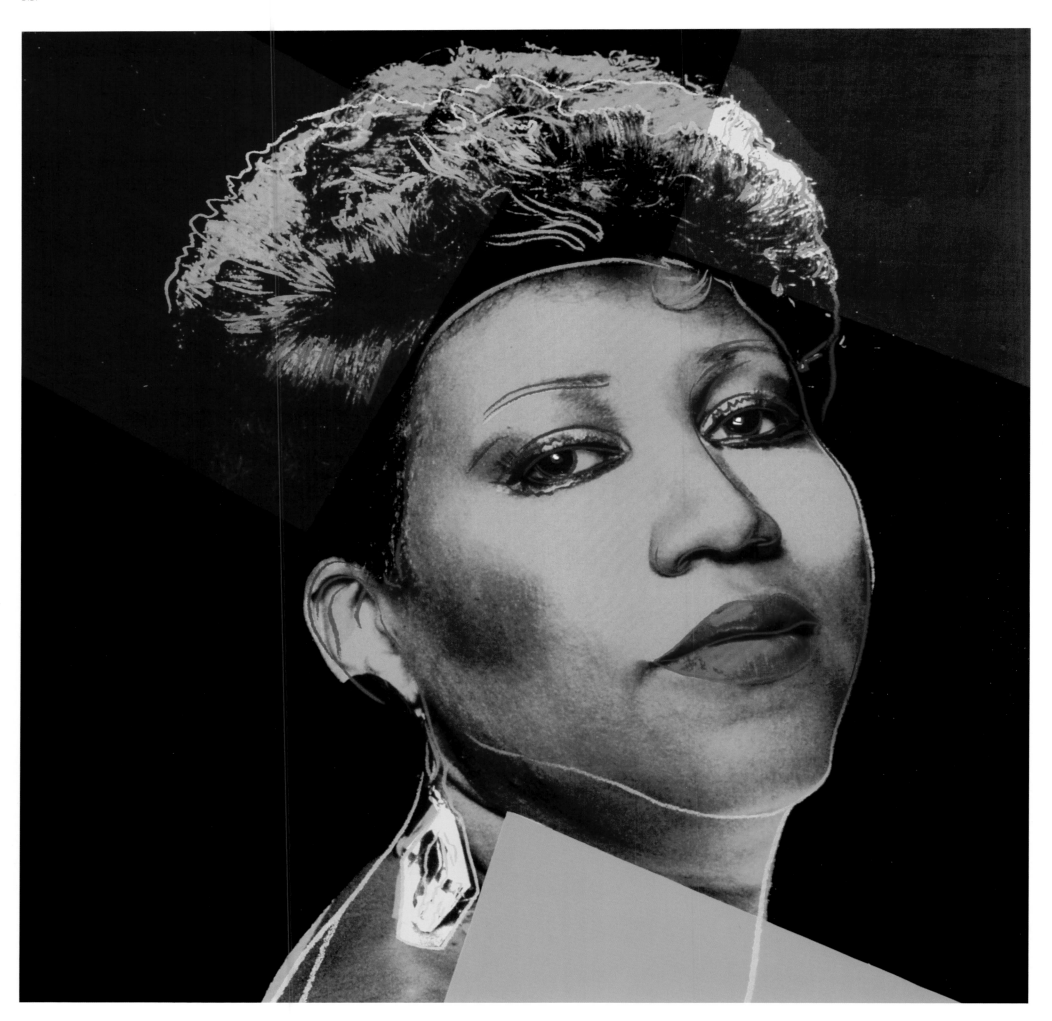

146 – *Aretha Franklin*, about 1986

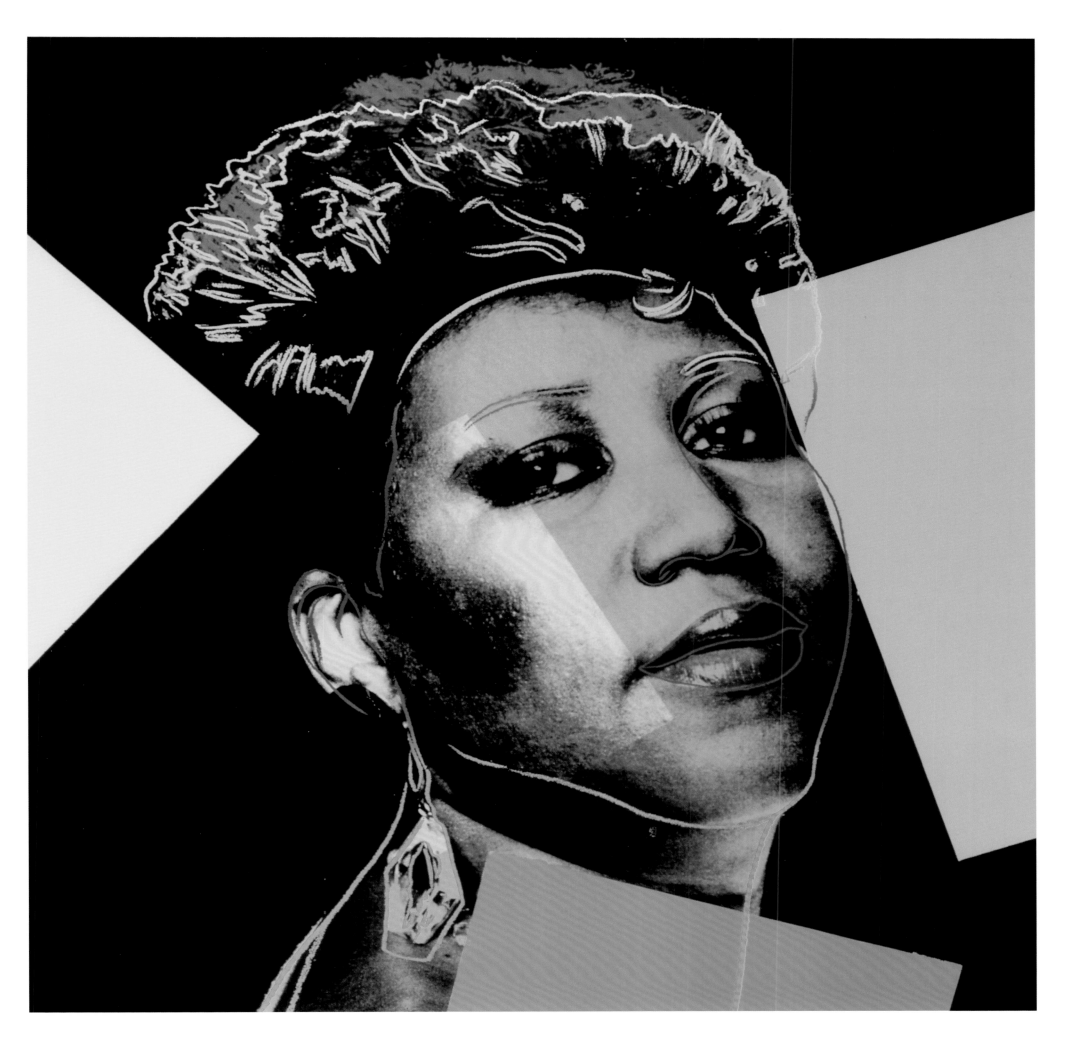

147 — *Aretha Franklin*, about 1986

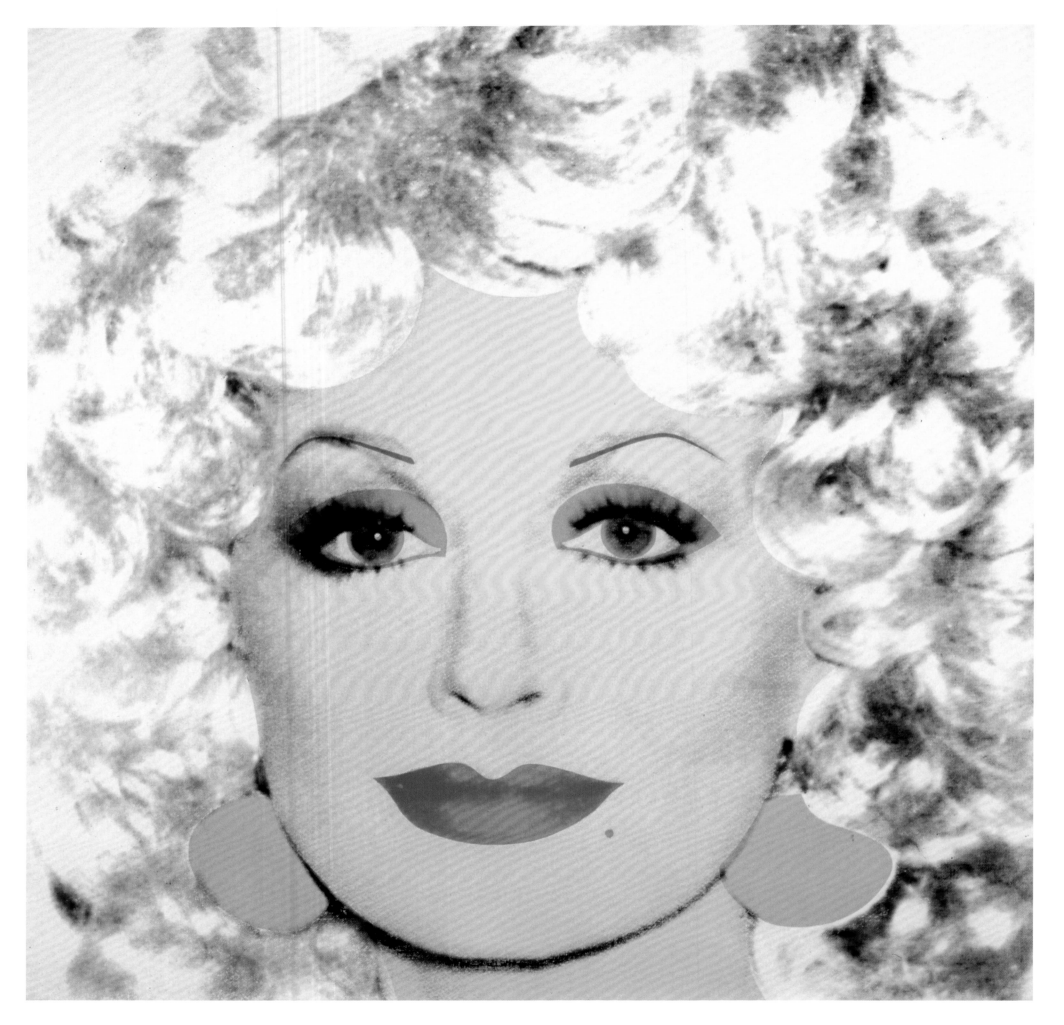

139 – *Dolly Parton*, 1985

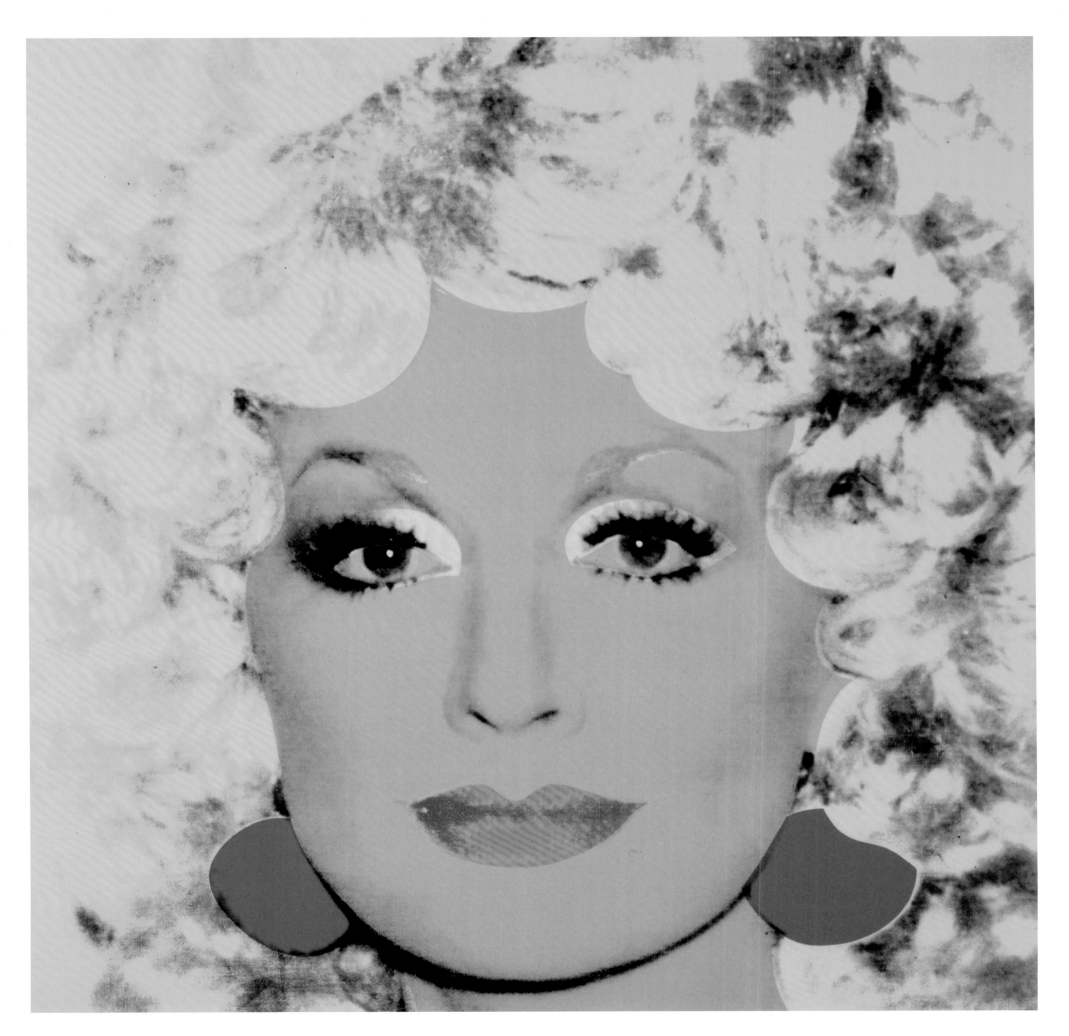

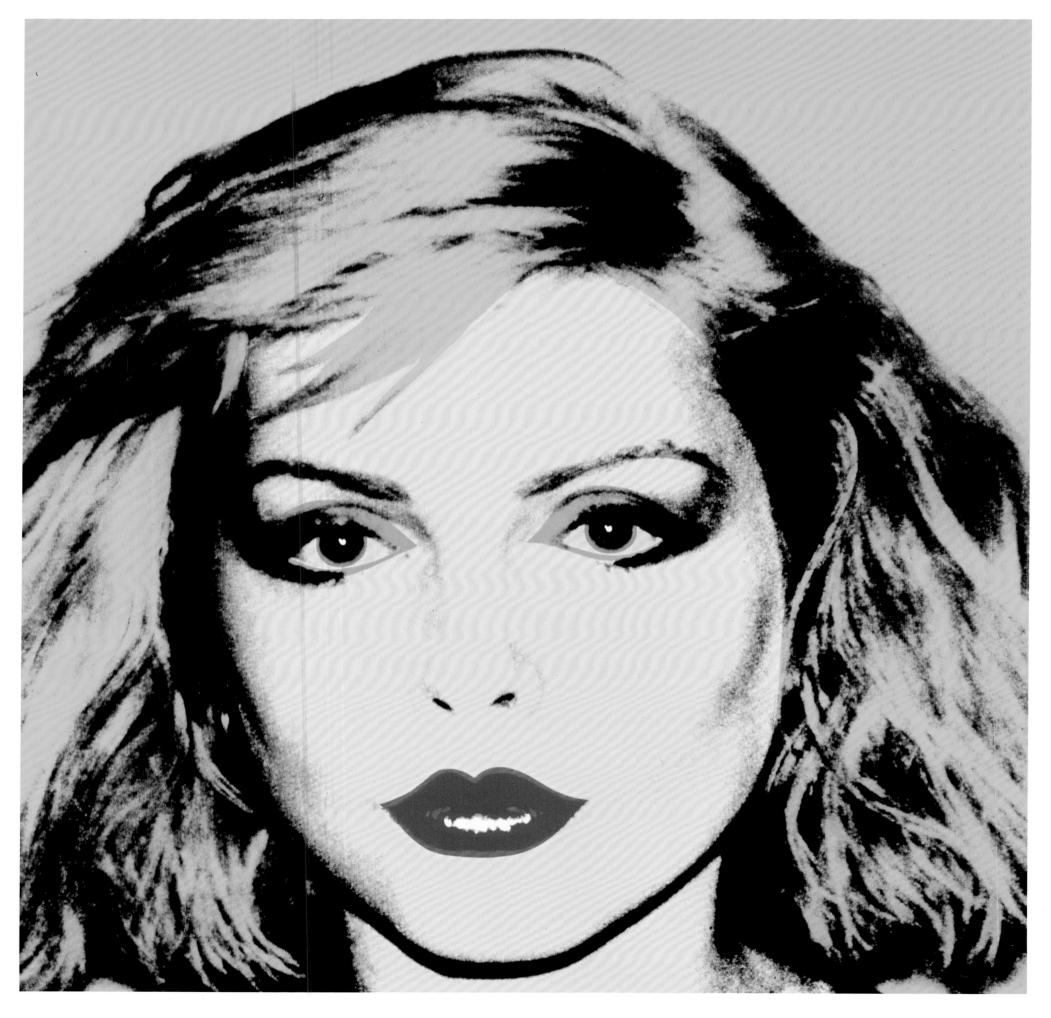

119 — *Debbie Harry*, 1980

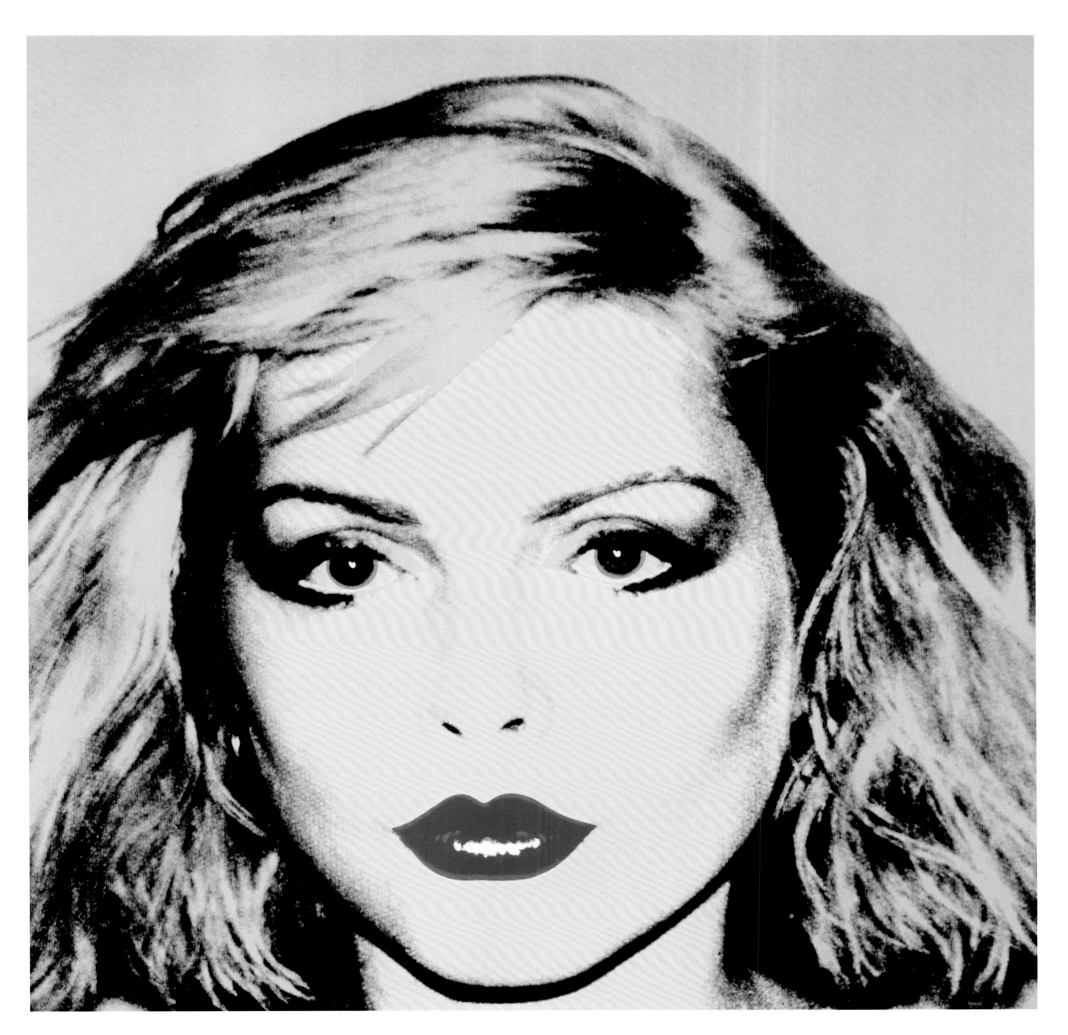

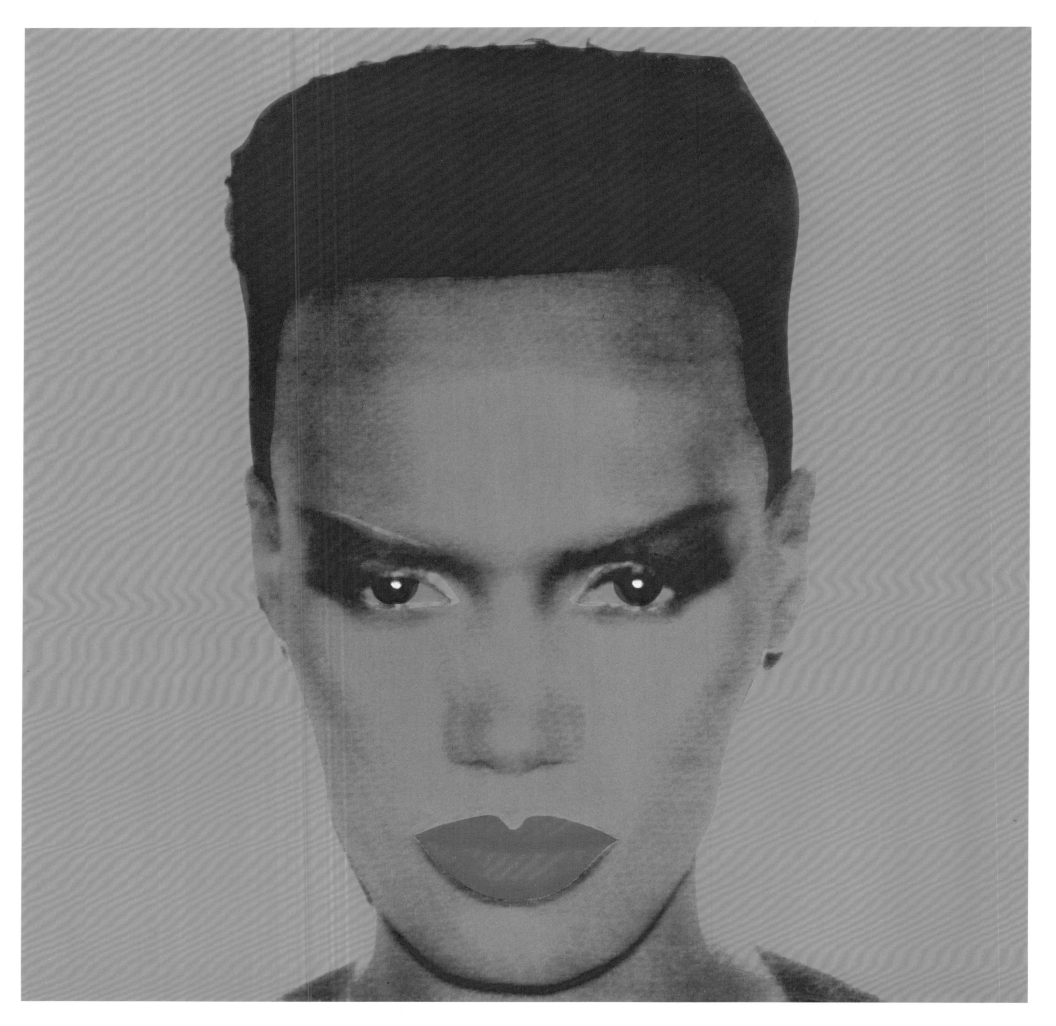

143 — *Grace Jones,* 1986

164 – *Shadows II*, portfolio of 6 screen prints, 1979

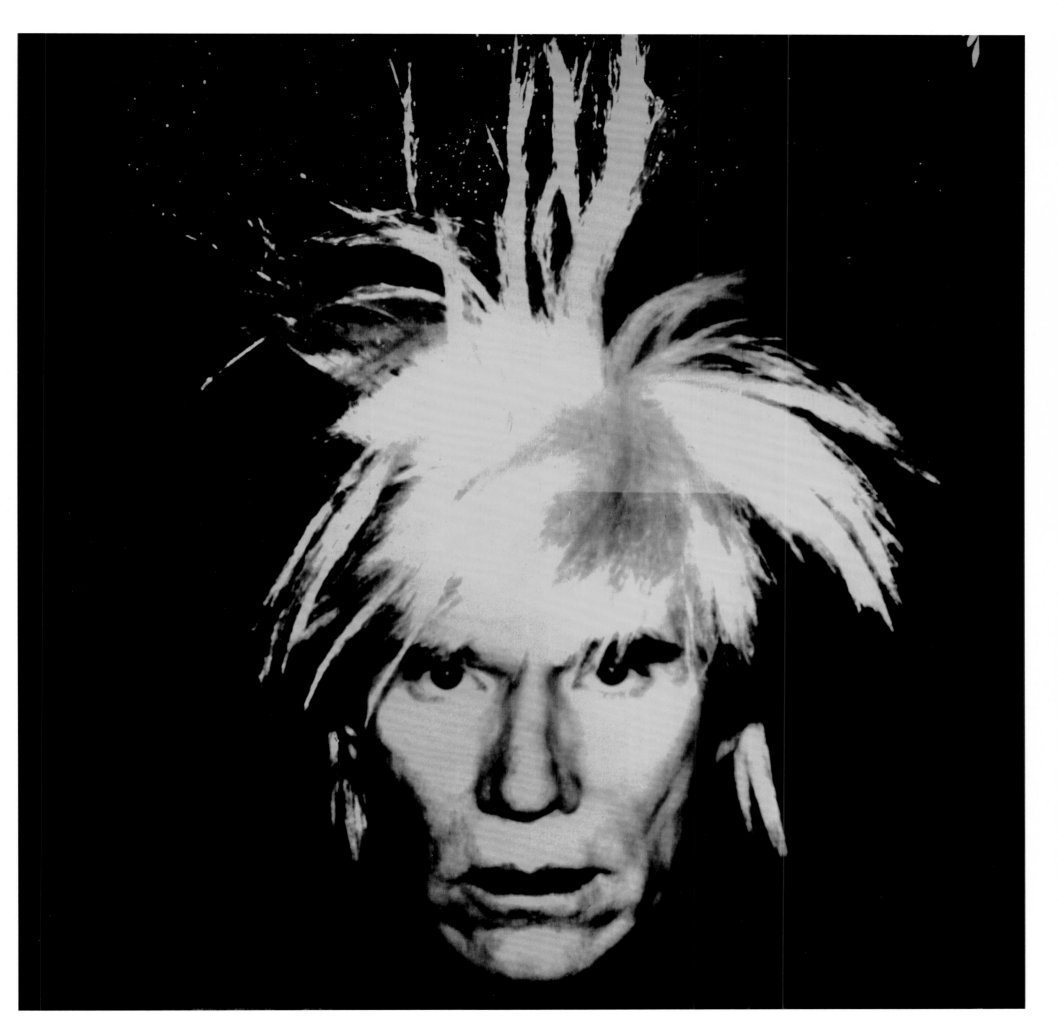

WORKS IN THE EXHI-BITION

—

WARHOL'S WORK

RECORD COVER ILLUSTRATIONS

1 [ill. p. 42]
A Program of Mexican Music
An orchestra of American and
Mexican musicians and the chorus
of the National Music League
Carlos Chávez, conductor
Sponsored by the Museum
of Modern Art
Columbia Masterworks, 1949
Relief print and letterpress
26 x 25.9 cm
Collection Paul Maréchal

2 [ill. p. 42]
Sergey Prokofiev
Alexander Nevsky
The Philadelphia Orchestra,
Westminster Choir, and Jennie Tourel
Eugene Ormandy, conductor
Columbia Masterworks, 1949
Relief print and letterpress
31.1 x 31.1 cm
Collection Paul Maréchal

3 [ill. p. 42]
Night Beat
NBC, 1950
Photo-offset
19 x 18.9 x 1.7 cm (box)
Collection Paul Maréchal

4 [ill. p. 42]
CBS Radio Network
*The Nation's Nightmare:
Traffic in Narcotics and
Crime on the Waterfront*
CBS
1952
Offset lithograph
31.1 x 31.1 cm
Collection Paul Maréchal

5
Latin Rhythms
The Boston Pops
Arthur Fiedler, conductor
RCA Victor, about 1952
Relief print and letterpress,
printer's proof
17.8 x 17.8 cm
The Andy Warhol Museum, Pittsburgh
Founding Collection, Contribution
The Andy Warhol Foundation for the
Visual Arts, Inc.
1998.3.3539

6 [ill. p. 42]
Latin Rhythms
The Boston Pops
Arthur Fiedler, conductor
RCA Victor, about 1952
Relief print and letterpress
17.8 x 17.8 cm
Collection Paul Maréchal

7 [ill. p. 42]
Margarita Madrigal
H. Andrés Morales, narrator
Madrigal's Magic Key to Spanish
Columbia, 1953
The Andy Warhol Museum, Pittsburgh
Founding Collection, Contribution
The Andy Warhol Foundation for the
Visual Arts, Inc.
"Time Capsule 31"—TC31.128

8 [ill. p. 42]
Thelonious Monk with
Sonny Rollins and Frank Foster
Monk
Prestige, 1954
Offset lithograph
31.1 x 31.1 cm
Collection Paul Maréchal

9 [ill. p. 42]
Gioacchino Rossini
*William Tell Overture and
Semiramide Overture*
NBC Symphony Orchestra
Arturo Toscanini, conductor
RCA Victor, 1954
Relief print
26.1 x 26.4 cm
Collection Paul Maréchal

10 [ill. p. 42]
Various artists (Art Tatum,
Erroll Garner, André Previn,
Lennie Tristano, Ellis Larkins,
Eddie Heywood, Beryl Booker,
Mary Lou Williams)
Progressive Piano
RCA Victor, about 1954
Offset lithograph, printer's proof
31.3 x 20 cm
The Andy Warhol Museum, Pittsburgh
Founding Collection, Contribution
The Andy Warhol Foundation for the
Visual Arts, Inc.
1998.3.3474

11 [ill. p. 43]
Count Basie
Count Basie
RCA Victor, 1955
Relief print and letterpress
31.1 x 31.1 cm
Collection Paul Maréchal

12 [ill. p. 69]
Maurice Ravel
Daphnis and Chloe
Boston Symphony Orchestra
Charles Munch, conductor
RCA Victor, 1955
Booklet drawings by Warhol
31.1 x 31.1 cm
Collection Paul Maréchal

13
Pyotr Ilyich Tchaikovsky
Swan Lake, Acts II and III
Members of the NBC Symphony
Leopold Stokowski, conductor
RCA Victor/Red Seal, 1955
Offset lithograph
31.1 x 31.1 cm
Collection Paul Maréchal

14 [ill. p. 43]
Kenny Burrell
Kenny Burrell
Blue Note, 1956
Offset lithograph
31.1 x 31.1 cm
Collection Paul Maréchal

15 [ill. p. 43]
Jay Jay Johnson, Kai Winding,
and Bennie Green
Trombone by Three
Prestige, 1956
Offset lithograph
31.1 x 31.1 cm
Collection Paul Maréchal

16 [ill. p. 43]
Wolfgang Amadeus Mozart
4 Divertimenti
The wind instrument ensemble of
the Vienna Symphony Orchestra
Bernhard Paumgartner, conductor
Epic, 1956
Relief print and letterpress
31.1 x 31.1 cm
Collection Paul Maréchal

17 [ill. p. 43]
The Joe Newman Octet
I'm Still Swinging
RCA Victor, 1956
Relief print and letterpress
31.1 x 31.1 cm
Collection Paul Maréchal

18 [ill. p. 43]
Artie Shaw and his orchestra
Both Feet in the Groove
RCA Victor, 1956
Relief print and letterpress
31.1 x 31.1 cm
Collection Paul Maréchal

19 [ill. p. 43]
Various artists
(Conte Candoli, Nick Travis,
Dick Sherman, Bernie Glow,
Phil Sunkel, Don Strattons,
Al De Risi, Elliot Lawrence,
Burgher Jones, Sol Gubin)
Cool Gabriels
RCA/Groove, 1956
Relief print and letterpress
31.1 x 31.1 cm
Collection Paul Maréchal

20 [ill. p. 43]
Frédéric Chopin
Chopin: Nocturnes, Vol. 2
Jan Smeterlin, piano
Epic, about 1956
Offset lithograph
31.1 x 31.1 cm
Collection Paul Maréchal

21 [ill. p. 44]
Johnny Griffin
The Congregation
Blue Note, 1957
Offset lithograph
31.1 x 31.1 cm
Collection Paul Maréchal

22 [ill. p. 44]
Moondog (Louis Thomas Hardin)
The Story of Moondog
Prestige, 1957
Offset lithograph
31.1 x 31.1 cm
Collection Paul Maréchal

23 [ill. p. 44]
Kenny Burrell
Blue Lights, Vol. I
Blue Note, 1958
Offset lithograph
31.1 x 31.1 cm
Collection Paul Maréchal

24 [ill. p. 44]
Kenny Burrell
Blue Lights, Vol. 2
Blue Note, 1958
Offset lithograph
31.1 x 31.1 cm
Collection Paul Maréchal

25
Frédéric Chopin
Les Sylphides
Boston Pops Orchestra
Arthur Fiedler, conductor
RCA Victor/Red Seal, 1950s
Offset lithograph
26.4 x 26 cm
The Andy Warhol Museum, Pittsburgh
Founding Collection, Contribution
The Andy Warhol Foundation for the
Visual Arts, Inc.
2000.2.3186

26 [ill. p. 44]
*Tennessee Williams Reading
from the "Glass Menagerie,"
"The Yellow Bird," and "Five Poems"*
Caedmon, 1960
Offset lithograph
31.1 x 31.1 cm
Collection Paul Maréchal

27 [See p. 45, fig. 2]
Giant Size $1.57 Each
Interviews with artists in the 1963
Popular Image Exhibition at the
Washington Gallery of Modern Art,
organized by Billy Klüver and
Alice Denney (In the exhibition:
George Brecht, Jim Dine, Jasper Johns,
Roy Lichtenstein, Claes Oldenburg,
Robert Rauschenberg, James Rosenquist,
Andy Warhol, Robert Watts,
John Wesley, Tom Wesselmann)
Recorded and edited by Billy Klüver,
1963
Screen print
31.4 x 31.6 cm
The Andy Warhol Museum, Pittsburgh
Founding Collection, Contribution
The Andy Warhol Foundation for the
Visual Arts, Inc.
"Time Capsule 63"—TC. 63.1.2

28 [See p. 45, fig. 2]
Giant Size $1.57 Each
Interviews with artists in the 1963
Popular Image Exhibition at the
Washington Gallery of Modern Art,
organized by Billy Klüver and
Alice Denney (In the exhibition:
George Brecht, Jim Dine, Jasper Johns,
Roy Lichtenstein, Claes Oldenburg,
Robert Rauschenberg, James Rosenquist,
Andy Warhol, Robert Watts,
John Wesley, Tom Wesselmann)
Recorded and edited by Billy Klüver,
1963
Screen print, 75/75
31.1 x 31.1 cm
Collection Paul Maréchal

29 [ill. p. 44]
John Wallowitch
This is John Wallowitch!!!
Serenus, 1964
Offset lithograph
31.1 x 31.1 cm
Collection Paul Maréchal

30 [ill. p. 44]
John Wallowitch
*This is the Other Side of
John Wallowitch!!!*
Serenus, 1965
Offset lithograph
31.1 x 31.1 cm
Collection Paul Maréchal

31
Various artists (including Warhol)
The East Village Other
ESP-Disk, 1966
Offset lithograph
31.1 x 31.1 cm
Collection Paul Maréchal

32 [ill. p. 44, 163, 164]
The Velvet Underground & Nico
Verve, 1967
Offset lithograph, collage and
relief print
31.1 x 31.1 cm
Collection Paul Maréchal

33 [ill. p. 44]
The Velvet Underground
White Light/White Heat
Verve, 1968
Offset lithograph
31.1 x 31.1 cm
Collection Paul Maréchal

34 [ill. p. 46, 195]
The Rolling Stones
Sticky Fingers
Rolling Stones, 1971
Offset lithograph and zipper
31.1 x 31.1 cm
Collection Paul Maréchal

35 [ill. p. 46]
John Cale
The Academy in Peril
Reprise, 1972
Offset lithograph
31.1 x 31.1 cm
Collection Paul Maréchal

36 [ill. p. 212]
The Rolling Stones
Love You Live
Original record cover mock-up with
a single-page instructional note and
small sketch by Vincent Fremont
describing the finished product and
alternative photographic choices
1976–77
Offset lithograph, with graphite and
felt-tip ink note on lined coloured paper
31.4 x 31.4 cm
The Andy Warhol Museum, Pittsburgh
Founding Collection, Contribution
The Andy Warhol Foundation for the
Visual Arts, Inc.
"Time Capsule 157"—TC157.1, 2

37 [ill. p. 46]
Paul Anka
The Painter
United Artists, 1977
Offset lithograph
31.1 x 31.1 cm
Collection Paul Maréchal

38 [ill. p. 46, 212, 213]
The Rolling Stones
Love You Live
Rolling Stones, 1977
Offset lithograph
31.1 x 31.1 cm
Collection Paul Maréchal

39 [ill. p. 46]
Walter Steding and the Dragon People
The Joke / Chase the Dragon
Earhole Productions, 1980
Offset lithograph
31.1 x 31.1 cm
Collection Paul Maréchal

40 [ill. p. 46]
Loredana Bertè
Made in Italy
CGD, 1981
Offset lithograph
31.1 x 31.1 cm
Collection Paul Maréchal

41 [ill. p. 46]
John Cale
Honi Soit . . .
A&M, 1981
Offset lithograph
31.1 x 31.1 cm
Collection Paul Maréchal

42 [ill. p. 46]
Liza Minnelli
Liza Minnelli Live at Carnegie Hall
Altel, 1981
Offset lithograph
31.1 x 31.1 cm
Collection Paul Maréchal

43 [ill. p. 47]
Querelle
Original soundtrack with vocals by
Jeanne Moreau for
Rainer Werner Fassbinder's film
DRG, 1982
Offset lithograph
31.1 x 31.1 cm
Collection Paul Maréchal

44 [ill. p. 41, 47]
Diana Ross
Silk Electric
RCA, 1982
Offset lithograph
31.1 x 31.1 cm
Collection Paul Maréchal

45 [ill. p. 47]
Billy Squier
Emotions in Motion
Capitol, 1982
Offset lithograph
31.1 x 31.1 cm
Collection Paul Maréchal

46 [ill. p. 47]
Miguel Bosé
Made in Spain
CBS, 1983
Offset lithograph
31.1 x 31.1 cm
Collection Paul Maréchal

47 [ill. p. 47]
Miguel Bosé
Milano–Madrid
CBS, 1983
Offset lithograph
31.1 x 31.1 cm
Collection Paul Maréchal

48 [ill. p. 47]
Rats & Star
Soul Vacation
Epic, 1983
Offset lithograph
31.1 x 31.1 cm
Collection Paul Maréchal

49 [ill. p. 47]
The Smiths
Rough Trade, 1984
Offset lithograph
31.1 x 31.1 cm
Collection Paul Maréchal

50 [ill. p. 47]
Aretha Franklin
Aretha
Arista, 1986
Offset lithograph
31.1 x 31.1 cm
Collection Paul Maréchal

51
Debbie Harry
French Kissin
Geffen, 1986
Offset lithograph
31.1 x 31.1 cm
Collection Paul Maréchal

52
Debbie Harry
Rockbird
Geffen, 1986
Offset lithograph
31.1 x 31.1 cm
Collection Paul Maréchal

53
Debbie Harry
Rockbird
Geffen, 1986
Offset lithograph
31.1 x 31.1 cm
Collection Paul Maréchal

54
Debbie Harry
Rockbird
Geffen, 1986
Offset lithograph
31.1 x 31.1 cm
Collection Paul Maréchal

55
Debbie Harry
Rockbird
Geffen, 1986
Offset lithograph
31.1 x 31.1 cm
Collection Paul Maréchal

56 [ill. p. 47]
John Lennon
Menlove Ave.
EMI, Capitol, 1986
Offset lithograph
31.1 x 31.1 cm
Collection Paul Maréchal

57
The Smiths
Sheila Take a Bow
Rough Trade, 1987
Offset lithograph
31.1 x 31.1 cm
Collection Paul Maréchal

58 [ill. p. 47]—Various artists—MTV
High Priority
Benefit album for breast cancer
RCA, 1987
Offset lithograph
31.1 x 31.1 cm
Collection Paul Maréchal

POSTERS AND ANNOUNCE-MENTS
VELVET UNDERGROUND SHOWS AND OTHER WARHOL EVENTS

59 [ill. p. 151]
Anonymous
Open stage, at the Dom,
23 St. Mark's Place, New York,
featuring Andy Warhol with
the Velvet Underground and Nico,
Exploding Plastic Inevitable
1966, poster
Letterpress on coated poster board
55.9 x 35.6 cm
The Andy Warhol Museum, Pittsburgh
Founding Collection, Contribution
The Andy Warhol Foundation for the
Visual Arts, Inc.
1998.3.4562

60 [ill. p. 150]
Anonymous
Andy Warhol's Up-Tight,
featuring the Velvet Underground,
Edie Sedgwick, Gerard Malanga,
Donald Lyons, Barbara Rubin,
Bob Neuwirth, Paul Morrissey, Nico,
Daniel Williams, and Billy Linich,
at Film-Makers' Cinematheque,
New York, February 8–13, 1966.
"Uptight Rock 'n' Roll, whips,
dancers . . ."
1966, announcement
Offset lithograph on paper
21.9 x 27.9 cm
The Andy Warhol Museum, Pittsburgh
Founding Collection, Contribution
The Andy Warhol Foundation for the
Visual Arts, Inc.
"Time Capsule 12"—TC12.180

61
Anonymous
Andy Warhol at the Ferus Gallery,
Los Angeles
Probably for the May 1966
Silver Clouds exhibition
1966, poster
Offset lithograph on paper
63.2 x 45.7 cm
The Andy Warhol Museum, Pittsburgh
Museum Loan, Sterling Morrison
Archives, Collection of Martha Morrison
L1996.1.2

62
Anonymous
Andy Warhol presents the
Exploding Plastic Inevitable with
the Velvet Underground and Nico,
at the Trip, Los Angeles, May 3–18
1966, poster
Offset lithograph on coated poster
board
55.9 x 35.9 cm
The Andy Warhol Museum, Pittsburgh
Museum Loan, Sterling Morrison
Archives, Collection of Martha Marrison
L1996.1.3

63 [ill. p. 152]
Anonymous
Andy Warhol and his
Exploding Plastic Inevitable (Show)
featuring the Velvet Underground
[and Nico], at Poor Richard's,
Chicago. "Held Over thru July 3"
1966, poster
Letterpress on cardboard with
printed paper sticker
56.2 x 35.6 cm
The Andy Warhol Museum, Pittsburgh
Founding Collection, Contribution
The Andy Warhol Foundation for the
Visual Arts, Inc.
1998.3.5577

64 [ill. p. 152]
Anonymous [Signed Glaizek]
The Velvet Underground and Nico,
at the Chrysler Art Museum,
Provincetown, Massachusetts,
August 31–September 4, 1966
1966, poster
Screen print on heavyweight paper
34.8 x 40 cm
The Andy Warhol Museum, Pittsburgh
Museum Loan, Sterling Morrison
Archives, Collection of Martha Morrison
L1996.1.9

65 [ill. p. 152]
Anonymous
The Exploding Plastic
Inevitable and Nico,
at the Chrysler Art Museum,
Provincetown, Massachusetts,
August 31–September 4, 1966
1966, poster
Letterpress on coated cardboard
55.6 x 35.6 cm
The Andy Warhol Museum, Pittsburgh
Museum Loan, Sterling Morrison
Archives, Collection of Martha Morrison
L1996.1.10

66 [ill. p. 152]
Anonymous
Andy Warhol presents
Halloween Mod Happening,
featuring the Exploding Plastic
Inevitable, at Leicester Airport,
Leicester, Massachusetts,
Sunday, October 30
1966, poster
Letterpress on coated poster board
55.9 x 35.6 cm
The Andy Warhol Museum, Pittsburgh
Founding Collection, Contribution
The Andy Warhol Foundation for the
Visual Arts, Inc.
1998.3.5572

67
Anonymous
Andy Warhol's Exploding Plastic
Inevitable with the Velvet
Underground and Nico at
the Contemporary Arts Center,
Cincinnati, Ohio, November 3, 1966
1966, poster
Printed ink on acetate
21.6 x 14 cm
The Andy Warhol Museum, Pittsburgh
Founding Collection, Contribution
The Andy Warhol Foundation for the
Visual Arts, Inc.
"Time Capsule 59"—TC59.88.1

68
Anonymous
"Night Beat Magazine presents:
Freak-Out '66"
Timothy Leary, Andy Warhol,
the Velvet Underground and Nico,
the Fugs, GODZ, the Seventh Sons,
the Mothers of Invention, the Fantasy
Machines, the Topless girl from New
York's Crystal Room, and others
performing at Action House, Island
Park, New York, Sunday, December
4, 1966.
1966, poster
Printed coloured paper
17.8 x 10.2 cm
The Andy Warhol Museum, Pittsburgh
Founding Collection, Contribution
The Andy Warhol Foundation for the
Visual Arts, Inc.
"Time Capsule 17"—TC17.90

69 [ill. p. 152]
Anonymous
Andy Warhol with the
Velvet Underground and Nico,
at the Young Men's Hebrew
Association, Philadelphia,
December 10–11. "A mixed-media
discotheque complete with
Andy Warhol and underground films"
1966, poster
Letterpress with felt-tip ink
inscriptions on coated poster board
55.9 x 30.2 cm
The Andy Warhol Museum, Pittsburgh
Founding Collection, Contribution
The Andy Warhol Foundation for the
Visual Arts, Inc.
1998.3.4560

70 [ill. p. 152]
Anonymous
Andy Warhol's Exploding Plastic
Inevitable with Nico and the
Velvet Underground, at the
Rhode Island School of Design,
March 31–April 1
1967, poster
Metallic ink on coloured acetate
50.8 x 40.6 cm
The Andy Warhol Museum, Pittsburgh
Founding Collection, Contribution
The Andy Warhol Foundation for the
Visual Arts, Inc.
1998.3.4561

71 [ill. p. 152]
Anonymous
Andy Warhol's Velvet Underground
and the Beacon Street Union at
the Boston Tea Party, Boston,
June 9–10, 1967. "Held Over!"
1967, poster
Lithograph on paper
27.9 x 21.6 cm
The Andy Warhol Museum, Pittsburgh
Founding Collection, Contribution
The Andy Warhol Foundation for the
Visual Arts, Inc.
"Time Capsule 17"—TC17.123

PAINTINGS

72 [See. p. 215, cat. 73]
"Love You Live" (1977)
Used as decoration at Traxx,
New York, on the night of the
Rolling Stones record launch
1977, poster
Offset lithograph, ink on coated paper
122.6 x 91.4 cm
The Andy Warhol Museum, Pittsburgh
Founding Collection, Contribution
The Andy Warhol Foundation for the
Visual Arts, Inc.

73 [ill. p. 215]
"Love You Live" (1977)
Used as decoration at Traxx,
New York, on the night of the
Rolling Stones record launch
1977, poster
Offset lithograph, ink on coated paper
122.6 x 91.4 cm
Collection Paul Maréchal

74 [ill. p. 215]
Rainer Werner Fassbinder.
"Querelle"
1982, poster
Offset lithograph
99 x 70 cm
Collection Paul Maréchal

75 [ill. p. 152]
Wes Wilson
Bill Graham presents Pop-Op Rock:
Andy Warhol and his Plastic
Inevitable, the Velvet Underground
and Nico, and the Mothers of
Invention, at the Fillmore Auditorium,
San Francisco, May 27–29
1966, poster
Screen print on heavyweight paper
50.8 x 35.6 cm
The Andy Warhol Museum, Pittsburgh
Founding Collection, Contribution
The Andy Warhol Foundation for the
Visual Arts, Inc.
1998.3.5579

76 [See. p. 152, cat. 75]
Bill Graham presents Pop-Op Rock:
Andy Warhol and his Plastic
Inevitable, the Velvet Underground
and Nico, and the Mothers of
Invention, at the Fillmore Auditorium,
San Francisco, May 27–29
1966, poster
Screen print on heavyweight paper
50.8 x 35.6 cm
Fine Arts Museum of San Francisco
Museum Purchase, Achenbach
Foundation for Graphic Arts
Endowment Fund North America
(United States)
1972.53.36

77 [ill. p. 72]
Dance Diagram (2):
Fox Trot—The Double Twinkle-Man
[Early] 1962
Casein and graphite on linen
181.6 x 131.4 cm
The Andy Warhol Museum, Pittsburgh
Founding Collection, Contribution
The Andy Warhol Foundation for the
Visual Arts, Inc.
1998.1.11

78 [ill. p. 73]
Dance Diagram (6): The Charleston
Double Side Kick—Man and Woman
1962
Casein and pencil on linen
181.6 x 135.9 cm
Daros Collection, Switzerland

79 [ill. p. 95]
Green Coca-Cola Bottles
[June–July] 1962
Synthetic polymer paint, silkscreen ink,
and graphite on canvas
209.2 x 144.8 cm
Whitney Museum of American Art,
New York
Purchase, with funds from the Friends
of the Whitney Museum of American Art
68.25

80 [ill. p. 54–55]
Round Marilyn (Gold Marilyn)
[August–September] 1962
Silkscreen ink and gold paint on
canvas (two tondos)
45.3 cm (diam. of each)
Froehlich Collection, Stuttgart

81 [ill. p. 91]
Texan (Robert Rauschenberg)
[October] 1962
Acrylic, silkscreen ink, and
spray paint on linen
207 x 207 cm
Museum Ludwig, Cologne
Ludwig Donation

82 [ill. p. 93]
This Side Up
[April–May] 1962
Silkscreen ink and graphite on linen
205.4 x 127.6 cm
The Andy Warhol Museum, Pittsburgh
Founding Collection, Contribution
Dia Center for the Arts
1997.1.4

83 [ill. p. 90]
Triple Rauschenberg
1962
Synthetic polymer paint and
silkscreen ink on linen
53 x 86 cm
Sonnabend Collection
AW-0418

84 [ill. p. 75]
Bobby Short
[October–November 1963]
Silkscreen ink and acrylic on linen
50.8 x 40.6 cm
The Andy Warhol Museum, Pittsburgh
Founding Collection, Contribution
The Andy Warhol Foundation for the
Visual Arts, Inc.
1998.1.67

85 [ill. p. 75]
Bobby Short
[October–November] 1963
Silkscreen ink and acrylic on linen
50.8 x 40.6 cm
The Andy Warhol Museum, Pittsburgh
Founding Collection, Contribution
The Andy Warhol Foundation for the
Visual Arts, Inc.
1998.1.68

86 [ill. p. 75]
Bobby Short
1963
Silkscreen ink and acrylic on linen
50.8 x 40.6 cm
The Andy Warhol Museum, Pittsburgh
Founding Collection, Contribution
The Andy Warhol Foundation for the
Visual Arts, Inc.
1998.1.69

87 [ill. p. 75]
Bobby Short
[October–November] 1963
Silkscreen ink and acrylic on linen
50.8 x 40.6 cm
The Andy Warhol Museum, Pittsburgh
Founding Collection, Contribution
The Andy Warhol Foundation for the
Visual Arts, Inc.
1998.1.70

88 [ill. p. 58]
Double Elvis
Ferus Type
[June–July] 1963
Silkscreen ink and silver paint on linen
213.9 x 134.6 cm
The Andy Warhol Museum, Pittsburgh
Founding Collection, Contribution
The Andy Warhol Foundation for the
Visual Arts, Inc.
1998.1.59

89 [ill. p. 61]
Double Elvis (Elvis III)
Ferus Type
[June–July] 1963
Silkscreen ink and silver paint on linen
207 x 208.3 cm
Froehlich Collection, Stuttgart

90 [ill. p. 57]
Elvis I and II (Elvis Diptych I and II)
Ferus Type
Silver canvas: [June–July] 1963
Silkscreen ink and spray paint
Blue canvas: 1964 (?)
Silkscreen ink and acrylic
208.2 x 208.2 cm (each)
Art Gallery of Ontario,
Toronto Gift from the Women's
Committee Fund, 1966
6843

91 [ill. p. 100]
Merce Cunningham
[January–February] 1963
Silkscreen ink and graphite on linen
61 x 44.5 cm
The Andy Warhol Museum, Pittsburgh
Founding Collection, Contribution
The Andy Warhol Foundation for the
Visual Arts, Inc.
1998.1.36

92 [ill. p. 99]
Merce Cunningham
[January–February] 1963
Silkscreen ink and
black spray paint on linen
90.2 x 207 cm
Mugrabi Collection

93 [ill. p. 60]
Single Elvis
[June–July] 1963
Silkscreen ink and spray paint on linen
208.3 x 101.6 cm
Collection of the Akron Art Museum, Ohio
Purchased with the aid of funds
from the National Endowment for
the Arts and the L. L. Bottsford Estate
1972.1

94 [ill. p. 59]
Triple Elvis (Large Three Elvis)
Ferus Type
[June–July] 1963
Silkscreen ink, silver paint, and
spray paint on linen
209.2 x 180.7 cm
Virginia Museum of Fine Arts, Richmond
Gift of Sydney and Frances Lewis
85.453

95 [ill. p. 89]
White Burning Car III
1963
Silkscreen ink on linen
255.3 x 200 cm
The Andy Warhol Museum, Pittsburgh
Founding Collection,
Contribution Dia Center for the Arts
2002.4.9

96 [ill. p. 110]
Flowers
[August–September] 1964
Acrylic, silkscreen ink, and
pencil on linen
205.4 x 205.4 cm
The Andy Warhol Museum, Pittsburgh
Founding Collection, Contribution
The Andy Warhol Foundation for the
Visual Arts, Inc.
1998.1.24

97
Flowers
1964
Acrylic, silkscreen ink, and fluorescent
paint on linen
206.7 x 207.6 cm
The Andy Warhol Museum, Pittsburgh
Founding Collection, Contribution
The Andy Warhol Foundation for the
Visual Arts, Inc.
1998.1.25

98
Flowers
[July–August] 1964
Acrylic and silkscreen ink on linen
121.9 x 121.9 cm
The Andy Warhol Museum, Pittsburgh
Founding Collection, Contribution
The Andy Warhol Foundation for the
Visual Arts, Inc.
1998.1.26

99
Flowers
[July–August] 1964
Acrylic, silkscreen ink, and
pencil on linen
121.9 x 121.9 cm
The Andy Warhol Museum, Pittsburgh
Founding Collection, Contribution
The Andy Warhol Foundation for the
Visual Arts, Inc.
1998.1.27

100 [ill. p. 111]
Flowers
[August–September] 1964
Oil and photo silkscreen on linen
207.6 x 207.6 cm
Hirshhorn Museum and Sculpture
Garden, Smithsonian Institution,
Washington, DC
The Joseph H. Hirshhorn Bequest, 1981
HMSG86.5673

101 [ill. p. 108]
Coloured Campbell's Soup Can
[September–October] 1965
Synthetic polymer paint and silkscreen
ink on canvas
91.4 x 61 cm
Milwaukee Art Museum
Gift of Mrs. Harry Lynde Bradley
M1977.156

102 [ill. p. 108]
Coloured Campbell's Soup Can
[September–October] 1965
Synthetic polymer paint and
silkscreen ink on canvas
91.4 x 61 cm
Milwaukee Art Museum
Gift of Mrs. Harry Lynde Bradley
M1977.157

103 [ill. p. 107]
Self-portrait
[March–April] 1967
Acrylic and silkscreen ink on canvas
183.5 x 183.5 cm
San Francisco Museum of Modern Art
Gift of Harry W. and
Mary Margaret Anderson
92.283

104 [ill. p. 201]
Mick Jagger
1975
Silkscreen ink on
synthetic polymer paint on canvas
101.6 x 101.6 cm
Museum of Fine Arts, Boston
Gift of The Andy Warhol Foundation
for the Visual Arts, Inc., with
additional funds provided by the
Ernest Wadsworth Longfellow Fund
1993.686

105 [ill. p. 202]
Mick Jagger
1975
Acrylic and silkscreen ink on canvas
101.6 x 101.6 cm
The Andy Warhol Museum, Pittsburgh
Founding Collection,
Contribution Dia Center for the Arts
1997.1.8a

106 [ill. p. 203]
Mick Jagger
1975
Acrylic and silkscreen ink on canvas
101.6 x 101.6 cm
The Andy Warhol Museum, Pittsburgh
Founding Collection,
Contribution Dia Center for the Arts
1997.1.8b

107 [ill. p. 235]
Rudolf Nureyev
About 1975
Synthetic polymer paint and
silkscreen ink on canvas
101.6 x 101.6 cm
Mugrabi Collection
1329W280

108
Skull
1976
Acrylic and silkscreen ink on linen
38.1 x 48.3 cm
The Andy Warhol Museum, Pittsburgh
Founding Collection, Contribution
The Andy Warhol Foundation for the
Visual Arts, Inc.
1998.1.183

109 [ill. p. 220]
Studio 54
1976–77
Acrylic and silkscreen ink on linen
66 x 35.6 cm
The Andy Warhol Museum, Pittsburgh
Founding Collection, Contribution
The Andy Warhol Foundation for the
Visual Arts, Inc.
1998.1.427

110 [ill. p. 220]
Studio 54
1976–77
Acrylic and silkscreen ink on linen
67 x 35.6 cm
The Andy Warhol Museum, Pittsburgh
Founding Collection, Contribution
The Andy Warhol Foundation for the
Visual Arts, Inc.
1998.1.428

111 [ill. p. 229]
Liza Minnelli
1979
Acrylic and silkscreen ink on linen
101.6 x 101.6 cm
The Andy Warhol Museum, Pittsburgh
Founding Collection,
Contribution Dia Center for the Arts
1997.1.10a

112 [ill. p. 228]
Liza Minnelli
1979
Acrylic and silkscreen ink on linen
101.6 x 101.6 cm
The Andy Warhol Museum, Pittsburgh
Founding Collection,
Contribution Dia Center for the Arts
1997.1.10b

113 [ill. p. 240]
Truman Capote
1979
Acrylic and silkscreen ink on linen
101.6 x 101.6 cm
The Andy Warhol Museum, Pittsburgh
Founding Collection,
Contribution Dia Center for the Arts
1997.1.11a

114 [ill. p. 240]
Truman Capote
1979
Acrylic and silkscreen ink on linen
101.6 x 101.6 cm
The Andy Warhol Museum, Pittsburgh
Founding Collection,
Contribution Dia Center for the Arts
1997.1.11b

115 [ill. p. 51]
Judy Garland
About 1979
Acrylic and silkscreen ink on canvas
101.6 x 101.6 cm
The Andy Warhol Museum, Pittsburgh
Founding Collection, Contribution
The Andy Warhol Foundation for the
Visual Arts, Inc.
1998.1.553

116 [ill. p. 50]
Judy Garland
About 1979
Silkscreen ink and synthetic polymer
paint on canvas
101.6 x 101.6 cm
Museu Berardo, Lisbon

117 [ill. p. 53]
Judy Garland and Liza Minnelli
About 1979
Acrylic and silkscreen ink on canvas
101.6 x 101.6 cm
The Andy Warhol Museum, Pittsburgh
Founding Collection, Contribution
The Andy Warhol Foundation for the
Visual Arts, Inc.
1998.1.551

118 [ill. p. 52]
Judy Garland and Liza Minnelli
About 1979
Acrylic and silkscreen ink on canvas
101.6 x 101.6 cm
The Andy Warhol Museum, Pittsburgh
Founding Collection, Contribution
The Andy Warhol Foundation for the
Visual Arts, Inc.
1998.1.552

119 [ill. p. 246]
Debbie Harry
1980
Acrylic and silkscreen ink on linen
106.7 x 106.7 cm
The Andy Warhol Museum, Pittsburgh
Founding Collection, Contribution
The Andy Warhol Foundation for the
Visual Arts, Inc.
1998.1.564

120 [ill. p. 247]
Debbie Harry
1980
Acrylic and silkscreen ink on linen
106.7 x 106.7 cm
The Andy Warhol Museum, Pittsburgh
Founding Collection, Contribution
The Andy Warhol Foundation for the
Visual Arts, Inc.
1998.1.565

121 [ill. p. 232]
Martha Graham
1980
Acrylic and silkscreen ink on linen
101.6 x 101.6 cm
The Andy Warhol Museum, Pittsburgh
Founding Collection,
Contribution Dia Center for the Arts
1997.1.13a

122 [ill. p. 233]
Martha Graham
1980
Acrylic and silkscreen ink on linen
101.6 x 101.6 cm
The Andy Warhol Museum, Pittsburgh
Founding Collection,
Contribution Dia Center for the Arts
1997.1.13b

123
*Ten Portraits of Jews of the
Twentieth Century: George Gershwin*
1980
Acrylic and silkscreen ink on linen
101.6 x 101.6 cm
The Andy Warhol Museum, Pittsburgh
Founding Collection, Contribution
The Andy Warhol Foundation for the
Visual Arts, Inc.
1998.1.474

124
Ballet Slippers
1981–82
Acrylic and silkscreen ink on linen
81.3 x 50.8 cm
The Andy Warhol Museum, Pittsburgh
Founding Collection, Contribution
The Andy Warhol Foundation for the
Visual Arts, Inc.
1998.1.373

125 [ill. p. 68]
Ballet Slippers
1981–82
Acrylic and silkscreen ink on linen
81.3 x 50.8 cm
The Andy Warhol Museum, Pittsburgh
Founding Collection, Contribution
The Andy Warhol Foundation for the
Visual Arts, Inc.
1998.1.374

126 [ill. p. 238]
Miguel Bosé
1983
Acrylic and silkscreen ink on linen
91.4 x 91.4 cm
The Andy Warhol Museum, Pittsburgh
Founding Collection, Contribution
The Andy Warhol Foundation for the
Visual Arts, Inc.
1998.1.510

127 [ill. p. 238]
Miguel Bosé
1983
Acrylic and silkscreen ink on linen
91.4 x 91.4 cm
The Andy Warhol Museum, Pittsburgh
Founding Collection, Contribution
The Andy Warhol Foundation for the
Visual Arts, Inc.
1998.1.511

128 [ill. p. 241]
Princess Caroline of Monaco
1983
Acrylic and silkscreen ink on linen
101.6 x 101.6 cm
The Andy Warhol Museum, Pittsburgh
Founding Collection, Contribution
The Andy Warhol Foundation for the
Visual Arts, Inc.
1998.1.633

129 [ill. p. 241]
Princess Caroline of Monaco
1983
Acrylic and silkscreen ink on linen
101.6 x 101.6 cm
The Andy Warhol Museum, Pittsburgh
Founding Collection, Contribution
The Andy Warhol Foundation for the
Visual Arts, Inc.
1998.1.634

130 [ill. p. 236]
Ryuichi Sakamoto
1983
Acrylic and silkscreen ink on linen
101.6 x 101.6 cm
The Andy Warhol Museum, Pittsburgh
Founding Collection, Contribution
The Andy Warhol Foundation for the
Visual Arts, Inc.
1998.1.644

131 [ill. p. 237]
Ryuichi Sakamoto
1983
Acrylic and silkscreen ink on linen
101.6 x 101.6 cm
The Andy Warhol Museum, Pittsburgh
Founding Collection, Contribution
The Andy Warhol Foundation for the
Visual Arts, Inc.
1998.1.645

132 [ill. p. 239]
Michael Jackson
1984
Acrylic and silkscreen ink on linen
76.2 x 66 cm
The Andy Warhol Museum, Pittsburgh
Founding Collection, Contribution
The Andy Warhol Foundation for the
Visual Arts, Inc.
1998.1.582

133 [ill. p. 239]
Michael Jackson
1984
Acrylic and silkscreen ink on linen
76.2 x 66 cm
The Andy Warhol Museum, Pittsburgh
Founding Collection, Contribution
The Andy Warhol Foundation for the
Visual Arts, Inc.
1998.1.583

134 [ill. p. 238]
Stephen Sprouse
1984
Acrylic and silkscreen ink on linen
101.6 x 101.6 cm
The Andy Warhol Museum, Pittsburgh
Founding Collection, Contribution
The Andy Warhol Foundation for the
Visual Arts, Inc.
1998.1.661

135 [ill. p. 238]
Stephen Sprouse
1984
Acrylic and silkscreen ink on linen
101.6 x 101.6 cm
The Andy Warhol Museum, Pittsburgh
Founding Collection, Contribution
The Andy Warhol Foundation for the
Visual Arts, Inc.
1998.1.662

136 [ill. p. 239]
Prince
About 1984
Acrylic and silkscreen ink on canvas
50.8 x 40.6 cm
The Andy Warhol Museum, Pittsburgh
Founding Collection, Contribution
The Andy Warhol Foundation for the
Visual Arts, Inc.
1998.1.631

137 [ill. p. 239]
Prince
About 1984
Acrylic and silkscreen ink on canvas
50.8 x 40.6 cm
The Andy Warhol Museum, Pittsburgh
Founding Collection, Contribution
The Andy Warhol Foundation for the
Visual Arts, Inc.
1998.1.632

138
*Untitled ("New York Post"
front page—Madonna)*
In collaboration with Keith Haring
1984–85
Acrylic and silkscreen ink on linen
50.8 x 40.6 cm
The Andy Warhol Museum, Pittsburgh
Founding Collection, Contribution
The Andy Warhol Foundation for the
Visual Arts, Inc.
1998.1.494

139 [ill. p. 244]
Dolly Parton
1985
Acrylic and silkscreen ink on linen
106.7 x 106.7 cm
The Andy Warhol Museum, Pittsburgh
Founding Collection, Contribution
The Andy Warhol Foundation for the
Visual Arts, Inc.
1998.1.624

140 [ill. p. 245]
Dolly Parton
1985
Acrylic and silkscreen ink on linen
106.7 x 106.7 cm
The Andy Warhol Museum, Pittsburgh
Founding Collection, Contribution
The Andy Warhol Foundation for the
Visual Arts, Inc.
1998.1.625

141 [ill. p. 241]
Joan Collins
1985
Acrylic and silkscreen ink on linen
101.6 x 101.6 cm
The Andy Warhol Museum, Pittsburgh
Founding Collection, Contribution
The Andy Warhol Foundation for the
Visual Arts, Inc.
1998.1.525

142 [ill. p. 241]
Joan Collins
1985
Acrylic and silkscreen ink on linen
101.6 x 101.6 cm
The Andy Warhol Museum, Pittsburgh
Founding Collection, Contribution
The Andy Warhol Foundation for the
Visual Arts, Inc.
1998.1.526

143 [ill. p. 248]
Grace Jones
1986
Acrylic and silkscreen ink on linen
101.6 x 101.6 cm
The Andy Warhol Museum, Pittsburgh
Founding Collection, Contribution
The Andy Warhol Foundation for the
Visual Arts, Inc.
1998.1.587

144 [ill. p. 249]
Grace Jones
1986
Acrylic and silkscreen ink on linen
101.6 x 101.6 cm
The Andy Warhol Museum, Pittsburgh
Founding Collection, Contribution
The Andy Warhol Foundation for the
Visual Arts, Inc.
1998.1.588

145 [ill. p. 253]
Self-portrait
1986
Acrylic and silkscreen ink on linen
274.3 x 274.8 cm
The Andy Warhol Museum, Pittsburgh
Founding Collection, Contribution
The Andy Warhol Foundation for the
Visual Arts, Inc.
1998.1.815

146 [ill. p. 242]
Aretha Franklin
About 1986
Acrylic and silkscreen ink on canvas
101.6 x 101.6 cm
The Andy Warhol Museum, Pittsburgh
Founding Collection, Contribution
The Andy Warhol Foundation for the
Visual Arts, Inc.
1998.1.549

147 [ill. p. 243]
Aretha Franklin
About 1986
Acrylic and silkscreen ink on canvas
101.6 x 101.6 cm
The Andy Warhol Museum, Pittsburgh
Founding Collection, Contribution
The Andy Warhol Foundation for the
Visual Arts, Inc.
1998.1.550

WORKS ON PAPER

148 [ill. p. 66]
Sprite Heads Playing Violins
1948
Ink, graphite, and tempera
on Manila paper
27 x 23.5 cm
The Andy Warhol Museum, Pittsburgh
Founding Collection, Contribution
The Andy Warhol Foundation for the
Visual Arts, Inc.
1998.1.1590

149
Sprite Musicians
About 1948
Ink and tempera on Manila paper
27.9 x 39.7 cm
The Andy Warhol Museum, Pittsburgh
Founding Collection, Contribution
The Andy Warhol Foundation for the
Visual Arts, Inc.
"Time Capsule 44"—TC44.93

150 [ill. p. 65]
View of Concert Hall
1940s
Ink and tempera on cardboard
31.8 x 24.1 cm
The Andy Warhol Museum, Pittsburgh
Founding Collection, Contribution
The Andy Warhol Foundation for the
Visual Arts, Inc.
1998.1.1643

151 [ill. p. 67]
Sprite Head Playing a Trombone
Late 1940s–early 1950s
Ink and tempera on Strathmore paper
22.9 x 14.9 cm
The Andy Warhol Museum, Pittsburgh
Founding Collection, Contribution
The Andy Warhol Foundation for the
Visual Arts, Inc.
1998.1.1588

152 [ill. p. 70]
Two Horns
About 1958
Sprayed paint stencil on paper
73.7 x 58.1 cm
The Andy Warhol Museum, Pittsburgh
Founding Collection, Contribution
The Andy Warhol Foundation for the
Visual Arts, Inc.
1998.1.1474

153 [ill. p. 64]
The Magic Flute
About 1959
Ink and Dr. Martin's aniline dye on
Strathmore Seconds paper
57.5 x 37.5 cm
The Andy Warhol Museum, Pittsburgh
Founding Collection, Contribution
The Andy Warhol Foundation for the
Visual Arts, Inc.
1998.1.972

154 [ill. p. 66]
Piano Keys
1950s
Ink and Dr. Martin's aniline dye on
Strathmore paper
42.9 x 28.9 cm
The Andy Warhol Museum, Pittsburgh
Founding Collection, Contribution
The Andy Warhol Foundation for the
Visual Arts, Inc.
1998.1.1110

155
Progressive Piano
1950s
Ink on Strathmore paper
29.8 x 33 cm
The Andy Warhol Museum, Pittsburgh
Founding Collection, Contribution
The Andy Warhol Foundation for the
Visual Arts, Inc.
1998.1.1172

156
Three Music Staffs with Faces
1950s
Ink on Strathmore paper
40.3 x 43.8 cm
The Andy Warhol Museum, Pittsburgh
Founding Collection, Contribution
The Andy Warhol Foundation for the
Visual Arts, Inc.
1998.1.1109

157 [ill. p. 71]
Violin and Bow
1950s
Sprayed paint on paper
43.8 x 38.9 cm
The Andy Warhol Museum, Pittsburgh
Founding Collection, Contribution
The Andy Warhol Foundation for the
Visual Arts, Inc.
1998.1.1473

158 [See p. 113, fig. 36]
Flowers
1970
Portfolio of 10 screen prints on paper
91.4 x 91.4 cm (each)
Mugrabi Collection

159 [ill. p. 207, 209]
Ladies and Gentlemen
1975
From a portfolio of 10 screen prints on
Arches paper, artist's proof, 15/25
Printer: Alexander Heinrici, New York
Publisher: Luciano Anselmino, Milan
111.8 x 73.3 cm (each)
The Andy Warhol Museum, Pittsburgh
Founding Collection, Contribution
The Andy Warhol Foundation for the
Visual Arts, Inc.
1998.1.2411.1, 7, 8, 10

160 [ill. p. 206, 208, 209]
Mick Jagger
1975
Portfolio of 10 screen prints on
Arches Aquarelle (rough) paper
110.5 x 73.7 cm (each)
The Andy Warhol Museum, Pittsburgh
Founding Collection, Contribution
The Andy Warhol Foundation for the
Visual Arts, Inc.
1998.1.2412.1–10

161 [ill. p. 213]
Rolling Stones—Love You Live
1975
Screen print on acetate collage on
Strathmore paper on cardboard
78.7 x 106.7 cm
Collection Thaddaeus Ropac,
Salzburg–Paris
AW2369

162
Mick Jagger
About 1975
Graphite on J. Green paper
102.9 x 69.5 cm
Collection Thaddaeus Ropac,
Salzburg–Paris
AW2393

163 [ill. p. 217, 221]
Celebrity Collage
1978
Screen print, coloured acetate, and
graphic art paper collage on Manila
paper
42.9 x 67.1 cm
Collection Thaddaeus Ropac,
Salzburg–Paris
AW2251

164 [ill. p. 250, 251]
Shadows II
1979
Portfolio of 6 screen prints with
diamond dust on Arches 88 paper
109.2 x 77.5 cm (each)
Courtesy Galerie Chantal Crousel, Paris
AW07-97-A–D

165 [ill. p. 63]
*Martha Graham: Letter to the World
(The Kick)*
1986
Screen print on Lenox Museum Board
91.5 x 91.5 cm
Vancouver Art Gallery
Gift of Dr. George Sakata
VAG 91.8.3

SCULPTURE

166 [ill. p. 109]
Brillo Boxes
1964, 1969 version
Acrylic and silkscreen on wood
50.8 x 50.8 x 43.2 cm (each)
Norton Simon Museum, Pasadena,
California
Gift of the artist, 1969
P. 1969.144.001-100 / TD 7.98

167
Silver Clouds
1966
Helium-filled metalized plastic film
(Scotchpak)
91.4 x 129.5 cm (each)
The Andy Warhol Museum, Pittsburgh
IA1994.13

168 [ill. p. 109]
You're In
[May] 1967
24 spray painted Coca-Cola bottles
in painted wood crate
20.3 x 43.2 x 30.5 cm
The Andy Warhol Museum, Pittsburgh
Founding Collection, Contribution
The Andy Warhol Foundation for the
Visual Arts, Inc.
1998.1.789a-x

FILMS AND VIDEOS
(TRANSFERRED TO DIGITAL FILES—HDD)

169 [ill. p. 34, 103]
D. A. Pennebaker and Richard Leacock
Rainforest
Produced by David Oppenheim
Pennebaker Hegedus Films
1968
16mm colour film
26 min 43 s
Commissioned by the National
Endowment for the Arts and
the Office of Education
Courtesy of Pennebaker Hedegus Films
(PHFilms.com)

170 [ill. p. 34, 88]
Sleep
1963
16mm film, b/w, silent
5 h 21 min at 16 fps
The Andy Warhol Museum, Pittsburgh
Founding Collection, Contribution
The Andy Warhol Foundation for the
Visual Arts, Inc.

171 [ill. p. 94]
Empire
1964
16mm film, b/w, silent
8h 5 min at 16 fps
The Andy Warhol Museum, Pittsburgh
Founding Collection, Contribution
The Andy Warhol Foundation for the
Visual Arts, Inc.

172 [ill. p. 92]
*Partial recreation of Warhol's
New York Film Festival installation
(1964)*
Four 3 min 8mm excerpts of
the following films:
Kiss
1963–64
16mm film, b/w, silent
54 min at 16 fps
The Andy Warhol Museum, Pittsburgh
Founding Collection, Contribution
The Andy Warhol Foundation for the
Visual Arts, Inc.
Sleep
1963
16mm film, b/w, silent
5 h 21 min at 16 fps
With John Giorno
The Andy Warhol Museum, Pittsburgh
Founding Collection, Contribution
The Andy Warhol Foundation for the
Visual Arts, Inc.
Eat
1964
16mm film, b/w, silent
39 min at 16 fps
The Andy Warhol Museum, Pittsburgh
Founding Collection, Contribution
The Andy Warhol Foundation for the
Visual Arts, Inc.
Haircut (No. 2)
1963
16mm film, b/w, silent
3 min at 16 fps
With John Daley, Freddy Herko,
Billy Linich (Name), James Waring
The Andy Warhol Museum, Pittsburgh
Founding Collection, Contribution
The Andy Warhol Foundation for the
Visual Arts, Inc.
Warhol invited La Monte Young,
who was interested in static sound,
to create soundtracks for the
installation's films. Young recorded
a realization of his *Composition 1960
No. 9* and used the same sound for the
music on all four films. At the opening
reception, Young withdrew his sound
from the collaboration when a Festival
official asked that the volume be
brought down.

173 [ill. p. 116]
Camp
1965
16mm film, b/w, sound
66 min
The Andy Warhol Museum, Pittsburgh
Founding Collection, Contribution
The Andy Warhol Foundation for the
Visual Arts, Inc.

174 [ill. p. 116]
Hedy
1965
16mm film, b/w, sound
66 min
The Andy Warhol Museum, Pittsburgh
Founding Collection, Contribution
The Andy Warhol Foundation for the
Visual Arts, Inc.

175
Horse
1965
16mm film, b/w, sound
99 min
The Andy Warhol Museum, Pittsburgh
Founding Collection, Contribution
The Andy Warhol Foundation for the
Visual Arts, Inc.

176
John and Ivy
1965
16mm film, b/w, sound
33 min
The Andy Warhol Museum, Pittsburgh
Founding Collection, Contribution
The Andy Warhol Foundation for the
Visual Arts, Inc.

177
Lupe
1965
16mm film, b/w, sound
72 min
The Andy Warhol Museum, Pittsburgh
Founding Collection, Contribution
The Andy Warhol Foundation for the
Visual Arts, Inc.

178 [ill. p. 116]
More Milk Yvette
1965
16mm film, b/w, sound
66 min
The Andy Warhol Museum, Pittsburgh
Founding Collection, Contribution
The Andy Warhol Foundation for the
Visual Arts, Inc.

179 [ill. p. 117]
Poor Little Rich Girl
1965
16mm film, b/w, sound
66 min
The Andy Warhol Museum, Pittsburgh
Founding Collection, Contribution
The Andy Warhol Foundation for the
Visual Arts, Inc.

180 [ill. p. 117]
Space
1965
16mm film, b/w, sound
66 min
The Andy Warhol Museum, Pittsburgh
Founding Collection, Contribution
The Andy Warhol Foundation for the
Visual Arts, Inc.

181 [ill. p. 117]
Vinyl
1965
16mm film, b/w, sound
66 min
The Andy Warhol Museum, Pittsburgh
Founding Collection, Contribution
The Andy Warhol Foundation for the
Visual Arts, Inc.

182 [ill. p. 118, 119]
The Chelsea Girls
1966
16mm film, b/w and colour, sound
204 min in double screen
The Andy Warhol Museum, Pittsburgh
Founding Collection, Contribution
The Andy Warhol Foundation for the
Visual Arts, Inc.

183 [ill. p. 147]
*EPI Background:
Original Salvador Dalí*
1966
16mm film, b/w, silent
25 min
The Andy Warhol Museum, Pittsburgh
Founding Collection, Contribution
The Andy Warhol Foundation for the
Visual Arts, Inc.

184 [ill. p. 142]
Screen Test: John Cale
1966
16mm film, b/w, silent
4 min at 16 fps
The Andy Warhol Museum, Pittsburgh
Founding Collection, Contribution
The Andy Warhol Foundation for the
Visual Arts, Inc.

185 [ill. p. 147]
Screen Test: John Cale (Eye)
Part of *EPI Background:
Velvet Underground*
1966
16mm film, b/w, silent
4 min at 16 fps
The Andy Warhol Museum, Pittsburgh
Founding Collection, Contribution
The Andy Warhol Foundation for the
Visual Arts, Inc.

186 [ill. p. 142]
Screen Test: Lou Reed
1966
16mm film, b/w, silent
4 min at 16 fps
The Andy Warhol Museum, Pittsburgh
Founding Collection, Contribution
The Andy Warhol Foundation for the
Visual Arts, Inc.

187 [ill. p. 147]
Screen Test: Lou Reed (Lips)
Part of *EPI Background:
Velvet Underground*
1966
16mm film, b/w, silent
4 min at 16 fps
The Andy Warhol Museum, Pittsburgh
Founding Collection, Contribution
The Andy Warhol Foundation for the
Visual Arts, Inc.

188 [ill. p. 142]
Screen Test: Maureen Tucker
1966
16mm, b/w, silent
4 min at 16 fps
The Andy Warhol Museum, Pittsburgh
Founding Collection, Contribution
The Andy Warhol Foundation for the
Visual Arts, Inc.

189 [ill. p. 142]
Screen Test: Nico
1966
16mm film, b/w, silent
4 min at 16 fps
The Andy Warhol Museum, Pittsburgh
Founding Collection, Contribution
The Andy Warhol Foundation for the
Visual Arts, Inc.

190 [ill. p. 147]
Screen Test: Nico (Coke)
Part of *EPI Background:*
Velvet Underground
1966
16mm film, b/w, silent
4 min at 16 fps
The Andy Warhol Museum, Pittsburgh
Founding Collection, Contribution
The Andy Warhol Foundation for the
Visual Arts, Inc.

191 [ill. p. 142]
Screen Test: Sterling Morrison
1966
16mm film, b/w, silent
4 min at 16 fps
The Andy Warhol Museum, Pittsburgh
Founding Collection, Contribution
The Andy Warhol Foundation for the
Visual Arts, Inc.

192 [ill. p. 147]
The Velvet Underground
1966
16mm film, b/w, sound
66 min
The Andy Warhol Museum, Pittsburgh
Founding Collection, Contribution
The Andy Warhol Foundation for the
Visual Arts, Inc.

193 [ill. p. 145]
The Velvet Underground and Nico
1966
16mm film, b/w, sound
66 min
The Andy Warhol Museum, Pittsburgh
Founding Collection, Contribution
The Andy Warhol Foundation for the
Visual Arts, Inc.

194 [ill. p. 120]
Lonesome Cowboys
1967–68
16mm film, colour, sound
109 min
The Andy Warhol Museum, Pittsburgh
Founding Collection, Contribution
The Andy Warhol Foundation for the
Visual Arts, Inc.

195 [ill. p. 120]
The Loves of Ondine
1967–68
16mm film, colour, sound
85 min
The Andy Warhol Museum, Pittsburgh
Founding Collection, Contribution
The Andy Warhol Foundation for the
Visual Arts, Inc.

196 [ill. p. 120]
The Nude Restaurant
1967–68
16mm film, colour, sound
99 min
The Andy Warhol Museum, Pittsburgh
Founding Collection, Contribution
The Andy Warhol Foundation for the
Visual Arts, Inc.

197 [ill. p. 187]
Factory Diary: David Bowie and Group
at the Factory, September 14, 1971
1971
½" reel-to-reel videotape, b/w, sound
14 min
The Andy Warhol Museum, Pittsburgh
Founding Collection, Contribution
The Andy Warhol Foundation for the
Visual Arts, Inc.

198 [ill. p. 184]
Andy Warhol's TV (Episode 3)
1980
¾" videotape, colour, sound
45 min
The Andy Warhol Museum, Pittsburgh
Founding Collection, Contribution
The Andy Warhol Foundation for the
Visual Arts, Inc.

199 [ill. p. 22, 184]
Andy Warhol's TV (Episode 12)
1981
¾" videotape, colour, sound
30 min
The Andy Warhol Museum, Pittsburgh
Founding Collection, Contribution
The Andy Warhol Foundation for the
Visual Arts, Inc.

200
Movie Movie
Andy Warhol TV Productions
for Loredana Bertè
1981
1" videotape, colour, sound
4 min
The Andy Warhol Museum, Pittsburgh
Founding Collection, Contribution
The Andy Warhol Foundation for the
Visual Arts, Inc.

201 [ill. p. 288]
The Secret Spy
Andy Warhol TV Productions
for Walter Steding on Earhole Records
1981
1" videotape, colour, sound
3 min
The Andy Warhol Museum, Pittsburgh
Founding Collection, Contribution
The Andy Warhol Foundation for the
Visual Arts, Inc.

202 [ill. p. 288]
Fuego
Andy Warhol TV Productions
for Miguel Bosè
1983
1" videotape, colour, sound
4 min
The Andy Warhol Museum, Pittsburgh
Founding Collection, Contribution
The Andy Warhol Foundation for the
Visual Arts, Inc.

203 [ill. p. 288]
Hello Again
Andy Warhol TV Productions
for the Cars
1984
1" videotape, colour, sound
5 min
The Andy Warhol Museum, Pittsburgh
Founding Collection, Contribution
The Andy Warhol Foundation for the
Visual Arts, Inc.

204 [ill. end sheet]
Misfit
Andy Warhol TV Productions
for Curiosity Killed the Cat
1986
1" videotape, colour, sound
4 min
The Andy Warhol Museum, Pittsburgh
Founding Collection, Contribution
The Andy Warhol Foundation for the
Visual Arts, Inc.

205 [ill. p. 185]
Andy Warhol's Fifteen Minutes
(Episode 3)
1987
1" videotape, colour, sound
30 min
The Andy Warhol Museum, Pittsburgh
Founding Collection, Contribution
The Andy Warhol Foundation for the
Visual Arts, Inc.

206 [ill. p. 185]
Andy Warhol's Fifteen Minutes
(Episode 4)
1987
1" videotape, colour, sound
30 min
The Andy Warhol Museum, Pittsburgh
Founding Collection, Contribution
The Andy Warhol Foundation for the
Visual Arts, Inc.

PHOTOGRAPHS

207
Edward Villella
Source material for the article "New
Faces, New Forces, New Names in the
Arts" (*Harper's Bazaar*, June 1963)
1963
22 strips of photobooth pictures
20 x 4.1 cm (each)
The Andy Warhol Museum, Pittsburgh
Founding Collection, Contribution
The Andy Warhol Foundation for the
Visual Arts, Inc.
"Time Capsule 21"—TC21.73.113-134

208 [ill. p. 210]
Candy Darling
From "Little Red Book No. 110"
1969
Polaroid Polacolor Type 108, facsimile
10.8 x 8.6 cm
The Andy Warhol Museum, Pittsburgh
Founding Collection, Contribution
The Andy Warhol Foundation for the
Visual Arts, Inc.
1998.1.2996.12

209–220
Sticky Fingers (1971). Source material
for the record cover designed by Warhol
for the Rolling Stones

209 [ill. p. 197]
Male Torso
1970–71
Polaroid Type 107, facsimile
10.8 x 8.6 cm
The Andy Warhol Museum, Pittsburgh
Founding Collection, Contribution
The Andy Warhol Foundation for the
Visual Arts, Inc.
1998.3.3132.10

210 [ill. p. 197]
Male Torso
1970–71
Polaroid Type 107, facsimile
10.8 x 8.6 cm
The Andy Warhol Museum, Pittsburgh
Founding Collection, Contribution
The Andy Warhol Foundation for the
Visual Arts, Inc.
1998.3.3132.14

211 [ill. p. 197]
Male Torso
1970–71
Polaroid Type 107, facsimile
10.8 x 8.6 cm
The Andy Warhol Museum, Pittsburgh
Founding Collection, Contribution
The Andy Warhol Foundation for the
Visual Arts, Inc.
1998.3.3132.15

212 [ill. p. 197]
Male Torso
1970–71
Polaroid Type 107, facsimile
10.8 x 8.6 cm
The Andy Warhol Museum, Pittsburgh
Founding Collection, Contribution
The Andy Warhol Foundation for the
Visual Arts, Inc.
1998.3.3132.16

213 [ill. p. 197]
Male Torso
1970–71
Polaroid Type 107, facsimile
10.8 x 8.6 cm
The Andy Warhol Museum, Pittsburgh
Founding Collection, Contribution
The Andy Warhol Foundation for the
Visual Arts, Inc.
1998.3.3132.18

214 [ill. p. 199]
Male Torso
1970–71
Polaroid Type 107, facsimile
8.6 x 10.6 cm
The Andy Warhol Museum, Pittsburgh
Founding Collection, Contribution
The Andy Warhol Foundation for the
Visual Arts, Inc.
1998.3.3132.23

215 [ill. p. 197]
Male Torso
1970–71
Polaroid Type 107, facsimile
10.8 x 8.6 cm
The Andy Warhol Museum, Pittsburgh
Founding Collection, Contribution
The Andy Warhol Foundation for the
Visual Arts, Inc.
1998.3.3132.27

216 [ill. p. 197]
Male Torso
1970–71
Polaroid Type 107, facsimile
10.8 x 8.6 cm
The Andy Warhol Museum, Pittsburgh
Founding Collection, Contribution
The Andy Warhol Foundation for the
Visual Arts, Inc.
1998.3.3132.28

217
Male Torso
1970–71
Polaroid Type 107, facsimile
10.8 x 8.6 cm
The Andy Warhol Museum, Pittsburgh
Founding Collection, Contribution
The Andy Warhol Foundation for the
Visual Arts, Inc.
1998.3.3132.30

218 [ill. p. 197]
Male Torso
1970–71
Polaroid Type 107, facsimile
10.8 x 8.6 cm
The Andy Warhol Museum, Pittsburgh
Founding Collection, Contribution
The Andy Warhol Foundation for the
Visual Arts, Inc.
1998.3.3132.33

219 [ill. p. 197]
Male Torso
1970–71
Polaroid Type 107, facsimile
10.8 x 8.6 cm
The Andy Warhol Museum, Pittsburgh
Founding Collection, Contribution
The Andy Warhol Foundation for the
Visual Arts, Inc.
1998.3.3132.34

220 [ill. p. 199]
Male Torso
1970–71
Polaroid Type 107, facsimile
10.8 x 8.6 cm
The Andy Warhol Museum, Pittsburgh
Founding Collection, Contribution
The Andy Warhol Foundation for the
Visual Arts, Inc.
1998.3.3132.41

221 [ill. p. 198]
Sticky Fingers (1971)—
The Rolling Stones
Camera-ready photostat copy,
based on an original Polaroid
photograph by Warhol
1970–71
Positive photo print on sensitized paper
23.2 x 16.8 cm
The Andy Warhol Museum, Pittsburgh
Founding Collection, Contribution
The Andy Warhol Foundation for the
Visual Arts, Inc.
"Time Capsule 57"—TC57.3.1

222 [ill. p. 198]
Sticky Fingers (1971)—
The Rolling Stones
Camera-ready photostat copy,
based on an original Polaroid
photograph by Warhol
1970–71
Negative photo print on
sensitized paper
21.6 x 15.6 cm
The Andy Warhol Museum, Pittsburgh
Founding Collection, Contribution
The Andy Warhol Foundation for the
Visual Arts, Inc.
"Time Capsule 57"—TC57.3.2

223 [ill. p. 198]
Sticky Fingers (1971)—
The Rolling Stones
Camera-ready photostat copy,
based on an original Polaroid
photograph by Warhol
1970–71
Negative photo print on
sensitized paper
21.6 x 15.6 cm
The Andy Warhol Museum, Pittsburgh
Founding Collection, Contribution
The Andy Warhol Foundation for the
Visual Arts, Inc.
"Time Capsule 57"—TC57.3.3

224 [ill. p. 225]
Self-portrait with John Lennon and
Yoko Ono
1971
Polaroid Polacolor Type 108, facsimile
8.6 x 10.8 cm
The Andy Warhol Museum, Pittsburgh
Founding Collection, Contribution
The Andy Warhol Foundation for the
Visual Arts, Inc.
1998.1.2990.14

225
Self-portrait with Yoko Ono
From "Little Red Book No. 18"
1971
Polaroid Polacolor Type 108, facsimile
10.8 x 8.6 cm
The Andy Warhol Museum, Pittsburgh
Founding Collection, Contribution
The Andy Warhol Foundation for the
Visual Arts, Inc.
1998.1.2990.8

226–228
Ladies and Gentlemen (1975).
Source material for the series

226 [ill. p. 210]
Drag Queen
1974
Polaroid Polacolor Type 108, facsimile
10.8 x 8.6 cm
The Andy Warhol Museum, Pittsburgh
Founding Collection, Contribution
The Andy Warhol Foundation for the
Visual Arts, Inc.
2001.2.1204

227 [ill. p. 210]
Drag Queen
1974
Polaroid Polacolor Type 108, facsimile
10.8 x 8.6 cm
The Andy Warhol Museum, Pittsburgh
Founding Collection, Contribution
The Andy Warhol Foundation for the
Visual Arts, Inc.
2001.2.1774
228 [ill. p. 210]
Drag Queen (Helen/Harry Morales)
1974
Polaroid Polacolor Type 108, facsimile
10.8 x 8.6 cm
The Andy Warhol Museum, Pittsburgh
Founding Collection, Contribution
The Andy Warhol Foundation for the
Visual Arts, Inc.
2001.2.1763

229 [ill. p. 205]
Mick Jagger
From "Little Red Book No. 66"
1975
Polaroid, facsimile
10.8 x 8.6 cm
The Andy Warhol Museum, Pittsburgh
Founding Collection, Contribution
The Andy Warhol Foundation for the
Visual Arts, Inc.
1998.1.2995.10

230 [ill. p. 205]
Mick Jagger
From "Little Red Book No. 66"
1975
Polaroid, facsimile
10.8 x 8.6 cm
The Andy Warhol Museum, Pittsburgh
Founding Collection, Contribution
The Andy Warhol Foundation for the
Visual Arts, Inc.
1998.1.2995.12

231 [ill. p. 204]
Mick Jagger
From "Little Red Book No. 66"
1975
Polaroid Polacolor Type 108, facsimile
10.8 x 8.6 cm
The Andy Warhol Museum, Pittsburgh
Founding Collection, Contribution
The Andy Warhol Foundation for the
Visual Arts, Inc.
1998.1.2995.14

232 [ill. p. 205]
Mick Jagger
From "Little Red Book No. 66"
1975
Polaroid, facsimile
10.8 x 8.6 cm
The Andy Warhol Museum, Pittsburgh
Founding Collection, Contribution
The Andy Warhol Foundation for the
Visual Arts, Inc.
1998.1.2995.15

233
Mick Jagger
From "Little Red Book No. 66"
1975
Polaroid, facsimile
10.8 x 8.6 cm
The Andy Warhol Museum, Pittsburgh
Founding Collection, Contribution
The Andy Warhol Foundation for the
Visual Arts, Inc.
1998.1.2995.18

234 [ill. p. 205]
Mick Jagger
From "Little Red Book No. 66"
1975
Polaroid, facsimile
10.8 x 8.6 cm
The Andy Warhol Museum, Pittsburgh
Founding Collection, Contribution
The Andy Warhol Foundation for the
Visual Arts, Inc.
1998.1.2995.19

235 [ill. p. 204]
Mick Jagger
From "Little Red Book No. 275"
1975
Polaroid Polacolor Type 108, facsimile
10.8 x 8.6 cm
The Andy Warhol Museum, Pittsburgh
Founding Collection, Contribution
The Andy Warhol Foundation for the
Visual Arts, Inc.
1998.1.3003.2

236 [ill. p. 204]
Mick Jagger
From "Little Red Book No. 275"
1975
Polaroid, facsimile
10.8 x 8.6 cm
The Andy Warhol Museum, Pittsburgh
Founding Collection, Contribution
The Andy Warhol Foundation for the
Visual Arts, Inc.
1998.1.3003.4

237 [ill. p. 204]
Mick Jagger
From "Little Red Book No. 275"
1975
Polaroid Polacolor Type 108, facsimile
10.8 x 8.6 cm
The Andy Warhol Museum, Pittsburgh
Founding Collection, Contribution
The Andy Warhol Foundation for the
Visual Arts, Inc.
1998.1.3003.6

238 [ill. p. 200]
Mick Jagger
From "Little Red Book No. 275"
1975
Polaroid Polacolor Type 108, facsimile
10.8 x 8.6 cm
The Andy Warhol Museum, Pittsburgh
Founding Collection, Contribution
The Andy Warhol Foundation for the
Visual Arts, Inc.
1998.1.3003.8

239
Liza Minnelli
1977
Polaroid Polacolor Type 108, facsimile
10.8 x 8.6 cm
The Andy Warhol Museum, Pittsburgh
Founding Collection, Contribution
The Andy Warhol Foundation for the
Visual Arts, Inc.
2000.2.328

240 [ill. p. 230]
Liza Minnelli
1977
Polaroid Polacolor Type 108
10.8 x 8.6 cm
The Andy Warhol Museum, Pittsburgh
Contribution The Andy Warhol
Foundation for the Visual Arts, Inc.
2000.2.329

241 [ill. p. 231]
Liza Minnelli
1977
Polaroid Polacolor Type 108, facsimile
10.8 x 8.6 cm
The Andy Warhol Museum, Pittsburgh
Founding Collection, Contribution
The Andy Warhol Foundation for the
Visual Arts, Inc.
2000.2.330

242 [ill. p. 230]
Liza Minnelli
1977
Polaroid Polacolor Type 108, facsimile
10.8 x 8.6 cm
The Andy Warhol Museum, Pittsburgh
Founding Collection, Contribution
The Andy Warhol Foundation for the
Visual Arts, Inc.
2000.2.331

243 [ill. p. 230]
Liza Minnelli
1977
Polaroid Polacolor Type 108, facsimile
10.8 x 8.6 cm
The Andy Warhol Museum, Pittsburgh
Founding Collection, Contribution
The Andy Warhol Foundation for the
Visual Arts, Inc.
2000.2.332

244–252
Love you Live (1977). Source material
for the record cover designed by Warhol
for the Rolling Stones

244 [ill. p. 214]
*Charlie Watts biting
Mick Jagger's ear*
1977
Polaroid Polacolor Type 108, facsimile
10.8 x 8.6 cm
The Andy Warhol Museum, Pittsburgh
Founding Collection, Contribution
The Andy Warhol Foundation for the
Visual Arts, Inc.
2001.2.1200

245 [ill. p. 214]
Keith Richards
1977
Polaroid Polacolor Type 108, facsimile
10.8 x 8.6 cm
The Andy Warhol Museum, Pittsburgh
Founding Collection, Contribution
The Andy Warhol Foundation for the
Visual Arts, Inc.
2001.2.1193
246 [ill. p. 214]
Keith Richards
1977
Polaroid Polacolor Type 108, facsimile
10.8 x 8.6 cm
The Andy Warhol Museum, Pittsburgh
Founding Collection, Contribution
The Andy Warhol Foundation for the
Visual Arts, Inc.
2001.2.1196
247 [ill. p. 214]
Keith Richards
1977
Polaroid Polacolor Type 108, facsimile
10.8 x 8.6 cm
The Andy Warhol Museum, Pittsburgh
Founding Collection, Contribution
The Andy Warhol Foundation for the
Visual Arts, Inc.
2001.2.1198
248 [ill. p. 214]
Keith Richards
1977
Polaroid Polacolor Type 108, facsimile
10.8 x 8.6 cm
The Andy Warhol Museum, Pittsburgh
Founding Collection, Contribution
The Andy Warhol Foundation for the
Visual Arts, Inc.
2001.2.1201
249 [ill. p. 214]
Mick Jagger
1977
Polaroid Polacolor Type 108, facsimile
10.8 x 8.6 cm
The Andy Warhol Museum, Pittsburgh
Founding Collection, Contribution
The Andy Warhol Foundation for the
Visual Arts, Inc.
2001.2.1195
250 [ill. p. 214]
Mick Jagger and Charlie Watts
1977
Polaroid Polacolor Type 108, facsimile
10.8 x 8.6 cm
The Andy Warhol Museum, Pittsburgh
Founding Collection, Contribution
The Andy Warhol Foundation for the
Visual Arts, Inc.
2001.2.1197
251 [ill. p. 214]
Mick Jagger and Charlie Watts
1977
Polaroid Polacolor Type 108, facsimile
10.8 x 8.6 cm
The Andy Warhol Museum, Pittsburgh
Founding Collection, Contribution
The Andy Warhol Foundation for the
Visual Arts, Inc.
2001.2.1199

252 [ill. p. 214]
Mick Jagger and unidentified woman
1977
Polaroid Polacolor Type 108, facsimile
10.8 x 8.6 cm
The Andy Warhol Museum, Pittsburgh
Founding Collection, Contribution
The Andy Warhol Foundation for the
Visual Arts, Inc.
2001.2.1194

253
*Stavros Merjos, Studio 54 busboy,
serving Warhol champagne in a
beer pitcher*
About 1977–78
Gelatin silver print
25.4 x 20.3 cm
The Andy Warhol Museum, Pittsburgh
Founding Collection, Contribution
The Andy Warhol Foundation for the
Visual Arts, Inc.
2001.2.473

254
*Andy Warhol, Joan Quinn,
and Mick Jagger*
1978
Chromogenic print
8.9 x 8.9 cm
The Andy Warhol Museum, Pittsburgh
Founding Collection, Contribution
The Andy Warhol Foundation for the
Visual Arts, Inc.
"Time Capsule 214"—TC214.124.24

255
*Jerry Hall, Andy Warhol,
and Mick Jagger*
1978
Chromogenic print
8.9 x 8.9 cm
The Andy Warhol Museum, Pittsburgh
Founding Collection, Contribution
The Andy Warhol Foundation for the
Visual Arts, Inc.
"Time Capsule 214"—TC214.124.22

256 [ill. p. 218]
Liza Minnelli
1978
Gelatin silver print
20.3 x 25.1 cm
The Andy Warhol Museum, Pittsburgh
Founding Collection, Contribution
The Andy Warhol Foundation for the
Visual Arts, Inc.
2001.2.814

257
Henry Geldzahler and Raymond Foye
1979
Gelatin silver print
20.3 x 25.4 cm
The Andy Warhol Museum, Pittsburgh
Founding Collection, Contribution
The Andy Warhol Foundation for the
Visual Arts, Inc.
2001.2.168

258
*Liza Minnelli on stage at
Carnegie Hall, New York,
September 1979*
1979
Gelatin silver print
20.3 x 25.2 cm
The Andy Warhol Museum, Pittsburgh
Founding Collection, Contribution
The Andy Warhol Foundation for the
Visual Arts, Inc.
2001.2.796

259 [ill. p. 218]
Steven Tyler and Bebe Buell
1979
Gelatin silver print
20.3 x 25.4 cm
The Andy Warhol Museum, Pittsburgh
Founding Collection, Contribution
The Andy Warhol Foundation for the
Visual Arts, Inc.
2001.2.167

260 [ill. p. 230]
Debbie Harry
1980
Polaroid Polacolor Type 108, facsimile
10.8 x 8.6 cm
The Andy Warhol Museum, Pittsburgh
Founding Collection, Contribution
The Andy Warhol Foundation for the
Visual Arts, Inc.
2000.2.320

261 [ill. p. 230]
Debbie Harry
1980
Polaroid Polacolor Type 108, facsimile
10.8 x 8.6 cm
The Andy Warhol Museum, Pittsburgh
Founding Collection, Contribution
The Andy Warhol Foundation for the
Visual Arts, Inc.
2000.2.321

262
Debbie Harry
1980
Polaroid Polacolor Type 108, facsimile
10.8 x 8.6 cm
The Andy Warhol Museum, Pittsburgh
Contribution The Andy Warhol
Foundation for the Visual Arts, Inc.
2000.2.322

263 [ill. p. 230]
Debbie Harry
1980
Polaroid Polacolor Type 108, facsimile
10.8 x 8.6 cm
The Andy Warhol Museum, Pittsburgh
Founding Collection, Contribution
The Andy Warhol Foundation for the
Visual Arts, Inc.
2000.2.323

264
Debbie Harry
1980
Gelatin silver print
20.3 x 25.4 cm
The Andy Warhol Museum, Pittsburgh
Founding Collection, Contribution
The Andy Warhol Foundation for the
Visual Arts, Inc.
2001.2.88

265 [ill. p. 210]
Self-portrait in drag
1980
Polaroid Polacolor 2, facsimile
10.8 x 8.6 cm
The Andy Warhol Museum, Pittsburgh
Founding Collection, Contribution
The Andy Warhol Foundation for the
Visual Arts, Inc.
1998.1.2910

266 [ill. p. 218]
Steve Rubell and Bianca Jagger
1980
Gelatin silver print
20.3 x 25.4 cm
The Andy Warhol Museum, Pittsburgh
Founding Collection, Contribution
The Andy Warhol Foundation for the
Visual Arts, Inc.
2001.2.169

267 [ill. p. 218]
*Unidentified woman, Liza Minnelli,
Rudolf Nureyev, and Martha Graham*
About 1980
Gelatin silver print
20.3 x 25.1 cm
The Andy Warhol Museum, Pittsburgh
Founding Collection, Contribution
The Andy Warhol Foundation for the
Visual Arts, Inc.
2001.2.204

268 [ill. p. 230]
Diana Ross
1981
Polaroid Polacolor 2
10.8 x 8.6 cm
The Andy Warhol Museum, Pittsburgh
Contribution The Andy Warhol Founda-
tion for the Visual Arts, Inc.
2000.2.277

269 [ill. p. 230]
Diana Ross
1981
Polaroid Polacolor 2
10.8 x 8.6 cm
The Andy Warhol Museum, Pittsburgh
Contribution The Andy Warhol Founda-
tion for the Visual Arts, Inc.
2000.2.278

270 [ill. p. 230]
Diana Ross
1981
Polaroid Polacolor 2, facsimile
10.8 x 8.6 cm
The Andy Warhol Museum, Pittsburgh
Founding Collection, Contribution
The Andy Warhol Foundation for the
Visual Arts, Inc.
2000.2.279

271
Diana Ross
1981
Polaroid Polacolor 2, facsimile
10.8 x 8.6 cm
The Andy Warhol Museum, Pittsburgh
Contribution the Andy Warhol
Foundation for the Visual Arts, Inc.
2000.2.280

272
Diana Ross
1981
Gelatin silver print
20.3 x 25.4 cm
The Andy Warhol Museum, Pittsburgh
Founding Collection, Contribution
The Andy Warhol Foundation for the
Visual Arts, Inc.
2001.2.106

273 [ill. p. 219]
*Martha Graham, Andy Warhol,
and a birthday cake*
1981
Gelatin silver print
20.3 x 25.4 cm
The Andy Warhol Museum, Pittsburgh
Founding Collection, Contribution
The Andy Warhol Foundation for the
Visual Arts, Inc.
2001.2.829

274 [ill. p. 210]
Self-portrait in drag
1981
Polaroid Polacolor 2, facsimile
10.8 x 8.6 cm
The Andy Warhol Museum, Pittsburgh
Founding Collection, Contribution
The Andy Warhol Foundation for the
Visual Arts, Inc.
1998.1.2923

275
Self-portrait in rag
1981
Polaroid Polacolor 2, facsimile
10.8 x 8.6 cm
The Andy Warhol Museum, Pittsburgh
Founding Collection, Contribution
The Andy Warhol Foundation for the
Visual Arts, Inc.
1998.1.2924

276 [ill. p. 211]
Self-portrait in drag
1981
Polaroid Polacolor 2, facsimile
10.8 x 8.6 cm
The Andy Warhol Museum, Pittsburgh
Founding Collection, Contribution
The Andy Warhol Foundation for the
Visual Arts, Inc.
1998.1.2929

277 [ill. p. 210]
Self-portrait in drag
1981
Polaroid Polacolor 2, facsimile
10.8 x 8.6 cm
The Andy Warhol Museum, Pittsburgh
Founding Collection, Contribution
The Andy Warhol Foundation for the
Visual Arts, Inc.
1998.1.2930

278 [ill. p. 210]
Self-portrait in drag
1981
Polaroid Polacolor 2, facsimile
10.8 x 8.6 cm
The Andy Warhol Museum, Pittsburgh
Founding Collection, Contribution
The Andy Warhol Foundation for the
Visual Arts, Inc.
1998.1.2932

279
Tina Turner
1981
Gelatin silver print
20.3 x 25.4 cm
The Andy Warhol Museum, Pittsburgh
Founding Collection, Contribution
The Andy Warhol Foundation for the
Visual Arts, Inc.
2001.2.830

280
Jerry Hall
About 1981
Gelatin silver print
20.3 x 25.4 cm
The Andy Warhol Museum, Pittsburgh
Founding Collection, Contribution
The Andy Warhol Foundation for the
Visual Arts, Inc.
2001.2.128

281 [ill. p. 224]
Boy George and Quentin Crisp
1982
Gelatin silver print
20.3 x 25.4 cm
The Andy Warhol Museum, Pittsburgh
Founding Collection, Contribution
The Andy Warhol Foundation for the
Visual Arts, Inc.
2001.2.657

282 [ill. p. 190]
Chris Stein and Debbie Harry
1982
Gelatin silver print
20.3 x 25.4 cm
The Andy Warhol Museum, Pittsburgh
Founding Collection, Contribution
The Andy Warhol Foundation for the
Visual Arts, Inc.
2001.2.776

283 [ill. p. 87, 272]
John Cage and Andy Warhol
1982
Gelatin silver print
20.3 x 25.4 cm
The Andy Warhol Museum, Pittsburgh
Founding Collection, Contribution
The Andy Warhol Foundation for the
Visual Arts, Inc.
2001.2.866

284
Male Models
1982
Gelatin silver print
25.4 x 20.3 cm
The Andy Warhol Museum, Pittsburgh
Founding Collection, Contribution
The Andy Warhol Foundation for the
Visual Arts, Inc.
2001.2.307

285–287
Querelle (1982). Source material
for Warhol's poster for Rainer Werner
Fassbinder's film

285 [ill. p. 215]
Untitled
1982
Polaroid Polacolor 2, facsimile
10.8 x 8.6 cm
The Andy Warhol Museum, Pittsburgh
Founding Collection, Contribution
The Andy Warhol Foundation for the
Visual Arts, Inc.
2001.2.1561

286 [ill. p. 215]
Untitled
1982
Polaroid Polacolor 2, facsimile
10.8 x 8.6 cm
The Andy Warhol Museum, Pittsburgh
Founding Collection, Contribution
The Andy Warhol Foundation for the
Visual Arts, Inc.
2001.2.1562

287
Untitled
1982
Polaroid Polacolor 2, facsimile
10.8 x 8.6 cm
The Andy Warhol Museum, Pittsburgh
Founding Collection, Contribution
The Andy Warhol Foundation for the
Visual Arts, Inc.
2001.2.1564

288
*Rainer Werner Fassbinder,
Brad Davis, and Andy Warhol on
the set of "Querelle," Berlin*
1982
Gelatin silver print
20.3 x 25.2 cm
The Andy Warhol Museum, Pittsburgh
Founding Collection, Contribution
The Andy Warhol Foundation for the
Visual Arts, Inc.
2001.2.176

289 [ill. p. 223]
Sting
1982
Gelatin silver print
25.6 x 20.2 cm
The Andy Warhol Museum, Pittsburgh
Founding Collection, Contribution
The Andy Warhol Foundation for the
Visual Arts, Inc.
2001.2.556

290 [ill. p. 133]
Telephone
1982
Gelatin silver print
25.2 x 20.3 cm
The Andy Warhol Museum, Pittsburgh
Founding Collection, Contribution
The Andy Warhol Foundation for the
Visual Arts, Inc.
2001.2.949

291
The Jacksons and Don King
1983
Gelatin silver print
20.2 x 25.4 cm
The Andy Warhol Museum, Pittsburgh
Founding Collection, Contribution
The Andy Warhol Foundation for the
Visual Arts, Inc.
2001.2.250

292
The Jacksons and Don King
1983
Gelatin silver print
20.3 x 25.4 cm
The Andy Warhol Museum, Pittsburgh
Founding Collection, Contribution
The Andy Warhol Foundation for the
Visual Arts, Inc.
2001.2.251

293
*Jellybean Benitez, Debbie Harry,
and Calvin Klein*
About 1983
Gelatin silver print
20.3 x 25.4 cm
The Andy Warhol Museum, Pittsburgh
Founding Collection, Contribution
The Andy Warhol Foundation for the
Visual Arts, Inc.
2001.2.215

294 [ill. p. 224]
*Kenny Scharf, Madonna, Juan
Dubose, and Keith Haring*
About 1983
Gelatin silver print
18.7 x 25.4 cm
The Andy Warhol Museum, Pittsburgh
Founding Collection, Contribution
The Andy Warhol Foundation for the
Visual Arts, Inc.
2001.2.220

295
*Robert Rauschenberg, Bianca Jagger,
and Keith Haring*
About 1983
Gelatin silver print
20.3 x 25.4 cm
The Andy Warhol Museum, Pittsburgh
Founding Collection, Contribution
The Andy Warhol Foundation for the
Visual Arts, Inc.
2001.2.214

296 [ill. p. 224]
Liberace and John Sex
1984
Gelatin silver print
20.3 x 25.4 cm
The Andy Warhol Museum, Pittsburgh
Founding Collection, Contribution
The Andy Warhol Foundation for the
Visual Arts, Inc.
2001.2.656

297 [ill. p. 224]
Cher
1984–85
Gelatin silver print
20.3 x 25.4 cm
The Andy Warhol Museum, Pittsburgh
Founding Collection, Contribution
The Andy Warhol Foundation for the
Visual Arts, Inc.
2001.2.126

298
*Andy Warhol and
Jean-Michel Basquiat*
1985
Gelatin silver print
20.3 x 25.4 cm
The Andy Warhol Museum, Pittsburgh
Founding Collection, Contribution
The Andy Warhol Foundation for the
Visual Arts, Inc.
2001.2.177

299
*Steve Rubell at the Palladium,
New York, with Kenny Scharf artwork
in the background*
1985
Gelatin silver print
20.3 x 25.4 cm
The Andy Warhol Museum, Pittsburgh
Founding Collection, Contribution
The Andy Warhol Foundation for the
Visual Arts, Inc.
2001.2.435

300 [ill. p. 223]
*Anthony Kiedis (Red Hot Chili
Peppers)*
About 1985
Gelatin silver print
20.3 x 25.4 cm
The Andy Warhol Museum, Pittsburgh
Founding Collection, Contribution
The Andy Warhol Foundation for the
Visual Arts, Inc.
2001.2.429

301 [ill. p. 224]
Grace Jones
About 1985
Gelatin silver print
20.3 x 25.4 cm
The Andy Warhol Museum, Pittsburgh
Founding Collection, Contribution
The Andy Warhol Foundation for the
Visual Arts, Inc.
2001.2.95

302
*Unidentified man, Grace Jones,
and Keith Haring*
About 1985
Gelatin silver print
25.4 x 20.3 cm
The Andy Warhol Museum, Pittsburgh
Founding Collection, Contribution
The Andy Warhol Foundation for the
Visual Arts, Inc.
2001.2.94

303 [ill. p. 223]
Bob Dylan and unidentified woman
1986
Gelatin silver print
25.1 x 20.2 cm
The Andy Warhol Museum, Pittsburgh
Founding Collection, Contribution
The Andy Warhol Foundation for the
Visual Arts, Inc.
2001.2.794

304
*Curiosity Killed the Cat and
Don Monroe (?)*
1986
Gelatin silver print
20.3 x 25.4 cm
The Andy Warhol Museum, Pittsburgh
Founding Collection, Contribution
The Andy Warhol Foundation for the
Visual Arts, Inc.
2001.2.199

305
Shelly Fremont and Bob Dylan
1986
Gelatin silver print
25.2 x 20.2 cm
The Andy Warhol Museum, Pittsburgh
Founding Collection, Contribution
The Andy Warhol Foundation for the
Visual Arts, Inc.
2001.2.795

306 [ill. p. 218]
David Byrne
n.d.
Gelatin silver print
20.3 x 25.4 cm
The Andy Warhol Museum, Pittsburgh
Founding Collection, Contribution
The Andy Warhol Foundation for the
Visual Arts, Inc.
2001.2.359

307
Fran Lebowitz
n.d.
Gelatin silver print
20.3 x 25.4 cm
The Andy Warhol Museum, Pittsburgh
Founding Collection, Contribution
The Andy Warhol Foundation for the
Visual Arts, Inc.
2001.2.96

308
Fred Hughes and Bianca Jagger
n.d.
Gelatin silver print
20.3 x 25.4 cm
The Andy Warhol Museum, Pittsburgh
Founding Collection, Contribution
The Andy Warhol Foundation for the
Visual Arts, Inc.
2001.2.652

309 [ill. p. 223]
Joan Jett and unidentified woman
n.d.
Gelatin silver print
20.3 x 25.4 cm
The Andy Warhol Museum, Pittsburgh
Founding Collection, Contribution
The Andy Warhol Foundation for the
Visual Arts, Inc.
2001.2.719

310 [ill. p. 223]
Joey Arias
n.d.
Gelatin silver print
20.3 x 25.4 cm
The Andy Warhol Museum, Pittsburgh
Founding Collection, Contribution
The Andy Warhol Foundation for the
Visual Arts, Inc.
2001.2.386

311
Lance Loud
n.d.
Gelatin silver print
20.3 x 25.4 cm
The Andy Warhol Museum, Pittsburgh
Founding Collection, Contribution
The Andy Warhol Foundation for the
Visual Arts, Inc.
2001.2.369

312
Lou Reed
n.d.
Gelatin silver print
20.3 x 25.4 cm
The Andy Warhol Museum, Pittsburgh
Founding Collection, Contribution
The Andy Warhol Foundation for the
Visual Arts, Inc.
2001.2.356

313
Lou Reed
n.d.
Gelatin silver print
20.3 x 25.4 cm
The Andy Warhol Museum, Pittsburgh
Founding Collection, Contribution
The Andy Warhol Foundation for the
Visual Arts, Inc.
2001.2.366

314 [ill. p. 223]
*Michael Monroe and Andy McCoy
of Hanoi Rocks*
n.d.
Gelatin silver print
20.3 x 25.4 cm
The Andy Warhol Museum, Pittsburgh
Founding Collection, Contribution
The Andy Warhol Foundation for the
Visual Arts, Inc.
2001.2.207

315
Mick Jagger
n.d.
Gelatin silver print
25.4 x 20.3 cm
The Andy Warhol Museum, Pittsburgh
Founding Collection, Contribution
The Andy Warhol Foundation for the
Visual Arts, Inc.
2001.2.347

316
Nick Rhodes
n.d.
Gelatin silver print
20.3 x 25.4 cm
The Andy Warhol Museum, Pittsburgh
Founding Collection, Contribution
The Andy Warhol Foundation for the
Visual Arts, Inc.
2001.2.432

317 [ill. p. 222]
Nick Rhodes
n.d.
Gelatin silver print
20.3 x 25.4 cm
The Andy Warhol Museum, Pittsburgh
Founding Collection, Contribution
The Andy Warhol Foundation for the
Visual Arts, Inc.
2001.2.433

318 [ill. p. 224]
Ozzy Osbourne
n.d.
Gelatin silver print
20.3 x 25.4 cm
The Andy Warhol Museum, Pittsburgh
Founding Collection, Contribution
The Andy Warhol Foundation for the
Visual Arts, Inc.
2001.2.422

319 [ill. p. 179, 272]
Self-portrait with Stevie Wonder
From "Little Red Book No. 43"
n.d.
Polaroid, facsimile
10.8 x 8.6 cm
The Andy Warhol Museum, Pittsburgh
Founding Collection, Contribution
The Andy Warhol Foundation for the
Visual Arts, Inc.
1998.1.2992.5

320 [ill. p. 218]
*Unidentified man, Ella Fitzgerald,
and Vincent Minnelli*
n.d.
Gelatin silver print
20.3 x 25.4 cm
The Andy Warhol Museum, Pittsburgh
Founding Collection, Contribution
The Andy Warhol Foundation for the
Visual Arts, Inc.
2001.2.201

321
*Unidentified man, John Sex,
and Keith Haring*
n.d.
Gelatin silver print
20.3 x 25.4 cm
The Andy Warhol Museum, Pittsburgh
Founding Collection, Contribution
The Andy Warhol Foundation for the
Visual Arts, Inc.
2001.2.209

SLIDES

322–369 [ill. p. 146]
Slides used in the light shows
at Warhol's **Exploding Plastic
Inevitable** events
1968
Acetate in printed cardboard mount
5.1 x 5.1 cm
The Andy Warhol Museum, Pittsburgh
Founding Collection, Contribution
The Andy Warhol Foundation for the
Visual Arts, Inc.

322
*Clear acetate with black grid
design with oval-shaped cut-out*
About 1967
T330

323
Blue acetate
About 1967
T347

324
*Blue-green acetate
with dot pattern*
About 1967
T349

325
*Blue-green acetate
with dot pattern*
About 1967
T350

326
*Blue-green acetate
with ten dots*
About 1967
T342

327
Blue-green acetate with ten dots
About 1967
T343

328
*Clear acetate with black
checkerboard pattern*
About 1967
T368

329
*Clear acetate with black
checkerboard pattern*
About 1967
T369

330
*Clear acetate with black
diagonal bars*
About 1967
T356

331
*Clear acetate with black
diamond grid*
About 1967
T361

332
*Clear acetate with black
diamond grid*
About 1967
T367

333
*Clear acetate with black
diamond mesh*
About 1967
T362

334
*Clear acetate with black
diamond mesh*
About 1967
T363

335
Clear acetate with black dot pattern
About 1967
T364

336
Clear acetate with black dot pattern
About 1967
T365

337
Clear acetate with black dot pattern
About 1967
T366

338
Clear acetate with black grid
About 1967
T359

339
Clear acetate with black grid
About 1967
T360

340
*Clear acetate with black
horizontal bars*
About 1967
T355

341
*Clear acetate with black
horizontal lines*
About 1967
T357

342
*Clear acetate with black
horizontal lines*
About 1967
T358

343 [ill. p. 148]
*Clear acetate with black
vertical bars*
About 1967
T353

344
*Clear acetate with small black
checkerboard pattern*
About 1967
T370

345
*Dark blue acetate with
diamond pattern*
About 1967
T348

346
Green acetate with fifteen dots
About 1967
T344

347
*Green acetate with
star-shaped cut-out*
About 1967
T328

348
*Multicoloured acetate with
heart-shaped cut-out*
About 1967
T324

349
Pink acetate with black knit pattern
About 1967
T352

350
*Pink acetate with
diamond-shaped cut-out*
About 1967
T327

351
Pink acetate with eight dots
About 1967
T339

352
Pink acetate with one dot
About 1967
T341

353
*Pink acetate with
oval-shaped cut-out*
About 1967
T325

354 [ill. p. 149]
Pink acetate with nine dots
About 1967
T338

355
Pink acetate with sixteen dots
About 1967
T337

356
Pink acetate with sixteen dots
About 1967
T340

357
*Pink acetate with
star-shaped cut-out*
About 1967
T326

358
*Purple acetate with
diamond-shaped cut-out*
About 1967
T329

359
Purple acetate with ten dots
About 1967
T345

360
*Red acetate with
black knit pattern*
About 1967
T351

361
Red acetate with eight dots
About 1967
T336

362
Red acetate with nine dots
About 1967
T334

363
Red acetate with nine dots
About 1967
T335

364
Red acetate with seven dots
About 1967
T333

365
Red and blue acetates with nine blue dots
About 1967
T346

366
Clear acetate with small black checkerboard pattern
About 1967
T371

367
Two clear acetates with black vertical bars
About 1967
T354

368
Black acetate in square-shaped mount
1968
T331

369
Black acetate in square-shaped mount
1968
T332

PUBLICATIONS

370 [ill. p. 66]
Cover design for the Carnegie Institute of Technology student magazine "Cano"
November 1948
22.9 x 15.4 cm
The Andy Warhol Museum, Pittsburgh
Founding Collection, Contribution
The Andy Warhol Foundation for the
Visual Arts, Inc.
1998.2.5

371
Theatre Arts—Vol. 33, no. 9 (October 1949)
Cover photograph by Richard Avedon;
Illustration by Warhol, p. 16
1949
28.9 x 21.6 cm
The Andy Warhol Museum, Pittsburgh
Founding Collection, Contribution
The Andy Warhol Foundation for the
Visual Arts, Inc.
T556

372
Dance Magazine—Vol. 29, no. 1 (January 1954)
Cover photograph of Giselle and
François Szony; illustrations by Warhol,
pp. 14, 16, and 75
1954
27.9 x 21.6 cm
The Andy Warhol Museum, Pittsburgh
Founding Collection, Contribution
The Andy Warhol Foundation for the
Visual Arts, Inc.
T559

373
Dance Magazine—Vol. 29, no. 5 (May 1954)
Cover photograph of Electa Arenal
and Jonathan Watts; illustrations by
Warhol, pp. 10, 23 and 37
1954
27.9 x 21.6 cm
The Andy Warhol Museum, Pittsburgh
Founding Collection, Contribution
The Andy Warhol Foundation for the
Visual Arts, Inc.
2000.2.3031

374
Dance Magazine—Vol. 29, no. 6 (June 1954)
Cover photograph of Jaunele Maya;
illustration by Warhol, p. 10
1954
27.9 x 21.6 cm
The Andy Warhol Museum, Pittsburgh
Founding Collection, Contribution
The Andy Warhol Foundation for the
Visual Arts, Inc.
2000.2.3035

375
Dance Magazine—Vol. 29, no. 8 (August 1954)
Cover photograph of Maggie Newman
and Helen Heinman by Jay Maisel; illus-
trations by Warhol, pp. 33, 38, and 61
1954
27.9 x 21.6 cm
The Andy Warhol Museum, Pittsburgh
Founding Collection, Contribution
The Andy Warhol Foundation for the
Visual Arts, Inc.
T555

376 [ill. p. 68]
Dance Magazine—Vol. 32, no. 1 (January 1958)
Cover design by Warhol
1958
27.9 x 21.6 cm
The Andy Warhol Museum, Pittsburgh
Founding Collection, Contribution
The Andy Warhol Foundation for the
Visual Arts, Inc.
1998.3.3730

377
Dance Magazine—Vol. 32, no. 9 (September 1958)
Illustrations by Warhol, pp. 34–36
1958
27.9 x 21.6 cm
The Andy Warhol Museum, Pittsburgh
Founding Collection, Contribution
The Andy Warhol Foundation for the
Visual Arts, Inc.
T560

378 [ill. p. 64]
Opera News—December 1, 1958
Cover design by Warhol
1958
25.3 x 17.4 cm
Collection Paul Maréchal

379
Opera News—December 1, 1958
Cover design by Warhol
1958
25.3 x 17.4 cm
The Andy Warhol Museum, Pittsburgh
Founding Collection, Contribution
The Andy Warhol Foundation for the
Visual Arts, Inc.
1998.3.4079

380 [ill. p. 64]
Sheet music:
A Hand of Bridge: For Four Solo Voices and Chamber Orchestra
Music by Samuel Barber; text by
Gian Carlo Menotti;
Cover by Warhol; lettering by
Julia Warhola
1960
Offset lithograph
30.2 x 22.9 cm
The Andy Warhol Museum, Pittsburgh
Founding Collection, Contribution
The Andy Warhol Foundation for the
Visual Arts, Inc.
1998.3.3620; 3679; 4226

381
Aspen—Vol. 1, no. 3 (December 1966)
Issue designed by Warhol and
David Dalton
Roaring Fork Press, New York
1966
Hinged box containing various items
(folder containing 3 press kit texts and
a flex disc; a Christmas card; 12 cards
reproducing artworks by Pop artists;
a flip book, a ticket book; an under-
ground newspaper; advertisements)
24.1 x 31.8 x 2 cm
Collection Paul Maréchal

382 [ill. p. 167]
Andy Warhol's Index (Book)
With the assistance of Stephen Shore,
Paul Morrissey, Ondine, Nico,
Christopher Cerg, Alan Rinzler,
Gerald Harrison, Akihito Shirakawa,
David Paul, Nat Finkelstein,
and Billy Name
Random House, New York
1967 (first run)
Offset lithograph and lenticular photo-
graphy inside buckram board cover
28.6 x 22.2 x 1.6 cm
Collection Paul Maréchal

383 [ill. p. 181]
Inter/VIEW—Vol. 1, no. 2 (1969)
Cover photograph of Mick Jagger in
Performance by Cecil Beaton
1969
41.9 x 29.5 cm
The Andy Warhol Museum, Pittsburgh
Founding Collection, Contribution
The Andy Warhol Foundation for the
Visual Arts, Inc.
1998.3.11251

384
Inter/VIEW—Vol. 1, no. 6 (1970)
Cover photograph of exotic dancer
Donna Mae Roberts in *Footlight Parade*;
full-page advertisement for the
world premiere on March 26 of
Woodstock the Movie
1970
42.5 x 29.8 cm
The Andy Warhol Museum, Pittsburgh
Founding Collection, Contribution
The Andy Warhol Foundation for the
Visual Arts, Inc.
1998.3.14809

385 [ill. p. 180]
Inter/VIEW—Vol. 1, no. 7 (1970)
Cover photograph of Mick Jagger in
Jean-Luc Godard's *Sympathy for the
Devil*; photograph on back cover of
Richard Harris in *A Man Called Horse*
1970
42.5 x 29.8 cm
The Andy Warhol Museum, Pittsburgh
Founding Collection, Contribution
The Andy Warhol Foundation for the
Visual Arts, Inc.
1998.3.14815

386 [ill. p. 180]
Inter/VIEW—Vol. 1, no. 8 (1970)
Cover photograph of Mick Jagger in
Ned Kelly; photograph on back cover
of Don Johnson in *The Magic Garden
of Stanley Sweetheart*
1970
42.5 x 29.2 cm
The Andy Warhol Museum, Pittsburgh
Founding Collection, Contribution
The Andy Warhol Foundation for the
Visual Arts, Inc.
1998.3.148.14

387 [ill. p. 180]
Inter/VIEW—Vol. 1, no. 12 (1970)
"Special Elvis Issue" with photographs
of Elvis Presley on the front and
back covers
1970
42.4 x 29.2 cm
The Andy Warhol Museum, Pittsburgh
Founding Collection, Contribution
The Andy Warhol Foundation for the
Visual Arts, Inc.
1998.3.2470.1

388 [ill. p. 181]
Interview—No. 22 (June 1972)
Colour Polaroid photographs of
John Lennon, Yoko Ono, and
Rudolf Noureïev by Warhol;
cover design by Richard Bernstein
1972
41 x 29.5 cm
The Andy Warhol Museum, Pittsburgh
Founding Collection, Contribution
The Andy Warhol Foundation for the
Visual Arts, Inc.
1998.3.1689.1

389 [ill. p. 180]
Interview—No. 24 (August 1972)
Cover photograph of Liza Minnelli
by Berry Berenson; cover design by
Richard Bernstein; full-size colour
photograph of Shirley Temple on the
back cover
1972
41.9 x 30.8 cm
The Andy Warhol Museum, Pittsburgh
Founding Collection, Contribution
The Andy Warhol Foundation for the
Visual Arts, Inc.
1998.3.2476.1

390
Interview—Vol. 4, no. 8 (September 1974)
Cover photographs of John Phillips
and Geneviève Waite by Bill King;
cover design by Richard Bernstein;
photograph of 1950s supermodel
Dovima by Richard Avedon on
the back cover
1974
38.7 x 29.8 cm
The Andy Warhol Museum, Pittsburgh
Founding Collection, Contribution
The Andy Warhol Foundation for the
Visual Arts, Inc.
1998.3.2494.1

391 [ill. p. 180]
Interview—Vol. 4, no. 12 (December 1974)
Cover photograph of Cher by Bill King;
cover design by Richard Bernstein
1974
38.7 x 29.8 cm
The Andy Warhol Museum, Pittsburgh
Founding Collection, Contribution
The Andy Warhol Foundation for the
Visual Arts, Inc.
1998.3.2550.1

392 [ill. p. 180]
Interview—Vol. 6, no. 9 (September 1976)
Cover photograph of Diana Ross by
Chris von Wangenheim; cover design
by Richard Bernstein
1976
39.4 x 29.8 cm
The Andy Warhol Museum, Pittsburgh
Founding Collection, Contribution
The Andy Warhol Foundation for the
Visual Arts, Inc.
1998.3.2562.1

393 [ill. p. 181]
Interview—Vol. 7, no. 12 (December 1977)
Cover photograph of Mick Jagger
as Santa Claus with Iman and
Paul von Ravenstein by Ara Gallant;
cover design by Richard Bernstein
1977
38.7 x 29.8 cm
The Andy Warhol Museum, Pittsburgh
Founding Collection, Contribution
The Andy Warhol Foundation for the
Visual Arts, Inc.
1998.3.2623

394
The Rolling Stones on Tour (1975 US Tour)
Foreword by Mick Jagger; photographs
by Annie Leibovitz and Christopher
Sykes; text by Terry Southern; photo-
graphs and artwork by Warhol on pp.
18–19
Dragon's Dream, Paris
June 1978 (first edition)
30.5 x 30.2 x 1 cm
The Andy Warhol Museum, Pittsburgh
Founding Collection, Contribution
The Andy Warhol Foundation for the
Visual Arts, Inc.
TC217.1

395
Andy Warhol's Exposures
photographs by Warhol;
text by Warhol with Bob Colacello
Grossett & Dunlop, New York
1979 (first printings)
29.2 x 24.1 x 2.5 cm
The Andy Warhol Museum, Pittsburgh
Founding Collection, Contribution
The Andy Warhol Foundation for the
Visual Arts, Inc.
Three copies: 1998.3.2462.1a-b;
1998.3.2462.2a-b; 1998.3.2462.3a-b

396 [ill. p. 182]
Interview—Vol. 9, no. 2 (February 1979)
Cover photograph of Steve Rubell
by Barry McKinley; cover design by
Richard Bernstein
1979
42.2 x 28.3 cm
The Andy Warhol Museum, Pittsburgh
Founding Collection, Contribution
The Andy Warhol Foundation for the
Visual Arts, Inc.
1998.3.14806

397 [ill. p. 182]
Interview—Vol. 9, no. 6 (June 1979)
Cover photograph of Debbie Harry
by Barry McKinley; cover design by
Richard Bernstein
1979
42.5 x 28.3 cm
The Andy Warhol Museum, Pittsburgh
Founding Collection, Contribution
The Andy Warhol Foundation for the
Visual Arts, Inc.
1998.3.2592

398 [ill. p. 182]
Interview—Vol. 9, no. 9 (September 1979)
Cover photograph of Liza Minnelli
by Clive Arrowsmith; cover design
by Richard Bernstein
1979
42.5 x 27.9 cm
The Andy Warhol Museum, Pittsburgh
Founding Collection, Contribution
The Andy Warhol Foundation for the
Visual Arts, Inc.
1998.3.14807

399 [ill. p. 182]
Interview—Vol. 11, no. 8 (August 1981)
Cover photograph of Mick Jagger by Peter Strongwater; cover design by Richard Bernstein
1981
42.9 x 27.6 cm
The Andy Warhol Museum, Pittsburgh; Gift of Mark. W. Van Sweringen
1999.5.5

400 [ill. p. 182]
Interview—Vol. 11, no. 10 (October 1981)
Cover photograph of Diana Ross by Peter Strongwater; cover design by Richard Bernstein
1981
43.2 x 27.9 cm
The Andy Warhol Museum, Pittsburgh
Founding Collection, Contribution
The Andy Warhol Foundation for the Visual Arts, Inc.
1998.3.2646

401 [ill. p. 182]
Interview—Vol. 12, no. 5 (May 1982)
Cover photograph of Cher by Peter Strongwater, cover design by Richard Bernstein
1982
43.2 x 27.6 cm
The Andy Warhol Museum, Pittsburgh
Founding Collection, Contribution
The Andy Warhol Foundation for the Visual Arts, Inc.
1988.3.14808

402 [ill. p. 182]
Interview—Vol. 12, no. 10 (October 1982)
Cover photograph of Michael Jackson by Matthew Rolston; cover design by Richard Bernstein
1982
43.2 x 27.6 cm
The Andy Warhol Museum, Pittsburgh
Gift of Mark. W. Van Sweringen
1999.5.13

403 [ill. p. 182]
Interview—Vol. 13, no. 1 (January 1983)
Cover photograph of Sting by Peter Strongwater; cover design by Richard Bernstein; illustrated article on Rainer Werner Fassbinder and *Querelle* by Bob Colacello ("Dieter Schidor," 49–51)
1983
43.2 x 27.6 cm
The Andy Warhol Museum, Pittsburgh
Founding Collection, Contribution
The Andy Warhol Foundation for the Visual Arts, Inc.
1998.3.2611

404
Interview—Vol. 14, no. 7 (July 1984)
Cover portrait of Dolly Parton by Robert Risko
1984
43.2 x 27.6 cm
The Andy Warhol Museum, Pittsburgh
Founding Collection, Contribution
The Andy Warhol Foundation for the Visual Arts, Inc.
1998.3.14810

405 [ill. p. 182]
Interview—Vol. 15, no. 1 (January 1985)
Cover photograph of Yoko Ono by Albert Watson; cover design by Richard Bernstein
1985
43.2 x 27.9 cm
The Andy Warhol Museum, Pittsburgh
Founding Collection, Contribution
The Andy Warhol Foundation for the Visual Arts, Inc.
1998.3.11151

406 [ill. p. 170]
Interview—Vol. 15, no. 2 (February 1985)
Cover photograph of Mick Jagger by Albert Watson; cover design by Richard Bernstein
1985
43.2 x 27.6 cm
The Andy Warhol Museum, Pittsburgh
Museum Purchase
2001.4.2

407 [ill. p. 182]
Interview—Vol. 15, no. 5 (May 1985)
Cover photograph of Annie Lennox by Bradford Branson; cover design by Richard Bernstein
1985
43.5 x 27.8 cm
The Andy Warhol Museum, Pittsburgh
Founding Collection, Contribution
The Andy Warhol Foundation for the Visual Arts, Inc.
1998.3.14813

408 [ill. p. 182]
Interview—Vol. 15, no. 11 (November 1985)
Cover photograph of Nick Rhodes by Albert Watson; cover design by Richard Bernstein
1985
43.2 x 27.6 cm
The Andy Warhol Museum, Pittsburgh
Founding Collection, Contribution
The Andy Warhol Foundation for the Visual Arts, Inc.
1998.3.14812

409 [ill. p. 183]
Interview—Vol. 15, no. 12 (December 1985)
Cover photograph of Madonna by Herb Ritts; cover design by Richard Bernstein
1985
43.2 x 27.6 cm
The Andy Warhol Museum, Pittsburgh
Founding Collection, Contribution
The Andy Warhol Foundation for the Visual Arts, Inc.
1998.3.14811

410 [ill. p. 172]
File, Art & Text—No. 25 (1986)
Cover portrait of Sid Vicious by Warhol
Special issue "Sex, Drugs, Rock 'n' Roll"
1986
36 x 28 cm
The Montreal Museum of Fine Arts
Library Collection

411 [ill. p. 182]
Interview—Vol. 16, no. 4 (April 1986)
Cover photograph of Cyndi Lauper by Matthew Rolston; cover design by Richard Bernstein
1986
42.9 x 27.9 cm
The Andy Warhol Museum, Pittsburgh
Gift of Mark. W. Van Sweringen
1999.5.24

VARIA: PHOTOGRAPHS

CYRUS ANDREWS
412 [ill. p. 172]
The Rolling Stones posing outdoors on a bench
From left to right: Bill Wyman, Mick Jagger, Keith Richards, Brian Jones, and Charlie Watts on the ground
About 1964
Gelatin silver print
26 x 20.3 cm
The Andy Warhol Museum, Pittsburgh
Founding Collection, Contribution
The Andy Warhol Foundation for the Visual Arts, Inc.
"Time Capsule 57"—TC57.2

ANONYMOUS
413
Bill Wyman, Keith Richards, Mick Jagger, Charlie Watts, and Brian Jones (The Rolling Stones)
London Records publicity photo with handwritten label
1964
Gelatin silver print with felt-tip ink on label
23.5 x 25.4 cm
The Andy Warhol Museum, Pittsburgh
Founding Collection, Contribution
The Andy Warhol Foundation for the Visual Arts, Inc.
"Time Capsule - 10"—TC-10.13

ANONYMOUS
414 [ill. p. 193]
Andy Warhol holding a 1964 publicity photograph of the Rolling Stones
1969
Gelatin silver print
20 x 21.3 cm
The Andy Warhol Museum, Pittsburgh
Founding Collection, Contribution
The Andy Warhol Foundation for the Visual Arts, Inc.
T553

NAT FINKELSTEIN
415
Danny Williams, Andy Warhol, Lou Reed, Sterling Morrison, John Cale, Edie Sedgwick, Gerard Malanga, and others seated on a couch at Panna Grady's apartment, Dakota Building, New York
Probably during the time Warhol was filming *Lupe*
1965
Gelatin silver print
23.8 x 34.9 cm
The Andy Warhol Museum, Pittsburgh
Founding Collection, Contribution
The Andy Warhol Foundation for the Visual Arts, Inc.
1998.3.2753

—
416
Banner outside the Dom, St. Mark's Place, New York, for Warhol's Exploding Plastic Inevitable with the Velvet Underground
1966, reprint 1996
Gelatin silver print
18.1 x 24.4 cm
The Andy Warhol Museum, Pittsburgh
Museum Purchase
1996.9.39

417 [ill. p. 153]
Gerard Malanga, Mary Woronov, Andy Warhol, and the Velvet Underground, 1966
1966, reprint 1966
Gelatin silver print
18.3 x 24.3 cm
The Andy Warhol Museum, Pittsburgh
Museum Purchase
1996.9.45

—
418 [ill. p. 162]
Lou Reed, Paul Morrissey, Nico and three unidentified men listening to playback of "All Tomorrow's Parties" at Capitol Studios, Los Angeles
1966, reprint 1966
Gelatin silver print
17.8 x 23.8 cm
The Andy Warhol Museum, Pittsburgh
Museum Purchase
1996.9.36

419
Moe [Maureen] Tucker carrying drums outside tour van
1966, reprint 1966
Gelatin silver print
24.1 x 18.1 cm
The Andy Warhol Museum, Pittsburgh
Museum Purchase
1996.9.47

—
420
Sterling Morrison, John Cale, Nico, Lou Reed, and unidentified person listening to playback of "All Tomorrow's Parties" at Capitol Studios, Los Angeles
1966, reprint 1966
Gelatin silver print
17.8 x 23.8 cm
The Andy Warhol Museum, Pittsburgh
Museum Purchase
1996.9.37

421 [ill. end sheets, p. 272]
Andy double tambourine
About 1966
Gelatin silver print
Photo Nat Finkelstein

422
Gerard Malanga, Nico, Donovan, Barbara Rubin, John Cale, Danny Williams, Sterling Morrison, Paul Morrissey, Andy Warhol, Lou Reed, and Moe [Maureen] Tucker at the Silver Factory
1966–67, reprint 1966
Gelatin silver print
18.1 x 24.3 cm
The Andy Warhol Museum, Pittsburgh
Museum Purchase
1996.9.48

BILLY NAME
423
The Dom, 23 St. Mark's Place, New York, exterior shot at night, with "Andy Warhol" [Exploding Plastic Inevitable] advertised on the marquee
1966
Gelatin silver print
20.5 x 25.2 cm
The Andy Warhol Museum, Pittsburgh
Founding Collection, Contribution
The Andy Warhol Foundation for the Visual Arts, Inc.
2000.2.1733

—
424
Ondine and Ingrid Superstar performing in "The Chelsea Girls"
1966
Gelatin silver print, felt-tip ink
23.7 x 17.6 cm
The Andy Warhol Museum, Pittsburgh
Founding Collection, Contribution
The Andy Warhol Foundation for the Visual Arts, Inc.
T320

425 [ill. p. 156]
The Velvet Underground and Nico at the Dom, St. Mark's Place, New York
1966, reprint 1996
Gelatin silver print
27.9 x 35.6 cm
The Andy Warhol Museum, Pittsburgh
Museum Purchase
1996.9.61.1

—
426 [ill. p. 157]
The Velvet Underground and Nico at the Dom, St. Mark's Place, New York
1966, reprint 1996
Gelatin silver print
27.9 x 35.6 cm
The Andy Warhol Museum, Pittsburgh
Museum Purchase
1996.9.61.2

—
427
Andy Warhol at the Silver Factory with various works in progress, including "Banana" prints and "Self-portrait" paintings
1966–67, reprint 1996
Gelatin silver print
35.6 x 27.9 cm
The Andy Warhol Museum, Pittsburgh
Museum Purchase
1996.9.59

428
Andy Warhol at the Silver Factory with various works in progress, including "Kellogg's Corn Flakes" and "Banana"
1966–67, reprint 1996
Gelatin silver print
35.6 x 27.9 cm
The Andy Warhol Museum, Pittsburgh
Museum Purchase
1996.9.60

429
Andy Warhol at the Silver Factory working on the "Banana" series
1966–67, reprint 1996
Gelatin silver print
35.6 x 27.9 cm
The Andy Warhol Museum, Pittsburgh
Museum Purchase
1996.9.53

430 [ill. p. 153]
Moe [Maureen] Tucker, Lou Reed, Nico, Sterling Morrison, and John Cale (The Velvet Underground and Nico)
1966–67
Gelatin silver print
20.6 x 25.4 cm
The Andy Warhol Museum, Pittsburgh
Founding Collection, Contribution
The Andy Warhol Foundation for the Visual Arts, Inc.
1998.3.4987

431
Ondine and Ingrid Superstar
1966–67
Gelatin silver print, felt-tip ink
17.9 x 12.1 cm
The Andy Warhol Museum, Pittsburgh
Founding Collection, Contribution
The Andy Warhol Foundation for the
Visual Arts, Inc.
T321

432
Psychedelic car, New York
1966–67
Gelatin silver print
16.2 x 24 cm
The Andy Warhol Museum, Pittsburgh
Founding Collection, Contribution
The Andy Warhol Foundation for the
Visual Arts, Inc.
T322

433 [ill. p. 155]
*The Velvet Underground at
the Gymnasium, New York*
1967, reprint 1996
Gelatin silver print
27.9 x 35.6 cm
The Andy Warhol Museum, Pittsburgh
Museum Purchase
1996.9.70.1

434 [ill. p. 22]
*The Velvet Underground at
the Trauma, Philadelphia*
1967, reprint 1996
Gelatin silver print
27.9 x 35.6 cm
The Andy Warhol Museum, Pittsburgh
Museum Purchase
1996.9.68

435 [ill. p. 153]
*Sterling Morrison, Lou Reed, Nico,
John Cale, and Moe [Maureen] Tucker
(The Velvet Underground and Nico)*
About 1967
Gelatin silver print
19.1 x 11.4 cm
The Andy Warhol Museum, Pittsburgh
Founding Collection, Contribution
The Andy Warhol Foundation for the
Visual Arts, Inc.
1998.3.14775

436
*Sterling Morrison, Lou Reed, Nico,
John Cale, and Moe [Maureen] Tucker
(The Velvet Underground and Nico)*
About 1967
Gelatin silver print
19.7 x 11.4 cm
The Andy Warhol Museum, Pittsburgh
Founding Collection, Contribution
The Andy Warhol Foundation for the
Visual Arts, Inc.
1998.3.14816

RICHARD RUTLEDGE
437 [ill. p. 98]
*Contact sheet. Merce Cunningham
dancing "Antic Meet"*
1958
Gelatin silver print
25.4 x 20.3 cm
The Andy Warhol Museum, Pittsburgh
Founding Collection, Contribution
The Andy Warhol Foundation for the
Visual Arts, Inc.
1998.3.5004

438 [ill. p. 98]
*Contact sheet. Merce Cunningham
dancing "Antic Meet"*
1958
Gelatin silver print
25.4 x 20.3 cm
The Andy Warhol Museum, Pittsburgh
Founding Collection, Contribution
The Andy Warhol Foundation for the
Visual Arts, Inc.
1998.3.5005

STEVE SCHAPIRO
439 [ill. p. 141, 272]
*Mary Woronov, Gerard Malanga,
the Velvet Underground, Nico,
and Warhol, Los Angeles*
1966, reprint 2008
Gelatin silver print
40.6 x 50.8 cm
Collection of Steve Schapiro

440
*Nico, Moe [Maureen] Tucker, Sterling
Morrison, Lou Reed, and John Cale
(The Velvet Underground and Nico)*
1966
Gelatin silver print
17.1 x 24.8 cm
The Andy Warhol Museum, Pittsburgh
Founding Collection, Contribution
The Andy Warhol Foundation for the
Visual Arts, Inc.
T554

441 [ill. p. 153]
*Nico, Warhol, and the
Velvet Underground, Los Angeles*
1966, reprint 2008
Gelatin silver print
40.6 x 50.8 cm
Collection of Steve Schapiro

STEPHEN SHORE
442 [ill. p. 112]
Bathroom wall
1965–67
b/w photograph
32.4 x 48.3 cm
Courtesy of 303 Gallery, New York
SS853

443
*Donald Lyons, Edie Sedgwick,
Dorothy Dean, Chuck Wein,
unidentified guests*
1965–67
b/w photograph
32.4 x 48.3 cm
Courtesy of 303 Gallery, New York
SS856

444
*Donald Lyons, Edie Sedgwick,
Genevieve Charbon Cerf*
1965–67
b/w photograph
32.4 x 48.3 cm
Courtesy of 303 Gallery, New York
SS855

445
*Edie Sedgwick, Andy Warhol,
unidentified guests*
1965–67
b/w photograph
32.4 x 48.3 cm
Courtesy of 303 Gallery, New York
SS852

446
Factory Entrance
1965–67
b/w photograph
32.4 x 48.3 cm
Courtesy of 303 Gallery, New York
SS854

447 [ill. p. 144]
John Cale
1965–67
b/w photograph
48.3 x 32.4 cm
Courtesy of 303 Gallery, New York
SS859

448 [ill. p. 144]
*John Cale, Lou Reed,
Sterling Morrison*
1965–67
b/w photograph
32.4 x 48.3 cm
Courtesy of 303 Gallery, New York
SS708

449 [ill. p. 144]
John Cale, Sterling Morrison
1965–67
b/w photograph
32.4 x 48.3 cm
Courtesy of 303 Gallery, New York
SS860

450 [ill. p. 144]
Lou Reed, John Cale
1965–67
b/w photograph
32.4 x 48.3 cm
Courtesy of 303 Gallery, New York
SS861

451 [ill. p. 144]
Nico
1965–67
b/w photograph
32.4 x 48.3 cm
Courtesy of 303 Gallery, New York
SS858

452 [ill. p. 144]
*Sterling Morrison, John Cale,
Lou Reed*
1965–67
b/w photograph
32.4 x 48.3 cm
Courtesy of 303 Gallery, New York
SS857

453
*Sterling Morrison, John Cale,
and Lou Reed*
About 1967
Gelatin silver print
12.7 x 20.3 cm
The Andy Warhol Museum, Pittsburgh
Founding Collection, Contribution
The Andy Warhol Foundation for the
Visual Arts, Inc.
1998.3.14537

VARIA: PRESS CLIPPINGS

454
*KRLA Beat—Vol. 2, no. 11
(May 28, 1965)*
Includes a full-page photomontage,
"A Happening!", p. 13, regarding
the Velvet Underground and Nico at
the Trip, Hollywood; photographs by
Howard L. Bingham of Gerard Malanga,
Nico, Ryan O'Neil, John Phillips, and
others dancing at the event
1965
39.4 x 29.5 cm
The Andy Warhol Museum, Pittsburgh
Founding Collection, Contribution
The Andy Warhol Foundation for the
Visual Arts, Inc.
"Time Capsule 85"—TC85.150

455
*Newspaper article: "Non-stop
Horror Show: Warhol's Brutal
Assemblage"(By Michaela Williams,
"Chicago Daily News," Wednesday,
June 22, 1966, p. 34)*
About the Exploding Plastic Inevitable
show at Poor Richard's, Chicago,
June 21, 1966, in which Warhol was a
no-show, being "up tight" with nerves
1966
21 x 38.1 cm
The Andy Warhol Museum, Pittsburgh
Founding Collection, Contribution
The Andy Warhol Foundation for the
Visual Arts, Inc.
"Time Capsule 7"—TC7.36.1

456
*Newspaper article: "Rebellion in
the Arts" (By Jerry Tallmer, "New
York Post," August 5, 1966, p. 33)*
About mixed-media art, environments,
and "Be-ins," using the Exploding
Plastic Inevitable show at the Dom,
St. Mark's Place, New York, as an
example of a mixed-media happening;
with social commentary by
Allen Ginsberg and John Cage
1966
38.4 x 27.9 cm
The Andy Warhol Museum, Pittsburgh
Founding Collection, Contribution
The Andy Warhol Foundation for the
Visual Arts, Inc.
"Time Capsule 37"—TC37.76

457
*Newspaper article:"The Velvet
Underground" (By Susan Pile,
"Barnard Bulletin: Notes from the
Underground," November 29, 1967)*
1967
44.8 x 28.9 cm
The Andy Warhol Museum, Pittsburgh
Founding Collection, Contribution
The Andy Warhol Foundation for the
Visual Arts, Inc.
"Time Capsule 40"—TC40.11

458 [ill. p. 171]
*Magazine illustration: Stuart
Kaufman's "The Emergence
of Andy Warhol"(Illustrating
the article "The Party's Over,"
by Gay Talese, "Esquire Magazine,"
December 1967, p. 49)*
Painting of the Rolling Stones,
Baby Jane Holzer, and Warhol,
at the Gymnasium, New York
From "Small Scrapbook No. 3"
1967
33.7 x 26 cm
The Andy Warhol Museum, Pittsburgh
Founding Collection, Contribution
The Andy Warhol Foundation for the
Visual Arts, Inc.
T577

459
*Advertisement for the
Rolling Stones' "Sticky Fingers"
album, showing the band posing
with Warhol's cover design*
1971
75.9 x 101.3 cm
The Andy Warhol Museum, Pittsburgh
Founding Collection, Contribution
The Andy Warhol Foundation for the
Visual Arts, Inc.
"Time Capsule 82"—TC82.71

460
*Newspaper article: "The Trade Prizes
Prize for Record Jacket Art"
(By Ernest Leogrande, New York's
"Daily News," March 14, 1972)*
About the Grammy award nominees
for best album cover design, including
the Rolling Stones' "Sticky Fingers"
by Warhol
1972
38.1 x 27.9 cm
The Andy Warhol Museum, Pittsburgh
Founding Collection, Contribution
The Andy Warhol Foundation for the
Visual Arts, Inc.
"Time Capsule 42"—TC42.23

VARIA: OTHER ITEMS

461
Lou Reed's Gretsch Guitar
2-tone Cadillac Cruiser created
in celebration of Gretsch's
75th anniversary
1958
2-tone green finish
64.8 cm (length)
Stewart Hurwood

462
*Silver trunk from the basement
of the Silver Factory building*
Painted by Billy Name in 1964
67.9 x 102.9 x 62.2 cm
The Andy Warhol Museum, Pittsburgh
Founding Collection, Contribution
The Andy Warhol Foundation for the
Visual Arts, Inc.
T579

463
*Norelco audio cassette recorder
used for "a: A Novel"*
1965
5.4 x 19.7 x 11.5 cm
The Andy Warhol Museum, Pittsburgh
Founding Collection, Contribution
The Andy Warhol Foundation for the
Visual Arts, Inc.
T499
a: A Novel consists of transcribed tape
recordings by Warhol, focusing
on superstar Ondine (Bob Olivo).
Warhol's intention was to record
24 hours, but it is now believed that
the recordings were made between
July 1965 and 1967

464
Contract between MGM Records and members of the Velvet Underground and Nico, dated May 2, 1966
Includes statements naming the band as sole owner of 12 master recordings, and detailing services, terms, and conditions as to the delivery and use of said masters to MGM; signed by all members of the band, and Nico
1966
27.9 x 21.6 cm
The Andy Warhol Museum, Pittsburgh
Founding Collection, Contribution
The Andy Warhol Foundation for the Visual Arts, Inc.
"Time Capsule 11"—TC11.10.2

465
Contract between MGM Records and members of the Velvet Underground and Nico, regardrg production services for May 2, 1966—May 1, 1967
Includes agreement to record a minimum of 6 forty-fives, and detailing other services, terms, and conditions outlined by MGM; signed by all members of the band, and Nico
1966
27.9 x 21.6 cm
The Andy Warhol Museum, Pittsburgh
Founding Collection, Contribution
The Andy Warhol Foundation for the Visual Arts, Inc.
"Time Capsule 11"—TC11.10.1

466
Contract between American Federation of Musicians and Lou Reed (The Velvet Underground) and Eric Kelley, Williams College, Williamstown, Massachusetts, dated December 2, 1966
Contract rider outlines
Exploding Plastic Inevitable
production requirements
1966
27.9 x 21.6 cm
The Andy Warhol Museum, Pittsburgh
Founding Collection, Contribution
The Andy Warhol Foundation for the Visual Arts, Inc.
"Time Capsule 11"—TC11.16a-b

467
Contract between American Federation of Musicians and Lou Reed (The Velvet Underground) and Roy Fuchs, Phi Epsilon Pi Fraternity, Tufts University, Medford, Massachusetts, dated December 2, 1966
Contract rider outlines
Exploding Plastic Inevitable
production requirements
1966
27.9 x 21.6 cm
The Andy Warhol Museum, Pittsburgh
Founding Collection, Contribution
The Andy Warhol Foundation for the Visual Arts, Inc.
"Time Capsule 11"—TC11.15a-b

468 [ill. p. 166]
Publicity for the Velvet Underground and Nico—MGM/Verve
1966
Gelatin silver print and felt-tip ink on cardboard
76.2 x 101.6 cm
The Andy Warhol Museum, Pittsburgh
Museum Loan, Sterling Morrison
Archives, Collection of Martha Morrison
L1996.1.16

469
Sterling Morrison's Fender Stratocaster with original case
1966
64.8 cm (length)
Collection of Martha Morrison
Courtesy of the Rock and Roll Hall of Fame and Museum, Cleveland, Ohio
L2006.38.5a-b

470
Press release written by William Kermit Smith for the Exploding Plastic Inevitable with the Velvet Underground and Nico, at Steve Paul's the Scene, New York, January 2–14, 1967
1966–67
27.9 x 21.6 cm
The Andy Warhol Museum, Pittsburgh
Founding Collection, Contribution
The Andy Warhol Foundation for the Visual Arts, Inc.
T561.1-T561.3

471
Stroboscope (Model 963) used by Warhol and the Velvet Underground in the Exploding Plastic Inevitable stage show
About 1966–67
27.3 x 18.4 x 15.2 cm
The Andy Warhol Museum, Pittsburgh
Founding Collection, Contribution
The Andy Warhol Foundation for the Visual Arts, Inc.
1998.3.2019

472 [ill. p. 143]
Lou Reed's handwritten music and lyrics for "I'm Waiting for the Man" (on the 1967 album "The Velvet Underground & Nico")
1967
34.3 x 26.7 cm
The Andy Warhol Museum, Pittsburgh
Founding Collection, Contribution
The Andy Warhol Foundation for the Visual Arts, Inc.
"Time Capsule 40"—TC40.31.5

473
Lou Reed's handwritten music and lyrics for "Wrap Your Troubles in Dreams" (on the 1967 album "The Velvet Underground & Nico")
1967
34.3 x 26.7 cm
The Andy Warhol Museum, Pittsburgh
Founding Collection, Contribution
The Andy Warhol Foundation for the Visual Arts, Inc.
"Time Capsule 40"—TC40.31.9

474
Lou Reed and John Cale's handwritten music and lyrics for "Little Sister" (on the 1967 album "The Velvet Underground & Nico")
1967
34.3 x 26.7 cm
The Andy Warhol Museum, Pittsburgh
Founding Collection, Contribution
The Andy Warhol Foundation for the Visual Arts, Inc.
"Time Capsule 40"—TC40.31.6

475 [ill. p. 165]
Three unused "Banana" stickers
Part of Warhol's design for
"The Velvet Underground & Nico"
record cover (1967)
About 1967
Relief print
33.3 x 32.4 cm
The Andy Warhol Museum, Pittsburgh
Gift of David Herrera
1996.14

476
VIP backstage pass for the Rolling Stones' American Tour, Madison Square Garden, New York, July 24, 1972
Image of a small car driving off a pier
1972
6.4 cm (diam.)
The Andy Warhol Museum, Pittsburgh
Founding Collection, Contribution
The Andy Warhol Foundation for the Visual Arts, Inc.
"Time Capsule 38"—TC38.171.1

477
Two VIP backstage passes for the Rolling Stones' American Tour, Madison Square Garden, New York, July 25, 1972
Image of an ocean liner
1972
6.4 cm (diam.)
The Andy Warhol Museum, Pittsburgh
Founding Collection, Contribution
The Andy Warhol Foundation for the Visual Arts, Inc.
"Time Capsule 38"—TC38.171.2.1—2

478
VIP backstage pass for the Rolling Stones' American Tour, Madison Square Garden, New York, July 25, 1972
Image of an Air France Concord
1972
6.4 cm (diam.)
The Andy Warhol Museum, Pittsburgh
Founding Collection, Contribution
The Andy Warhol Foundation for the Visual Arts, Inc.
"Time Capsule 38"—TC38.171.3

479
VIP backstage pass for the Rolling Stones' American Tour, Madison Square Garden, New York, July 26, 1972
Image of stones rolling down a hillside
1972
6.4 cm (diam.)
The Andy Warhol Museum, Pittsburgh
Founding Collection, Contribution
The Andy Warhol Foundation for the Visual Arts, Inc.
"Time Capsule 38"—TC38.171.4

480
Warhol's backstage pass for the Rolling Stones' American Tour, Madison Square Garden, New York, June 22, 1975
Signed by Bianca Jagger
1972
8.9 x 13 cm
The Andy Warhol Museum, Pittsburgh
Founding Collection, Contribution
The Andy Warhol Foundation for the Visual Arts, Inc.
"Time Capsule 105"—TC105.1

481
The Rolling Stones' "Love You Live" T-shirt designed with photographs by Warhol
1977
Printed cotton
59.7 x 64.8 cm
The Andy Warhol Museum, Pittsburgh
Founding Collection, Contribution
The Andy Warhol Foundation for the Visual Arts, Inc.
"Time Capsule 279"—TC279.1

482
Wig (Silver and Brown)
Worn by Warhol in the 1980s; also worn by David Bowie in the 1996 film *Basquiat*
1980s
Natural and synthetic hair on dyed cloth
48.3 x 40.6 x 3.8 cm (flat)
Manufactured by Paul Bochicchio Inc., New York
The Andy Warhol Museum, Pittsburgh
Founding Collection, Contribution
The Andy Warhol Foundation for the Visual Arts, Inc.
1998.3.6158.1

ITEMS IN WARHOL'S POSSES-SION

RECORDS

483 [ill. p. 188]
Giacomo Puccini
La Bohème, Vol. 1
The Chorus and Orchestra of the Metropolitan Opera Association
Giuseppe Antonicelli, conductor
Columbia Masterworks, 1949
The Andy Warhol Museum, Pittsburgh
Founding Collection, Contribution
The Andy Warhol Foundation for the Visual Arts, Inc.
"Time Capsule 31"—TC31.136a-b

484
Richard Rodgers, music, and
Lorenz Hart, lyrics
Pal Joey
Columbia Masterworks, 1950
The Andy Warhol Museum, Pittsburgh
Founding Collection, Contribution
The Andy Warhol Foundation for the Visual Arts, Inc.
"Time Capsule 31"—TC31.140

485
Leonard Sillman
Leonard Sillman's New Faces of 1952
Original Broadway cast
RCA Victor, 1952
The Andy Warhol Museum, Pittsburgh
Founding Collection, Contribution
The Andy Warhol Foundation for the Visual Arts, Inc.
2000.2.3181a-b

486
Leonard Bernstein, music
Betty Comden and Adolph Green, lyrics
Wonderful Town
Rosalind Russell with members of the New York production
Decca, 1953
The Andy Warhol Museum, Pittsburgh
Founding Collection, Contribution
The Andy Warhol Foundation for the Visual Arts, Inc.
2000.2.3190a-b

487
Mabel Mercer
Songs by Mabel Mercer, Vol. 1
Atlantic, 1953
The Andy Warhol Museum, Pittsburgh
Founding Collection, Contribution
The Andy Warhol Foundation for the Visual Arts, Inc.
"Time Capsule 31"—TC31.144a-b

488
Mabel Mercer
Songs by Mabel Mercer, Vol. 2
Atlantic, 1953
The Andy Warhol Museum, Pittsburgh
Founding Collection, Contribution
The Andy Warhol Foundation for the Visual Arts, Inc.
"Time Capsule 31"—TC31.143a-b

489
Mabel Mercer
Songs by Mabel Mercer, Vol. 3
Atlantic, 1953
The Andy Warhol Museum, Pittsburgh
Founding Collection, Contribution
The Andy Warhol Foundation for the
Visual Arts, Inc.
2000.2.3183a-b

490
Ethel Merman and Mary Martin
Ethel Merman and Mary Martin:
The Actual Recording of the
Duet from the Ford 50th Anniversary
Television Show!
Decca, 1953
The Andy Warhol Museum, Pittsburgh
Founding Collection, Contribution
The Andy Warhol Foundation for the
Visual Arts, Inc.
"Time Capsule 31"—TC31.145a-b

491 [ill. p. 188]
Judy Garland
"A Star is Born"
Columbia, 1954
The Andy Warhol Museum, Pittsburgh
Founding Collection, Contribution
The Andy Warhol Foundation for the
Visual Arts, Inc.
"Time Capsule 31"—TC31.131a-b

492
Eartha Kitt
Henri René, conductor
"That Bad Eartha"
RCA Victor, 1954
The Andy Warhol Museum, Pittsburgh
Founding Collection, Contribution
The Andy Warhol Foundation for the
Visual Arts, Inc.
"Time Capsule 31"—TC31.132

493
Kurt Weill, music
Bertolt Brecht, original lyrics
The Threepenny Opera
MGM, 1954
The Andy Warhol Museum, Pittsburgh
Founding Collection, Contribution
The Andy Warhol Foundation for the
Visual Arts, Inc.
"Time Capsule 31"—TC31.148a-b

494
René Touzet and the
Cha-Cha Rhythm Boys
All Time Cha-Cha-Cha and
Merengue Hit Parade
Fiesta, about 1955
The Andy Warhol Museum, Pittsburgh
Founding Collection, Contribution
The Andy Warhol Foundation for the
Visual Arts, Inc.
"Time Capsule 31"—TC31.130a-b

495
Charles Trenet
Le Cœur de Paris
Angel, about 1955
The Andy Warhol Museum, Pittsburgh
Founding Collection, Contribution
The Andy Warhol Foundation for the
Visual Arts, Inc.
"Time Capsule 31"—TC31.146

496
Pyotr Ilyich Tchaikovsky
Concerto No. 1
Van Cliburn, piano
Kiril Kondrashin, conductor
RCA Victor/Red Seal, 1958
The Andy Warhol Museum, Pittsburgh
Founding Collection, Contribution
The Andy Warhol Foundation for the
Visual Arts, Inc.
"Time Capsule 31"—TC31.135a-b

497
The Cadillacs and the Orioles
Cadillacs Meet the Orioles
Jubilee, 1960
The Andy Warhol Museum, Pittsburgh
Founding Collection, Contribution
The Andy Warhol Foundation for the
Visual Arts, Inc.
2000.2.3299

498 [ill. p. 188]
Elvis Presley
Elvis' Gold Records, Vol. 2
RCA Victor, 1960
The Andy Warhol Museum, Pittsburgh
Founding Collection, Contribution
The Andy Warhol Foundation for the
Visual Arts, Inc.
1998.3.9206

499
Noël Coward
Sail Away
Original Broadway cast
Capitol, 1961
The Andy Warhol Museum, Pittsburgh
Founding Collection, Contribution
The Andy Warhol Foundation for the
Visual Arts, Inc.
1998.3.9205

500
Fabian
Rockin' Hot!
Chancellor, 1961
The Andy Warhol Museum, Pittsburgh
Founding Collection, Contribution
The Andy Warhol Foundation for the
Visual Arts, Inc.
2000.2.2714

501
The Everly Brothers
I'm Not Angry / Crying in the Rain
Warner Bros., 1962
The Andy Warhol Museum, Pittsburgh
Founding Collection, Contribution
The Andy Warhol Foundation for the
Visual Arts, Inc.
2000.2.3300

502
Ben E. King
Don't Play That Song!
Atco, 1962
The Andy Warhol Museum, Pittsburgh
Founding Collection, Contribution
The Andy Warhol Foundation for the
Visual Arts, Inc.
1998.3.9214

503
The Rolling Stones
12 x 5
London, 1965
The Andy Warhol Museum, Pittsburgh
Founding Collection, Contribution
The Andy Warhol Foundation for the
Visual Arts, Inc.
1998.3.6501

504 [ill. p. 188]
The Shangri-Las
I Can Never Go Home Any More
Red Bird, 1965
The Andy Warhol Museum, Pittsburgh
Founding Collection, Contribution
The Andy Warhol Foundation for the
Visual Arts, Inc.
1998.3.6399a-c

505
The Rolling Stones
Aftermath
London, 1966
The Andy Warhol Museum, Pittsburgh
Founding Collection, Contribution
The Andy Warhol Foundation for the
Visual Arts, Inc.
TC35-86a-b

506
The Rolling Stones
Got Live if You Want It!
London, 1966
The Andy Warhol Museum, Pittsburgh
Founding Collection, Contribution
The Andy Warhol Foundation for the
Visual Arts, Inc.
"Time Capsule 35"—TC35.75a-c

507
The Rolling Stones
Have You Seen Your Mother,
Baby, Standing in the Shadow? /
Who's Driving Your Plane?
London, 1966
The Andy Warhol Museum, Pittsburgh
Museum Loan, Collection of Jay Reeg
L2005.3.1.1-2

508
The Rolling Stones
Between the Buttons
London, 1967
The Andy Warhol Museum, Pittsburgh
Founding Collection, Contribution
The Andy Warhol Foundation for the
Visual Arts, Inc.
"Time Capsule 35"—TC35-82a-b

509
The Rolling Stones
Beggers Banquet
London, 1968
The Andy Warhol Museum, Pittsburgh
Founding Collection, Contribution
The Andy Warhol Foundation for the
Visual Arts, Inc.
"Time Capsule 35"—TC35.81a-c

510
The Rolling Stones
Jumpin' Jack Flash /
Child of the Moon
London, 1968
The Andy Warhol Museum, Pittsburgh
Museum Loan, Collection of Jay Reeg
L2005.3.6

511
The Rolling Stones
Honky Tonk Women / You Can't
Always Get What You Want
London, 1969
The Andy Warhol Museum, Pittsburgh
Museum Loan, Collection of Jay Reeg
L2005.3.5

512
David Bowie
Hunky Dory
Signed by the singer
"To Andy with respect"
RCA, 1971
The Andy Warhol Museum, Pittsburgh
Founding Collection, Contribution
The Andy Warhol Foundation for the
Visual Arts, Inc.
1998.3.9392.1–4

513
Fred Astaire
Starring Fred Astaire:
The 1935–1938
Brunswick Recordings
Columbia, 1973
The Andy Warhol Museum, Pittsburgh
Founding Collection, Contribution
The Andy Warhol Foundation for the
Visual Arts, Inc.
2000.2.3303a-c

514 [ill. p. 210]
The Rolling Stones
Goats Head Soup
Rolling Stones, 1973
The Andy Warhol Museum, Pittsburgh;
Museum Loan, Collection of Brett Day
L2007.2

515
Shirley Temple
Remember Shirley
20th Century, 1973 promotional copy
The Andy Warhol Museum, Pittsburgh
Founding Collection, Contribution
The Andy Warhol Foundation for the
Visual Arts, Inc.
2000.2.3302a-c

516
Eric Andersen
Be True To You
Arista, 1975
The Andy Warhol Museum, Pittsburgh
Founding Collection, Contribution
The Andy Warhol Foundation for the
Visual Arts, Inc.
1998.3.6483.2a-c

517 [ill. p. 210]
The Rolling Stones
Some Girls
Rolling Stones, 1978
The Andy Warhol Museum, Pittsburgh
Founding Collection, Contribution
The Andy Warhol Foundation for the
Visual Arts, Inc.
1998.3.8769a-c

518
Liquid Gold
Liquid Gold
Parachute, 1979
The Andy Warhol Museum, Pittsburgh
Founding Collection, Contribution
The Andy Warhol Foundation for the
Visual Arts, Inc.
2000.2.3301a-c

519
Grace Jones
Inside Story
Capitol, 1986
The Andy Warhol Museum, Pittsburgh
Founding Collection, Contribution
The Andy Warhol Foundation for the
Visual Arts, Inc.
1998.3.6373a-c

AUDIO CASSETTES

520
Wolfgang Amadeus Mozart
Don Giovanni
Chorus and orchestra of
London's Royal Opera
Colin Davis, conductor
Philips, 1973
German, English, and French libretti
The Andy Warhol Museum, Pittsburgh
Founding Collection, Contribution
The Andy Warhol Foundation for the
Visual Arts, Inc.
1998.3.14021a-d

521
Richard Strauss
Der Rosenkavalier
Vienna Philharmonic Orchestra
Sir Georg Solti, conductor
London, 1976
Includes libretto
The Andy Warhol Museum, Pittsburgh
Founding Collection, Contribution
The Andy Warhol Foundation for the
Visual Arts, Inc.
1998.3.14028a-b

522
Richard Wagner
Die Meistersinger von Nurnberg
Chorus and orchestra of the Deutsche
Oper Berlin
Eugen Jochum, conductor
Deutsche Grammophon, 1976
German, English, and French libretti
The Andy Warhol Museum, Pittsburgh
Founding Collection, Contribution
The Andy Warhol Foundation for the
Visual Arts, Inc.
1998.3.14033a-f

523
Giuseppe Verdi
La Forza del Destino
London Symphony Orchestra
and Placido Domingo
James Levine, conductor
RCA Red Seal, 1977
Includes libretto
The Andy Warhol Museum, Pittsburgh
Founding Collection, Contribution
The Andy Warhol Foundation for the
Visual Arts, Inc.
1998.3.14032a-d

524
Giuseppe Verdi
Il Trovatore
London's National Philharmonic
Orchestra, and Luciano Pavarotti
and Joan Sutherland
Richard Bonynge, conductor
London, 1977
Includes libretto
The Andy Warhol Museum, Pittsburgh
Founding Collection, Contribution
The Andy Warhol Foundation for the
Visual Arts, Inc.
1998.3.14024a-c

525
Giacomo Puccini
Turandot
Orchestra and choir of the Scala, Milan,
with Maria Callas, Eugenio Fernandi,
Elisabeth Schwarzkopf, Nicola Zaccarla
Tullio Serafin, conductor
EMI, 1978
Includes libretto
The Andy Warhol Museum, Pittsburgh
Founding Collection, Contribution
The Andy Warhol Foundation for the
Visual Arts, Inc.
1998.3.14026.1-2

RECORDINGS COPIED TO REEL-TO-REEL TAPES

526
Giuseppe Verdi
Aida
With Maria Callas
Recording dubbed by Billy Name,
labelled "Verdi—Aida / Maria Callas,
Mexico City, July 3, 1951"
About 1964–65
The Andy Warhol Museum, Pittsburgh
Founding Collection, Contribution
The Andy Warhol Foundation for the
Visual Arts, Inc.
1998.3.14086.1-3

527
Giuseppe Verdi
Macbeth
With Maria Callas
Recording dubbed by Billy Name,
labelled "Verdi / MacBeth /
Callas—1952"
About 1964–65
The Andy Warhol Museum, Pittsburgh
Founding Collection, Contribution
The Andy Warhol Foundation for the
Visual Arts, Inc.
1998.3.14117a-b

528
Giuseppe Verdi
Rigoletto
Umberto Giordano
Andrea Chénier
With Maria Callas
Recordings dubbed by Billy Name
About 1964–65
The Andy Warhol Museum, Pittsburgh
Founding Collection, Contribution
The Andy Warhol Foundation for the
Visual Arts, Inc.
1998.3.14112a-b

529
Maria Callas
Recording dubbed by Billy Name,
labelled "Maria Callas—
Performance Excerpts"
About 1966
The Andy Warhol Museum, Pittsburgh
Founding Collection, Contribution
The Andy Warhol Foundation for the
Visual Arts, Inc.
1998.3.14075a-b

530
Maria Callas
Reel-to-reel tape box labelled "Callas
RAI Recital" that once contained
a copy of a Maria Callas recording
dubbed by Billy Name
About 1966
18.4 x 18.4 x 1.9 cm
The Andy Warhol Museum, Pittsburgh
Founding Collection, Contribution
The Andy Warhol Foundation for the
Visual Arts, Inc.
1998.3.14101

PUBLICATIONS

531 [ill. p. 52]
*Movie Story—Vol. 14, no. 70
(February 1940)*
Cover illustration of Olivia de Havilland
and David Niven in *Raffles*, includes
illustrated synopsis of the 1940 movie
The Bluebird, starring Shirley Temple,
pp. 44–45, 70
1940
28.6 x 21.6 cm
The Andy Warhol Museum, Pittsburgh
Founding Collection, Contribution
The Andy Warhol Foundation for the
Visual Arts, Inc.
"Time Capsule 13"—TC13.2

532 [ill. p. 74]
Dance Guild
Fox Trot Made Easy
Book Guild of America Publishing
Corporation, New York
1956
25.7 x 18.7 cm
The Andy Warhol Museum, Pittsburgh
Gift of Thomas Ammann
Fine Art Gallery, Zurich, Switzerland
1993.1.7

533
*Dance diagram illustration torn from
the book "Fox Trot Made Easy"(1956):
"The Pivot Turn"—Man"*
Source for Warhol's 1962
Dance Diagram series
1956
25.4 x 17.8 cm
The Andy Warhol Museum, Pittsburgh
Founding Collection, Contribution
The Andy Warhol Foundation for the
Visual Arts, Inc.
1998.3.4511

534
The Playbill—Mark Hellinger Theatre
Cover photograph of Julie Andrews
and Rex Harrison in *My Fair Lady*
1956
22.9 x 16.8 cm
The Andy Warhol Museum, Pittsburgh
Founding Collection, Contribution
The Andy Warhol Foundation for the
Visual Arts, Inc.
T558

535 [ill. p. 74]
*Dance diagram illustration torn
from an unknown dance instruction
book:"The Charleston Double Side
Kick—Man and Woman"*
Source for Warhol's 1962
Dance Diagram series
About 1956
26.7 x 20.3 cm
The Andy Warhol Museum, Pittsburgh
Founding Collection, Contribution
The Andy Warhol Foundation for the
Visual Arts, Inc.
1998.3.4500

536
*Dance diagram illustration torn from
an unknown dance instruction
book: "The Lindy Back-Hand Turn"—Man*
Source for Warhol's 1962
Dance Diagram series
About 1956
25.4 x 18.3 cm
The Andy Warhol Museum, Pittsburgh
Founding Collection, Contribution
The Andy Warhol Foundation for the
Visual Arts, Inc.
1998.3.4503

537
*Dance diagram illustration torn from
an unknown dance instruction book:
"The Lindy Tuck-In Turn—Man"*
Source for Warhol's 1962
Dance Diagram series
About 1956
27.9 x 19.1 cm
The Andy Warhol Museum, Pittsburgh
Founding Collection, Contribution
The Andy Warhol Foundation for the
Visual Arts, Inc.
1998.3.4499

538
*Dance diagram illustration torn from
an unknown dance instruction book:
"The Lindy Tuck-In Turn—Woman"*
Source for Warhol's 1962
Dance Diagram series
About 1956
25.4 x 18.3 cm
The Andy Warhol Museum, Pittsburgh
Founding Collection, Contribution
The Andy Warhol Foundation for the
Visual Arts, Inc.
1998.3.4509

539
*New York's Metropolitan Opera
libretto for "Vanessa"*
Samuel Barber, composer
Gian Carlo Menotti, librettist
1957
25.4 x 17.3 cm
The Andy Warhol Museum, Pittsburgh
Founding Collection, Contribution
The Andy Warhol Foundation for the
Visual Arts, Inc.
T558

540
*Opera News—Vol. 23, no. 3
(November 10, 1958)*
Cover image by Eldon Elder
1958
25.4 x 17.5 cm
The Andy Warhol Museum, Pittsburgh
Founding Collection, Contribution
The Andy Warhol Foundation for the
Visual Arts, Inc.
1998.3.4710

541
*Opera News—Vol. 23, no. 6
(December 8, 1958)*
Cover image by Mozelle Thompson
1958
25.4 x 17.5 cm
The Andy Warhol Museum, Pittsburgh
Founding Collection, Contribution
The Andy Warhol Foundation for the
Visual Arts, Inc.
1998.3.4711

542 [ill. p. 169]
Who's Who in Rock 'n Roll
Frederick Fell, New York
1958
22.9 x 15.2 x 0.6 cm
The Andy Warhol Museum, Pittsburgh
Founding Collection, Contribution
The Andy Warhol Foundation for the
Visual Arts, Inc.
1998.3.10831

543
Fluxus
Fluxus: Preview Review
Includes photographs and listings
of Fluxus actions by John Cale,
Dick Higgins, Alison Knowles, Robert
Filliou, Jackson Mac Low, Jonas Mekas,
Nam June Paik, and others

1963
29.2 x 10.8 cm (folded)
165.7 x 9.8 cm (open)
The Andy Warhol Museum, Pittsburgh
Founding Collection, Contribution
The Andy Warhol Foundation for the
Visual Arts, Inc.
T563

544
Fluxus
*Fluxus: CC Valise e Trangle—No. [3]
(March 1964)*
Edited by Fluxus Editorial Council
1964
28.6 x 44.5 cm
The Andy Warhol Museum, Pittsburgh
Founding Collection, Contribution
The Andy Warhol Foundation for the
Visual Arts, Inc.
T562

545
*Full-page magazine advertisement
for the Rollings Stones' "Have you
seen your mother, baby, standing in
the shadow?" ("Billboard Magazine,"
October 1, 1966)*
1966
38.7 x 27.6 cm
The Andy Warhol Museum, Pittsburgh
Museum Loan, Collection of Jay Reeg
L2005.3.19

546
*Magazine advertisement for the
Rolling Stones' "Street Fighting Man"
("Billboard Magazine,"
September 7, 1968)*
1968
38.1 x 55.2 cm
The Andy Warhol Museum, Pittsburgh
Museum Loan, Collection of Jay Reeg
L2005.3.18

547
*A Year from Monday:
New Lectures and Writings by
John Cage*
Wesleyan University Press,
Middletown, Connecticut
1969 (first paperback edition)
21 x 17.8 x 1.3 cm
The Andy Warhol Museum, Pittsburgh
Founding Collection, Contribution
The Andy Warhol Foundation for the
Visual Arts, Inc.
1998.3.7741

548
*Grapefruit:
Works and Drawings by Yoko Ono*
Introduction by John Lennon;
signed "To Andy—Love Yoko"
1970
14 x 14.6 x 2.5 cm
The Andy Warhol Museum, Pittsburgh
Founding Collection, Contribution
The Andy Warhol Foundation for the
Visual Arts, Inc.
2000.2.1623.1 / 2000.2.1623.2

549
Museum of Modern [F]Art
A conceptual work in the form of an
exhibition catalogue by Yoko Ono
with a set of instructions; Signed
"To Andy—Love Yoko"
1971
30.5 x 30.5 x 0.6 cm
The Andy Warhol Museum, Pittsburgh
Founding Collection, Contribution
The Andy Warhol Foundation for the
Visual Arts, Inc.
"Time Capsule 38"—TC38.142

VARIA

550
Paramount Pictures plaque
After 1920
Cast bronze
50.8 x 50.8 x 1.6 cm
The Andy Warhol Museum, Pittsburgh
Founding Collection, Contribution
The Andy Warhol Foundation for the
Visual Arts, Inc.
T578

551 [ill. p. 52]
*Publicity material for "The Scarlet
Empress," starring Marlene Dietrich,
John Lodge, Sam Jaffe, and
Louise Dresser*
1934
35.6 x 24.4 cm
The Andy Warhol Museum, Pittsburgh
Founding Collection, Contribution
The Andy Warhol Foundation for the
Visual Arts, Inc.
1998.3.8297.1

552
*Publicity material for "Wife Versus
Secretary," starring Clark Gable,
Jean Harlow, and Myrna Loy*
1936
Includes poster and promotional
sales materials, black-and-white
photographs of the three leads
and others, sample lobby posters,
and reviews
50.2 x 35.6 cm
The Andy Warhol Museum, Pittsburgh
Founding Collection, Contribution
The Andy Warhol Foundation for the
Visual Arts, Inc.
1998.3.8954

553 [ill. p. 49, 272]
Shirley Temple
Signed "To Andrew Worhola [sic]
from Shirley Temple"
1941
Hand-coloured sepia tone print
25.4 x 20.3 cm
The Andy Warhol Museum, Pittsburgh
Founding Collection, Contribution
The Andy Warhol Foundation for the
Visual Arts, Inc.
"Time Capsule 61"—TC61.3

554
*Collection of ticket stubs to various
places and events, including
cinemas, theatres, the opera,
and rock concerts*
About 1957–66
The Andy Warhol Museum, Pittsburgh
Founding Collection, Contribution
The Andy Warhol Foundation for the
Visual Arts, Inc.
Time Capsules: 39.46; 39.678;
56.10.1-5, 8-12; 56.36; 56.55.1-2, 4-8;
56.100; 56.212.1-15; 61.15.1-10

555
*Ivan Davis at Town Hall,
November 30, 1960*
1960, announcement
Offset lithograph on paper
24.8 x 17.1 cm
The Andy Warhol Museum, Pittsburgh
Founding Collection, Contribution
The Andy Warhol Foundation for the
Visual Arts, Inc.
1998.3.9574

556 [ill. p. 98]
*Card from Merce Cunningham
to Warhol*
About the artist's 1963 painting
of the dancer
About 1964
Felt-tip ink on offset lithograph
on coated paper
9 x 31.4 cm
The Andy Warhol Museum, Pittsburgh
Founding Collection, Contribution
The Andy Warhol Foundation for the
Visual Arts, Inc.
"Time Capsule 32"—TC. 32.162

557 [ill. p. 154]
Attributed to Ingrid Superstar
The Dom—April 1966
Sketch of the Exploding Plastic
Inevitable performing at the Dom,
including Mo "Mu" [Tucker], John Cale,
"Stella" [Morrison], "Lois LuLu" [Reed],
Nico, Andy Warhol in what appears to
be the projection booth overlooking
them all
1966
Graphite on lined paper
20.3 x 26.7 cm
The Andy Warhol Museum, Pittsburgh
Founding Collection, Contribution
The Andy Warhol Foundation for the
Visual Arts, Inc.
"Time Capsule 85"—TC85.109

558 [ill. p. 77]
Warhol's receipt from New York's Metropolitan Opera Association for his 1967–68 subscription ($581, 2 seats, Grand Tier, Thursdays)
1967
14 x 18.4 cm
The Andy Warhol Museum, Pittsburgh Founding Collection, Contribution The Andy Warhol Foundation for the Visual Arts, Inc.
"Time Capsule 39"—TC39.678

559
Promotional material for the Robert Joffrey Ballet
About 1967
23.2 x 23.2 cm
The Andy Warhol Museum, Pittsburgh Founding Collection, Contribution The Andy Warhol Foundation for the Visual Arts, Inc.
"Time Capsule 30"—TC30.72

560
Max's Kansas City reservation book—"National Diary for 1969"
Signed "To Brigid [Berlin]—The only book I'll ever sign myself—Micky [Ruskin]"
1969
31.8 x 21 x 3.8 cm
The Andy Warhol Museum, Pittsburgh Founding Collection, Contribution The Andy Warhol Foundation for the Visual Arts, Inc.
T564

561
Max's Kansas City reservation book of—"National Diary for 1970"
1970
32.1 x 20.6 x 3.8 cm
The Andy Warhol Museum, Pittsburgh Founding Collection, Contribution The Andy Warhol Foundation for the Visual Arts, Inc.
T565

562
Pin-back button of "New York City" with the Rolling Stones tongue logo on a white background
About 1972
Plastic-coated printed paper with metal backing
4.4 cm (diam.)
The Andy Warhol Museum, Pittsburgh Founding Collection, Contribution The Andy Warhol Foundation for the Visual Arts, Inc.
"Time Capsule 38"—TC38.176

563
Invitation to the opening of Studio 54, addressed to Andy Warhol, posted April 18, 1977, New York
Includes large, poster-style invitation requesting attendance at the premier opening of Studio 54, April 26, 1977, along with a membership fee card ($75), return envelope, and small, Studio 54 door pass for the party
1977
Mixed media
24.1 x 32.1 cm (envelope)
61 x 45.7 cm (poster)
9.2 x 16.5 cm (membership form envelope)
8.3 x 14 cm (membership card)
5.6 x 9.2 cm (party pass)
The Andy Warhol Museum, Pittsburgh Founding Collection, Contribution The Andy Warhol Foundation for the Visual Arts, Inc.
"Time Capsule 161"—TC161.1.1–4

564
Guest pass to Xenon, made out to Andy Warhol, dated June 7, and signed "Steve Rubell" (recto and verso)
1978
5.4 x 8.7 cm
The Andy Warhol Museum, Pittsburgh Founding Collection, Contribution The Andy Warhol Foundation for the Visual Arts, Inc.
"Time Capsule 237"—TC237.99

565
$5 token for Studio 54
About 1978
4 cm (diam.)
The Andy Warhol Museum, Pittsburgh Founding Collection, Contribution The Andy Warhol Foundation for the Visual Arts, Inc.
1998.3.2014

566
Roll of Studio 54 VIP drink tickets
About 1978
25.4 x 25.4 x 7.6 cm
The Andy Warhol Museum, Pittsburgh Founding Collection, Contribution The Andy Warhol Foundation for the Visual Arts, Inc.
"Time Capsule 249"—TC249.206

567
Seven Studio 54 VIP drink tickets
About 1978
5.1 x 11.4 cm (each)
The Andy Warhol Museum, Pittsburgh Founding Collection, Contribution The Andy Warhol Foundation for the Visual Arts, Inc.
1998.3.7147.8-13

568
Studio 54 guest pass
"KH" written on verso (possibly Keith Haring)
About 1978
6.4 x 16.5 cm
The Andy Warhol Museum, Pittsburgh Founding Collection, Contribution The Andy Warhol Foundation for the Visual Arts, Inc.
T557

CORRE-SPON-DENCE

569 [ill. p. 68]
Christmas Card from Warhol to George Klauber, posted December 26, 1948, Pittsburgh: "Merry Christmas and Happy New Year, from André"
1948
Ink, tempera and gouache on paper
25.7 x 51.4 cm
The Andy Warhol Museum, Pittsburgh Gift of George Klauber
1998.2.3

570 [ill. p. 56]
Postcard of a publicity still of Elvis Presley from "Flaming Star" (1960) sent by Charles Henri Ford to Warhol, dated July 1963
1960
Colour photo postcard
23.7 x 18.7 cm
The Andy Warhol Museum, Pittsburgh Founding Collection, Contribution The Andy Warhol Foundation for the Visual Arts, Inc.
1998.3.4589
Source material for Warhol's 1963 paintings series *Elvis* (Studio and Ferus Type)

571 [ill. p. 194]
Letter from Mick Jagger to Warhol, dated April 21, 1969
About commissioning Warhol's artwork for a new record cover (probably *Through the Past, Darkly*)
1969
Typewritten on letterhead
25.4 x 20.3 cm
The Andy Warhol Museum, Pittsburgh Founding Collection, Contribution The Andy Warhol Foundation for the Visual Arts, Inc.
1998.3.5519.68.1

572
Letter from Peter Swales to Andy Warhol, n.d.
About Warhol's agreement to do the artwork for the Stones new hits album, (probably *Through the Past, Darkly*) and mentioning the material Mick Jagger referenced in a previous letter, and that it would be sent separately at a later date
From Scrapbook "Factory Stars"
1969
Typewritten on letterhead
25.4 x 20.3 cm
The Andy Warhol Museum, Pittsburgh Founding Collection, Contribution The Andy Warhol Foundation for the Visual Arts, Inc.
1998.3.5519.68.2

573
Postcard announcing the world premiere of "Hell Can Wait," the "diabolical movie party starring Disco Sally," on February 7, 1979, at Xenon. From Xenon to Jed Johnson, c/o Warhol Enterprises, posted February 1, 1979, New York
1979
Printed coated cardstock with typewritten paper label
17.8 x 12.7 cm
The Andy Warhol Museum, Pittsburgh Founding Collection, Contribution The Andy Warhol Foundation for the Visual Arts, Inc.
"Time Capsule 237"—TC237.12

574
Valentine's Day party invitation from Studio 54, New York, to Mr. Jed Johnson, posted February 7, 1979, New York
Contains a cupid's arrow with inscribed party information
1979
Box: glossy, black box with black tissue inside; printed paper label on top ("Studio 54" and typewritten address and red stamped postmark date)
3.8 x 33.3 x 5.4 cm
Card: black ink on bright red paper ("Studio 54 lovingly invites you and your Valentine to an intimate gathering—St. Valentine's Day—Wednesday Evening, February 14, 1979—10 o'clock—$20 per person")
19.7 x 19.7 cm
Arrow: gold painted wooden dowel with moulded plastic, gold painted point and white feather flights painted gold (Black printed inscription on shaft: "Studio 54 St. Valentine's Day, February 14, 1979")
2.5 x 32.4 x 2.5 cm
The Andy Warhol Museum, Pittsburgh Founding Collection, Contribution The Andy Warhol Foundation for the Visual Arts, Inc.
"Time Capsule 237"—TC237.49.1; 2a-b; 3

421

553, 283

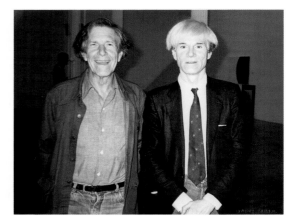

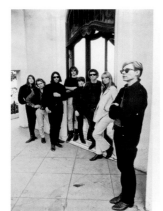

439

319

421 – Andy double tambourine, about 1966. Photo Nat Finkelstein (details end sheets) 553 – Autographed photograph of Shirley Temple made out to the young Andrew Worhola [*sic*], 1941 (detail p. 49) 283 – John Cage and Andy Warhol, 1982 (detail p. 87) 439 – Mary Woronov, Gerard Malanga, the Velvet Underground, Nico and Warhol, Los Angeles, 1966. Photo Steve Schapiro (detail 141) 319 – Self-portrait with Stevie Wonder, n.d. (detail 179)

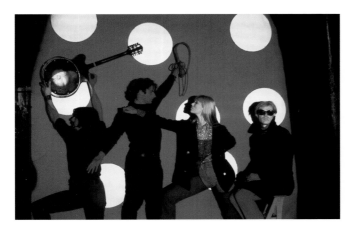

a

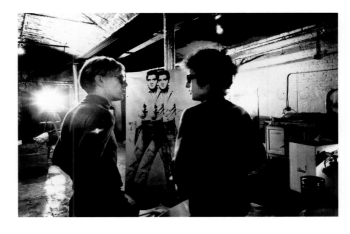

b

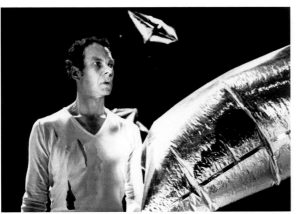

c, d

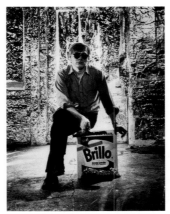

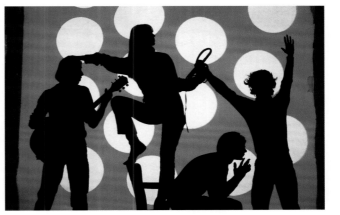

e

a – Andy Warhol and the Velvet Underground, 1966. Photo Hervé Gloaguen (detail end sheet and first page)　　**b** – Andy Warhol and Bob Dylan, with *Double Elvis*, the Factory, New York, 1965. Photo Nat Finkelstein (detail pages 8 and 9)
c – Merce Cunningham in *Rainforest*, 1968. Photo Oscar Bailey (detail p. 97)　　**d** – Andy Warhol at the Silver Factory, seated on one of his Brillo Boxes, about 1965. Photo Billy Name (detail p. 105)　　**e** – Andy Warhol and the Velvet Underground, 1966. Photo Hervé Gloaguen (detail p. 287)

FIGURES

ANDY WARHOL, MUSICIAN
Stéphane Aquin
[pp. 18–23]

FIG. 1
"The flip side of Andy Warhol"
Magazine advertisement for Pioneer
Rolling Stone, September 27, 1973
36.8 x 27.8 cm
Collection Paul Maréchal

FIG. 2
Andy Warhol and Mick Jagger,
New York
1977
b/w photograph
4.2 x 5.8 cm
Photo Bob Gruen
Collection Paul Maréchal

FIG. 3
Judy Garland as Dorothy Gale in
Victor Fleming's *The Wizard of Oz*
1939
Film still
MGM/Photofest

FIG. 4 (cat. 434)

FIG. 5 (cat. 198)

"SOMETHING IS ALWAYS HAPPENING" SET TO MUSIC
Emma Lavigne
[pp. 24–29]

FIG. 1
A party at the Factory
on East Forty-seventh Street,
walls covered with silver foil.
Andy at the rear, near the centre,
wearing sunglasses
September 1, 1965
b/w photograph
Photo Fred W. McDarrah
1106

FIG. 2
Andy Warhol at the Factory,
New York
1965–67
Gelatin silver print
32.4 x 48.3 cm
Photo Stephen Shore

FIG. 3
Andy Warhol on the phone at
the Factory
1966
Gelatin silver print
23.5 x 17.8 cm
The Andy Warhol Museum, Pittsburgh
Founding Collection, Contribution
The Andy Warhol Foundation for the
Visual Arts, Inc.

FIG. 4
Andy Warhol posing in a sheet
and turban
1981
Gelatin silver print, altered image
35mm contact sheet No. 6, frame 4
15.2 x 22.9 cm
Photo Christopher Makos

FIG. 5
Andy Warhol up in the projection booth,
centre, for the Velvet Underground at
the Dom, 23 St. Mark's Place
April 1, 1966
Photo Fred W. McDarrah
1189

FIG. 6
Andy Warhol as the *Invisible Sculpture*
at the Area, New York
1985
Gelatin silver print
Photo Patrick McMullan
Collection of Patrick McMullan

SEEING WITHOUT PARTICIPATING: ANDY WARHOL'S UNSHAKABLE DETERMINATION NOT TO BE MOVED
Roger Copeland
[pp. 30–35]

FIG. 1
A performance by the
Velvet Underground at the Dom,
John Cale silhouetted against
a projection of an eye
April 1, 1966
b/w photograph
Photo Fred W. McDarrah
1189

FIG. 2
Billy Name photographing Andy Warhol
at the Silver Factory, New York
1965
Gelatin silver print
12.7 x 20.3 cm
Photo Stephen Shore
The Andy Warhol Museum, Pittsburgh.
Founding Collection, Contribution
The Andy Warhol Foundation for the
Visual Arts, Inc.
1998.3.14748

FIG. 3
Yvonne Rainer's *Terrain*: *Sleep* and
Death solos performed simultaneously
by Trisha Brown (background) and
Albert Reid (foreground)
1963
Colour photograph
Photo Al Giese
Courtesy of Mary Hottelet

FIG. 4 (cat. 169)

FIG. 5 (cat. 170)

CHAPTER 1
TUNING IN

WORKS
[pp. 42–47]

1
Johann Strauss, Jr.
Waltzes by Johann Strauss, Jr.
Century Symphony Orchestra
Camden, 1956
Offset lithograph
Collection Paul Maréchal

2
Giant Size $1.57 Each
Interviews with artists in the 1963
Popular Image Exhibition at the
Washington Gallery of Modern Art,
organized by Billy Klüver and
Alice Denney (In the exhibition:
George Brecht, Jim Dine, Jasper Johns,
Roy Lichtenstein, Claes Oldenburg,
Robert Rauschenberg, James
Rosenquist, Andy Warhol, Robert Watts,
John Wesley, Tom Wesselmann)
Recorded and edited by Billy Klüver,
1963
Screen print
31.4 x 31.6 cm
The Andy Warhol Museum, Pittsburgh
Founding Collection, Contribution
The Andy Warhol Foundation for the
Visual Arts, Inc.

3
Ultra Violet
Ultra Violet
Capitol Records / Warner Music, 1972
Offset lithograph
31.1 x 31.1 cm
Collection Paul Maréchal

WORKS
[pp. 64–75]

4
Self-portrait with Bobby Short
1963
Photobooth photos
19.8 x 4 cm
The Andy Warhol Museum, Pittsburgh.
Founding Collection, Contribution
The Andy Warhol Foundation for the
Visual Arts, Inc.
1998.1.2747

WARHOL AND OPERA: ANDY'S SECRET
John Hunisak
[pp. 76–81]

FIG. 1 (cat. 558)

FIG. 2
Maria Callas in Vincenzo Bellini's opera
Norma, Paris Opera
1965
b/w photograph
Photo Roger Pic
Bibliothèque - musée de l'Opéra.
Fonds Pic
Cliché Bibliothèque national de France

FIG. 3
Tristam and Isolde
Final drawing, page 21, for Warhol's
portfolio *Love is a Pink Cake*
About 1953
Ink on coloured bond paper
27.9 x 21.6 cm
The Andy Warhol Museum, Pittsburgh.
Founding Collection, Contribution
The Andy Warhol Foundation for the
Visual Arts, Inc.
1998.1.1909

FIG. 4
Mildred Cook
In *The Threepenny Opera*,
Theatre de Lys
n.d.
Ink on tan paper
40.6 x 29.8 cm
The Andy Warhol Museum, Pittsburgh.
Founding Collection, Contribution
The Andy Warhol Foundation for the
Visual Arts, Inc.
1998.1.1827

CHAPTER 2 SOUND AND VISION

[p. 97]
Merce Cunningham in *Rainforest*
1968
b/w photograph
Photo Oscar Bailey
Merce Cunningham Dance Company

WORKS
[pp. 98–103]

5
Merce
[January–February] 1963
Silkscreen ink and black spray
paint on linen
208.3 x 207 cm
Daros Collection, Switzerland

6
Stephen Shore photographing
Silver Clouds at the Silver Factory,
New York
1965–66
Gelatin silver print
12.7 x 20.3 cm
Photo Stephen Shore
The Andy Warhol Museum, Pittsburgh
Founding Collection, Contribution
The Andy Warhol Foundation for the
Visual Arts, Inc.
1998.3.14533

7
Andy Warhol and two unidentified men
with Silver Clouds at the Leo Castelli
Gallery
May 1966, reprint 1996
Gelatin silver print
18.1 x 24.1 cm
Nat Finkelstein
The Andy Warhol Museum, Pittsburgh
Museum Purchase
1996.9.29

8
The Silver Clouds at the
Leo Castelli Gallery
May 1966, reprint 1996
Gelatin silver print
18.1 x 24.1 cm
Photo Nat Finkelstein
The Andy Warhol Museum, Pittsburgh
Museum Purchase
1996.9.30

9
Andy Warhol exhibiting Silver Clouds
1966, reprint 1996
Gelatin silver print
20.3 x 25.4 cm
Photo Stephen Shore
The Andy Warhol Museum, Pittsburgh.
Contribution Dia Center for the Arts
1996.19.7

10
Danny Williams, Paul America,
Gerard Malanga, Andy Warhol,
Pontus Hultén, Harold Stevenson
and Billy Klüver posing with
two unidentified men, and the
Infinite Sculpture on the roof of
the Silver Factory
October 4, 1965
Gelatin silver print
24.4 x 16.5 cm
Photo Billy Name
The Andy Warhol Museum, Pittsburgh.
Founding Collection, Contribution
The Andy Warhol Foundation for the
Visual Arts, Inc.
1998.3.14801

11
Andy Warhol at the Ferus Gallery,
Los Angeles
1966
Gelatin silver print
Photo Steve Schapiro

12
Andy Warhol blowing up a Silver Cloud
at the Ferus Gallery, Los Angeles
1966
Gelatin silver print
Photo Steve Schapiro

13
Andy Warhol with his Silver Clouds
at the Leo Castelli Gallery
May 1966, reprint 1996
Gelatin silver print
25 x 18.1 cm
Photo Nat Finkelstein
The Andy Warhol Museum, Pittsburgh
Museum Purchase
1996.9.28

14
Andy Warhol at the Ferus Gallery,
Los Angeles
1966
Gelatin silver print
Photo Steve Schapiro

15
Leo Castelli with Silver Clouds at
the Leo Castelli Gallery
May 1966, reprint 1996
Gelatin silver print
24 x 18.1 cm
Photo Nat Finkelstein
The Andy Warhol Museum, Pittsburgh
Museum Purchase

16
Andy Warhol at the Leo Castelli Gallery,
New York
1965
Gelatin silver print
Photo Steve Schapiro

17
Andy Warhol outside the Leo Castelli
Gallery, New York
1965
Gelatin silver print
Photo Steve Schapiro

[p. 105]
Andy Warhol at the Silver Factory,
seated on a Brillo Box sculpture,
holding a squeegee
About 1965, reprint 1990
Gelatin silver print
35.6 x 27.9 cm
Photo Billy Name
The Andy Warhol Museum, Pittsburgh
Gift of Jay Reeg
1994.8.26

WORKS
[pp. 106–121]

18
Billy Linich, Chuck Wein,
Dorothy Dean, and unidentified man
at the Silver Factory during the
filming of Warhol's film *Prison* (1965)
1965
Gelatin silver print
20.3 x 12.7 cm
Photo Stehen Shore
The Andy Warhol Museum, Pittsburgh
Founding Collection, Contribution
The Andy Warhol Foundation for the
Visual Arts, Inc.
1998.3.14629

19
Sally Kirkland
1965
Gelatin silver print
12.7 x 20.3 cm
Photo Stehen Shore
The Andy Warhol Museum, Pittsburgh
Founding Collection, Contribution
The Andy Warhol Foundation for the
Visual Arts, Inc.
1998.3.14691

20
Donald Lyons, Ed Hennessey,
Dorothy Dean, Pat Hartley,
Edie Sedgwick, Gerard Malanga,
Genevieve Charbon, Bibbe Hansen
and Chuck Wein dancing at the
Silver Factory, New York
1965
Gelatin silver print
12.7 x 20.3 cm
Photo Stehen Shore
The Andy Warhol Museum, Pittsburgh
Founding Collection, Contribution
The Andy Warhol Foundation for the
Visual Arts, Inc.
1998.3.14568

21
Ondine, Donald Lyons, Edie Sedgwick,
Pat Hartley, Dorothy Dean, Chuck Wein
and Bibbe Hansen dancing at the
Silver Factory, New York
1965
Gelatin silver print
12.7 x 20.3 cm
Photo Stehen Shore
The Andy Warhol Museum, Pittsburgh
Founding Collection, Contribution
The Andy Warhol Foundation for the
Visual Arts, Inc.
1998.3.14569

22
Ondine, Donald Lyons, Ed Hennessey,
Edie Sedgwick, Pat Hartley,
Gerard Malanga, Chuck Wein,
Genevieve Charbon and Bibbe Hansen
dancing at the Silver Factory, New York
1965
Gelatin silver print
12.7 x 20.3 cm
Photo Stehen Shore
The Andy Warhol Museum, Pittsburgh
Founding Collection, Contribution
The Andy Warhol Foundation for the
Visual Arts, Inc.
1998.3.14570

23
Unidentified people dancing at
the Silver Factory, New York
1965
Gelatin silver print
12.7 x 20.3 cm
Photo Stehen Shore
The Andy Warhol Museum, Pittsburgh
Founding Collection, Contribution
The Andy Warhol Foundation for the
Visual Arts, Inc.
1998.3.14603

24
Unidentified people dancing at
the Silver Factory, New York
1965
Gelatin silver print
12.7 x 20.3 cm
Photo Stehen Shore
The Andy Warhol Museum, Pittsburgh
Founding Collection, Contribution
The Andy Warhol Foundation for the
Visual Arts, Inc.
1998.3.14602

25
Edie Sedgwick and Andy Warhol
with unidentified people dancing at
the Silver Factory, New York
1965
Gelatin silver print
12.7 x 20.3 cm
Photo Stehen Shore
The Andy Warhol Museum, Pittsburgh
Founding Collection, Contribution
The Andy Warhol Foundation for the
Visual Arts, Inc.
1998.3.14616

26
Edie Sedgwick and Gerard Malanga
with unidentified people dancing at
the Silver Factory, New York
1965
Gelatin silver print
12.7 x 20.3 cm
Photo Stehen Shore
The Andy Warhol Museum, Pittsburgh
Founding Collection, Contribution
The Andy Warhol Foundation for the
Visual Arts, Inc.
1998.3.14619

27
Lou Reed, John Cale, Gerard Malanga,
Debbie Cain, Moe Tucker and
Sterling Morrison rehearsing at
the Silver Factory, New York
1965–66, reprint 1996
Gelatin silver print
20.3 x 25.4 cm
Photo Stehen Shore
The Andy Warhol Museum, Pittsburgh
Founding Collection,
Contribution Dia Center for the Arts
1996.19.22

28
Edie Sedgwick and Gerard Malanga
on stage, the Cinematheque, New York
1965
Gelatin silver print
Photo Nat Finkelstein

29
Andy Warhol at the Silver Factory,
working on Flowers paintings
1965
Gelatin silver print
20.3 x 12.7 cm
Photo Stephen Shore
The Andy Warhol Museum, Pittsburgh
Founding Collection, Contribution
The Andy Warhol Foundation for the
Visual Arts, Inc.
1998.3.14683

30
Andy Warhol at the Silver Factory,
working on his Flowers series
1964, reprint 1996
Gelatin silver print
35.6 x 27.9 cm
Photo Billy Name
The Andy Warhol Museum, Pittsburgh
Museum Purchase
1996.9.57

31
Andy Warhol at the Silver Factory,
working with Flowers paintings
1965
Gelatin silver print
20.3 x 12.7 cm
Photo Stephen Shore
The Andy Warhol Museum, Pittsburgh
Founding Collection, Contribution
The Andy Warhol Foundation for the
Visual Arts, Inc.
1998.3.14674

32
Andy Warhol at the Silver Factory,
working on a Flowers painting
1965, reprint 1996
Gelatin silver print
35.4 x 27.9 cm
David McCabe
The Andy Warhol Museum, Pittsburgh
Museum Purchase
1996.9.118

33
Warhol's Silver Factory, with various
works in progress including
Campbell's Tomato Juice boxes and
Jackie paintings
1964, reprint 1996
Gelatin silver print
27.9 x 35.6 cm
Photo Billy Name
The Andy Warhol Museum, Pittsburgh
Museum Purchase
1996.9.65

34
Andy Warhol on the telephone at
the Silver Factory, with a Most Wanted
Men painting in the background
1964, reprint 1996
Gelatin silver print
27.9 x 35.6 cm
Photo Billy Name
The Andy Warhol Museum, Pittsburgh
Museum Purchase
1996.9.74

35
Andy Warhol and Gerard Malanga at
the Silver Factory, New York
1965
Gelatin silver print
12.7 x 20.3 cm
Photo Stephen Shore
The Andy Warhol Museum, Pittsburgh.
Founding Collection, Contribution
The Andy Warhol Foundation for the
Visual Arts, Inc.
1998.3.14696

36
Flowers
1970
Portfolio of 10 screen prints on paper,
published edition 236/250
91.4 x 91.4 cm (each)
The Andy Warhol Museum, Pittsburgh
Founding Collection, Contribution
The Andy Warhol Foundation for the
Visual Arts, Inc.
1998.1.2395.1-10

37
Andy Warhol filming Pat Hartley at
the Silver Factory on the set of
his film Prison (1965)
1965
Gelatin silver print
20.3 x 12.7 cm
Photo Stephen Shore
The Andy Warhol Museum, Pittsburgh
Founding Collection, Contribution
The Andy Warhol Foundation for the
Visual Arts, Inc.
1998.3.14649

38
Chuck Wein and Andy Warhol at
the Silver Factory, New York
1965
Gelatin silver print
12.7 x 20.3 cm
Photo Stephen Shore
The Andy Warhol Museum, Pittsburgh
Founding Collection, Contribution
The Andy Warhol Foundation for the
Visual Arts, Inc.
1998.3.14594

39
Edie Sedgwick and Andy Warhol
with unidentified men at
the Silver Factory, New York
1965
Gelatin silver print
12.7 x 20.3 cm
Photo Stephen Shore
The Andy Warhol Museum, Pittsburgh
Founding Collection, Contribution
The Andy Warhol Foundation for the
Visual Arts, Inc.
1998.3.14710

40
Gerard Malanga, Andy Warhol and
Buddy Wirtschafter with Warhol's
16mm Auricon movie camera at
the Silver Factory on the set of his
film Prison (1965)
1965
Gelatin silver print
12.7 x 20.3 cm
Photo Stephen Shore
The Andy Warhol Museum, Pittsburgh
Founding Collection, Contribution
The Andy Warhol Foundation for the
Visual Arts, Inc.
1998.3.14646

41
Film screening at the Factory (Vinyl),
at the Fifty Most Beautiful People party
1965, reprint 1996
Gelatin silver print
27.9 x 35.2 cm
Photo David McCabe
The Andy Warhol Museum, Pittsburgh
Museum Purchase
1996.9.122

42
Chuck Wein, Andy Warhol and
Edie Sedgwick at the Silver Factory,
New York
1965
Gelatin silver print
12.7 x 20.3 cm
Photo Stephen Shore
The Andy Warhol Museum, Pittsburgh
Founding Collection, Contribution
The Andy Warhol Foundation for the
Visual Arts, Inc.
1998.3.14766

43
The Factory at rest: with rolled
paintings and artworks strewn
about including Cow Wallpaper,
Flowers and Marlon Brando
1966–67, reprint 1996
Gelatin silver print
18.1 x 24.1 cm
Photo Nat Finkelstein
The Andy Warhol Museum, Pittsburgh
Museum Purchase
1996.9.41

**NO MORE APOLOGIES:
POP ART AND POP
MUSIC, CA. 1963
Branden W. Joseph**
[pp. 122–129]

FIG. 1
Keith McCormack
Hound Dog / Cute Little Frown
Dot, 1963
The Andy Warhol Museum, Pittsburgh
Founding Collection, Contribution
The Andy Warhol Foundation for the
Visual Arts, Inc.
"Time Capsule 36"—TC36.15a-b

FIG. 2
The Sherrys
Pop Pop Pop Pie / Your Hand in Mine
Guyden, 1962
The Andy Warhol Museum, Pittsburgh
Founding Collection, Contribution
The Andy Warhol Foundation for the
Visual Arts, Inc.
"Time Capsule 36"—TC36.17

FIG. 3
Brian Lord and the Midnighters
Not Another One! / The Big Surfer
Capitol, 1963
The Andy Warhol Museum, Pittsburgh
Founding Collection, Contribution
The Andy Warhol Foundation for the
Visual Arts, Inc.
"Time Capsule 36"—TC36.18a-b

FIG. 4
Kathy Brandon
Surfin' Doll / A Boy to Love Me
Crystalette, 1963
The Andy Warhol Museum, Pittsburgh
Founding Collection, Contribution
The Andy Warhol Foundation for the
Visual Arts, Inc.
"Time Capsule 36"—TC36.16a-b

FIG. 5
Taylor Mead as Tarzan in Warhol's
Tarzan and Jane Regained . . .
Sort Of (1963)
1963
Film still
The Andy Warhol Museum, Pittsburgh

FIG. 6
Jasper Johns
Gray Alphabets
1956
Beeswax and oil on newspaper
and paper on canvas
168 x 123.8 cm
The Menil Collection, Houston, Texas
X 801

FIG. 7
210 Coca-Cola Bottles
[June–July] 1962
Silkscreen ink, acrylic,
and pencil on linen
209.6 x 266.7 cm
Daros Collection, Switzerland
F-11347-C

**IMPULSE, TYPES
AND INDEX:
WARHOL'S AUDIO
ARCHIVE
Melissa Ragona**
[pp. 130–135]

FIG. 1 (cat. 290)

FIG. 2
With Brigid Berlin
Early 1970s
b/w photograph
Photo Billy Name

FIG. 3
Installation of Warhol's Time Capsules
in the archives of the Andy Warhol
Museum
1983
Colour photograph
Photo Richard Stoner
The Andy Warhol Museum, Pittsburgh
Founding Collection, Contribution
The Andy Warhol Foundation for the
Visual Arts, Inc.

FIG. 4
Andy Warhol's dining room
shortly after his death
1987
b/w photograph
Photo Evelyn Hofer
Evelyn Hofer Archive, New York

CHAPTER 3 PRODUCER

WORKS
[pp. 142–167]

44
John Cale at the Factory, New York
1966
Gelatin silver print
Photo Nat Finkelstein

45
Maureen Tucker at the Factory,
New York
1966
Gelatin silver print
Photo Nat Finkelstein

46
John Cale, Sterling Morrison and
Lou Reed, Paraphernalia opening,
New York
1966
Gelatin silver print
Photo Nat Finkelstein

47
The Velvet Underground with Andy,
Gerard Malanga and Mary Woronov
1966
Gelatin silver print
Photo Nat Finkelstein

48
The Velvet Underground
with Andy and Mary Woronov
1966
Gelatin silver print
Photo Nat Finkelstein

49
Sterling Morrison on Factory couch,
New York
About 1966
Gelatin silver print
Photo Nat Finkelstein

50
The Dom (Polski Dom Narodowy),
23 St. Mark's Place,
home of Warhol's psychedelic
extravaganza featuring Nico
and the Velvet Underground
March 31, 1966
Photo Fred W. McDarrah
1188

51
Danny Williams at light projector
with crowd, the Dom, New York
1966
Gelatin silver print
Photo Nat Finkelstein

52
Danny Williams at light projector
with crowd, the Dom, New York
1966
Gelatin silver print
Photo Nat Finkelstein

TIMELINE

WARHOL'S LIFE IN RELATION TO MUSIC AND DANCE

Matt Wrbican

with Stéphane Aquin and Emma Lavigne

1928

Andrew Warhola was born in Pittsburgh on August 6 to Julia and Andrej Warhola, Carpatho-Rusyn immigrants from the village of Mikova in present-day eastern Slovakia. He had two older brothers, Paul and John.

The family regularly attended St. John Chrysostom Byzantine Catholic Church.

1934

After years of renting small apartments, the Warholas purchased a home at 3252 Dawson Street, where Andy lived until he moved to New York in 1949.

1937

Andy grew interested in photography and took pictures with the family's Kodak Brownie camera. An area of the Warholas' basement was cleared for use as a darkroom.

He took a few violin lessons, but quit because he did not like the teacher.

From about 1937 to 1941, he attended free Saturday art classes at the Carnegie Institute of Technology (now Carnegie Mellon University).

After contracting rheumatic fever, Andy was stricken with Sydenham's chorea (St. Vitus' dance) and confined to home for more than two months, during which his mother encouraged his interests in art, comics and movies.

1939

He began collecting photographs of movie stars, which he kept in a scrapbook album.

He attended Hollywood films at his neighbourhood cinemas: the Oakland, the Schenley and the Strand. He preferred musicals, and his favourite stars were Shirley Temple and Alice Faye.

The family bought their first radio. Andy listened to popular radio programs, including *The Shadow,* the ventriloquist Edgar Bergen and others.

1942

He graduated from Holmes Elementary School and entered Schenley High School, where he received the highest marks in his art classes; music and dance were not among his studies.

Andrej Warhola died after a lengthy illness. He had saved several thousand dollars to be used for Andy's education.

1945

Andy Warhola was admitted to Carnegie Tech and enrolled in the Department of Painting and Design.

He met Philip Pearlstein, through whom he discovered the music of Bartok, Stravinsky and Mahler.

1947

He attended a lecture and performance by John Cage and William Masselos.

He performed in a musical for his fellow art students, *Oaklandhoma!* a parody of their teachers and classes based on the popular Broadway musical *Oklahoma!*

At about this time, his costume designs for a student play called *Molecule Man* were rejected.

He made a painting of a classical quartet on a concert-hall stage.

1948

His university did not offer classes in dance, but he joined the students' club for modern dance instead and attended a performance of Martha Graham's dance company in Pittsburgh.

His painting *I Like Dance* and his print *Dance in Black and White* were included in the annual exhibition of the Associated Artists of Pittsburgh.

He served as art editor for the student magazine *Cano*.

1949

His painting *The Broad Gave Me My Face, But I Can Pick My Own Nose* was rejected for the annual exhibition of the Associated Artists of Pittsburgh.

He graduated from Carnegie Tech with a Bachelor of Fine Arts degree in pictorial design. His professors included Samuel Rosenberg and Robert Lepper.

Shortly after graduating, he moved to New York City with Philip Pearlstein. For a few months they shared a living space with the dance therapist Franziska Boas, whose students included John Cage, Merce Cunningham, Katherine Dunham and Alwin Nikolais.

He began to work as a commercial artist, usually under the name Andy Warhol. Throughout the 1950s and early 1960s, he illustrated a great variety of published projects, including drawings for *Dance Magazine* and *Opera News*.

He designed his first record cover, for *A Program of Mexican Music* for Columbia Records and the Museum of Modern Art.

1950

He moved to West 103rd Street to share an apartment with many musicians, dancers and other creative people.

At about this time, he illustrated ads for NBC radio programs.

"I ALWAYS WANTED TO BE A TAP DANCER, JUST LIKE BETTY FORD AND BARBARA WALTERS. WHEN I WAS A KID NOT GROWING UP IN PITTSBURGH, I SAVED MY PENNIES, WOLFED DOWN MY SALT AND PEPPER SOUP, AND RAN DOWN-TOWN TO SEE EVERY JUDY GARLAND MOVIE. THAT'S WHY IT'S SO GREAT TO BE GOOD FRIENDS WITH HER DAUGHTERS, LIZA MINNELLI AND LORNA LUFT."

"GOING OUT WITH SUSAN BLOND IS SO MUCH FUN, BECAUSE I GET TO SEE ALL MY IDOLS LIKE DION AND LOU RAWLS, WHO DOES THOSE WONDERFUL OLD-FASHIONED BALLADS THAT I LIKE SO MUCH. PAUL ANKA'S ANOTHER FAVOURITE OF MINE. AND NEIL SEDAKA."

1951

He received an Art Directors Club Medal for his newspaper illustrations that advertised the CBS radio feature "The Nation's Nightmare," for which he also designed an LP cover. He received numerous graphic arts awards throughout the 1950s.

As he achieved professional success, he began to attend more films, operas, symphonies, ballets and Broadway musicals.

1952

His first solo exhibition, *Fifteen Drawings Based on the Writings of Truman Capote*, was held at the Hugo Gallery, New York, which is managed by Alexander Iolas, a former dancer with the Ballets Russes.

Julia Warhola moved to New York, where she lived with her son until 1971.

1953

He joined a small drama group, Theater 12, and created the stage decorations.

He exhibited portraits of dancer John Butler at Loft Gallery; this show is not well documented and may have occurred in 1954.

1954

He self-published the artist's book *25 Cats Name Sam and One Blue Pussy* with a simple repetitive text credited to theatre designer Charles Lisanby, who was an assistant to Cecil Beaton.

1955

He used hand-carved rubber stamps to create repeated images, which were often coloured by hand; he employed this technique through the early 1960s.

He designed elements of the record covers for Ravel's *Daphnis and Chloe*, Tchaikovsky's *Swan Lake*, Chopin's *Nocturnes* and the cover of *Count Basie*. He became a frequent illustrator for the jazz record labels Blue Note and Prestige.

1956

Warhol attended what was probably his first opening night at the Metropolitan Opera; Maria Callas performed Bellini's *Norma*. He continued to be a season subscriber to the Metropolitan Opera for many years.

Warhol drawings were used as record covers for Mozart's *Divertimenti*, Jay Jay Johnson's *Trombone by Three* and Artie Shaw's *Both Feet in the Groove*.

A Warhol drawing was included in the exhibition "Recent Drawings USA" at the Museum of Modern Art.

He took a two-month world tour with Lisanby, focusing on Asia and Europe; during the trip, he attended performances of traditional music and dance throughout Asia and the opera in Italy.

He created a painting titled *Rock and Roll*.

1957

Andy Warhol Enterprises was legally incorporated.

1958

Warhol designed the record covers of Kenny Burrell's *Blue Lights Vol. 1 & 2*, for Blue Note, and Johnny Griffin's *The Congregation*; his mother designed the cover of Moondog's *The Story of Moondog*, which won an award from the American Institute of Graphic Arts.

He designed covers for *Opera News* and *Dance Magazine*.

He illustrated "The Homemade Orchestra" for Volume 7 of *The Best in Children's Books,* published by Doubleday Books.

1959

Warhol met filmmaker Emile de Antonio, who became an informal agent for his paintings.

1960

He acquired a townhouse at 1342 Lexington Avenue, which gave him the space needed to create larger artworks.

Warhol's stage designs appeared in performances of the Lukas Foss / Gian Carlo Menotti operetta *Introductions and Goodbyes* at the Festival of Two Worlds in Spoleto, Italy.

"I THINK JOHN CAGE HAS BEEN VERY INFLUENTIAL, AND MERCE CUNNINGHAM, TOO, MAYBE."

1961

He painted his first works based on comics and advertisements, using an opaque projector to enlarge the original image onto a canvas, which he then traced and painted.

He met Ivan Karp of Leo Castelli Gallery and Henry Geldzahler, curator of the Metropolitan Museum of Art.

He began attending avant-garde dance performances.

1962

He published *Cooking Pot*, the first of his edition prints, a photoengraving of a detail from a newspaper advertisement. In the following years, Warhol created over four hundred print editions.

He used rubber stamps to create *S & H Green Stamps* and other works, including portrait illustrations of orchestra conductor Loren Maazel and other cultural figures for *Harper's Bazaar*.

Warhol based his *Dance Diagram* paintings on illustrations from common dance instruction manuals.

He made paintings of entire newspaper front pages.

After creating a few series of works using hand-drawn silkscreens, he began to use the photo-silkscreen technique.

After silkscreening portraits of the teen idols Natalie Wood, Troy Donahue and Warren Beatty, Warhol began his photo-silkscreened *Marilyn* paintings after Marilyn Monroe's death.

Warhol's hand-painted *Campbell's Soup Can* paintings were shown at the Ferus Gallery, Los Angeles.

His recent paintings were shown at the Stable Gallery, New York.

He began his friendship with Robert Rauschenberg.

1963

He bought a 16mm movie camera.

He made the films *Sleep, Rollerskate* and *Tarzan and Jane Regained . . . Sort Of,* and the first of more than five hundred Screen Tests. Subjects of the Screen Tests include Bob Dylan, Donovan, Cass Elliot and other musicians, as well as dance and music critics.

He exhibited his *Elvis* and *Liz* paintings at the Ferus Gallery, Los Angeles.

He painted portraits of choreographer Merce Cunningham, based on photographs by Richard Rutledge that show the dancer performing his choreography *Antic Meet* (1958).

He attended a marathon performance of Erik Satie's *Vexations*, which was interpreted by ten pianists including John Cage, David Tudor and John Cale.

Jonas Mekas, director of the Film-Makers' Cooperative and film critic of the *Village Voice*, became an enthusiastic defender of Warhol's films.

He attended rock-and-roll concerts hosted by New York deejay Murray "The K" Kaufman. He sang back-up vocals in the rock-and-roll band the Druds; the other members of the short-lived group were Patty Oldenburg, Lucas Samaras, Walter De Maria and Larry Poons, with lyricist Jasper Johns.

Warhol rented an abandoned firehouse near his home to use as a painting studio.

He painted portraits of pianist Bobby Short, which are based on photographs made in photobooths; the same technique was used in other portrait paintings.

Warhol's photobooth pictures of cultural figures, including composer La Monte Young and flamenco guitarist Juan Serrano, were published in *Harper's Bazaar*.

He hired Gerard Malanga as his painting assistant; a student of poetry, Malanga had been a frequent dancer on a pop music television show.

He designed costumes for a Broadway production of James Thurber's *The Beast in Me*, but was not credited because he was not a union member; the commission occurred through his friendship with dancer John Butler, the show's choreographer.

"CLAES OLDENBURG AND PATTY OLDENBURG AND LUCAS SAMARAS AND JASPER JOHNS AND I WERE STARTING A ROCK AND ROLL GROUP WITH PEOPLE LIKE LA MONTE YOUNG AND THE ARTIST WHO DIGS HOLES IN THE DESERT NOW, WALTER DE MARIA. . . . WE MET TEN TIMES . . . I WAS SINGING BADLY."

1964

Baby Jane Holzer, Taylor Mead and Ondine (Bob Olivo) became his associates at about this time, and acted in his films. Warhol's first Superstars, they became synonymous with his work.

Sleep premiered on January 17, accompanied by pop music playing on a radio; this was the only time it was shown with a soundtrack.

Warhol commissioned musician Joel Forrester to tape-record an improvised jazz piano accompaniment for one of his silent films; Forrester later became the keyboardist for the Microscopic Septet.

He established his studio at 231 East Forty-seventh Street, soon to be known as "the Factory"; it was painted silver and covered with aluminum foil by Billy Name (Billy Linich), a theatre-lighting designer whom Warhol had met the year before.

He made the films *Eat*, *Empire*, *Jill Johnston Dancing* and *Harlot* (his first with live sound).

A Warhol film installation (consisting of short loops of *Eat*, *Kiss*, *Sleep* and *Haircut*) with a soundtrack by La Monte Young was exhibited at the New York Film Festival.

He bought an Auricon 16mm film sound camera

He received the Independent Film Award from *Film Culture*, the avant-garde film periodical edited by Jonas Mekas.

Baby Jane Holzer introduced Warhol to Mick Jagger of the Rolling Stones.

Warhol designed the record cover *Giant Size $1.57*, which was based on a collage by David Hays; the recording contains interviews with the ten artists in *The Popular Image Exhibition* at the Washington Gallery of Modern Art, Washington, DC.

Warhol's photobooth portraits of pianist and composer John Wallowitch—in which his face cannot be seen—served as the ironic record cover for *This is John Wallowitch!*

1965

He acquired his first tape recorder, which was to become his constant companion.

He made the films *Poor Little Rich Girl*, *Vinyl* (both with pop music playing in the background), *Camp*, *Paul Swan*, *The Life of Juanita Castro* and others.

He exhibited his video art, the first artist to do so.

While in Paris for the opening of his *Flowers* exhibition at the Galerie Ileana Sonnabend, Warhol described himself as a "retired artist" who planned to devote himself to film. He also met Nico for the first time.

The opening-night crowd was overwhelming at the first retrospective of Warhol's work at the Institute of Contemporary Art, Philadelphia.

Film producer Lester Persky hosted "The Fifty Most Beautiful People" party at the Factory; Judy Garland, Rudolf Nureyev, Tennessee Williams, Allen Ginsberg, Montgomery Clift and many others attended.

Ron Tavel, writer of many of Warhol's films at this time, offered his script *Piano*, a musical, but Warhol chose not to shoot it.

1966

He produced the Exploding Plastic Inevitable, multi-media shows featuring the Velvet Underground rock band, dance performances, films and light shows; Warhol travelled with the show throughout the country.

He co-designed with David Dalton an issue of *Aspen* magazine, which was devoted mainly to rock and roll.

At the Castelli Gallery, Warhol exhibited his *Cow* wall-paper in one room and filled a second, white-walled room with his floating *Silver Clouds*.

He made the films *Hedy*, *The Velvet Underground and Nico* and *The Chelsea Girls*.

He produced the first LP by the Velvet Underground and Nico and designed its cover, which incorporates a banana with vinyl skin that can be peeled off to expose the pink fruit; a larger fine-art print of this image was also produced.

The following advertisement appeared in the February 10 issue of the *Village Voice*: "I'll endorse with my name any of the following: clothing AC-DC, cigarettes small, tapes, sound equipment, ROCK N' ROLL RECORDS, anything, film and film equipment, Food, Helium, Whips, MONEY!! love and kisses ANDY WARHOL, EL 5-9941."

He gave away the bride at the Mod Wedding at Detroit's Michigan State Fairgrounds Coliseum; the event featured an Exploding Plastic Inevitable performance.

Warhol and his Superstars began to frequent the backroom of the notorious bar-restaurant Max's Kansas City on Union Square.

1967

Andy Warhol's Index (Book) was published.

Frederick W. Hughes began to work for Warhol; they had met at a benefit party for the Merce Cunningham Dance Company at which the Velvet Underground performed.

Superstars Joe Dallesandro, Candy Darling and Viva first appear in Warhol's films.

"I'M STILL FRIENDS WITH LOU REED, THE VELVET'S LEAD SINGER, WHO'S GONE ON TO BECOME A BIG STAR ON HIS OWN. IN FACT, I WANTED TO PRODUCE HIS HIT ALBUM, *BERLIN*, AS A MUSICAL COMEDY CO-STARRING LORNA LUFT. BUT IT DIDN'T WORK OUT BECAUSE IN THE MEAN-TIME LOU HAD DONE ANOTHER ALBUM CALLED *ROCK AND ROLL ANIMAL* AND WAS LIVING UP TO THAT TITLE. HE WEIGHED NINETY POUNDS, HAD JET-BLACK HAIR SHAVED IN THE SHAPE OF A STAR, SILVER FINGERNAILS, BLACK LEATHER CLOTHES— AND WOULD ONLY SEE ME ALONE. SINCE I DON'T WORK ALONE, THE PROJECT NEVER GOT OFF THE GROUND."

1968

In January, Warhol moved his studio to a white-walled office space on the sixth floor of 33 Union Square West.

On June 3, Valerie Solanas, who appeared in Warhol's film *I, A Man* and was the founder and sole member of SCUM (Society for Cutting Up Men), shot Warhol in his studio.

a: A Novel, a transcription of Warhol's tape recordings featuring Ondine, was published, by Grove Press.

His Silver Clouds were used as the set for Merce Cunningham's dance *Rainforest*.

A retrospective of Warhol's work was held at the Moderna Museet, Stockholm, and travelled throughout Scandinavia.

He designed the record cover of the Velvet Underground's *White Light/White Heat*.

In October, he hosted the release party for Nico's new album, *The Marble Index*.

1969

The first issue of *Interview* magazine was published.

Vincent Fremont began to work for Warhol; he became a close associate on video and television projects.

Warhol's design for the Rolling Stones album *Through the Past, Darkly* was not published.

1970

Warhol's production of commissioned portraits increased in the early 1970s; most were based on his Polaroid photographs of sitters, including collectors, friends and celebrities.

He acquired a portable video camera and began to work regularly with video.

A major retrospective of Warhol's work was held at the Pasadena Art Museum; the exhibition travelled to Chicago, Eindhoven, Paris, London and New York.

The first monograph on Warhol was published, written by art historian Rainer Crone.

Bob Colacello and Glenn O'Brien began to work for *Interview*.

Warhol purchased a building on Great Jones Street, intending to convert and operate it as a theatre, but the plan was never carried out.

"IMAGE IS SO IMPORTANT TO ROCK STARS. MICK JAGGER IS THE ROCK STAR WITH THE LONGEST RUNNING IMAGE. HE'S THE ONE ALL THE YOUNG WHITE KIDS COPY. THAT'S WHY EVERY DETAIL OF HIS APPEARANCE IS REALLY IMPORTANT."

1971

With Vincent Fremont and Michael Netter, Warhol began *Factory Diaries*, a series of videotaped recordings of life at the studio, including music performances by Eric Emerson with the Magic Tramps and Geri Miller.

He designed the cover of the Rolling Stones' *Sticky Fingers* in collaboration with Craig Braun; the cover, which showed a man in jeans and consisted of a real zipper, was nominated for a Grammy Award.

Warhol's play *Pork*, based on his tape recordings, was performed in London and New York. David Bowie attended the London performances, having already written his songs *Andy Warhol* and *Queen Bitch (For Velvets)*; three members of the cast later became the core of Bowie's production company, MainMan.

1972

Warhol removed the films he had directed from circulation.

Julia Warhola died in Pittsburgh; she had returned there from New York in 1971.

Warhol's design for John Cale's album *The Academy in Peril* won an award for graphic design.

1973

He made the videos *Vivian's Girls* and *Phoney*, co-directed with Vincent Fremont.

Ronnie Cutrone became Warhol's studio assistant; he had previously danced with the Exploding Plastic Inevitable.

1974

He began assembling Time Capsules in standard-sized boxes; this collection of ephemera, antiques and works of art from his entire life eventually numbered more than six hundred boxes.

He moved his studio to 860 Broadway, which became known as "the Office."

He acquired a townhouse at 57 East Sixty-sixth Street.

He discussed producing a stage version of Lou Reed's album *Berlin*.

Warhol's Superstars Holly Woodlawn and Jackie Curtis performed their *Cabaret in the Sky* at Reno Sweeney in New York.

1975

He made portraits of Mick Jagger and the *Ladies and Gentlemen* paintings, drawings and prints depicting transvestites.

The Rolling Stones rented Warhol's home on Long Island.

He made the video *Fight*, co-directed with Vincent Fremont.

He produced the musical *Man on the Moon*, directed by Paul Morrissey, with book, music and lyrics by John Phillips.

"THE TINA TURNER CONCERT WAS GREAT. I THOUGHT SHE WAS COPYING MICK JAGGER BUT THEN SOMEBODY TOLD ME *SHE* TAUGHT *HIM* HOW TO DANCE."

1976

He began dictating his diary to Pat Hackett, which was published posthumously and became a bestseller.

1977

He designed the record cover for the Rolling Stones' *Love You Live*.

He began to frequent the nightclub Studio 54 with friends Halston, Bianca Jagger and Liza Minnelli.

1978

He painted S*elf-portraits* with skulls, *Shadows* and *Oxidations*.

He designed the record covers for Liza Minnelli's *Live at Carnegie Hall* and John Cale's *Honi Soit*.

"THE SEX PISTOLS ARRIVED IN THE US TODAY. PUNK IS GOING TO BE SO BIG. THEY'RE SO SMART, WHOEVER'S RUNNING THEIR TOUR, BECAUSE THEY'RE STARTING IN PITTSBURGH WHERE THE KIDS HAVE NOTHING TO DO, SO THEY'LL GO REALLY CRAZY."

1979

Andy Warhol's Exposures, with photographs by Warhol and text co-written with Bob Colacello, was published by Andy Warhol Books / Grosset and Dunlap.

Warhol's *Shadows* paintings were exhibited at the Heiner Friedrich Gallery, New York.

Andy Warhol: Portraits of the Seventies was exhibited at the Whitney Museum of American Art, New York.

1980

He developed *Andy Warhol's TV*, directed by Don Munroe, for Manhattan Cable TV. Guests included Debbie Harry and Chris Stein of Blondie, Fred Schneider of the B-52s, Jim Carroll, David Johansen, Lenny Kaye, Ashford and Simpson, Lisa Robinson, the Peking Opera and Liza Minnelli. The show featured many of New York's current music clubs.

Popism: The Warhol Sixties, by Warhol and Pat Hackett, was published by Harcourt Brace Jovanovich.

A life mask of Warhol was made for a robot that was intended for an unrealized theatre project conceived by Peter Sellars and Lewis Allen.

He established the Earhole Productions record label.

1981

He produced and starred in three one-minute episodes of *Andy Warhol's TV*, directed by Don Munroe, for the late-night television program *Saturday Night Live*.

1982

He designed the posters and cover of the soundtrack for Rainer Werner Fassbinder's film *Querelle.*

He designed the record cover for Diana Ross's *Silk Electric* and Billy Squier's *Emotions in Motion.*

1983

Andy Warhol's TV was moved to the Madison Square Garden TV network, with new episodes commissioned by Peter Rudge, former tour manager of the Rolling Stones. Debbie Harry was an announcer, and guests on the new show included Duran Duran, Frank Zappa, Sparks, Sting and Andy Summers of the Police, Hall and Oates, and the Glades High School Marching Band.

Warhol, Jean-Michel Basquiat and Francesco Clemente began collaborating on paintings; Warhol and Basquiat became close friends and worked together into 1985.

Warhol began a series of works, many of them hand-painted, based on advertisements, commercial imagery and illustrations.

He designed the record covers of Miguel Bosé's *Made in Spain* and the Japanese band Rats & Star's *Soul Vacation.*

He appeared in a Japanese television commercial for TDK.

He made two music videos for Miguel Bosé, *Fuego* and *Angeli Cadutti*.

1984

He made a music video with Don Munroe for the Cars' *Hello Again*, which also featured Warhol.

He moved his studio, *Interview* magazine and video production facility to a former Consolidated Edison building at 22 East Thirty-third Street.

His portrait of Michael Jackson appeared on the cover of *Time* magazine, March 19.

Warhol's portrait of Prince appeared in *Vanity Fair*.

1985

He exhibited his *Invisible Sculpture*, consisting of a pedestal, a wall label and Warhol himself on a pedestal, at the nightclub Area; an earlier version consisted of motion detectors and alarms.

Andy Warhol's Fifteen Minutes, directed by Don Munroe, aired on MTV from 1985 to 1987. Guests included Courtney Love, Grace Jones, Bryan Adams, concert pianist Christopher O'Riley, Bo Diddley, Saqqara Dogs, rockabilly star Smutty Smiff, Das Furlines, the Fleshtones and others. There were also visits to New York's nightclubs, from the Apollo uptown to the Pyramid downtown.

Using a computer, Warhol did a portrait of Debbie Harry.

1986

He collaborated with Keith Haring on the official poster for the Montreux Jazz Festival.

He designed the record covers of John Lennon's *Menlove Ave.* and Aretha Franklin's *Aretha*. His *Camouflage* painting was used in the background of Debbie Harry's *Rockbird* record cover.

He worked on a cover for the Aretha Franklin / Keith Richards collaboration, *Jumping Jack Flash*, but it was not published.

He produced *Last Supper* and *Camouflage* paintings.

He made *Self-portrait* paintings, which were exhibited at the Anthony d'Offay Gallery, London.

"JEAN MICHEL WAS PICKING ME UP TO GO SEE MILES DAVIS AT THE BEACON . . . B. B. KING PLAYED FIRST AND HE'S JUST GREAT. AND THEN MILES DAVIS CAME OUT, BLOND, IN GOLD LAMÉ, AND HE PLAYS REALLY TERRIFIC MUSIC. HIGH HEELS."

"WILFREDO HAD GOTTEN TICKETS FOR PRINCE AT MADISON SQUARE GARDEN. . . . IT'S THE GREATEST CONCERT I'VE EVER SEEN THERE, JUST SO MUCH ENERGY AND EXCITEMENT. . . . HE WAS JUST GREAT, THAT IMAGE OF HIM BEING WEIRD AND ALWAYS WITH THE BODYGUARDS AND EVERYTHING WAS JUST DISPELLED . . . AND BILLY IDOL WAS THERE AND YOU KNOW, SEEING THESE TWO GLAMOUR BOYS, IT'S LIKE BOYS ARE THE NEW HOLLYWOOD GLAMOUR GIRLS, LIKE HARLOW AND MARILYN. SO WEIRD."

1987

He created an edition of portraits of *Beethoven*.

After suffering acute pain for several days, Warhol had gallbladder surgery at New York Hospital; the operation was successful, but complications during recovery led to his death on February 22. He is buried near his parents in St. John Chrysostom Byzantine Catholic Cemetery in Pittsburgh.

TO READ MORE . . .

ON ANDY WARHOL

Eva Meyer-Hermann, ed. *Andy Warhol: Other Voices, Other Rooms —A Guide to 706 Items in 2 Hours 56 Minutes*, exhib. cat. Rotterdam: NAi Publishers, 2008.

Suhanya Raffel, ed. *Andy Warhol*, exhib. cat. South Brisbane, Australia: Queensland Art Gallery / The Andy Warhol Museum, 2007.

Callie Angell. *Andy Warhol Screen Tests: The Films of Andy Warhol: Catalogue Raisonné,* vol. 1. New York: Harry N. Abrams / Whitney Museum of American Art, 2006.

Phaidon editors. *Andy Warhol. "Giant" Size.* London: Phaidon Press, 2006.

Clinton Heylin. *All Yesterday's Parties. The Velvet Underground in Print, 1966–1971.* Cambridge, Massachusetts: Da Capo Press, 2005.

Branden W. Joseph. "The Play of Repetition: Andy Warhol's Sleep," *Grey Room,* no. 19 (spring 2005), 22–53, and "'My Mind Split Open': Andy Warhol's Exploding Plastic Inevitable," *Grey Room,* no. 8 (summer 2002), 80–107.

The Andy Warhol Museum. *Andy Warhol 365 Takes: The Andy Warhol Museum Collection.* New York: Harry N. Abrams / The Andy Warhol Museum, 2004.

Kenneth Goldsmith, ed. *I'll Be Your Mirror. The Selected Andy Warhol Interviews.* New York: Carroll and Graf Publishers, 2004.

Georg Frei and Neil Printz, eds. *The Andy Warhol Catalogue Raisonné: Paintings and Sculptures, 1964–1969.* London: Phaidon Press, 2004, 2 vols.

Frayda Feldman and Jorg Schellman, eds. *Andy Warhol Prints: A Catalogue Raisonné, 1962–1987,* 4th ed. Revised and expanded by Frayda Feldman and Claudia Defendi. New York: Distributed Art Publishers, 2003.

Georg Frei and Neil Printz, eds. *The Andy Warhol Catalogue Raisonné: Paintings and Sculptures, 1961–1963.* London: Phaidon Press, 2002.

Michel Nuridsany. *Andy Warhol.* Paris: Flammarion, coll. "Grandes biographies," 2001.

Nat Finkelstein. *Andy Warhol: The Factory Years 1964–1967.* New York: Powerhouse Books, 2000.

Mark Francis, Margery King and Hilton Als, eds. *The Warhol Look,* exhib. cat. Boston; London: Bulfinch Press, 1997.

John O'Connor and Benjamin Liu, eds. *Unseen Warhol.* New York: Rizzoli, 1996.

Van M. Cagle. *Reconstructing Pop/Subculture: Art, Rock, and Andy Warhol.* Thousand Oaks, California: Sage Publications, 1995.

Stephen Shore and Lynne Tillman. *The Velvet Years: Warhol's Factory 1965–67.* New York: Thunder's Mouth Press, 1995.

Sally Banes. *Greenwich Village 1963: Avant-Garde Performance and the Effervescent Body.* Durham, North Carolina: Duke University Press, 1993.

Bernard Blistène and Jean-Michel Bouhours, eds. *Andy Warhol, cinéma,* exhib. cat. Paris: Centre Georges Pompidou / Éditions Carré, 1990.

Bob Colacello. *Holy Terror: Andy Warhol Close Up.* New York: HarperCollins, 1990.

David Bourdon. *Andy Warhol.* New York: Harry N. Abrams, 1989.

Kynaston McShine, ed. *Andy Warhol. A Retrospective*, exhib. cat. New York: The Museum of Modern Art, 1989.

Andy Warhol. *The Andy Warhol Diaries.* Edited by Pat Hackett. New York: Warner Books, 1989.

Patrick S. Smith. *Warhol: Conversations about the Artist.* Ann Arbor, Michigan: UMI Research Press, 1988.

John Coplans, Jonas Mekas and Calvin Tomkins. *Andy Warhol.* Greenwich, Connecticut: New York Graphic Society, 1970.

ON RELATED TOPICS

Roger Copeland. *Merce Cunningham: The Modernizing of Modern Dance.* New York: Routledge, 2004.

Tim Mitchell. *Sedition and Alchemy: A Biography of John Cale.* London: Peter Owen Publishers, 2003.

Georges Belmont, ed. *Marilyn Monroe and the Camera.* New York: Te Neues, 2000.

John Cale and Victor Bockris. *What's Welsh for Zen: The Autobiography of John Cale.* New York: Bloomsbury Press, 2000.

Mel Cheren, Gabriel Rotello and Brent Nicholson Earle. *My Life and the Paradise Garage: Keep On Dancin'.* New York: 24 Hours for Life, 2000.

Lou Reed. *Pass Thru Fire: The Collected Lyrics.* New York: Hyperion, 2000.

Debbie Harry, Chris Stein and Victor Bockris. *Making Tracks: The Rise of Blondie.* New York: Da Capo Press, 1998.

Anthony Haden-Guest. *The Last Party: Studio 54, Disco, and the Culture of the Night.* New York: William Morrow, 1997.

Hanif Kureishi and Jon Savage, eds. *The Faber Book of Pop.* London; Boston: Faber and Faber, 1995.

Peter Guralnick. *Last Train to Memphis: The Rise of Elvis Presley.* Boston: Little, Brown and Company, 1994.

Jane Feuer. *The Hollywood Musical,* 2nd ed. Bloomington: Indiana University Press, 1993.

Dan Graham. *Rock My Religion. Writings and Art Projects, 1965–1990.* Edited by Brian Wallis. Cambridge, Massachusetts: MIT Press, 1993.

Clinton Heylin. *From the Velvets to the Voidoids: A Pre-Punk History for a Post-Punk World.* New York: Penguin Books, 1993.

Anthony DeCurtis, ed. *Present Tense: Rock & Roll and Culture.* Durham, North Carolina: Duke University Press, 1992.

Peter Doggett. *Lou Reed: Growing Up in Public.* London; New York: Omnibus Press, 1992.

Michael C. Kostek. *The Velvet Underground Handbook.* London: Black Spring, 1992.

Richard Kostelanetz. *Conversing with Cage.* New York: Limelight, 1988.

Merce Cunningham. *Le danseur et la danse. Entretiens avec Jacqueline Lesschaeve.* Paris: Belfond, 1980.

PHOTO CREDITS

WORKS IN THE EXHIBITION

Akron Art Museum, Ohio: Cat. 93

Art Gallery of Ontario: Cat. 90

Courtesy of *Dance Magazine*: Cat. 376

Daros Collection, Switzerland: Cat. 78

Hirshhorn Museum and Sculpture Garden, Smithsonian Institution, Washington, DC. Photo Lee Stalsworth: Cat. 100

Courtesy *Interview Magazine*: Cats. 383, 385, 386, 388, 391, 392, 393, 393, 397, 398, 399, 400, 401, 402, 403, 405, 406, 407, 408, 409, 411

Milwaukee Art Museum. Photo Efraim Lev-er: Cats. 101, 102

Mugrabi Collection: Cats. 92, 107

The Montreal Museum of Fine Arts, Christine Guest: Cats. 1, 2, 3, 4, 6, 8, 9, 11, 12, 13, 14, 15, 16, 17, 18, 19, 20, 21, 22, 23, 24, 26, 28, 29, 30, 32, 33, 34, 35, 37, 38, 39, 40, 41, 42, 43, 44, 45, 46, 48, 49, 50, 56, 58, 73, 74, 410

Museu Berardo, Lisbon, Portugal: Cat. 116

Museum of Fine Arts, Boston: Cat. 104

Norton Simon Museum, Pasadena, California: Cat. 166

Photo Courtesy of Pennebaker Hedegus Films (PHFilms.com): Cat. 169

Rheinisches Bildarchiv Köln: 81

Collection Thaddaeus Ropac, Salzburg – Paris: Cats. 161, 163, 164

San Francisco Museum of Modern Art. Photo Ben Blackwell: Cat. 103

Sonnabend Collection: Cat. 83

© Tate Gallery / Andrew Dunkley: Cats. 80, 89

Vancouver Art Gallery: Cat. 165

Virginia Museum of Fine Arts, Richmond. Photo Katherine Wetzel: Cat. 94

© 2008 The Andy Warhol Museum, Pittsburgh, PA, a museum of Carnegie Institute. All rights reserved. Film stills courtesy of The Andy Warhol Museum: Cats. 170, 171, 172, 173, 174, 175, 176, 177, 178, 179, 180, 181, 182, 183, 184, 185, 186, 187, 188, 189, 190, 191, 192, 193, 194, 195, 196

© 2008 The Andy Warhol Museum, Pittsburgh, PA, a museum of Carnegie Institute. All rights reserved. Video stills courtesy of The Andy Warhol Museum: Cats. 197, 198, 199, 205, 206

Whitney Museum of American Art, New York: Cat. 79

FIGURES

[end pages and first page, pp. 287, 273]
© Hervé Gloaguen / Rapho

—

[pp. 8, 9, 273]
© Nat Finkelstein

[pp. 18–23]
Fig. 1: The Montreal Museum of Fine Arts, Christine Guest;
Fig. 2: © Bob Gruen / www.bobgruen.com;
Fig. 3: © MGM / Photofest

[pp. 24–29]
Figs. 1, 5: © Estate of Fred McDarrah;
Fig. 2: © Stephen Shore / Courtesy 303 Gallery, New York;
Fig. 3: The Andy Warhol Museum, Pittsburgh;
Fig. 4: Christopher Makos, 1981, www.christophermakos.com;
Fig. 6: © Patrick McMullan

[pp. 30–35]
Fig. 1: © Estate of Fred McDarrah;
Fig. 2: © Stephen Shore / Courtesy 303 Gallery, New York;
Fig. 3: Courtesy of Mary Hottelet

CHAPTER 1
TUNING IN

—

[pp. 42–47]
1: SONY-BMG Entertainment. Photo The Montreal Museum of Fine Arts, Brian Merrett;
2: The Andy Warhol Museum, Pittsburgh;
3: EMI Group Limited. Photo The Montreal Museum of Fine Arts, Christine Guest

[pp. 64–75]
4: The Andy Warhol Museum, Pittsburgh

[pp. 76–81]
Fig. 2: Bibliothèque nationale de France;
Figs. 3, 4: The Andy Warhol Museum, Pittsburgh

CHAPTER 2
SOUND AND VISION

—

[p. 97]
Oscar Bailey 1968. Reproduced courtesy of the Archives of the Merce Cunningham Dance Company

[pp. 98–103]
5: Collection Daros. Reproduced courtesy of the Archives of the Merce Cunningham Dance Company;
7, 8, 13, 15: © Nat Finkelstein;
10: Billy Name / OvoWorks, Inc;
11, 12, 14, 16, 17: © Steve Schapiro;
6, 9: © Stephen Shore / Courtesy 303 Gallery, New York

[p. 105]
Billy Name / OvoWorks, Inc.

[pp. 106–121]
28, 43: © Nat Finkelstein;
18, 30, 33, 34: Billy Name / OvoWorks, Inc.;
32, 41: David McCabe Photography;
19, 20, 21, 22, 23, 24, 25, 26, 27, 29, 31, 35, 37, 38, 39, 40, 42: © Stephen Shore / Courtesy 303 Gallery, New York;
36: The Andy Warhol Museum, Pittsburgh

[pp. 122–129]
Fig. 1: Reproduced by permission of Universal Music Group;
Fig. 2: Courtesy of Jamie Record Co., Philadelphia PA, special thanks to Frank Lipsius;
Fig. 3: EMI Group Limited;
Fig. 4: Warner Chapell Music;
Fig. 5: © 2008 The Andy Warhol Museum, Pittsburgh, PA, a museum of Carnegie Institute. All rights reserved. Film still courtesy of The Andy Warhol Museum;
Fig. 6: Robertson, Houston;
Fig. 7: Collection Daros, Switzerland

[pp. 130–135]
Fig. 2: Billy Name / OvoWorks, Inc.;
Fig. 3: The Andy Warhol Museum, Pittsburgh;
Fig. 4: © Evelyn Hofer, New York

CHAPTER 3
PRODUCER

—

[pp. 142–167]
67: Photo D. James Dee;
44, 45, 46, 47, 48, 49, 51, 52, 53, 54, 55, 56, 57, 58, 59, 61, 62, 63, 64, 65, 66: Nat Finkelstein;
50: © Estate of Fred McDarrah;
60: Billy Name / OvoWorks, Inc.

[pp. 168–173]
Figs. 2, 7: The Andy Warhol Museum, Pittsburgh;
Fig. 5: David McCabe Photography

CHAPTER 4
FAME

—

[pp. 186–191]
Fig. 6: © Stephen Shore / Courtesy 303 Gallery, New York;
Fig. 8: Photo Mischa Richter / ESP

[pp. 194–215]
68: Promotone B. V.;
69: The Andy Warhol Museum, Pittsburgh

[pp. 218–253]
70, 71, 72: Collection of Mr. Marc S. Dreir

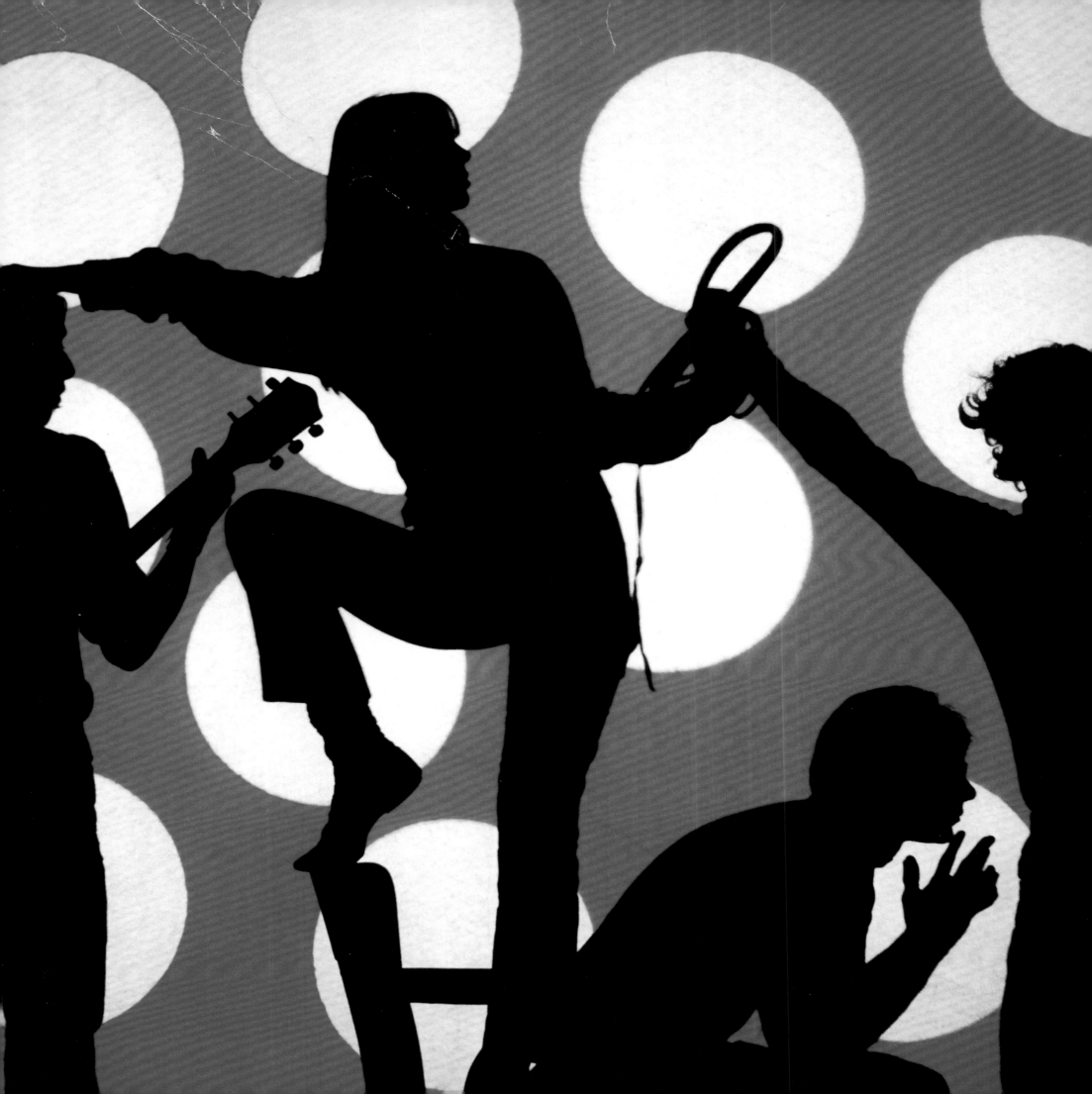

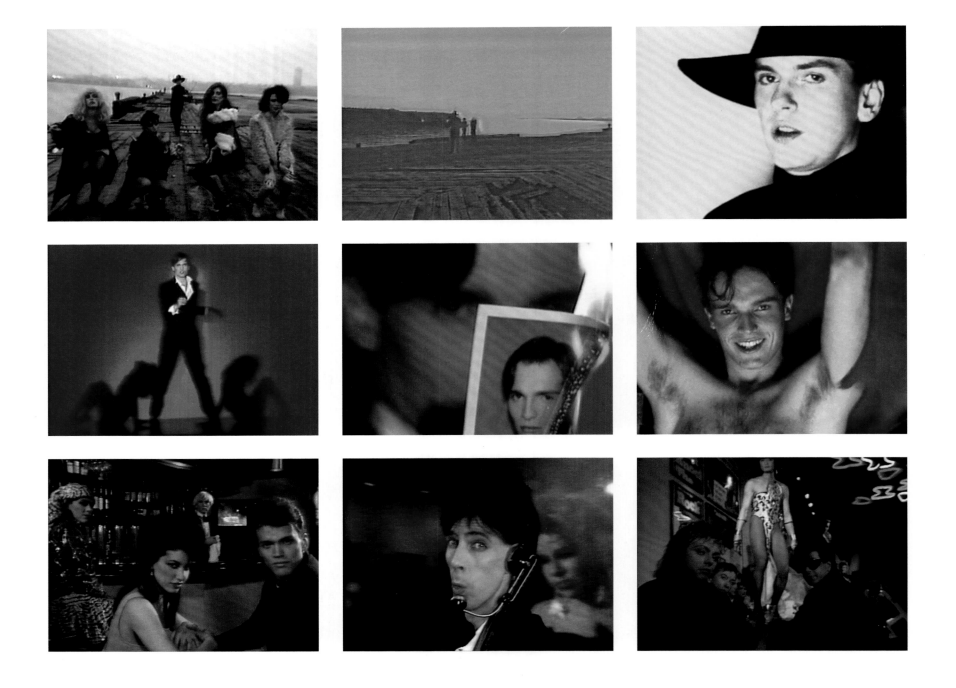

201

202

203

Preceding page: Andy Warhol and the Velvet Underground, 1966. Photo Hervé Gloaguen (detail) 201 – *The Secret Spy*, Andy Warhol TV Productions for Walter Steding on Earhole Records, 1981 202 – *Fuego*, Andy Warhol TV Productions
for Miguel Bosè, 1983 203 – *Hello Again*, Andy Warhol TV Productions for the Cars, 1984

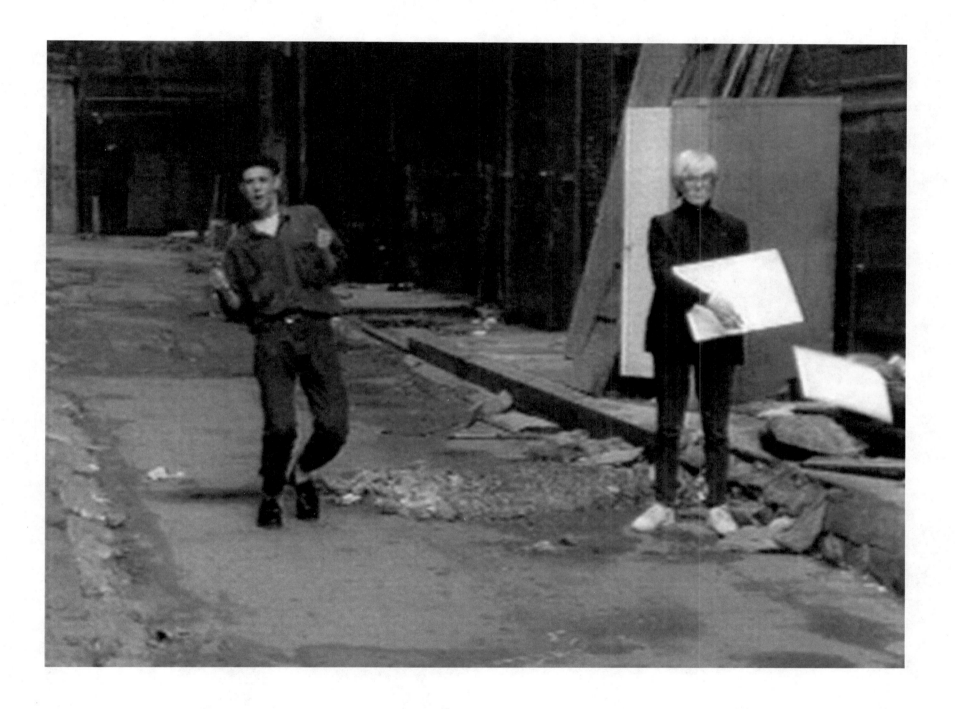

204 – *Misfit*, Andy Warhol TV Productions for Curiosity Killed the Cat, 1986 Following pages: **421** – Andy double tambourine, about 1966. Photo Nat Finkelstein (detail)

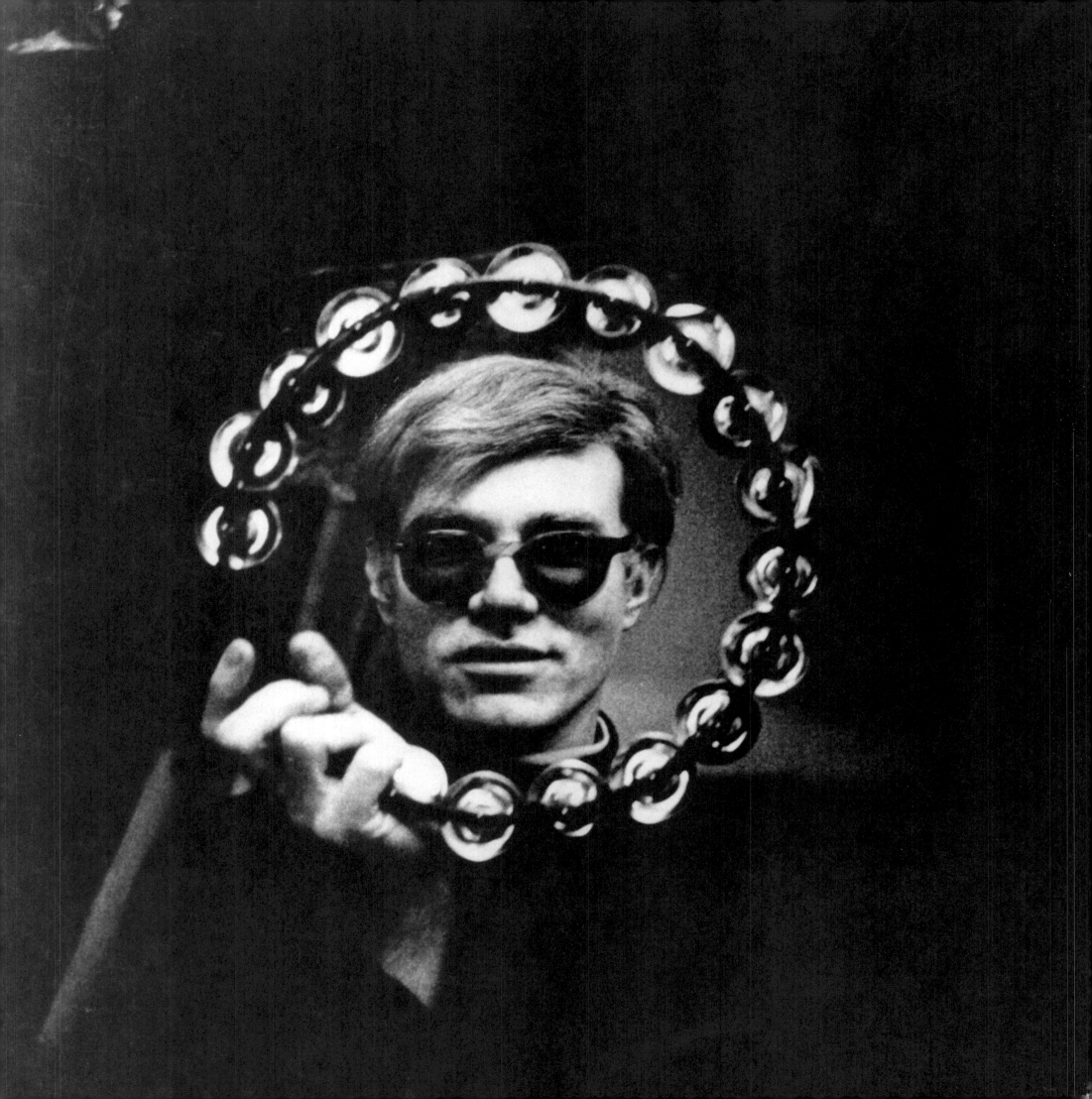